THE OXFORD HISTORY
OF ENGLISH ART

Edited by T. S. R. BOASE

THE OXFORD HISTORY OF ENGLISH ART

Edited by T. S. R. BOASE

President of Magdalen College, Oxford

Plan of Volumes

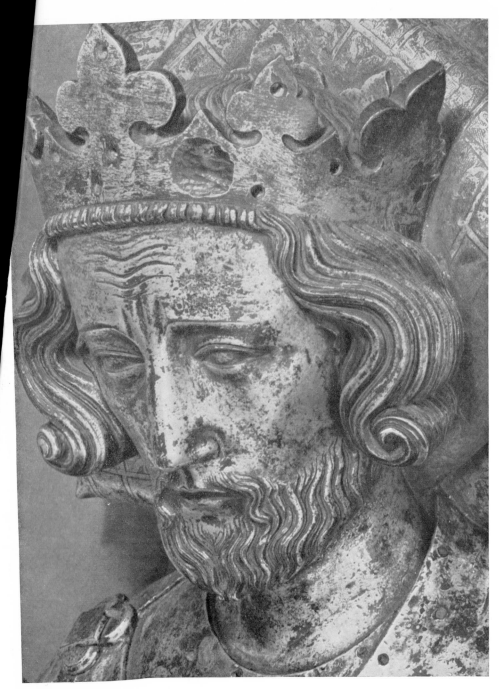

EFFIGY OF KING HENRY III
WESTMINSTER ABBEY

ENGLISH ART

1216–1307

PETER BRIEGER

OXFORD

AT THE CLARENDON PRESS

Oxford University Press, Ely House, London W.1

GLASGOW NEW YORK TORONTO MELBOURNE WELLINGTON
CAPE TOWN SALISBURY IBADAN NAIROBI LUSAKA ADDIS ABABA
BOMBAY CALCUTTA MADRAS KARACHI LAHORE DACCA
KUALA LUMPUR HONG KONG TOKYO

FIRST PUBLISHED 1957
REPRINTED LITHOGRAPHICALLY IN GREAT BRITAIN
FROM CORRECTED SHEETS OF THE FIRST EDITION
AT THE UNIVERSITY PRESS, OXFORD
BY VIVIAN RIDLER, PRINTER TO THE UNIVERSITY
1968

PREFACE

IT is more than twenty-five years ago that the great books on English Gothic Art were written. Since then High Gothic Art, once revered by the Romantics and the Victorians, has lost its hold, at least over scholars, who have tended to concentrate their studies upon the arts of the earlier or later middle ages. Minds in troubled times respond more easily to those periods of art which express similar conflicts and struggles, while a style which aims at classical perfection, such as that of the first half of the thirteenth century, seems remote in its serenity. Certain aspects of English thirteenth-century art have been freshly examined by G. Webb and M. Hastings for architecture, A. Andersson, C. J. P. Cave, and P. Wynn Reeves for sculpture, and F. Wormald for painting, but there are still many problems which require a new study. They could only be touched on lightly in this volume, which is built on the foundations laid by F. Bond, A. Gardner, M. R. James, E. Prior, and A. H. Thompson. The more recent monumental publication on wall painting by E. W. Tristram belongs to the same tradition. In my attempt to understand what lies behind the history of art in this period I am greatly indebted to Professor D. Knowles, 'The Religious Orders in England', and most of all to Sir F. M. Powicke in whose 'King Henry III and the Lord Edward' I found not only a wealth of information but an inspiring enthusiasm.

This book could not have been written without frequent visits to England and I owe a deep gratitude to President Sidney Smith of the University of Toronto and to Mr. Leslie Farrer-Brown of the Nuffield Foundation, who made this possible. The staff of the Department of Art and Archaeology, University of Toronto, gave its loyal and generous support by undertaking work which my leave of absence or visits to England prevented me from doing. I should also like to thank the librarians of the University Library of Toronto, of the Medieval Institute, and of the Pierpont Morgan Library for their assistance. While in England I met with the kindest response from the librarians of the Department of Manuscripts in the British Museum, the Victoria and Albert Museum, the National Buildings Record, the Society of

Antiquaries, Lambeth Palace, the Bodleian Library, and All Souls College at Oxford, the University Library, the Fitzwilliam Museum, and many of the colleges in Cambridge, especially Corpus Christi, St. John's, and Trinity. My visit to Malvern and the kindness of Dr. Dyson Perrins are among the most pleasant memories associated with my work, as are also the meetings with Professor Francis Wormald, who helped me with his advice. The greatest burden was carried by the Courtauld Institute where Miss Rhoda Welsford and Dr. George Zarnecki were always ready to answer questions and to smooth my path, and where Miss Ursula Pariser did much excellent photographic work for me.

Acknowledgements are due to the following for their generous permission to reproduce photographs of works of art in their possession: the Most Reverend the Archbishop of Canterbury and the Church Commissioners; the Dean and Chapter of Westminster Abbey; the Bishop of Chichester; the Dean and Chapter of Durham Cathedral; His Grace the Duke of Rutland; Sir Chester Beatty; Dr. C. W. Dyson Perrins; Dr. E. G. Millar; the British Museum; the Victoria and Albert Museum; the Bibliothèque Nationale, Paris; the Bodleian Library; the Cambridge University Library; the John Rylands Library, and Chetham's Library, Manchester; the Library of Trinity College, Dublin; the Society of Antiquaries; the Fitzwilliam Museum, Cambridge; the Pierpont Morgan Library, New York; the Walters Art Gallery, Baltimore; and the governing bodies of All Souls College, Oxford; New College, Oxford; Corpus Christi College, Cambridge; Emmanuel College, Cambridge; St. John's College, Cambridge; Trinity College, Cambridge; and Eton College.

Miss C. Tooth, Miss E. Burson, and Miss J. W. Nash were very helpful in various ways. Professor G. S. Vickers, University of Toronto, and Dr. E. O. Blake, University of Southampton, read the whole manuscript and contributed by critical argument and valuable hints. Above all, the patience, judgement, and advice of the editor were a firm support and I should like to regard this volume as a tribute to him.

P. H. B.

Toronto, 1955

CONTENTS

LIST OF PLATES

(The measurements of the manuscripts are the size of the page unless otherwise stated)

Frontispiece: EFFIGY OF KING HENRY III: WESTMINSTER ABBEY. *Photograph by courtesy of the Warburg Institute.*

AT END

68 *a.* BOOK OF PSALMS WITH COMMENTARY. Durham Cathedral, MS. A. II. 10: initial to Ps. 52: f. 122ᵛ. [15½ × 10⅓ in.] *Photograph by Victoria and Albert Museum, Crown copyright reserved.*

 b. PSALTER. Coll. E. G. Millar, Esq., f. 95: JUDITH AND HOLOFERNES. [13⅞ × 9⅜ in.] *Photograph by courtesy of the Courtauld Institute of Art.*

69. YORK MINSTER: 'FIVE SISTERS' AND CHAPTER-HOUSE. *Photograph by K. le Green.*

70 *a.* BINHAM PRIORY: WEST FRONT. *Photograph by National Buildings Record.*

 b. NETLEY ABBEY. *Photograph by Ministry of Works, Crown copyright reserved: reproduced by permission of the Controller of H.M. Stationery Office.*

71. LINCOLN CATHEDRAL: THE ANGEL CHOIR. *Photograph by Miss M. F. Harker.*

72 *a.* SALISBURY CATHEDRAL: CHAPTER-HOUSE. *Photograph by A. F. Kersting.*

 b. SOUTHWELL MINSTER: CHAPTER-HOUSE. *Photograph by National Buildings Record.*

73 *a.* LICHFIELD CATHEDRAL: THE NAVE. *Photograph by courtesy of the Courtauld Institute of Art.*

 b. HEREFORD CATHEDRAL: NORTH TRANSEPT. *Photograph by Walter Scott.*

74. LINCOLN CATHEDRAL: ANGELS FROM ANGEL CHOIR. *Photographs by National Buildings Record.*

75 *a.* OSCOTT PSALTER. Dyson Perrins Coll. MS. 11, f. 16ʳ: APOSTLE. *Photograph by courtesy of the Courtauld Institute of Art.*

 b. LINCOLN CATHEDRAL, JUDGEMENT PORCH: VIRTUES. *Photograph by National Buildings Record.*

76. WESTMINSTER ABBEY: EFFIGIES.

 a. QUEEN ELEANOR.

 b. WILLIAM OF VALENCE. *Photographs by courtesy of the Warburg Institute.*

77 *a.* CLIFFORD, HEREFORDSHIRE: WOODEN EFFIGY OF PRIEST. *Photograph by courtesy of the Courtauld Institute of Art.*

 b. HEREFORD CATHEDRAL: EFFIGY OF JOHN SWINFIELD. *Photograph by the late F. H. Crossley.*

78 *a.* ANAGNI COPE: DETAIL. *Photograph by Archivio Fotograf. Gall. Mus. Vaticani.*

 b. CLARE CHASUBLE: VIRGIN AND CHILD. *Photograph by Victoria and Albert Museum, Crown copyright reserved.*

LIST OF FIGURES

ABBREVIATIONS

Antiq. Journ.	*Antiquaries Journal*
Archaeol.	*Archaeologia*
Arch. Journ.	*Archaeological Journal*
B.M.	British Museum
Burl. Mag.	*Burlington Magazine*
Cal. Close Rolls	*Calendar of Close Rolls, 1216–72*
Cal. Lib. Rolls	*Calendar of Liberate Rolls, 1226–51*
C.C.C.	Corpus Christi College
E.H.R.	*English Historical Review*
Journ. Brit. Arch. Ass.	*Journal of the British Archaeological Association*
Journ. R.I.B.A.	*Journal of the Royal Institute of British Architects*
O.H.E.A.	*Oxford History of English Art*
R.C.H.M.	*Royal Commission on Historical Monuments*
R.S.	Rolls Series
V.C.H.	*Victoria County History*

I

THE EPISCOPAL STYLE

What was the house of the Lord in the castle but the Ark of the Covenant
In the temple of Baal—each place was a prison.
Zion was a prisoner in Jericho, Jerusalem in Babylon;
Jericho and Babylon both alike fell to ruin:
Then they seemed changed, Zion and Jerusalem,
They that before were sad, both now were joyful.

IN 1220 the body of St. Thomas was brought to his shrine in
the new choir at Canterbury. In the same year the canoniza-
tion of St. Hugh of Lincoln was granted by the pope and the
cathedral of Salisbury removed from Old Sarum was begun on a
new site. A new era in the history of the English church had begun
as well as a new chapter in the history of the arts. It coincided with
the beginning of the reign of Henry III, who was crowned in 1220
at Westminster abbey, but during the first twenty-five years of his
reign the king played more a watching than an initiating role,
observing and assisting the new building activity, which brought
great changes to many of the ecclesiastical buildings of the Anglo-
Norman period and established a new style in England.

The roots of this new style reached back into the later part of
the twelfth century, but the reign of King John (1199–1216), with
all its troubles, had not been favourable to any rapid growth,
checked as it was by the Interdict, the absence of most of the
bishops, financial difficulties, and the general state of insecurity. In
the end the delay proved to be beneficial to the arts, giving time
for the clarification of the new principles involved so that they
could be applied with vigour and unity of purpose during the
following twenty-five years.

The poem which was written probably by the court poet, Henry
D'Avranches, to commemorate the moving of the cathedral from
Old Sarum to Salisbury appealed in its closing lines to the three
main forces which were responsible for the completion of the
new structure: the king's virtue, the bishop's devotion, and the

workmen's faith (*regis virtus—presulis affectus—artificium fides*).[1] Of
these the bishop's devotion was the primary driving power in this
period of the 'golden age of English churchmanship'. It will never
be possible to ascertain what part the bishops personally played in
the designing of the new fabrics, how much of guidance was in the
hands of the chapter, and not least how much was due to the genius
of the leading mason. But the group of enlightened bishops who
guided the church during the first part of Henry III's reign were
the patrons of a new art which was the expression of their clear
and elevated concept of the church's function.

With the exception of Hugh of Northwold, bishop of Ely (1229–
54), all the other bishops, during whose term of office the main
buildings were erected, were members of the secular clergy, born
in the last quarter of the twelfth century and now in their prime of
life. Some, like the two brothers, Jocelin of Wells (1206–42) and
Hugh II of Lincoln (1209–35), Walter de Gray, archbishop of
York (1215–55), Ralph Neville, bishop of Chichester (1224–44),
were experienced in matters of state, servants of the crown as well
as of the church, who had played under the leadership of Stephen
Langton an active part in the shaping of policies during the
troubled times of John. Others were primarily learned men with a
university training, scholars and theologians, like Richard Poore of
Salisbury (1217–28) and Durham (1228–37), Roger Niger, bishop
of London (1229–41), William of Blois, bishop of Worcester
(1218–36), Robert Grosseteste, bishop of Lincoln (1235–53).[2] They
were bound by common interests and policy, eager to put their
dioceses in order and to carry out the decrees of the Lateran
Council of 1215. If the realities of politics and human failings made
the work of reform often one of frustration and recurrent struggles,
their ideals could at least be made visible in the arts in an un-
blemished and lasting form. The stylistic phase commonly called
the 'Early English' has thus a fair claim to be called the 'Episcopal',

[1] A. R. Malden, 'A Contemporary Poem on the Translation of the Cathedral from
Old to New Sarum', *Wilts. Arch. Soc. Mag.* xxx (1898), 210. The book containing
the poem was given to St. Albans by Matthew Paris, who quoted some lines in the
Chronica Majora, R.S. lvii (1876), iii, 189, 391.

[2] M. Gibbs and J. Lang, *Bishops and Reform, 1215–1272* (1934).

whatever part the chapters, secular or monastic, had in shaping it. If the bishops were hampered in their actual reform of human behaviour, they were free to erect a new Jerusalem on earth in the new churches and their fittings. The Salisbury poem likened the joyfulness of the new Salisbury to that of Zion and Jerusalem when delivered from the bondage of Jericho and Babylon, and for a short span, as short as that during which Phidias or Raphael worked, a spirit of optimism carried the aspiring arts to a state of perfection in which heaven and earth were at peace.

The leadership was in the hands of the secular clergy and had its strongest effect on the secular cathedrals.[1] The whole of Salisbury and the greater portion of Lincoln are completely of this period. The new cathedral at Wells, begun late in the twelfth century, was completed as evidence of the supremacy of secular Wells over monastic Bath. The rebuilding of Exeter cathedral was begun, and Archbishop de Gray fostered important new structures at the secular minsters of his province of York. Of the monastic cathedrals, those of Durham, Worcester, and Ely received only new choirs, as had those at Canterbury, Rochester, and Winchester late in the twelfth and early in the thirteenth centuries; but where monastic chapters, of whatever order, altered their churches as at Benedictine Pershore and St. Albans or Cistercian Rievaulx and Fountains, they built simpler variations of the 'episcopal' style.

It was a truly English formulation of Gothic art, adapted to the peculiar needs and conceptions of the English secular clergy. The decision to remove the cathedral of Old Sarum was based partly on practical grounds such as the lack of water on the hilly site, but other reasons were more important. The poet compared the position of the old cathedral within the confines of the royal castle to that of the Ark of the Covenant in the temple of Baal. Bishop Richard aimed at the separation of the clerics from the laity as represented by the inhabitants of the castle, breaking their chains asunder and hurling away the yoke ('A laicis equidem clerum dimovit, eorum vincula disrumpens proiciensque jugum'). The

[1] For the reorganization of the secular cathedrals and their role in the thirteenth century see K. Edwards, *The English Secular Cathedrals in the Middle Ages* (1949).

reforming bishops endeavoured to define and to establish firmly the position of the English church in relation to the crown and to the papacy. The church which they tried to establish had a strong national bias in which respect for the office of the pope and loyalty to the universal church were balanced carefully against a strong consciousness of the rights of the English church. In the same way the 'episcopal' style is an English version of the Gothic that had developed internationally in western Europe during the second half of the twelfth century, and had already produced local versions in the choirs of Canterbury, Wells, Ripon, and Tynemouth.[1] The loss of Normandy and the threat of invasion from France were bound to strengthen the tendency to find a national version of the new Gothic more strongly tied to Anglo-Norman tradition. When William of Sens was entrusted with the rebuilding of Canterbury choir, he was not given a free hand by the monks, who were anxious to preserve as much as possible of the building in which St. Thomas had suffered martyrdom. They may have sighed with relief when William the Englishman took over and finished the choir along lines which in many respects were followed by the new buildings after 1220.

The work of greatest quantity and highest quality was concentrated in a belt stretching diagonally from Wells to Salisbury and through the vast diocese of Lincoln between the middle Thames and the Humber. The main offshoots of this region were located at Worcester and in Yorkshire. The oolite ridge which runs from Portland to the neighbourhood of Lincoln provided excellent building stone, while other building materials only second in quality were available in the other districts.

The designing of the ground plan of the new choirs was in itself a reform which revised older customs in order to relate the layout of the church to the reformed and clarified rites. A number of factors combined to cause the desire for an extension of this most important part of any church. In the majority of Anglo-Norman cathedrals and abbeys the part east of the main transept was never long enough to house the choir. In consequence, the stalls extended westward into the crossing and into the first or second bay of the

[1] T. S. R. Boase, O.H.E.A. iii (1953), Chap. ix.

nave. The main screen, the pulpitum, which separated the liturgical choir from the nave, was an artificial insertion into the uniform architectural design of the bays of the nave from the west end to the crossing. It merely cut off rather arbitrarily as much space as was required for the choir. At the same time it had the advantage that the members of the choir could enter into their reserved portion directly from the east walk of the cloisters south of the transept, without crossing the nave west of the screen. This old arrangement was retained in spite of the new eastern extensions in the monastic cathedrals of Worcester and Ely and in the abbeys of Fountains and Westminster, but at Salisbury, Lincoln, Wells, and Lichfield, as well as in the Yorkshire minsters, the stalls were moved eastwards and the entrance through the screen was placed between the eastern piers of the crossing. The main transept thus became a proper vestibule of the choir, and the liturgical choir was at last in harmony with the main architectural divisions.

As the main transept now served as a vestibule for the whole of the choir, the second eastern transept fulfilled the same function for the sanctuary with the high altar. Since the new choir at Canterbury, as well as that of St. Hugh at Lincoln, had been laid out with a short eastern transept, it became a common feature of the new choirs at Salisbury, Worcester, and the northern minsters. It was due to the influence of Worcester that it was adopted by the abbey of Pershore. In the north such a transept usually projected only by one bay with, beyond, an eastern chapel as at Southwell, Beverley, and Worcester. The omission of the eastern chapel at Fountains and Durham was an exception. In most cases the second transept was provided with an eastern aisle divided into chapels, and in many cases the main transept also was limited to an eastern aisle. The western aisle of the Anglo-Norman plan, retained at Ely, Winchester, and St. Paul's and still used at Wells at the end of the twelfth century, went out of use even at Salisbury, which in this point did not follow the plan of Old Sarum. It was not deemed suitable for chapels, the altars of which could not be orientated towards the east.

This strict adherence to correct orientation caused also the most characteristic English modification of the eastern end. After the

builders of Canterbury and Lincoln choirs had chosen the round
or polygonal apse with encircling ambulatory and three radiating
chapels, this type was accepted generally, but with a modification
so typically English that examples outside England are exceedingly
rare: the squaring of the east end. If the Cistercians preferred the
squaring of the apse, ambulatory, and chapels their plan was not a
new idea in England. The foundations of the choir which Bishop
Roger (1107–39) had given to Old Sarum show this English ver-
sion of the ambulatory type in a cathedral church in Norman
times. Its example was taken up at Winchester and Chichester at
the turn of the century. After the new church at Salisbury had its
choir laid out along similar lines it became universally accepted,
just as the new constitution which Bishop Poore gave to his diocese
became a model for diocesan constitutions used by the bishops
elsewhere.[1] The square east end may not have the same flexibility
and compactness as the chevet of the French cathedrals of the
period, but it had, with its avoidance of curves and diverging
radii, a lucidity and logic of its own in the order of its component
parts.

Traditions of the pre-Conquest English church and the example
set by the choir built in honour of St. Thomas both contributed
to another feature in planning. After William the Englishman had
built the saint's chapel for the shrine of St. Thomas behind the
main choir at Canterbury, the setting up of such a chapel and
shrine behind the sanctuary became the custom for all larger
churches which owned important relics and thus were centres of
pilgrimage. The translation of Anglo-Saxon saints to new shrines,
a movement which had begun in the second half of the twelfth
century after the canonization of St. Thomas in 1174, gained full
impetus after his translation into his chapel in 1220. Translations
and rededications, the creation of new saints by papal or locally
accepted canonizations, seem to have formed part of a national
scheme worked out by bishops and abbots and supported by the
king.[2] Although the attraction of pilgrims was part of a financial
scheme to augment the building funds, the new shrines in all their

[1] M. Gibbs and J. Lang, *Bishops and Reform*, 108.
[2] E. W. Kemp, *Canonisation and Authority in the Western Church* (1948).

splendour could not fail to give fresh life to the people's devotion and to their loyalty to the English church. The principal shrines, which were all carefully marked on one of the maps by Matthew Paris, were on or near the main roads which converged from the south-west, the midlands, and the north towards London from where the pilgrims could proceed to Canterbury. Only the west was not yet drawn fully into the scheme, and most of its shrines were of a later date.

The discovery and translation of saintly bodies occurred most frequently in the last two decades of the twelfth century and in the beginning of the next:[1] St. Amphibalus at St. Albans in 1178 and 1186, St. Frideswide at Oxford in 1180, St. Felix, St. Ethelred, and St. Ethelbert at Ramsey in 1192, St. Guthlac at Crowland about the same time, St. Edmund at Bury St. Edmunds in 1198, St. John at Beverley in 1193, St. Oswin at Tynemouth about the same time, St. Swithin at Winchester after 1202. In 1203 St. Wulfstan of Worcester, the last of the Anglo-Saxon bishops, was canonized, and in 1226 St. Osmund was translated from Old Sarum to Salisbury. All this seems to suggest an intentional revival of the fame of those who had laid the foundation of the English church. But in the meantime this church had produced two new saints: St. Thomas and St. Hugh. Two cathedrals which were dedicated to apostles, St. Peter at York and St. Andrew at Rochester, and which could not claim the bodies of their patrons, sought to rival Canterbury and Lincoln. At Rochester William, the pious baker from Perth, who had accidentally been murdered on his way to Canterbury in 1201, was acclaimed martyr and saint in 1206, and for York Archbishop de Gray obtained the admission to the Calendar of Saints of his predecessor William of York (d. 1154), buried in the nave of York minster.

With few exceptions the new shrines, at least of the major saints, were placed after the model of that of St. Thomas in a specially prepared retro-choir behind the sanctuary, which formed at the same time part of the ambulatory by which the pilgrims could approach the feretory without disturbing the choir services, and through which they could pass to reach the eastern chapels with

[1] T. S. R. Boase, O.H.E.A. iii, 256.

their altars. The shrines thus stood between the high altar and the easternmost altar which, at least in the province of Canterbury, was placed in an eastern projecting chapel.

It is often held that the increasing popularity of the cult of the Virgin Mary, which had started in the second half of the twelfth century, caused the building of a lady chapel at the easternmost end, opening out of the retro-choir; but the problem is not as simple as that. The building of a lady chapel in such a position was not common usage throughout England at this time, and was in fact hardly known in the northern province. When Bishop Pudsey began to add a lady chapel at the east end of Durham cathedral, cracks in the walls prevented its completion and the lady chapel had to be transferred to its unusual position at the west front.[1] The story that St. Cuthbert's dislike of women prevented the building of a chapel dedicated to the Virgin so close to his shrine may indicate the general feeling prevailing in this area and this may have been a heritage of the Scottish mission. The refusal to build such a chapel extended as far as Worcester in the west, and Ely, and later Lincoln, in the east. All choirs rebuilt in this area received the so-called eastern front in which choir, eastern transept, and retro-choir were the same height.

The alternative to the eastern front was the east end with projecting eastern chapel, of which there were two types. The one was introduced by the 'Corona' at Canterbury.[2] There the altar was dedicated to the Holy Trinity, and although it became customary to apply the term lady chapel to almost all easternmost pro-

[1] T. S. R. Boase, O.H.E.A. iii, 226.

[2] R. Wallrath, 'Zur Bedeutung der mittelalterlichen Krypta (Chorumgang und Marienkapelle)' in Beiträge zur Kunst des Mittelalters: Vorträge der ersten deutschen Kunsthistoriker Tagung (Schloss Bruehl, 1948). According to Wallrath, the customary site for the altar dedicated to the Virgin from the ninth century on was in a hall-crypt beneath the eastern choir, unless the main altar above was dedicated to her. This had been the position of the lady altar in the earlier choir at Canterbury ('crypta sanctae Virginis Mariae'). But there were other cases in which an outer crypt was added to the east end in order to accommodate the lady altar. It was out of this outer crypt that the lady chapel seems to have developed. At Halberstadt in 974 a two-storeyed outer crypt had been dedicated which housed the altar of Our Lady in the lower storey and the altar of the Trinity above. This was the arrangement followed at Canterbury after 1174, where the Corona had the lady altar in the crypt and the Trinity altar above.

jecting chapels, their altars were not always dedicated to the Virgin, but more often to the Holy Trinity.[1] This did not prevent the mass to the Virgin on Saturday being celebrated in the easternmost chapel as at Salisbury, where this chapel contains the altar of the Holy Trinity and All Hallows, while the high altar was dedicated to the Blessed Virgin. The Corona at Canterbury was in its lower portions connected with the ambulatory, but in its upper part it was detached from the main body of the choir. It rose to a greater height and was covered with its own roof. This type of separate chapel partly joined to the main body, but with a square end, was used in the late twelfth century at Hereford cathedral, most likely at Westminster abbey in 1220, and probably also at Gloucester, although here the lady chapel is now lower than the choir. The other type of lady chapel seems to have originated in the area which once comprised old Wessex. It was considerably lower than the choir itself, but usually of the same height as the retro-choir from which it projected eastward with a narrower span. This was the arrangement at Winchester, Exeter, presumably at Wells, and at Salisbury.[2]

[1] Against the refusal of Rome to establish a separate festival for the Holy Trinity, Beckett prescribed the first Sunday after Whitsun as Trinity Sunday to be observed by all churches in his province. 'This was the day of his consecration as archbishop. He had celebrated his first mass in the Trinity chapel of Prior Conrad's choir and he used it constantly for private prayer. The great martyr was closely connected in the popular mind with the doctrine of the Trinity.' F. Bond, *Dedications and Patron Saints* (1917), 4.

[2] The square east end with eastern aisle and projecting low lady chapel seems to have been first used at Old Sarum by Bishop Roger. From there it was copied at Wells, where according to Prior an eastern lady chapel projected. This plan of the two secular cathedrals, Old Sarum and Wells, was adopted by Benedictine Glastonbury about 1190. Many of the larger Benedictine abbeys in the province of Canterbury added low lady chapels to their older apses in the first half of the thirteenth century, as for instance Malmesbury, Sherborne, Gloucester, and Chester. But the three large eastern Benedictine monasteries at Bury St. Edmunds, Ely, and Peterborough did not follow suit. At Ely, at the end of the century, the altar of Our Lady was still in the south aisle of the presbytery. This resulted in such disturbance to the monks from lay people, and especially from women who flocked to that altar, that Bishop Ralph Walpole in 1300 ordered that it should be screened off. S. J. A. Evans, 'Ely Chapter Ordinances and Visitation Records 1241–1515', *Camden Misc.* xvii (1940), 23: 'Item ne frequens accessus secularium et maxime mulierum contemplacionem impediat monachorum, statuimus et ordinamus quod inter altare beate virginis et vestiarium statim erigatur, per

The churches which were erected upon these reformed plans
were designed in a style which was derived in its main lines from
the first Gothic at Canterbury and Lincoln. There the new prin-
ciples of Gothic construction had been carefully grafted on to a
traditional concept dating from the Anglo-Norman period, with-
out carrying through the transformation from Romanesque into
Gothic as logically and thoroughly as it had been done in France.
All the new means, developed in France in the second half of the
twelfth century to overcome the inert massiveness and sombre
heaviness of the Romanesque, had been tried by English builders,
though reluctantly at times: the pointed arch, the rib vault with its
system of outer abutment, the increase of size in the windows.
But the context in which they were used in the 'episcopal' style was
basically different from French custom, and in some ways even less
progressive than at Wells and Canterbury. English builders found
their own manner of achieving lightness and light, articulate flexi-
bility and elastic firmness, without reaching as high towards heaven
and without sacrificing the appearance of common-sense stability.

The most characteristic feature of this phase of English Gothic
was the retention of the triforium storey between the nave arcade
and the clerestory as an intermediate but a self-contained part in
the interior elevation. Its height in proportion to the other two
storeys varied and it was no longer lighted by windows as at
Canterbury, but it was not reduced to a low blind screen as at
Rheims and Chartres, except in rare cases as at Chester St. John
and Southwark, where it was built with a wall passage, or at
Beverley and Worcester, where no passage was provided. Its con-
tinued popularity was partly due to the example of the new choir
at Canterbury, partly to the wish to blend the new interiors with
the older parts when only the choir was rebuilt, as at Ely and
Worcester, or to fashion the new structure upon that of its pre-

quod imposteram obloquendi malum materia abscidatur, et omnis cesset occasio ex
talibus delinquendi.'

It was only early in the fourteenth century that in these three abbeys separate large
lady chapels were erected which were attached to the east side of the northern transept.
At the church of the Cluniac priory at Thetford a square-ended lady chapel was built
on the north side of the presbytery early in the thirteenth century (*Ministry of Works
Guide* (1949)).

decessor as at Salisbury. But it had decisive consequences through-
out. On the exterior it allowed the builder to maintain the unity
of wall and contour, which in France had been sacrificed to the
pinnacled buttress and the flying arch. While at Canterbury and
Chichester the flying arch had made a modest appearance, it was
not used again except at Lincoln, Beverley, and Ely before West-
minster abbey. The buttresses were built with greater projection in
order to give a stronger relief to the walls, but the thrust of the
vaults was carried chiefly by the arches which were concealed under
the roof of the triforium storey and the thick clerestory wall. In the
interiors the increased stress on the horizontal continuity of the
triforium chamber masked the organic union of nave pillars and
ribbed vault. The main supports in all the new churches became
lighter and more articulated, composed of groups of columns and
shafts which varied in number, whether they were slender Purbeck
marble shafts or sturdier stone columns as was more common in the
north. But there was a decided reluctance to connect the pillars
with the vaulting shafts, although this had occurred in the first
phase in the two western bays of Worcester, at Rochester choir,
and later at Southwark, where the shafts rose from the ground,
and at Canterbury they started from the abaci of the main
pillars. Elsewhere the vaulting shafts begin at varying levels; at
Wells and at Salisbury in the spandrels of the triforium; in the
north almost at the main pillars, but still caught by corbels in the
spandrels of the main arcade, as at Rievaulx, Fountains, Beverley,
York, and at Ely, Lincoln, and Worcester.

The vault itself never rose as high as in France, and the interiors
retained an appearance of broad spaciousness. The spring of the
vault was placed either in the spandrels of the triforium as at
Lincoln, or at the clerestory sill. Only at Beverley and at Fountains
was it placed high, about half-way up the clerestory. The deep,
nearly square sexpartite bays of Canterbury and the Lincoln tran-
septs disappeared, and the narrower bay with normal quadripartite
vaults and level crown became the rule until 1250. But although
the rib vault became lighter and more flexible in appearance, it
never became an organic part of the structure. It always seemed to
be lowered from above as if hovering slightly, with the vaulting

shafts sliding downwards past the long stretches of wall.[1] In this way the development of the wall structure as design was independent of the vault. The division into vertical bays was only made effective in the upper regions, but the wall with its three successive horizontal storeys remained basically intact. In order to rob it of its heaviness, two main means were applied: screening and perforation.

The profuse use of Purbeck marble was one of the most distinctive features of the 'episcopal' style.[2] It was imported in large quantities from Portland along the south and east coast and up the rivers, up the Avon to Salisbury, up the Ouse to Ely, up the Witham to Lincoln, up the Humber to Beverley, up the Ouse to York, up the Wear to Durham. Where import was too costly or too difficult, local substitutes were found. The smooth surface of the darkly textured marble reminded the poet of the *Life of St. Hugh* of precious jasper, and as 'a seemly juncture disposeth a thousand columns in beautiful sequence there, these columns, firm, precious, and gleaming make stable the whole fabric of the church, enrich it and diffuse it with light'.[3] The dark colour which accentuated the precise shape of colonnettes, capitals, and mouldings was a welcome quality where it was desired to set up screens in front of a lighter wall, but the harsh contrast of black and stark white produced in so many restorations of the nineteenth century was avoided. The Salisbury poem warned against the harm of a whitened surface which hurts the eye.

[1] In the high vaults at Wells, Southwark, Salisbury, Lincoln, and Westminster the English builders made consistent use of 'ploughshare' vaulting. See F. Bond, *Gothic Architecture in England* (1906), 311. The webs of the lateral vaults were twisted back to allow for larger window space or unimpeded light. These vaults were thus not portions of a normal four-part vaulting unit built over each bay. On the contrary the effect produced was that of a barrel vault divided and strengthened by ribs, but otherwise continuous over the whole length of the nave with the separate vaulting sections over the clerestory windows cutting into it at right angles. This effect of a continuous, longitudinal vault was heightened when, as at Lincoln, a ridge rib ran straight along the crown of the vault from east to west, and it encouraged the use of multiple, spreading ribs as a surface decoration after 1250.

[2] L. F. Salzman, *Building in England* (1952), 134; *V.C.H. Dorset*, ii. 331; D. Knoop and G. P. Jones, 'The English Medieval Quarry', *Economic History Review* (1938), 24.

[3] Ed. J. F. Dimock (1860), 34.

The flat pattern of blind arcading, which was a favourite motif in late Romanesque times, was turned into a neatly fashioned screen of round colonnettes connected by moulded arches in front of the walls, usually in one layer, but sometimes as early as in St. Hugh's choir, in two, set off plastically from the walls behind. The arches never weighed upon the supports to which they were not really in structural relation. Their curving shapes, acutely pointed or flattened out or in trefoil design, always adjusted themselves easily to any width or height. They swing lightly across any distance or climb up from point to point, sometimes even without sinking down again, in order to form a bridge from one height to the other. The *Metrical Life of St. Hugh* praises the outer smoothness of the wall which contains the round windows of the transepts, while on the inside it is 'honeycombed'. Rows and rows of small niches were thus hollowed out of the walls, as if the architects intended a literal realization of the words: 'In my Father's house are many mansions'.[1] In this profuse use of screening, building in stone sometimes seems to be subordinated to the application of delicate patterns to a solid surface.

The richest screen design was given to the triforium arcade. The polished dark marble shafts, lavishly used, glittered and shone against the deeper darkness of the openings and the lighter walls. In practically every church the geometric pattern of the triforium arches differed from the others. With variations in the delightful interplay of arches within arches, the smaller units were held together in a well-ordered and lucid manner by one or two containing arches with foils in their heads. Each time the pattern was clear-cut with its sharply defined edges and curved planes. Unit was set off from unit with mathematical precision, the one added to the next until the sum total of the whole was reached. The mouldings in this period were always carefully cut in multiple orders, deep semicircular hollows which formed a black band alternating with undercut rolls catching the high lights.

The precise tangible definition of all the parts down to the undercut trefoiled foliage of the capitals was greatly assisted by the mode of lighting. The lancet window remained the normal form

[1] J. Summerson, *Heavenly Mansions, and Other Essays on Architecture* (1949).

of perforating solid walls. Its shape was clearly defined by the firm frame, its light opening was contrasted with the darker surrounding wall, and clearly circumscribed areas of light and shadow were created. The width of the windows was limited, especially in the north, and when wide spaces of wall had to be dealt with lancets were arranged in groups, preferably of uneven numbers. In the clerestory, which at first held one window only in each bay as at Wells, or two as at Canterbury, a group of three was introduced at Salisbury, where the lights were gradated in height, and was taken over at Lincoln, but there gradated in width. The northern school was particularly enamoured of the effect of tall, slender lancets in rows and in layers one above the other.

This mode of lighting created precise areas of light and shadow of a mathematical order.[1] The basic patterns of geometry had been used in the large circular windows of the Lincoln transepts, where there was an arrangement of circles within circles, cut out in plate tracery. Though the rose or wheel window was rarely employed except in gables, as at Salisbury, Whitby, Beverley, and York, the circle completely or three-quarters closed, as in the foils with their rounded petals set within its circle, could serve as a symbol of the 'episcopal' style. Concentric circles were the favoured form used in book illustrations to indicate the order in the universe or in the genealogies of men. Circles and foils perforate most of the tympana in the triforium storeys, and all the capitals of the round shafts are treated in the same manner, whether made of freestone or Purbeck marble. The round abacus has by now become the normal shape, treated as if turned by the lathe. The capitals are thus designed in a sequence of concentric rings or curved bands expanding or contracting in rhythmical alternation from the necking to the abacus.

[1] Bishop Grosseteste in his studies of optics was guided by his concept that light was ruled by mathematics. A. C. Crombie, *From Augustine to Galileo: the History of Science* (1952), 50: 'Grosseteste identified common corporeity of the neo-Platonists with light which had the property of dilating itself from a point in all directions and was the cause of all extension. He held that the universe arose from a point of light which by auto-diffusion generated the spheres of the four elements and the heavenly bodies and conferred on matter its form and dimensions. From this he concluded that the laws of geometrical optics were the foundation of physical reality and that mathematics was essential to the understanding of nature.'

The stalks of the carved foliage seem slipped over the bells like husks and the leaves are clearly separated from each other and set off from the dark hollows between. Whether they are gathered in crockets and bend over like volutes or curl upwards and sway sideways in a continuous scroll, they always stay within cylindrical planes (Pl. 16 a). The 'stiff-leaf' had been evolved in the 'transitional' period, at Chichester, at Wells, in St. Hugh's choir at Lincoln, but it is handled now with perfect mastery over its free but disciplined growth, basically the same in all new churches, but delightfully rich in local variations. The leaves with three or five or seven rounded petals and with a prominent mid-rib have no direct relation to any known natural form, but, though an abstract geometric design, they are imbued with the semblance of vigorous growth.[1]

All these features of the 'episcopal' style were uniformly accepted by the architects of the new buildings, but each building provided its individual solution. The close relations between the bishops without doubt fostered exchange of ideas and even of architects, but the chapters, with their continuous care and responsibility for the work in hand while the bishops were away on their manifold occupations, presented a local element which, together with local workmen, caused the same structural and decorative features to be used in their own particular context. The three roots of Early Gothic in England in the south-east, in the west and in the north, were not to be denied, even after the penetration of the 'episcopal' style which was grafted to the older growth. When Bishop Richard Poore was translated from Salisbury to Durham, he might well have brought with him plans and even masons, by which certain ideas carried out at Salisbury could be introduced, but a building like Salisbury cathedral would have been as much a foreigner in the county of Durham as the 'Nine Altars' of Durham would have been in the south. In the great variety of the individual buildings lie the youth and the vigour of the 'episcopal' style.

[1] T. S. R. Boase, O.H.E.A. iii. 263–5; S. Gardner, *English Gothic Foliage Sculpture* (1927); P. Wynn Reeves, *English Stiff Leaf Sculpture* (dissertation for London Univ., 1952, unpublished).

II

SALISBURY, LINCOLN, AND WELLS

SALISBURY and Lincoln were the two poles at either end of a diagonal line which stretched from south-west to north-east. In each the 'episcopal' style was formulated in the most complete and perfect manner, but only at Salisbury could the new style be carried through in flawless unity because the new cathedral was built from the ground on a virgin site.[1]

Bishop Herbert Poore had planned to move the see because the bishop and chapter found themselves too heavily encumbered within the walls of Old Sarum, where the proximity of the castle and the settlement round it disturbed the peace of the close and the dignity of the service. But it was left to his brother Richard to carry it through. No one could have been better suited to direct the building of a new cathedral that would express the strength of the reformed church and the order of its services. Richard Poore had been dean at Salisbury under his brother from 1198 to 1215 and had perfected the cathedral statutes in the *Nova Constitutio* (1213–14). He was bishop of Chichester in the years 1215 to 1217 at a time when the new retro-choir there was still in building.

The site was chosen with great care, although, according to tradition, it was decided upon either by the fall of an arrow shot from the ramparts of Old Sarum or by a dream in which the Virgin ordered Richard to build at a place called Myrfield. After the abbess of Wilton had refused to give land near her abbey, Poore provided a piece of his own in a valley, whose amenities are described in the poem on the translation of the cathedral:[2]

There is in a valley a site, near to a grove, well suited for hunting,
Ringed round with crops and rich with water.
There thou mayest see the birds rival each other in song,
Birds which inhabit the thickets, the woods, the rivers, the meads.

[1] G. H. Cook, *Portrait of Salisbury Cathedral* (1949).

[2] This translation and that of the *Metrical Life of St. Hugh* (below, pp. 26–28) are by Professor D. F. S. Thomson, Department of Classics, University of Toronto.

Sometimes the nightingale, often the lark, pours forth from
A tiny throat a great melody of song.
The skylark praises the place and the nightingale
Utters a delightful song, that is a song of love

.

Against the tuneful laments of the swan the 'ormella' contends
The one bird sings before dawn, the other before death.
The earth brings forth the yellow crocus and white lilies,
Blue violets and red roses.
The plentiful deep pool issues in springs and rivulets,
The shining clear water feeds fish and birds.

.

Lighter than a spark, clearer than a crystal, purer
Than gold, sweeter than ambrosia is this water.
The onrush of the water gladdens
The city and abundance of crops nourishes them.
The royal forest gives wood to build houses, the beauty of flowers
Relieves the sick, the power of herbs overcomes sickness.

This description ends with a statement which would have
shocked a monastic conscience:

If Adam, driven from Paradise, had come hither,
He would have preferred his exile to his native land.

In 1218 a papal bull authorized the move of the see, and on
Trinity Sunday, 1219, Bishop Poore celebrated mass in a temporary
wooden chapel on the new site. Two years later, in the same year
in which St. Thomas was translated, on St. Vitalis's Day, 28 April,
the foundation stones were laid, one for Pope Honorius III, one
for Archbishop Stephen Langton, and one for Richard Poore. The
Countess Ela of Salisbury and her husband, William Longespée,
added their own, followed by other noblemen and members of the
chapter. In 1225, on the vigil of St. Michael, Poore could consecrate
three altars, that of the Trinity and All Saints in the lady chapel,
that of St. Peter and All Apostles in the northern section, and that
of St. Stephen and All Martyrs in the southern. The next day

Stephen Langton preached in the presence of the papal nuncio
Otho and of Edmund Rich, the future archbishop, then canon of
Salisbury. The following Thursday, young Henry III and Hubert
de Burgh came to hear mass in the lady chapel. The king granted
the right to hold a fair and presented a golden ring with a ruby,
which was used later in the decoration of the gilt and jewelled
cover for the text of the Gospel of St. John given by Hubert de
Burgh. After Poore was translated to Durham in 1228, the work on
the church was carried on under his successors, Robert Bingham
(1229–46), William of York (1247–56), and Giles of Bridport
(1257–62). Under the latter the church was covered with lead. On
20 September 1268 Archbishop Boniface of Savoy consecrated
the cathedral in the presence of Henry III and his queen. According
to the *Book of Statutes* of Bishop Roger Mortival (1315–30), the
work was completed on 25 March 1262, the whole expense
amounting to forty-two thousand marks.

From the beginning, the financing of the enterprise was put on
a sound footing. A chapter held in August 1220 at which the bishop
was present decided on certain steps to be taken if a canon did not
pay a fourth of his revenue as a contribution to the fabric for seven
years. The dean collected alms through the diocese of London.
Good limestone was available near by at Chilmark, and the ease
with which Purbeck marble could be shipped up the Avon
accounted for the liberal use of it in the construction. Henry III
gave oaks from his forest at Alderbury. There was one severe set-
back when the attempt to gain papal canonization for Bishop
Osmund failed. Still, St. Osmund's body was translated from Old
Sarum on 12 June 1226, together with those of Bishop Roger and
Bishop Jocelin, and though the shrine was not set up in the new
retro-choir, pilgrims came to show their devotion at the tomb of a
man whom they considered a saint.

The design of the new cathedral may have been due to the advice
of Elias of Dereham,[1] who was, at the least, an administrator
familiar with building processes, fully aware of the new trends of

[1] J. C. Russell, 'The Many-sided Career of Master Elias of Dereham', *Speculum* v
(1930), 378; L. F. Salzman, *Building in England* (1952), 9; A. H. Thompson,
'Master Elias of Dereham and the King's Works', *Arch. Journ.* xcviii (1941), 1.

the time and an intimate of many of the great builder-bishops. A royal clerk under King John, he went abroad with Hugh and Jocelin of Wells during the Interdict, serving the latter as steward. His contact with Stephen Langton brought him to Canterbury where he was responsible together with Walter of Colesworth, sacristan of St. Albans, for the shrine and the ceremony of translation of St. Thomas in 1220.[1] He was canon of Salisbury at least from 1222 until his death in 1245, though his residence became irregular after Poore had moved to Durham. It is testimony to his trustworthiness and business acumen that he was named as executor of wills for Archbishop Hubert Walter at Canterbury, where Elias acted as custodian of the archbishopric from 1205 to 1207, for Hugh of Lincoln (1212), for Stephen Langton (1228), for Richard Poore and Peter des Roches (1236). Henry III entrusted him with the construction of the royal hall at Winchester and repeated grants for kilns and timber confirm his connexion with the building trade. But even the payment that the sheriff of Wiltshire was ordered to make to Elias[2] in 1238 for the marble tomb of Joan, queen of Scotland and the king's sister, then being set up at Tarrant, does not entitle him to be called the architect responsible for the design of Salisbury cathedral.

The plan must have been in perfect conformity with the liturgical practices laid down in the 'Use of Sarum', the customs of the English church which were adopted almost universally by the secular cathedrals in the thirteenth century.[3] The pride in the Sarum tradition was expressed by Bishop Giles of Bridport: 'Like the sun in the heavens the church of Sarum is conspicuous above all other churches of the world, diffusing its light everywhere and supplying their defects.' In the plan (Fig. 1) are laid down the proper relations between nave and choir: ten bays for nave and

[1] Matthew Paris, *Hist. Angl.*, R. S. xliv (1866), ii. 242.

[2] *Cal. Lib. Rolls, 1226–40*, 316. Robert Cementarius, who according to the Salisbury cathedral accounts for 1262 was in charge for twenty-five years, cannot have been responsible for the design. According to J. H. Harvey this Robert was active in the early fourteenth century (*English Medieval Architects* (1954), 226). Nicholas of Ely has been suggested as the designer of the cathedral (ibid. 93).

[3] W. H. Frere, *The Use of Sarum* (1898–1901), 2 vols.; C. Wordsworth, *Ceremonies and Processions of the Cathedral Church of Salisbury* (1901).

seven for the eastern limb, plus two for the ambulatory and two
more for the lady chapel, but the eastern portion, though equal in
length to the nave, was made much more prominent by the triple
repetition of the transept. The main transept (204 feet in length, a
few feet longer than the nave) projects by three bays, followed by
the eastern transept with a two-bay projection and by the ambu-

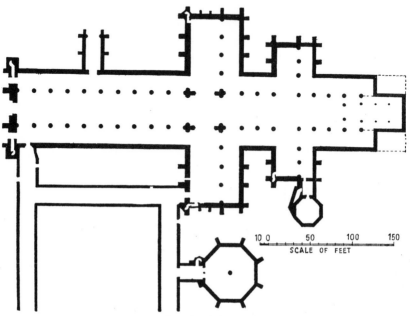

FIG. 1. *Plan of Salisbury Cathedral*

latory which functioned as a transept of one bay to the lady chapel.
In contrast to monastic custom the liturgical choir, withdrawn from
the nave, began east of the main crossing, and the chapels, on the
east side only of the transepts, allowed for the many altars, all duly
orientated eastward.

The high altar of the Assumption of the Virgin stood originally
between the eastern pillars of the second transept raised on steps of
which traces are still visible.[1] Only here have the marble shafts of
the pillars foliated capitals, and by the northern pier is a small
winch, a wooden roller with an iron handle, that was used for the
drawing of the Lenten veil across the high altar. In the painted

[1] G. G. Scott, *Salisbury Cathedral: Report on the Position of the High Altar* (1876).

medallions in the vaults above, Christ in Majesty appeared over the high altar surrounded by apostles and evangelists; in the western vault were kings and prophets and above the eastern bays the twelve Labours of the Months.[1] As already mentioned the builders at Salisbury rejected the apse of Lincoln and Canterbury and introduced the square east end. Just as the Use of Sarum was based upon its Norman predecessor drawn up by Bishop Osmund, the east end of the new cathedral was most likely derived from the choir which Bishop Roger had given to the Norman cathedral of Old Sarum in 1132.

The new site, unlike the hill which gave its prominence to Lincoln cathedral, did not give any help to the architect. The building rose, self-reliant, from the even flat surface of a marshy meadow, where deep foundations were required, sunk five to six feet to a gravel bed. But from the level ground the building seems to spring lightly, set off by its multiple base course, a truly classical feature. Its five mouldings are repeated around the buttresses, which are not allowed to rise above the parapet of the aisles. In addition the corbel-table and the second parapet, as well as the unbroken roof-line, tie the various parts together and seem to hold down the structure, which otherwise, by virtue of its proportions and its tall windows, soars so gracefully. The regularly cut stones had been laid with such care that the joints between them are almost invisible and lichen and moss have given to the grey of the stone a patina which blends it into the greensward. Only the fourteenth-century tower and spire slightly upset the quiet balance. Apparently no high tower was originally intended and as at Westminster a separate bell tower stood to the north-west. The whole exterior is treated like a thin shell, each part covered by its own roof and indicating clearly the role it plays in the composition of the whole. There is just enough stone wall left to give the effect of youthful strength, the rest is consumed by the coupled lancets of the aisles and the triplets of the clerestory. In even regularity buttress stands beside buttress, rather shallow, with the coupled lancets between them almost flush with the wall, producing the

[1] E. W. Tristram, *English Medieval Wall Painting: The 13th Century* (1950), text, 26, 207.

gentlest relief. The distance from ground base to the aisle parapet is almost equal to that of the upper part, and the walls of the eastern chapel are approximately two-thirds of the whole height to the peak of the gables, which are equilateral triangles (Pl. 2).

About twenty-five years before, the retro-choir at Winchester had been built as a spacious hall church, perhaps inspired by the hall churches of Poitou.[1] But its lowness and heaviness was no longer acceptable when lady chapel and ambulatory at Salisbury were built in a lightness of structure which borders on fragility. Nowhere else have Purbeck shafts, less than ten inches in diameter and nearly thirty feet in height, been allowed to stand singly by themselves as do those which divide the chapel into nave and shallow aisles, covered with oblong vaults. Nothing but marble was used in all the slender supports in chapel and ambulatory, where they arise with smooth elegance, encircled with thin bronze annulets, in well-calculated variations of groups of four around the thin core. This division of the chapel into nave and aisles produced a superbly effective design for the eastern wall of the retro-choir with its group of three arches. Two narrow arches, on the sides which are acutely pointed, flank the wider one in the centre, the whole forming a transparent screen which allows an unimpeded view from the high and well-lit choir into the low and darker east end.

Although the basic design is the same throughout in choir, transepts, and nave, subtle changes in the shape of the main supports give to each part its proper weight: pairs of two cylindrical columns of stone with two detached marble shafts in the eastern wall, eight marble shafts around the quatrefoil stone core in the choir, twenty marble shafts around the piers of the main crossing, stone columns only in the main transept and four marble shafts against the stone pillars of the nave. All is marked out with mathematical precision. Each straight section of the wall, whether the inner fronts of transept, west wall, or choir, is worked out with ruler and compass as a geometric design of oblongs, circles, and half-circles.

It is not in the view from the entrance towards the east that the quality of the design can best be perceived. The interior divided up by screens was not conceived primarily as a space enclosed by

[1] T. S. R. Boase, *O.H.E.A.* iii (1953), 255.

walls. The emphasis was upon each section of the straight wall, as it can be seen by facing it directly. The vaults, which here appear in the clean-cut simple form of the four-part rib vault, seem to be merely lowered in between the straight walls in order to tie them together.[1] The proportions of height to width were two-and-a-half to one, better than in most other English cathedrals, and the total of 81 feet was divided into two, the nave arcade consuming half of the total. Since of the upper half the clerestory takes the larger portion, the triforium seems cramped and has frequently been criticized. The exceptional height of the nave pillars, which, though quatrefoil in plan, look like tall cylinders, and this low, unusual triforium are like the Gothic version of the similar arrangement employed in Norman times at Gloucester and Tewkesbury (Pl. 5). There is the possibility that Salisbury cathedral, just as its choir plan was modelled upon Roger's choir, tried to repeat in Gothic form the design of the Norman nave. This would suggest that the peculiar arrangement at Gloucester and Tewkesbury originated with the structure of the cathedral at Old Sarum.

The height of the pillars, increased by a continuous plinth which serves as a secure foothold in case of flooding, allows a free view into the side aisles with their coupled lancets. There the windows are framed by their Purbeck shafts, and the aisle vaults are supported upon free-standing shafts raised upon a wall bench. Just touching the top of the main arches, the sill of the triforium runs in a straight line from west to east. The vaulting shafts descend only to meet the curve of the triforium arches, with the ribs springing from the clerestory sill.[2] In order to give greater unity to each bay, the two main openings of the triforium chamber, which are subdivided again into two, are enclosed by an arch which is almost round and which rests upon the massed Purbeck shafts. Nothing is left to accident, trefoils and quatrefoils, cinquefoils and octofoils alternate in perfect regularity, a system of

[1] The structural support of the vault, the webs of which were filled with concrete, was provided by concealed flying arches in the triforium and by the thickness (7 feet) of the clerestory wall.

[2] On the west wall of both transepts angleshafts and one centreshaft descend to the triforium sill.

constellations rotating and held within their spheres. The present stark contrast of the dark frame against the white wall was not as pronounced originally when the walls still had their masonry pattern on the ivory tinted ground, when the spandrels were filled with their foliage scrolls on red and green ground, when the mouldings were decorated with red, green, and yellow, and when a silvery light from the grisaille windows, here and there speckled with bright colours, gave a soft cool light to an interior which in its purity of line and youthful perfection was worthy of a cathedral dedicated to the Virgin.

Lincoln cathedral was in many ways the antithesis to Salisbury.[1] While Salisbury was being planned and in building, large portions of Lincoln were rebuilt. If the whole lacked the unity of Salisbury, it gained in vigour, made lively by a spirit of experiment which took various ways to reach perfection.

The beginning of the new structure went back to the earliest growth of Gothic when Hugh of Avalon, called from Somerset to the see of Lincoln, began a new choir in 1192.[2] It is difficult to determine how far the new work had progressed by 1220. Shortly before his death in 1200, Hugh had urged his architect, de Noiers, to complete the chapel of St. John in the north arm of the eastern transept so that he could be buried there. Hugh II of Wells (1209–35), brother of Bishop Jocelin, who had acted as deputy for the archdeacon of Wells from 1199 to 1204, shared his brother's interest in building. At the end of his life he left to his cathedral a bequest of 100 marks and all the felled timber on his estate. But, before this, civil war, at the end of which Lincoln was besieged, and the Interdict must have slowed down the building activities. In 1216 10,000 marks, which the precentor had collected as a building fund, were misappropriated. Only after the canonization of St. Hugh in 1220, the indulgences of forty days promised to pilgrims brought in new funds. Henry III granted letters patent for the maintenance of the guild of St. Mary, founded by St. Hugh, whose members paid regular contributions towards the building. The

[1] G. H. Cook, *Portrait of Lincoln Cathedral* (1951); J. H. Srawley, *Lincoln Minster* (1947); J. W. F. Hill, *Medieval Lincoln* (1948).
[2] T. S. R. Boase, *O.H.E.A.* iii. 266.

western transept must have been completed under Hugh II, because the *Metrical Life of St. Hugh* praised its two circular windows, without mentioning the nave.[1] In 1237 or 1239 the central tower fell and caused considerable damage. Repairs were taken in hand, although their extent is disputed. The piers of the main crossing were strengthened by twelve stone and twelve marble shafts to support an elegant new central tower, decorated with slender marble shafts and trellis work, of which the two lower stages are from the time of Bishop Grosseteste (1235–53).[2] The choir of St. Hugh with its triangular apse and three radiating chapels remained, but the outer bays of its eastern transept were raised to the same height as the choir. The choir extended westward to the eastern piers of the crossing. Then the western transept projected by three bays with an eastern aisle divided into chapels, forming a large vestibule. A third vestibule at the entrance into the nave was provided by the broadening of the western front and the two chapels behind it.

While the design of Salisbury is tranquil and serene, that of Lincoln is full of energy and action. The cathedral seems to draw its strength from the hill upon which it is placed (Pl. 3). The warm yellow of its stone is enriched by the play of light and shadow in the bold relief of the wall. The architect of St. Hugh's choir, following the model of Canterbury, had used small intermediate buttresses which halve the interval between the widely projecting main buttresses. This rhythmical alteration, copied at York and at Durham, was carried through the main transept and nave. While the large buttresses correspond to the main pillars and the vaulting shafts of the nave, and support later flying arches to the clerestory walls, the smaller buttresses, which stop at the aisle roof, carry the thrust of the fifth intermediate rib of the aisle vault, another feature favoured by the architecture of the north. The aisles of the nave— the northern, with its simple, moulded capitals, earlier than that of the south—have no longer the low second storey, with small windows lighting the triforium chamber, of St. Hugh's choir. Their walls, with sharply cut, deep buttresses, topped by heavy

[1] Ed. J. F. Dimock (1860), 34.
[2] For Grosseteste see J. H. Srawley, *Robert Grosseteste* (1953).

saddlebacks and broken between the lancets by smaller buttresses and blind arches, are much solider than the light clerestory above. The flying arches seem to be an afterthought, as they cut into the arcade of narrow, sharply pointed arches, running the whole length of the clerestory, with a rhythmical succession of triple blind arches and triple lancet windows.

When the poet of the *Metrical Life*, written before St. Hugh's choir was completed, speaks of the eastern parts, he praises the roof (*testudo*) 'as if it were conversing with the winged birds, spreading out broad wings, and like a flying creature striking against the clouds'. He also gives high praise to the two circular windows in the transept fronts:

The two large windows are like two blazing lights, whose radiance is circular, looking at the north and south and surpassing all the windows with their twin light. The others may be compared with the common stars, but of these two, one is like the sun, the other the moon. Thus two candlesticks make sunlit the head of the church, imitating the rainbow in living and variegated colours. The north is the devil, the south is the Holy Ghost, upon whom two eyes look, for the Bishop looks upon the south and beckons, but the Dean looks upon the north to forbid. The church's brow is the candlestick of Heaven and with these eyes looks round at the darkness of Hell.

When the new nave was built, under Bishop Grosseteste, its dimensions were prescribed by what had been built previously[1] (Fig. 2). Its width of forty and a quarter feet was that of the Norman cathedral, only surpassed by the forty-five feet of York, and its seven bays had to be fitted into the space between the old Norman front, which was retained, and the main crossing (Pl. 4). The two western bays, the axis of which is slightly bent in order to join them to the inner wall of the old front, are nearest in character to those of St. Hugh's choir. But behind the extension of the old front they are widened into two side-chapels, which are

[1] The sequence of building operations in choir, transepts, and nave is still disputed and very problematical. For the problems involved see the different opinions by J. Bilson, F. Bond, W. Watkin, and W. R. Lethaby in *R.I.B.A. Journ.* 3rd ser. xviii (1911). For the attempt to solve the problems through the dating of the carving of capitals and bosses, see P. Wynn Reeves, *English Stiff Leaf Sculpture* (dissertation for London Univ., 1952, unpublished).

not a western transept since they are lower than the nave. The four main supports of the nave towards the east are much more widely spaced, as much as twenty-seven feet apart, and the ample width of the aisles gives to them an exceptional appearance of individual strength. They vary in shape, being either of the compact northern type, with eight clustered marble shafts attached to the core, or

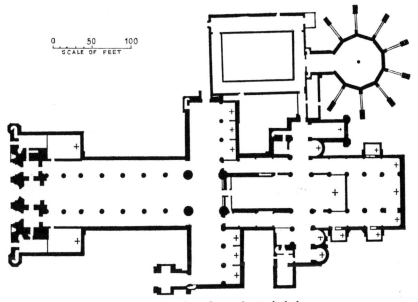

0 ____ 50 ____ 100
SCALE OF FEET

FIG. 2. *Plan of Lincoln Cathedral*

light and elegant with detached Purbeck shafting tied by annulets. To those the words of the *Metrical Life*, originally referring to pillars in the choir, could still be applied that 'the little columns which surround the large column seem to perform a kind of dance'—a statement which seems Greek in spirit. The wide span of the main arches lifts the triforium to a level higher than that of St. Hugh's choir with the nave opening more widely into the deep aisles. An exquisite interplay of lights and darks is combined with an interplay of numbers: two lancets in the aisles seen within the span of the nave arcade, two almost round arches in the triforium subdivided into a unique arrangement of double triplets, and the triple lancets with their shafted screen in the split walls of the clerestory above. The many shafts of polished marble 'which

diffused the fabric with light' may have put into Bishop Grosse-
teste's mind the words of one of his sermons in which he says:

As many heavy things when bound together descend the quicker,
and many light things when united ascend with greater velocity, in as
much as the inclination of each of the separate things has a general effect
upon the combined aggregate, so many individuals joined together
by the bond of love and prayer, are moved upwards more easily and
more swiftly as the prayer of each one of them has its influence upon
that of each of the others. For as polished objects when placed close
together, and illuminated by the power of the sun, in proportion to
their number, shine with greater brightness on account of the multitude
of the reflection of the light rays, so too the more souls that are illumi-
nated by the rays of the Sun of Righteousness, the more they shine by
reason of the reflection of their mutual love.[1]

The great width of the internal span in all parts of the cathedral
presented a challenge to the builders of the vaults. The main tran-
septs had been covered with the heavy six-part rib vault which
stemmed from Canterbury, but with the addition of a ridge rib.
Here the vaulting shafts rise in bundles from the round abaci of
the supports that mark the corners of each bay, while the single
shaft for the additional rib springs from a corbel just above the
triforium sill. The unique vaulting of the choir had been a com-
promise which allowed room for the crowded triplets of lancets
in the narrow bays. The two western chapels gave new scope for
experiment. In the one on the north a high slender column served
as support for its four-part vaults, while in the southern the archi-
tect dared to omit the central support and to build one vault with
ridge rib and tiercerons. Such complex vaults were given to the
aisles and finally, probably later than 1250, the nave vaults were
set up, which resemble those in the choir of Westminster abbey.
They required the outside flyers, which were added to the support-
ing arches in the triforium chamber below the roof, as an additional
support above the aisle roofs.

In the long-drawn-out period of rebuilding, slowly and almost
imperceptibly the simplicity of the earlier parts gave way to a ripe
richness. Stone trelliswork, hoodmould stops in form of whorls,

[1] F. S. Stevenson, *Robert Grosseteste* (1899), 36.

and ample use of dogtooth softened the hard surfaces and sharp edges as in the exquisite doorways which lead into the choir aisles. In three bays of the south aisle of the nave the first figured bosses appear, of beautiful workmanship. One boss in the third bay has foliage which differs from the many variations of trefoil leaf found throughout the cathedral, and shows a new interest in natural forms.[1] The galilee porch at the south-western corner of the main transept, built as a state entrance for the bishop, to be reached directly from his palace, had the solid weight of its buttresses lightened by slender shafts, single or in bundles, with elongated arches which formed an elegant screen and with dogtooth scattered over the whole like pearls embroidered into a vestment.

The 'Bridge of Paradies' (*Metrical Life*) which St. Hugh had begun was entered through a gatehouse of the most stately proportions. The plan to retain the massive front of the old Norman cathedral, with its five deep niches and the twin towers set up behind, but to extend its width, may go back to Hugh II's time. Not so long before, the front of Ely cathedral had been built as a broad screen with a western transept behind it, though with a single high tower in the centre. The new front at Lincoln, chiefly built during Grosseteste's time, extending by its flanking stair turrets beyond the two recently added west chapels, held the old Norman front like a relic or a solid jewel within a rich filigree setting (Pl. 6 a). Layer after layer of delicate arcades varying in shape and height, with a quick rhythm of suggested movement up and down and back and forth, contrasted with the plainness of the old front. The arcades were continued around the flanking turrets, binding them into the whole, and finally all sections were tied together at the top by a continuous band of the tallest arcade, into which a smaller one was inset. Narrow pointed doorways led into the vestibules of the western chapels, the northern of which is still lighted by its circular window. These circular windows, the upper curve of which referred to the round arches of the side niches in the old front, were planned in relation to the high pointed arch of

[1] C. J. P. Cave, *The Roof Bosses of Lincoln Minster*, Lincoln Minster Pamphlets no. 3 (1951), 7: 'If these bays of the south aisle were complete by 1253 this must be one of the earliest, if not the earliest example of natural foliage in the country.'

the centre niche, which was the only one of the old Norman arches to be altered and which enclosed a wheel window above the present perpendicular insertion.[1] Before the towers were raised in the following period, they probably carried pointed spires like those at the angles.

Judged by abstract aesthetic standards, the screen front of Lincoln was less 'functional' than the twin-towered façade of a French cathedral. But it provided a monumental stage set or scenic front for the triumphal entry of the processions, especially that of Palm Sunday, when the entry of Christ into Jerusalem was re-enacted year by year. Further the gigantic screen served the same function for the whole building as the screen inside for the choir. In the interior the entrance into the choir was flanked by the inner faces of the transept with its eastern array of chapels. Just as the saints to whom the altars in these chapels were dedicated formed a celestial court on either side of the approach to the high altar, so the statues of saints originally planned for the many niches of the front were spread out around the main gates into 'Zion'.

This concept of a cathedral front like a stretch of wall pierced by a triumphal gate and surmounted by towers, as if it were part of the wall which enclosed the Heavenly Jerusalem, occurred in two other versions, at Peterborough and at Wells.

The nave of the abbey church at Peterborough which was built slowly in the course of the century was lengthened to the full stretch of ten bays before 1200.[2] The west front was planned before the death of Abbot Benedict in 1194, and was to have two towers over the last bays of the aisles with three portals and to be broadened by the addition of a shallow western transept. This simple plan was discarded early in the thirteenth century, possibly under Acharius, formerly prior of St. Albans. Inspired by the new front which Abbot De Cella had provided for St. Albans, a new design was evolved with a vaulted porch of five bays of the same width as the western transept. A broad middle entrance was to be flanked

by two narrow ones opposite the entrance into the aisles. Before this work had gone very far, another and final change was made, probably under the influence of the new front at Lincoln, which resulted in the present unique design.[1]

For about four years King John had taken the revenues of the abbey for himself, but Henry III helped to restore the sunken fortunes by granting a weekly market at Kettering and a yearly

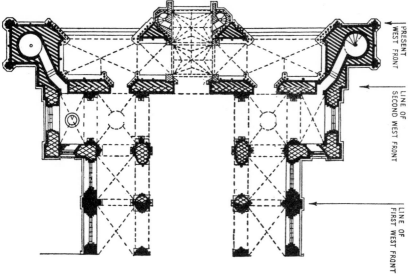

FIG. 3. *Peterborough Cathedral: Plan of West End*

fair at Peterborough in 1227, and the western front may have been ready in its main outlines when Bishop Grosseteste came to re-dedicate the church in 1237.[2] As at Lincoln, the façade was widened into a screen of about 170 feet to 180 feet in height (Fig. 3). Two stair turrets were set beyond the width of the west transept, in order to buttress the tall arches of the vaulted porch. The two outer bays on either side were thrown into one, each vaulted by one oblong vault, and opened to their full width, so that the huge cavities at the flanks now exceeded the central opening. But the most impressive effect was achieved by making all three porches of the same height, three huge archways leading into a high vestibule in

[1] C. R. Peers in *V.C.H. Northampton*, ii (1907).
[2] W. D. Sweeting, *The Cathedral Church of Peterborough* (1898).

front of the church proper, framed by six thin, bonded marble shafts on each jamb, and contrasted with the four smaller storeys of the turrets, covered by blind arcades of varying height (Pl. 8 *a*). The lines of the marble shafts were repeated in the orders of the arches, alternately enriched by dogtooth, leaf ornament, and double cones which lent a strong relief to the curves.

The anomaly of the central arch being set between two wider ones was counteracted not only by giving the centre jambs a greater richness of foliated crockets and enlarged dogtooth, but by a most ingenious architectural device. A perspective illusion was produced as if the side porches were leaning towards the centre, because their doorways leading into the aisles could not be in the middle of the side porches but had to be drawn more closely to the main portal, their jambs partly hidden behind the triangular pillars of the porch. Thus the fifth short rib of their vault descended, seemingly off centre, towards the wall. An effect of shifting patterns was created, but the movement ceased in the upper zone, above the string course, with its foliated crockets which bound towers and gables together. The great wheel windows of the gables came thus to sit above the point of each arch. Behind them the two western towers, of which only the northern now rises above the side turrets, seemed to move inwards, their inner angle pinnacles being masked by the octagonal ones which flanked the central gable. These were, in their turn, set slightly outside the line of clustered shafts rising from the triangular piers of the central archway, thereby giving greater width to the central gable.[1] Much more than at Lincoln, the front at Peterborough was designed boldly in depth, apparently activated by motion as if the main walls retreated into niches which are flat in the towers, deep in the spandrels and gables, and deepest in the sunken cavities of the great archways. At the same time, it seemed to rise in height from the sides, from the turrets to the towers, but to dip down again to the middle gable which alone stood free against the sky.

Above the wheels in the gables and the statues of saints in the niches stood the figures of St. Andrew and St. Paul with that of

[1] G. F. Webb, 'The Sources of the Design of the West Front of Peterborough Cathedral', *Arch. Journ.* cvi (Supplement, 1952), 113.

St. Peter in the middle. The abbey possessed the relics of St. Kyne-
burgha, St. Kyneswitha, and St. Tibba, as well as the arm of St.
Oswald which had been brought from Bamborough early in the
eleventh century. No need, however, was felt to enlarge the choir
of the abbey on their account, though attempts were made at this
time to vault it, to judge from the compound shafts inside and the
added parapet around the apse. But though pilgrims could not find
relics of the three apostles to whom the abbey was dedicated, at
least they were greeted from afar by their statues, just visible above
the gate-house, originally built by Abbot Benedict, which hid the
great porch below the gables from those who stood outside the
abbey close. It may have been to give equal rank to the apostles
that porches and gables were raised to the same height. A pil-
grimage to Peterborough was made equal in merit to one to Rome.
When Matthew Paris drew a symbolic picture of the Eternal City
in his *Chronica Majora*, he showed it as a block of wall, with gate
and towers, following the same concept as that of Peterborough
front.

The third screen front was built at Wells by Bishop Jocelin
(1206–42) who had watched the progress of Bishop Reginald's
first Gothic cathedral at Wells[1] while he was his chaplain and a
canon in the chapter. In 1190 he was archdeacon of Chichester. A
king's judge before he was elevated to the bishopric, he took an
active part under Archbishop Stephen Langton in the events lead-
ing to the Great Charter in 1215. At the Interdict he went into
exile in France in 1208 and did not return for five years.[2] The new
cathedral still lacked the completion of its western bays, but while
this work was to continue with only slight modification along
the lines laid down by his predecessor, Jocelin had a free hand in
the planning of the front. Even while in exile he may well have
given some thought to the final achievement that was to give to
his cathedral its unique position in English art, and have discussed
it with his fellow exiles, his brother Hugh, bishop of Lincoln, and
Elias of Dereham. Though he may have seen the new sculptured
fronts of Notre Dame at Paris and at Chartres, the scheme he

[1] T. S. R. Boase, *O.H.E.A.* iii. 261.
[2] C. M. Church, 'Jocelin, Bishop of Bath, 1206–42', *Archaeol.* li. 2 (1888), 281.

favoured was totally different from the French Gothic model and
seems rather to owe a large debt to the Romanesque fronts of
Poitou. There it had been customary to place figures standing or
seated in niches upon the surface of the wall, enclosed by the shafts
and arches which provided the architectural framework. At Wells
the preference for screening which was such a distinctive feature
of the 'episcopal' style provided a wide screen of niches spread in
tiers over the whole of the façade, niches which asked to be filled
by statues.[1]

Work on the new front apparently started in 1220 in the same
year in which Salisbury cathedral was begun. Hugh of Lincoln
assisted with a gift of 300 marks and Henry III granted oaks for
lime-kilns and money in the years between 1220 and 1225, with
the provision that the five marks granted in 1225 were to be paid
annually for the following eleven years. In 1239 a consecration
took place which might indicate that most of the work was
finished. In any case a few years afterwards (1243) a dispute with
Bath put such a heavy financial burden on the chapter that it is not
likely that money would have been available if much work had
still to be done.

In contrast to Lincoln and Peterborough, the front was thin, and
closed off the nave in a more organic fashion (Pl. 6 b). Its three
doorways led straight into the interior to which the windows gave
direct light. They were gradated in height and were made
exceptionally low, partly because they only served as a privileged
entrance for the clergy and the processions. The laity was admitted
by a beautiful north porch, a custom which prevailed in this
region and reached farther north in western England. At Salisbury,
Christchurch, and Glastonbury such side-porches were built. At
Romsey abbey a side-porch provided the only entrance into the
nave, and there the new west front was without any portal,

[1] The application of the main units containing the sculpture suggests that the whole
scheme was drawn in flat projection on paper before the carving was started; compare
the diagram drawn by William St. John Hope and W. R. Lethaby, 'The Imagery and
Sculptures on the West Front of Wells cathedral church', *Archaeol.* lix (1904), Pl. lii.
Only in this way can a satisfactory explanation be given for the folding of some of
the quatrefoils around the angle of the main buttresses, a typical English feature,
reducing their strength.

pierced by three tall lancets above a low solid base. At Hereford
and Worcester later porches were built in the same tradition.

Not the modest doorways, but the buttresses, the tall lancets
and blind niches received the greatest accentuation at Wells. In
order to widen the front the two main towers were set beyond the
line of the aisle walls so that they stood free on three sides and
flanked the front proper. Their width, combined with that of the
side-sections in front of the aisles, equalled that of the centre por-
tion which rose high to its crowning gable. This must have been
originally even more impressive before the towers were heightened
in the succeeding centuries. In spite of its great width, however,
the front was not heavy, but strong and very light at the same time.
An effect of vigorous disciplined movement was created by the
rhythmical repetition of tall projecting buttresses and by the tall
blind niches, changing to lancet windows in the central block; but
although a 'Gothic' design was produced of solid uprights and
light intervening wall spaces, such as is found nowhere else in the
country, it was subdued and toned down in its verticality by the
repeated bands of screening. These stretched in tier above tier
from one end to the other, following the relief of the whole front,
and the triangular gables above the niches formed a continuous
zigzag line, interspersed with quatrefoils containing biblical
scenes.[1]

The amazing wealth of sculpture, unprecedented elsewhere in
England, raises the question how Jocelin collected the masons who
could carry out the extensive scheme of about 176 standing figures,
30 angels in half-size, 49 narrative reliefs, and the frieze of the
Resurrection scenes. The possibility exists that Jocelin brought an
experienced mason from France, but there is no doubt that the
bulk of the statuary was made by English masons. The main
figures are comparatively uniform in style, but vary consider-
ably in quality, and this suggests that there were a few artists of

[1] A fragment from Old Sarum in the Salisbury Museum (see G. Zarnecki, *Later
English Romanesque Sculpture, 1140–1210* (1953), Pl. 42) indicates the use of the gable
in the twelfth century. A composition of gables and foils similar to and preceding that
at Wells has been suggested by G. Zarnecki ('The Faussett Pavilion', *Archaeol.
Cantiana* lxvi (1954), 10) for Canterbury. The motif of the overhanging gable without
visible support appears in Naumburg choir screen.

outstanding ability and originality in charge of a local body of less skilled labour. Other examples from the turn of the century, few though the survivals are, indicate that there was much talent available in England.

In the west country sculptors had been at work at Worcester, Bristol, and even closer at hand at Glastonbury. The relief of Christ in Majesty seated in a quatrefoil on the refectory wall at Worcester[1] points the way to Wells in its style and its concept. The carvings around the doorways of the 'lady chapel' at Glaston-bury are now considered early thirteenth-century work[2] and the close relation between Glastonbury and Wells is shown by the reappearance, but on a larger scale, of the intersecting mouldings in the pointed arches and of the blue limestone shafts in the upper parts of the Wells front. At Wells itself sculptors had been active in carving a series of tomb effigies of former bishops which represent the first of such consecutive series made all at one time—at Wells without doubt made in order to emphasize the priority of Wells over Bath.[3] In addition there were still on the spot the masons who had carved the capitals and head stops inside the cathedral and in the north porch.

The narrative scenes from the Old Testament in the quatrefoils of the first tier represent the Gothic version of the scheme used by the Romanesque sculptors in one of their most important decorative cycles—the reliefs added to Remigius's front of Lincoln cathedral under Bishop Alexander about the middle of the preceding century.[4] As at Lincoln, so at Wells, the Old Testament cycle occupies the south side, that is, the side to the left of Christ; and in addition to the scenes of Cain and Abel, of Lamech killing Cain and of the Deluge, the story of Adam and Eve is told with dramatic power and in great detail: from their creation to the fall and expulsion and to Eve spinning and Adam delving. But on the north side the twenty-nine scenes from the New Testament, which are introduced by the single winged figure of St. John, represent an

[1] T. S. R. Boase, *O.H.E.A.* iii. 291.

[2] G. Zarnecki, *Later Engl. Romanesque Sculpture*, 50.

[3] J. Armitage Robinson, 'Effigies of some Saxon Bishops at Wells', *Archaeol.* lxv (1913/14), 95. [4] T. S. R. Boase, *O.H.E.A.* iii. 119.

exceptionally detailed, though badly damaged, account of Christ's life and passion. The cycle ends with His ascension while the Lincoln scenes relating to the Last Judgement are completely omitted.

The change from the flat Romanesque relief to the new treatment of such scenes in rounded shapes, set boldly into the empty space of niche or foil, has precedents in the transitional period, such as for instance the half-figures of prophets, now in the cathedral library at Canterbury, dating from the late twelfth century.[1] The parapet of the apse at Peterborough, added *c.* 1220, has half-length figures of apostles in trefoils and circles.[2] But the angels in the quatrefoils at Wells, with the gentle contours of their bodies, their wings, and the folds of their garments, fit more harmoniously into their frames. The fully developed concept of the round figure is nowhere more manifest than in the angel who holds two crowns in his outstretched hands while the sudarium is draped from behind both arms and disappears behind his body (Pl. 12 *a*).

A master with a clear perception of dramatic accents and superb stage-craft overcame the difficulties presented by the shape of the quatrefoils, especially of those broken into two halves at right angles to each other. The setting in each scene is defined with only a few properties such as a table, a city gate, a piece of rock or a tree with vigorously curving stiff leaf foliage, and it neither crowds the figures nor leaves them lost in emptiness. With their original bold colouring, the scenes must have been clearly visible from a distance. All the actions have the fresh liveliness of those which are found in the roundels of psalters in the 'de Brailes' group, although they are mostly controlled by greater dignity, as in the scene of the Transfiguration. They reveal a power to visualize the biblical scenes in terms of ordinary human life on earth as in the well-known scene of Noah building the Ark. In most of the Old Testament scenes the style of the thin, finely pleated folds in parallel or V-shaped lines is the same slightly stiff and severe one of the Madonna and Child over the main door and of the angels. In the New Testament

[1] G. Zarnecki, 'The Faussett Pavilion', *Archaeol. Cantiana*, lxvi (1954), 8.
[2] E. S. Prior and A. Gardner, *Medieval Figure Sculpture in England* (1912), fig. 302.

scenes, the greater fluidity, softness, and freedom found in the Coronation of the Virgin prevails, with more slender figures moving with greater ease and gentler grace (Pl. 11 *a*).

It is the same slight variation in style which marks the chief difference between the single standing figures in the niches. Already in the early thirteenth century, figures were placed in niches over the central doorway of the old front at Lincoln cathedral.[1] The 'columnar' figure, that in France was the basic shape governing the development of Gothic sculpture in organic relation to the architectural framework, never took root in England in spite of its appearance at Rochester and St. Mary's abbey at York. The figures at Wells represent the most consistent use of the detached figure placed in the shelter of its niche (Pl. 1). Such figures in niches were uncommon in the rest of western Europe during the thirteenth century, although they began to replace the cylindrical columnar figure of French extraction on the Continent from the late thirteenth century onward, perhaps under English influence.

The connexion with the funeral effigy which was placed within a canopy on the tomb slab has often been argued, but the advance beyond the early effigies at Wells, Peterborough, and Exeter lies in the fully rounded shape, although the shadow of the niche is still reminiscent of the relief ground of the effigy slab and the figures retain the shape of the block from which they are carved. They have the same width at the base as at the shoulders and the contours are barely broken as the arms and hands, holding books or signs of rank or gripping the cord of the mantle, are kept close to the body. Most of the figures in the first two tiers (those in the lowest tier on the front are almost completely destroyed) have the proportions which in all times of classical revival and prevailing humanism are considered as normal; some of the bishops especially are solidly broad and stocky. But the four beautiful female figures on the east side of the north tower have a willowy slenderness and slight elongation that becomes more and more pronounced, particularly in the female figures, in the upper tier, where the height of the body is sometimes ten times the height of the head. This elonga-

[1] G. Zarnecki, *Later Engl. Romanesque Sculpture*, Pl. 128.

tion is accompanied by a more delicate system of flowing folds which, though they still adhere to the typical 'rippled drapery', show a softening and a greater complexity of the vertical arrangement (Pl. 10 *b*). Such a treatment of similarly fragile figures can be found also in some of the contemporary psalters produced at Peterborough and possibly at Salisbury.

The variations in shape and drapery have been explained in different ways: as due to the narrow shape of some of the niches; to the wish to counteract the perspective stunting of figures seen at such a great distance from the ground; to the activity of masons of different age, taste, and experience; to a progress of 'Gothification'. Here we shall only attempt to point out the characteristic English features of the Wells statuary that persist in spite of an approximation to classical models and to French Gothic sculpture of the first quarter of the thirteenth century. The affinity to the latter is more strongly apparent in some figures of kings and queens, usually standing on top of crouching figures which are supposed to provide a clue to their identity[1] (Pl. 9 *b, d*).

In spite of the roundness of the figures there is a decided reticence in showing more of the body than the general shape. Sometimes a belt is used to mark the hips and to break the predominant verticality of the folds, but generally a free fall of thin drapery is suggested especially in the folds which sweep gently round the feet. But the garment, even when a mantle hangs down from the shoulders to form the half of a shell around the kernel of the body, seems always undetachable. The prevailing impression is that of the original block of stone, which remains compact and inert and out of which heads, limbs, and folds are carved (Pl. 9 *c*). Dark areas of shadow nestle in the hollows always clearly circumscribed by contours and ridges. Where an arm is bent or a head turned, organic articulation is disregarded, and the

[1] For a classification of the statues as to groups and authorship see Prior and Gardner, *Medieval Figure Sculpture in England*, 296, and for a revision of this scheme see Aron Andersson, *English Influence in Norwegian and Swedish Figure Sculpture in Wood, 1220–1275* (Stockholm, 1949), 27. The same author attributes a number of wooden figures, now in Norway, to English artists. These, if the attribution entirely on stylistic grounds can be accepted, would to a limited extent fill the gap which has been caused by the total destruction of wooden sculpture of this period in England.

motion seems forced as in Solomon's sudden turn. This is even more pronounced when the figure breaks through the usual calm of pose as in most of the seated figures, when a foot is raised on a footstool or one leg is thrown over the other or arms are planted on knees.

Taking it all in all, it is neither the formal aesthetic quality nor the expressive power which is essential, but the general tenor of serenity, stability of rank, and faith in an aristocratic society. With a typical interest in costume, the various groups of this society are distinguished from each other (Pls. 9 and 10). The prophets and apostles still wear the nondescript timeless garment derived from the toga, but popes and bishops, priests and deacons,[1] monks and hermits, abbesses and queens, kings, nobles, and knights wear their proper garb. Such attention paid to contemporary dress is found elsewhere in European statuary of the time, but seldom in the same degree of detail and with the same range of variations. The series of knights in mail with scalloped tunics and different types of helmet is a unique gallery of contemporary armour.

As always in 'classical' times and in this phase of Gothic art, great stress is laid on youthfulness or prime. Hermits and apostles are elderly men, but the rest show a health and beauty unimpaired by the ravages of time or care, from the innocent youth of the deacons who look like angels, to the grave grace of the ladies and the firmness of kings and bishops. Yet the faces seem in many ways indefinably English, as is also the atmosphere of reticence and aloofness. Instead of falling into rank like the figures on a French portal, they stand quiet and remote each in its little mansion, as distant from the crowd as the cathedral is remote from the town, overlooking what was to become burial ground by act of the chapter in 1243.

Few of them, despite Cockerell's attempt, can be securely named. With rare exceptions, which may be partly due to later changes, the south side is occupied by bishops, monks, and hermits while most of the ladies, kings, and nobles stand or sit on the north

[1] W. H. St. John Hope, 'On Some Remarkable Ecclesiastical Figures in the Cathedral Church of Wells', *Archaeol.* liv (1894), 81.

side. Although Cockerell's identification[1] of the saints, spiritual leaders, and protectors of the Church as exclusively English, taken from William of Malmesbury's *Gesta Pontificum* and *Gesta Regum*, is no longer accepted, it seems justifiable to think that Jocelin gave preference to upholders of the English Church in conformity with the strong national feeling of the Church of his time. Above them, shorn of all trappings of human rank, the dead rise from their tombs, arranged in a continuous but rhythmically divided frieze across the whole front (Pl. 11 *b*). With an amazing agility and variety of movements, partly hiding their nakedness behind the covers of their tombs, they rise joyfully, looking towards Christ in Majesty in the gable without any sign of fear of judgement. This attitude together with the absence of the devils provides a clue to the meaning of Jocelin's front.

The programme at Wells differs from that of the French cathedrals because the Last Judgement scene and the references to human life on earth in the Signs of the Zodiac or the Labours of the Months are absent. Only the Virtues and Vices frame the main portal below the figure of Virgin and Child. On the other hand the suggestion that the gathering of saints, martyrs, and confessors is particularly connected with the worship of the Virgin cannot be supported. The scenes from the Life of the Virgin and especially that of her death which are found on French tympana dedicated to her, are missing. The scheme as a whole illustrates rather the triumph of the Church. First comes its establishment through the First Coming of Christ as shown in the group of Mother and Child above the centre door. Then there follows the Marriage of Church and Christ in the scene of the Coronation of the Virgin by her Son, with the story of the Old and the New Law on earth in the quatrefoils on either side. Finally Christ in the Second Coming is placed in the centre gable above the angelic hierarchy and the twelve apostles (though these statues are of later date). It is only if one accepts the statuary at Wells as an illustration of the Revelation of St. John that everything falls into place. The front as a whole represents the 'New Jerusalem, coming down from

[1] C. R. Cockerell, *Iconography of the West Front of Wells Cathedral* (1851); *A Descriptive Account of the Sculptures of the West Front of Wells Cathedral* (1862).

heaven, prepared as a bride adorned for her husband' (Rev. xxi. 2). The serenity of the figures and the joy of those who rise from their tombs proclaim that 'God shall wipe away all tears from their eyes; and there shall be no more death, neither sorrow, nor crying, neither shall there be any more pain: for the former things are passed away' (Rev. xxi. 4).

III

CATHEDRALS AND MINSTERS:
WORCESTER AND THE PROVINCE
OF YORK

THE 'episcopal' style was introduced into the north of
England by Archbishop Walter de Gray, the trusted adviser
of King John and King Henry who had been chancellor
from 1205 to 1214. He had been consecrated bishop of Worcester
in 1214. In 1215 he returned from the Lateran Council in Rome
with the pallium to begin his useful career of forty years as arch-
bishop of York (d. 1255). In 1220 he was present at the translation
of St. Thomas and assisted at the anointing of Henry III, who
entrusted him with a multitude of tasks all through his life. York
minster, as he found it, had still its Norman nave and the newer
choir which had been added sixty years before by Archbishop
Roger of Pont l'Evêque.[1] The latter was apparently still considered
by de Gray sufficient for the pilgrims visiting the shrine behind the
high altar of St. William of York who had been canonized at de
Gray's request by a bull of Pope Honorius III (18 March 1225-6).
It was not on his deeds as a man or as an archbishop (1143-54)
that his claim to sanctity rested, but on the miracles which occurred
at his tomb and the fact that the minster of St. Peter lacked the
shrine of a saint.

Soon after,[2] de Gray caused the building of a new, majestic
transept on a scale far larger than that of the older nave and
Roger's choir[3] (Fig. 5). His grandiose conception secured to the
minster the dignity fitting for the church of the northern primate.
The transept was laid out with aisles on both sides, following the
pattern of Byland abbey (the western aisles slightly narrower than
the eastern), 150 feet wide and projecting by three bays. The

[1] T. S. R. Boase, O.H.E.A. iii. 234.
[2] T. Harrison, 'York Minster', Arch. Journ. cv (1948), 75.
[3] A. H. Thompson, York Minster Historical Tracts (1927).

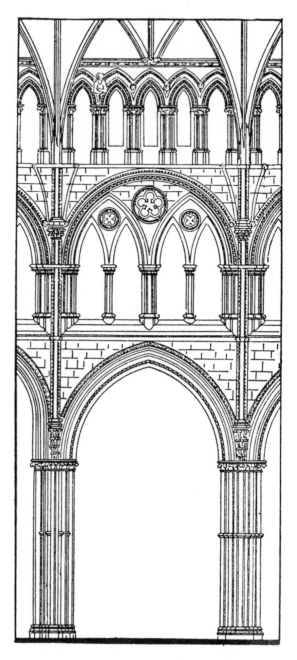

FIG. 4. *York: Bay of South Transept*

width of its original four bays was determined by that of the aisles of the Norman nave.[1] The height and the depth of the triforium corresponded to the Norman design. De Gray's transept combined a sense of vast space and height with large and simple forms; it blended the austerity of the earlier northern Gothic and the richness of the 'episcopal' style. Purbeck marble and carved capitals were used more sparingly than at Lincoln or Salisbury. Large dog-tooth marked the profiles only and the effect of the crisp and trenchant quality of the mouldings was more striking than decorative.

To the arches of the ground arcade was given a wide span of forty feet, and between their strong and many-shafted piers the two lancet windows and the quinquepartite vault of the aisle bay were visible. The piers carried the magnificent triforium, eighteen feet high, in which as at Whitby[2] the multiplicity of the four acutely pointed minor arches was reduced to two major containing arches and finally bracketed by one semicircular arch, of the same width as the arch of the main arcade (Fig. 4). Within the spandrels leaf rosettes and foils and circles toned down the sharpness of the pointed arches and thus increased the effect of stateliness and repose in the vast hall of the transept, which stretched to the length of 223 feet from south to north.[3] The vaulting shafts, which rose in groups of three from leaf corbels immediately above the arcade piers to capitals between the main triforium arches, were not emphatic enough to interrupt the stately horizontal progress of the three storeys, one above the other, the quiet rhythm of which was unfortunately destroyed by later alterations. These vaulting shafts as well as the beginning of the short curved ribs in the triforium spandrels could be taken as an indication that the architect intended to cover the vast width, nearly fifty feet, of the middle aisle with a vault, which, if carried out, would have given a height

[1] The original arrangement was altered late in the century in order to fit it to the broader aisles of the new nave.

[2] See below, p. 65.

[3] When the northern portion was completed under de Gray's successor, the whole transept was unique in resembling a church of its own, set at right angles to the Norman church, which had a front in the south and an end wall in the lancet screen of the 'Five Sisters' in the north.

of about 110 feet to the centre aisle. The present short clerestory
consisting of two thin walls (rebuilt in 1871), with its row of five
arches, three open and two closed, has always been felt to be too
low. It must have been designed after vaulting plans had been
given up.

On the exterior of the transept aisles, slender buttresses alternate
in strength as at Lincoln, and barely rise above the high parapet,

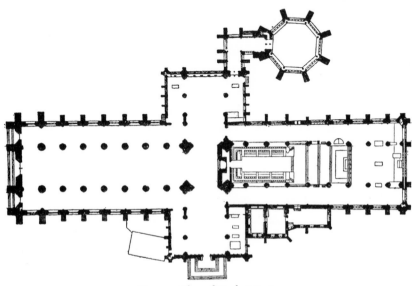

FIG. 5. *Plan of York Minster*

with nothing to bridge the gap between them and the clerestory
wall. As at Lincoln an arcade runs along the aisle walls, its arches
varying in width at the angles of the buttresses. A similar arcade,
though lower, decorates the clerestory wall, with two blind arches
flanking a group of three windows.

The north transept was completed only after de Gray's death.
The south transept façade was the only one in England designed in
the French manner, till the north transept front of Westminster
abbey was built (Pl. 15 a). In its main three vertical divisions it is
clearly related to the interior dispositions. The two narrow side
sections, between the lower outer and the higher inner buttresses,
cover the interior area of aisles and tribune. They are subordinated

to the central section, which rises triumphantly above them with a group of tall lancets, divided by blind arches, and a magnificent wheel window in the gable. Spoiled by restoration, especially in the three over-steep gables above the entrance porch, it is still a proud front which must have been completed, at least in its major parts, when at Christmas in 1251 the royal families of England and Scotland met as the guests of the archbishop to celebrate the wedding of King Alexander III of Scotland and Princess Margaret, daughter of King Henry III.[1] Two years later de Gray fell ill at York Place (now Whitehall) in London, after having acted for the second time as regent in the absence of the king and queen. He was brought home after his death and buried before the chantry altar that he had founded in 1241 in his new transept.

While the great enterprise at York was in progress, de Gray assisted the chapters of his three minsters in the remodelling of their churches. At Ripon in 1224 he had the relics of St. Wilfrid translated to a new shrine in the eastern bay of the north choir aisle, but the nave and choir of Bishop Roger of Pont L'Evêque remained unchanged. The new addition consisted of an impressive twin-towered front of a type rare in England except in the region north of the Humber.[2] Indulgences granted in 1233 by de Gray and in 1258 by Pope Alexander IV in favour of the fabric suggest the dates between which the new work was carried out. Two strong flanking towers were set outside the older aisleless nave, and the centre portion was treated, as was usual with the eastern fronts in the north, with two rows of fine lancets, framed by bonded shafts, the upper ones rising from the side towards the gable (Pl. 15 b) with its three small lancets; and below three gradated portals. The windows and arches in the three storeys of the towers, once capped by tall wooden spires, were tied in with the centre by thin string courses between the storeys. If there is a certain blankness in this stark front, largely due to over-restoration, its sober rectitude

[1] J. Solloway, 'Walter de Gray', *York Minster Hist. Tracts* (1927). 'Such was the primate's liberality on this occasion that he has been described as "behaving as the Prince of the North".'

[2] The Norman twin towers at Durham were heightened early in the century. At Bridlington part of the twin-towered façade built at this same time still remains, and at York minster and Beverley façades of this type were built later.

seems fitting as an entrance to the shrine of such a stiff-necked saint as Wilfrid had been.[1]

The rivalry between the collegiate chapters of York and Beverley, the location of Beverley minster in a flourishing town which was one of the most important ports in the north before the rise of Hull, the fame of its saint, St. John of Beverley who ranked with St. Cuthbert in seniority and popularity—all this contributed to make the new choir at Beverley the most perfect Gothic structure in the north, almost flawless in the unity of its design, cool and graceful in its sober elegance.[2]

The bones of its founder St. John (canonized 1037), the first archbishop of York, who ordained Bede and whose banner led King Athelstan to victory at Brunanburh, had been found in 1197 after a fire had caused severe damage to the Norman structure in 1188. But it took more than thirty years before a complete rebuilding began. In 1202 King John had extended the privileges of an already strong collegiate chapter in a charter which was reaffirmed by Henry III. A number of energetic provosts, among them Fulk Basset (about 1222–40), before his transfer to St. Paul's, and John Mansel, keeper of the Great Seal, headed the chapter while the new choir was in building. In 1232 Archbishop de Gray granted an indulgence to assist the new structure which was to replace the miserable ruin ('enormiter deformata') left by the fire.[3] The uniformity of the design suggests that the building was completed in about twenty years or that the initial design was adhered to as strictly as it was followed later in the fourteenth century, when the new nave was built continuing the design of the first bay west of the thirteenth-century crossing.

The mason, whose genius produced a highly individual design, used the double cross plan which was possibly derived from Roger's choir at York, whence stemmed at least the broadening of the first transept by aisles on either side. Four bays of an aisled choir stood between the first transept, which projected by three

[1] The new front of Old Malton Priory was copied after that at Ripon. See *V.C.H. Yorkshire, North Riding*, i (1914), 538.

[2] H. E. Nolloth, *Beverley and its Minster* (1930).

[3] R. H. Whiteing, 'Beverley Minster', *Journ. Brit. Arch. Assoc.*, N.S. xxix (1923), 135.

bays, and the eastern transept (Fig. 6). This latter had only one
narrow bay beyond the aisle, but to it was added an eastern aisle
and a projecting chapel dedicated to St. John. Upon this compact
plan the choir rose with easy loftiness, thoroughly logical in the
relation of narrowness and height, both equally unusual in English
Gothic, and with a happy harmony of firmness and springy light-

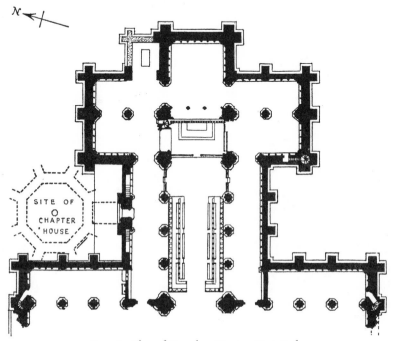

FIG. 6. *Plan of Beverley Minster: East End*

ness. In the solid clusters of eight stone pillars, four round columns,
frequently with vertical fillets, alternated with four squared ones,
an alternation which was reflected in the arch moulds: these sup-
ports stood upon high octagonal plinths, in quick succession to
one another as the bays were narrowed so as to provide oblong
compartments for the quadripartite vaults (Pl. 8 *b*). For once in
English Gothic wall and vault were truly related; the single vault-
ing shaft started from between the nave arches, became tripled
above the triforium sill, and from there continued into the clere-
story. The simple ribs of the vault were released, as later at West-
minster abbey, from a point high on the wall.

The cumbersome high triforium gallery of Norman tradition, still used at York, was replaced by a true triforium which was no more than a narrow strip about ten feet high between the lofty arcade and a clerestory of audacious lightness. The excellent effect of the low triforium required the use of flying arches visible above the aisle roofs. Its double arcade may have been inspired by that in the aisles of St. Hugh's choir in Lincoln, but its disciplined regularity was in keeping with the general design. The points of the rear arcade came below the capitals of the four trefoiled arches in front. This entailed the truncating of the colonnettes but it left room for quatrefoils to fill the gaps. Movement and depth were thus given to the middle zone from the solid back wall forward and upward in clearly articulated steps.

The clerestory, nearly double in height, was constructed in two thin shells: a light, graceful screen of five gradated, sharply pointed arches in front of a solid wall which has one window in the centre. The vault seems to rest lightly upon it as the ribs do not appear to have the backing of solid walls but spring from bundles of colonnettes set in front of it. The effect of lightness is slightly marred, however, by the curve of the ribs which, beginning steeply, are soon flattened out, with the transverse arches stilted and four-centred. This system was carried through transept and choir into the eastern chapel which was of the same height. An even light pours from the clerestory windows into all parts, as controlled and as lucid as the main design and as the careful pro-portioning of stone and marble. Dark marble was reserved chiefly for the upper parts above the stone structure and a note of sobriety was maintained in the use of bell capitals throughout, with the exception of the capitals in the trefoiled blind arcade along the lower walls of the aisles.[1] The only break in the design occurred in the piers of the crossing in the eastern transept. Apparently as an afterthought these were boxed in, after the projecting angle had been cut off to prevent the blocking of the narrow choir, the original cluster of columns peeping out incongruously almost at

[1] The wall arcade in the north choir aisle was turned into a beautiful double stair-case which led to the destroyed octagonal chapter-house. For its ground plan see J. Bilson, *Archaeol.* liv (1895), 425.

clerestory level. The surfaces of the square sides were overlaid by a wilful arrangement of stone and marble carpentry.

In the absence of towers, the exterior effect of Beverley minster centred upon the two transept fronts, which were separated by the three bays of the choir and were suitably distinguished by their different breadth and projection (Pl. 7 a). The front of the main transept was broad and well balanced in the placing of one single, broad window in the aisles with a quatrefoil in a circle above, and the grouping of three lancets in two storeys, with a wheel window and a vesica in the gable above. The whole was well articulated by buttresses and high pinnacles. The shorter transept was steep and narrow, its windows arranged in even numbers in four storeys and without a wheel, which would have toned down its steep verticals. It thus acted almost like a tower guarding the sanctuary. The straight walls of the choir between were divided by narrow buttresses with angle shafts and single lancets within a blind arcade which, though regular in height, varied in width. Inside and out the design of Beverley choir had a clarity and agility which could well compete with the chevet of the French cathedrals.

While Beverley choir aspired to the dignity of a cathedral, the new choir at Southwell minster came closer to the simple modesty of the parish church. The mother church of the southern arch-deaconry of York was set in Nottinghamshire, off the main road, withdrawn from the world, its solitude a contrast to the busy life of Beverley port. Its rural peace was generally broken only when the archbishop came to reside in his palace beside the minster or when the clergy of the county met at the yearly synod. For the rest of the year the canons were left to themselves and to the stately quiet of precincts which have preserved their peace until today.

Although in possession of the body of St. Eadburgh, the minster dedicated to St. Mary was never a thriving pilgrim centre but its role as a mother church was made manifest every year at Whitsun when according to earlier Norman practices (reaffirmed by a bull of Alexander III in 1171), clerks and laymen came in solemn pro-cession to receive the chrism which had been brought by the deans

of the county from the church at York.[1] The close ties between the minster and its parishes were indicated by the fact that the stalls of the canons were called by the names of their prebends.

In 1234 the king and the archbishop assisted the chapter in the task of rebuilding the choir. The king gave one hundred and fifty oaks from Sherwood Forest and the archbishop granted an in-

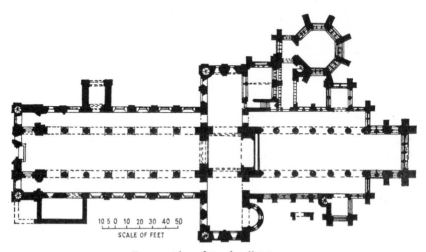

FIG. 7. *Plan of Southwell Minster*

dulgence of thirty days. As early as 1225, certain funds had been appropriated to the fabric fund, and a warden of the fabric existed before 1248, by which time the work must have been almost completed.[2] The canons were much less ambitious than their colleagues at Beverley, although the plan had much in common with that of Beverley choir—a choir of six-aisled bays, projecting by two more bays to form a square eastern chapel of the same height (Fig. 7). Two square chapels acted as a second transept although they were kept as low as the aisles. This transept marked the place of the high altar, which stood originally in the light from their windows, one bay west of its present position. Two more altars stood in the last bay of the aisle with the last choir bay left free for processions.

 [1] 'Visitations and Memorials of Southwell Minster', *Camden Soc.* N.S. xlviii (1891), xxxii.
 [2] A. H. Thompson, 'The Cathedral Church of the Blessed Virgin Mary,' *Thoroton Soc. Trans.* xv (1911), 15. A. Dimock, *The Cathedral Church of Southwell* (1898).

In building upon this plan the height of the Norman nave and transept, which were left intact, imposed limitations which gave to the interior an effect of stately breadth rather than height, whatever the Gothic piers, arches, and vault might promise. With a height of about thirty-three feet in the main arcade, only seventeen feet were left in the elevation (Pl. 14 a). The architect decided to dispense with the triforium, and to add only one more storey, thus creating one of the earliest examples of the two-storeyed construction outside the Cistercian sphere. It may be that the architect came from the archbishop's estate in Gloucestershire, with knowledge of the two-storeyed choir at Pershore. But his solution differed vastly from that at Pershore, and he achieved a unique effect, combining designs from Lincoln and the north, though no marble relieved their severity. The cluster of eight shafts set closely together, alternating in size and with fillets which were continued into the necking of the bell capitals, strong arch moulds, partly filleted and with one row of fine nail heads, with little room for hollows, a hood mould resting on leaf bosses—all this gave strength and fullness to the structure. The walls in the aisles were left plain without wall arcading, only pierced by a couple of narrow, deeply splayed lancets, two in each bay as at Lincoln. The spring of the vault was set low, and the sturdy triple vaulting shafts, with the vigorous leaves of their corbels and capitals, descended to the meeting-point of the hood mould. The vault's pressure was taken by the thick walls, which did not need the help of outside flyers (added later), and with the strength of its ribs it seems to hold the walls as in an iron clasp. The whole of the upper wall above the string course which bent around the vaulting shafts was taken up, bay by bay, by one order of pointed arches rising from clustered responds which were divided into two by four grouped columns. But the memory of the division of triforium and clerestory was retained in a wall passage with two blind arches below and the small coupled clerestory windows above. Only in the easternmost bay tall lancets of the full height of the upper storey joined with those of the lower walls to flood the eastern part with light and thus to prepare for the beautiful effect of the eastern wall with its two storeys of lancets. Instead of the customary uneven number, the

east wall was pierced by two storeys of four windows, apparently because the architect liked the effect of a rib descending continuously from the ridge rib of the vault to be received, eventually, by a dwarfed shaft in the centre between the windows. While the main vault was of four ribs and a rather uneven ridge rib, like that of Lincoln transept, with foliated bosses at the intersections, the aisle vaults and those of the transept chapels had an extra rib descending towards the outer wall between the double lancets of each bay, an effect which had been used in the choir aisles at Lincoln and in the transept at York.

It was, however, chiefly the choir at Lincoln which left its stamp upon the exterior of Southwell.[1] The neatness of the masonry, the clarity and precision in the gradual recession in width from chapels to aisles and to the eastern end, the sharp contrast of light and shade produced by the strong base course, the chamfered buttresses with overhanging pinnacles, the shafted jambs of the deeply set windows—all imbue the choir with an invigorating strength though its proportions cling tenaciously to the solidity and the spreading width of an earlier age (Pl. 7 b).

What was done for York and its minsters under Archbishop de Gray was planned for Durham cathedral by Richard Poore, who was translated to the northern see in 1228. Poore may have consulted Master Elias of Dereham when he visited the cathedral in 1231, but the actual work on the new choir was not begun before 1242 under the direction of Prior Melsonby (1233–44). In 1247 Bishop Nicholas of Farnham appropriated the revenues from the church at Beddington to the new fabric, and the bishop of Ely, Hugh of Northwold, assisted by an indulgence for those who contributed to the building fund. The monks were able to enter the new choir by 1253, when five of the nine altars were consecrated. The name of one architect at least has survived: Richard of Farnham, 'architector novae fabricae', and that of another mason, Thomas Moises, was inscribed upon one of the outer buttresses: 'Thomas Moises posuit hanc petram'.[2]

. [1] The effect is spoiled by the present low roof which replaces the high-pitched roof of the transeptal chapel which abutted against the lean-to roofs of the aisles.

[2] C. R. Peers in *V.C.H. Durham*, iii (1928); W. A. Pantin, *Durham Cathedral* (1948); G. H. Cook, *Portrait of Durham Cathedral* (1948).

It has been generally accepted that the new eastern chapel of Fountains abbey, which was in building at this time, set a model for the 'Nine Altars' at Durham (Fig. 8), but if so Fountains gave no more than the general idea of an eastern chapel which by its greater width than that of the choir formed the head of a T. The builders at Durham had to consider the old Norman choir, which remained unchanged but for its last bay. It may be that the rock upon which the cathedral had been lifted by its Norman builders limited the extent of the eastern chapel—160 feet in width, it still projected less than the older Norman transept, and was thus much more compact than that at Fountains. At the same time, while more massive, with its walls eight feet thick, it was much richer inside than the Cistercian choir, a glittering shrine for the most venerated saint of the north, encased in solid walls which maintained the character of a fortress church even in its Gothic form.

FIG. 8. *Plan of Durham Cathedral: East End*

In spite of the paring of the outer walls and other damages caused by the restoration under Wyatt, the east front has an almost Roman massiveness and simplicity in the sequence of nine lancets in two storeys, divided and flanked by square buttresses. The largest of the buttresses are ten feet in projection, and all of them are most cleverly graded in width and in height. Predominance is given to the centre section by the circular window (its weak tracery is by Wyatt), which is set back into the thickened wall between the three steep lancets below and a small gable above.

More than any other church of the north, more even than Beverley, the chapel of the Nine Altars sparkles inside with the reflections from its shafts of local Frosterley marble, a substitute for the Purbeck marble which earlier had been imported for Bishop Pudsey's Galilee. All along its eastern wall, which is built

in a series of screens, bundles of thin shafts alternating between marble and stone jut forward with their wedge shape, and something of the richness and the majesty of Peterborough front seems suggested in this east face of the vast hall (Pl. 18). Its height was increased to about eighty feet by the lowering of its floor below choir level. Nine recesses were made for the nine altars, arranged in a subtle rhythm. The three in the centre, of which the middle one was dedicated to St. Cuthbert and the Venerable Bede, face the shrine of Cuthbert which projected into the chapel, lifted upon a high base. These three altars stood against a stretch of wall arcading, consisting of nine arches below the three lancets, grouped together in the centre and framed by elegant shafts. This middle section, of the same width as the choir and nave, was flanked by the largest pillars, each with seven shafts. The wings in north and south were subdivided by smaller pillars, each with five shafts, with three arches of arcading and a single lancet in each compartment. Behind these pillars, rhythmically dividing the whole east face, the wall arcade seems to run as a separate screen, an impression strengthened by the fact that the pillars cut off parts of the lengthened and sunk quatrefoils that are set between the labels of the trefoiled arcade. The solid masonry between the shafted pillars and the windows was pierced by a wall passage, and the labels of the arches and the string course were enriched with leaf scrolls. If one looks along the eastern wall, there seems to be a continuous advance and retreat alternating from bay to bay, from the pillars and their shafts into the shadowy deep hollows of the windows. Nothing betrays the solid, supporting mass of the buttresses outside. The ingenious design of the vault, by which the unequal size of the bays was overcome, belongs, with much of the splendid carving of the capitals and of the bosses as well as the magnificent window in the northern wall of the chapel, to a later period.

Besides Durham, one other monastic cathedral, one which was favoured by its Anglo-Saxon saints and the royal house, the monastic cathedral at Worcester, received a new choir which was a notable example of the 'episcopal' style.[1] A series of important

[1] For the dates of rebuilding see W. M. Ede and H. Brakspear, *Worcester Cathedral*, 4th ed. (1937); J. M. Wilson and H. Brakspear, 'The Date of Building of the Present

events had brought pilgrims and wealth to the cathedral. From 1201 the miracles at the tomb of St. Wulfstan had increased so steadily that the pope approved his canonization in May 1203, thus giving to the west a saint who ranked with St. Cuthbert, St. Hugh, and St. Thomas. In 1216 King John was buried at his own wish between St. Oswald and St. Wulfstan before the high altar 'that the saying of Merlin should be fulfilled: Et inter sanctos collocabitur'.[1] He was the first Plantagenet who was not laid to rest at Fontevrault, but on English soil between two Anglo-Saxon saints. During this time repairs and remodelling of the old choir had been carried out to be concluded by the most solemn ceremony of rededication of the cathedral to Our Lady, St. Peter, and the Confessors Wulfstan and Oswald. The bones of St. Wulfstan, with the exception of those given to various abbots and of one rib which was carried off to St. Albans, were deposited in a new shrine in 1218 in the presence of the young King Henry, ten bishops, seventeen abbots, and many nobles.

But this choir which had seen such a splendid gathering was doomed. On the Feast of St. Andrew, in 1222, a great storm threw down two lesser towers which may have been flanking the old apse. Two years later Bishop William of Blois (1218–36) laid the foundation stones of the new work which was to sweep away everything east of the Norman transept and which went in the consummate perfection of its style far beyond the modest beginnings of Gothic in the two western bays of the nave.[2] When Bishop Walter Cantilupe (1237–66) called a synod at Worcester in 1240, much of the new work may have been ready, but the remodelling of the presbytery proceeded slowly. Bishop Giffard (1268–1302), according to Leland, gave to the columns in the

Choir at Worcester Cathedral', *Archit. Soc. Reports and Papers*, xxxv (1919–20), 17 and 357.

[1] *Annales Monastici*, R.S. xxxvi (1868), iv, 59.

[2] C. K. Floyer, 'Worcester Cathedral, The Dedication of 1218', *Archit. Soc. Reports and Papers*, xxxv (1920), 368: 'When the new work of 1224 was begun, there was founded a second fraternity in which another group of monasteries embracing nearly all those whose abbots were present at the dedication of 1218, engaged in return for a participation in their prayers, to find so much money each year.' *Annales Monastici*, R.S. xxxvi (1868), iv. 417.

eastern parts marble coronets having joints of gilded brass. As the
sixty marks which were given by Bishop Nicholas of Winchester
(trans. 1268 from Worcester) in 1280 were destined for the re-
building of the central tower, it can be assumed that the work east
of it had been completed.

The new eastern parts were laid out on such a vast scale that they
equalled the Norman nave in length. The four bays of an aisled
choir were followed by an eastern transept which projected by an

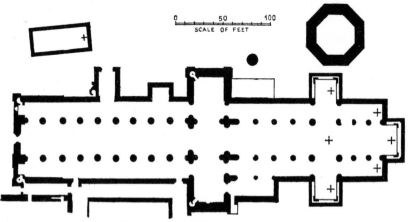

FIG. 9. *Plan of Worcester Cathedral*

almost square bay on either side, as at Beverley and Southwell (Fig.
9). Beyond it a deep retro-choir of three bays ending in a shallow
eastern chapel has an affinity to the retro-choir at Winchester, but
throughout the eastern parts the same vault level was maintained.
Thus the new work at Worcester was connected with the northern
province of York, and renewed the ties of the past when in early
times Christianity came to these parts from St. Hilda's at Whitby,[1]
and when, in return, the monastic revival of the ninth century was
brought from Worcester to York.

As suitable for a monastic cathedral, the choir stalls remained
until the reign of Queen Mary in the old positions, starting from
the easternmost bay of the nave in line with the eastern wing of the
cloisters. The high altar stood under the eastern crossing and at

[1] J. M. Wilson, 'The Worcester Antiphonar and the Cathedral Services of the
13th Century', *Worcs. Arch. Soc. Trans.*, N.S. ii (1924–5), 75.

least St. Oswald's tomb remained in its old position, while the tomb of King John was moved one bay westward into the new presbytery. The intention may have been to place the shrine of St. Wulfstan in the retro-choir, but at an unknown time his tomb was attached to the corner piers of the eastern crossing opposite to that of St. Oswald, and the tombs supposedly of William of Blois and of Walter Cantilupe, the builders of the new choir, were placed facing the altar in the eastern chapel, the dedication of which cannot be ascertained.

Even in spite of the cruel treatment in the course of the nineteenth century which caused the disappearance of the green Highley stone of the outer walls and gave to the east wall a modern row of lancets,[1] the choir at Worcester remains the most splendid blend of the northern and southern manner. The intention of its builders can be realized at its best in the retro-choir and the eastern transept, the floor of which lies below that of the old presbytery so that the full effect of height is gained in spite of the retaining of three storeys in the elevation. Here only has the system its full lofty height and elasticity, where the quatrefoil piers with their eight Purbeck marble shafts are two and a half feet higher than those in the presbytery. Twice as high as the width between them, they frame with their arches the windows in the aisle walls and the trefoiled wall arcade below with its splendidly sculptured spandrels. This arcade runs through behind the piers, just as a minor continuous arcade in the storey above runs along the solid back-wall of the triforium. The wish to build a high vault without the outer support of strong buttresses and outer flyers, even when built of light material as here of tufa stone, still required a strong wall which was most ingeniously designed in three layers above the main arcades.

In this example of the double arcade, which was more successful than at Lincoln and Beverley, the second file of single slender

[1] A. B. Pickney, *R.I.B.A. Journ.* viii (1901), 300: Perkin's restoration of the east end was suggested partly by the group of lancets in the east wall of the smaller transept and by the existence at the east end of passages leading from the triforium and indicating that there was originally a gallery across the east wall, dividing it as in the small transepts.

colonnettes and pointed arches was made shorter and lower than the main triforium arcades in front. It was fully detached with a narrow wall passage between, seemingly set much farther back in depth, and forms a screen against the blank wall, of two narrow arches flanking a broad one, divided by a sturdy bundle of Purbeck marble shafts. These in turn are subdivided into two sharply pointed units by slender shafts, and sculpture was added to the spandrels. Thus a sequence of four units stood in front of a sequence of three, the latter repeated in different proportions in the triplet of the clerestory above. This takes up almost all the wall between the steeply rising ribs, springing at the clerestory level from vaulting shafts that begin between the arches of the main arcade.

In the adjoining presbytery where the height was limited by the higher floor level above the crypt, the subtle system of the retro-choir was spread over lower and wider bays, thus losing its coherence. But the greatest triumph of lightness was achieved in the square arms of the eastern transept. Above the trefoiled wall arcade of the base, which has retained parts of the original sculpture in its spandrels, three narrow lancets in two tiers take up the whole height, with bundles of slender shafts standing freely in front of them. The lower tier rises as high as the choir arcade, but the upper comprises the height of triforium and clerestory together, both linked by a shaft which rises from the string course and is continued into that which supports the outer member of the upper arches (Pl. 17 *b*).

Severe restoration has dealt harshly with the sculptural decoration which was a special feature of the new choir. The spandrels in the wall arcade are filled with dramatic figural scenes—a new treatment in England and one that goes far beyond the usual decoration with foliage and beasts found at Wells, St. David's, and Bristol (old lady chapel). The reliefs in the spandrels of the southeast transept form a cycle beginning with the Fall and ending with the Judgement; those in the north transept have New Testament subjects. But in the south aisle of the eastern chapel there is a remarkable series of secular scenes, which seems to illustrate certain events or stages in the building of a church. Throughout the carvers found it difficult to cope with the awkward shape of the

spandrel, the frame of which they frequently ignore. The artist of the Doom series is more successful in accommodating his thin, pliable figures, which, with their lively, awkward gestures, recall the figures in a book such as the Trinity College psalter (MS. B. 11. 4). In the other carvings the style is very close to that of the Wells west front.[1]

[1] E. S. Prior and A. Gardner, *Medieval Figure Sculpture in England* (1912), 252. Fig. 268 shows a spandrel from the lady chapel at Bristol.

IV

MONASTIC AND PARISH CHURCHES

WITH the dissolution of the monasteries and subsequent decay of many buildings the evidence of building activity among the orders has become fragmentary and the remains are generally modest in scale, with the exception of some abbeys in the north. On the whole, the abbeys and priories which received important additions in the thirteenth century seem to have been few in number. It was a period when the seculars were in the lead, and the distinctive features of the architecture of the monastic orders, so strong in Anglo-Norman times, tended to disappear. Some work of good quality was carried out, as at Boxgrove priory and Waltham abbey, but the extensive work of remodelling the nave of St. Albans under Abbot Trumpington and his successor was undistinguished and done piecemeal, and could not measure up to the standards which the abbey set for painting and goldsmith work.

The remaining evidence points toward greater energy and ambition in building in the west and the north. While the choir at Worcester was in construction, the east end of Pershore abbey near by was remodelled in a most original manner. The eastern arm of the Norman building was destroyed by fire on St. Alban's Day in 1223, and rebuilding began at once, starting at the eastern end. Henry III, who visited the abbey three times, granted trees from the royal forest, and in 1227 he granted a fair, probably in order to restore the fortunes of the borough which had suffered from the fire. In 1239 the work was consecrated by Bishop Walter Cantilupe.[1] The new choir, east of the Norman transept, consisted of four slightly irregularly shaped bays, which led to the strangely shaped three-sided apse where the high altar stood between flanking chapels. The easternmost arch was raised to form a more impressive entrance into a lady chapel, three bays deep,

[1] A. W. Clapham in *V.C.H. Worcs.* iv. 159 ff.

which was still in progress of building in 1259. It was completed by Abbot Eler or Alfric, who resigned in 1264, and the present end of the apsidal chapel is modern.

The elevation of the new choir was, together with that at South-well, the only two-storeyed construction outside Cistercian circles, but it was made much more elegant in its appearance. The walls were evenly divided into two storeys of about twenty-five feet each (Pl. 14 *b*). The main pillars with their triplets of shafts on moulded bases and with foliated capitals were late examples of the western type of pier found at Wells and Shrewsbury. The storey above, combining triforium and clerestory, was built in two shells, with lancet windows in the outer wall and an open screen of gradated arches in front, which was tied to the outer walls only by stone lintels. Its graceful design must have been inspired by that of the windows of the eastern transept at Worcester. In 1288 a fire destroyed probably all the roofs and the superstructure of the Norman tower and the present intricate vault was added after-wards.

The new work at Pershore may have inspired rebuilding at the neighbouring abbey of Evesham, though nothing remains to indicate its nature and quality. It is reported that Thomas of Marl-borough (1229–36) repaired the walls of the presbytery and built an eastern aisle around it which was vaulted and flanked by turrets.[1] In 1233 the shrine of St. Wistan behind the high altar was con-secrated and the church rededicated in 1239, at the same time as Gloucester abbey. At Gloucester the towers of the Norman abbey were partly rebuilt or heightened and a rectangular lady chapel was added to the choir. The exquisite 'reliquary', now at the end of the north transept, may have formed the entrance into it. In 1242 the vaulting of the seven bays of the Norman nave was com-pleted, carried out by the monks themselves.[2] The carving of the vault bosses shows a connexion with Wells.[3] Remaining parts of Llandaff and Valle Crucis belong to this period. The chancel of

[1] *Chronicle of Evesham*, R.S. xxix (1863), 265.

[2] *Historia et Cartularium*, R.S. xxxiii (1863), i, 29.

[3] C. J. P. Cave, 'The Roof Bosses in Gloucester Cathedral', *Trans. of Bristol and Glouc. Arch. Soc.* liii (1931), 99.

Brecon priory is lighted by a row of deeply splayed tall lancets, the elegant contours of which are repeated in the inner screen of bundled shafts supporting the moulded rear arches on bell capitals: a design of great restraint and dignity, light and elegant like the clerestory of Pershore choir.

Farther north, the most extensive remains of monastic construction are those of the Cluniac house of Wenlock where a new church was built 350 feet in length, with a nave of eight and a choir of seven bays. Hugh Foliot, bishop of Hereford (1219–34) and Henry III assisted the monks with gifts of revenue and timber. In 1232 King Henry ordered that the prior should receive from Hawkhurst Wood timber for 30 tie-beams for the building of the church.[1] It was designed in a solid and austere Gothic with heavy piers of clustered stone columns and a simple triforium storey of two openings in each bay. The bays were separated from each other by the triple vaulting shafts, which were caught by corbels in the spandrels of the nave arcade and rose to the clerestory sill, where the ribs of the vault were released. Beginnings were made to new choirs for Chester abbey and Carlisle cathedral, and the new triforium and clerestory which were given to the church of St. John at Chester were an ingenious compromise between the Norman and the new Gothic.

But the greatest efforts were made by the Benedictines and Cistercians in Yorkshire. The noble beginnings of the northern branch of early Gothic, which had produced the churches at Hexham and Tynemouth and the Cistercian abbeys of Byland and Roche, ripened into a glorious fulfilment of its early promise in the monastic choirs of Benedictine Whitby and Cistercian Rievaulx and Fountains. They all received about the same time new choirs—three different versions of the type of choir which ran at the same height through to the east end, turning a steep eastern front towards the outside.

At Whitby,[2] after a set-back in the abbey's growth due to the

[1] Rose Graham, 'The History of the Alien Priory of Wenlock', *Journ. Brit. Arch. Assoc.* 3rd ser. iv (1939), 117.

[2] *Cartularium Abbatiae de Whitby*, ed. J. C. Atkinson, Surtees Soc., lxix (1878), 72. A. W. Clapham in *V.C.H. Yorks. North Riding*, ii. 508.

king's seizure of its revenue in 1211, the abbey of St. Hilda, one of the oldest in the country, reached its greatest period of security and wealth. The rebuilding of the abbey church started about 1220 with an extended choir of six bays (Fig. 11) to which was added in due course a broad transept projecting by two bays with an eastern aisle, and three bays of a new nave (Pl. 13 *b*). The builders followed the Benedictine tradition of a three-storeyed elevation (Fig. 10), though the horizontal emphasis and the heaviness of the masonry were counteracted by the height of the narrow nave and the accumulation of pointed arches and tall lancets. The sturdy piers, with eight engaged stone shafts, alternating in thickness and, as frequently in the northern school, sometimes keeled, support the arches of three moulded orders on simple moulded capitals. In the triforium above, four minor pointed arches were placed below two large ones and all were held together by one round comprising arch, a design which was followed in the new transept at York minster and in one bay at Rievaulx. Although three slender shafts were made to rise from

FIG. 10. *Whitby: Bay of Choir*

foliated corbels in the spandrels of the main arcade, no vaulting of the main span seems to have been intended. The low clerestory was simply divided into a wall arcade of even height, which contained one window in the widest arch in the centre. The abbey is now in ruins, the austerity of its masonry unrelieved by marble, and the fronts of the choir and transepts, with their three sets of

WHITBY

FOUNTAINS

RIEVAULX

TINTERN

FIG. 11. *Plans of Whitby, Fountains, Rievaulx, and Tintern*

tall lancets, repeat the effect of Tynemouth[1] in simple boldness and strength. Battered and roofless, it still rises proudly from a steep cliff above the sea, holding its own against the elements.

During the same years the Cistercian abbeys of Rievaulx and Fountains replaced their older sanctuaries by new structures. Though they still retained some of the pristine austerity of the Cistercian style, they went far beyond it in the size and the lightness of their Gothic construction. For both mother houses of the flourishing order in the north, the struggles of the early years were of the past. The fearful wilderness of rocks and thorns which had attracted the early settlers had given way to fertile fields and rich pastures where flocks of sheep grazed and brought trade and wealth to a large community of monks and lay brethren. The new choirs, in the peaceful calm of sheltered valleys, were not like the shrines of saints on the main roads, which were thronged with pilgrims and sparkled in colours and marble. They were quiet, noble oratories suited for private prayer and solemn mass in honour of their patron, the Virgin Mary. The skill of the builders in laying the stones and cutting strong, crisp mouldings as well as the reticence in ornament gave to them an aristocratic aloofness and purity (Fig. 11).

At Rievaulx[2] the new work was begun in the second quarter of the century, first with the eastern chapels which were added to the old transept, to be continued after in slightly richer form in a long choir of seven bays carried through to the east at level height (Pl. 13 a). The high altar stood at the end of the fifth bay with the following bay left clear for access to the altars set against the east wall, one in each aisle and three in the centre, five altogether. With four cardinal columns and three small stone shafts set between them on each side, the clustered octagonal piers produced a lively contrast of light and shade. The builders adopted the Benedictine custom of inserting a triforium gallery of two tall openings separated by a massive cluster of columns, bridged by elaborate mouldings enriched with dogtooth[3] (Fig. 12). They were

[1] T. S. R. Boase, *O.H.E.A.* iii. 257, Pl. 73 a.

[2] C. R. Peers (*Ministry of Works Guide*, 1938).

[3] G. Jack, 'The Development of the "Dog-tooth" Ornament', *Yorks. Arch. Soc. Journ.* xxxiv (1939), 358.

sub-divided again into two smaller openings divided by one shaft. Three quatrefoils pierced the plain wall in the central spandrels.

FIG. 12. *Rievaulx: Bay of Choir*

Only in one bay, the triforium arches were enclosed under one round arch as at Whitby. But the broad, level arched clerestory of Whitby had to give way to one which fitted into the vaulting ribs. These sprang from the clerestory sill, from triple vaulting shafts, which descended in the eastern bays to the triforium sill, while in the westernmost bays they reached down to between the nave arches. The tall broad arch in the centre of the clerestory arcade, between two lower blind arches, left room for two windows set in the outer wall behind a wall passage, and a simple quadripartite vault was spanned across the choir. In the eastern front the grouping of lancets deviated from the normal custom in the north in the size of the three tall, gradated windows of the second storey, where the openings have consumed almost all the wall space to leave only banded shafts between them.

But it was at Fountains that Cistercian architecture achieved its greatest beauty.[1] The east front of the Nine Altars, which traditionally had never been wider than nave and aisles, was now widened by the addition of the two more bays on either side (Fig. 11). A vast eastern vaulted hall of the

[1] W. H. St. John Hope, 'Fountains Abbey', *Yorks. Arch. Journ.* xv (1900), 269.

same width as the first transept formed the cross-beam of a T, with five bays of an aisled and vaulted choir between the two transepts, all of the same height. Under three abbots, John of York (1203–9), John of Ely (1209–19), and John of Kent (1219–47), the work was begun and completed. The whole, so high and light (over sixty feet), was on a much grander scale than in any other monastery, more ornate than customary for a Cistercian church, and one of the best lit.

All the choir arcades and walls above them have disappeared; only a few of the pier bases are left. But the remaining walls of the eastern chapel suggest that the builders at Fountains did not, as those at Rievaulx, adopt the Benedictine gallery-storey, but maintained the Cistercian two-storeyed elevation of the nave (Fig. 13), the most glorious example of this design in the first half of the century, in its airy lightness beyond anything constructed elsewhere. The height of its piers was the same as that of the nave, but they carried sharply pointed arches not very much lower than the lancet windows of the eastern chapel with a high clerestory above. A trefoiled arcade ran all along the base of the wall in aisles and chapels. It was divided into groups along the east wall to back the nine altars: three groups containing four arches in the north and south arm and three groups of three in the centre, all separated by stone walls eighty-two feet high with gabled tops.

Above the arcade each bay of the aisles was treated like the clerestory at Rievaulx, but with a rather unfortunate attempt to let the side arches of the triple arcade ascend ungracefully towards the middle. In the chapel two acutely pointed blind arches were set between the tall lancets, reminiscent of Lincoln, with the clerestory above. In order to vault the eastern hall, a simple, clear solution was devised. The original quadripartite vault of the choir was carried through the centre bays of the chapel, but the similar vaults of the three bays in north and south were set at right angles against them, running from east to west. This necessitated the building of the two octagonal pillars inside the eastern hall in line with the choir piers. Rising to the full height of the hall (fifty feet), twice as high as the choir piers, their fragile slenderness was increased by eight attached marble shafts of which the bell capitals only remain

(Pl. 17 a). The exceptional grace and lightness of the eastern transept was reflected also in the broad east front with its quick succession of narrow lanceted bays and slender buttresses, though its full

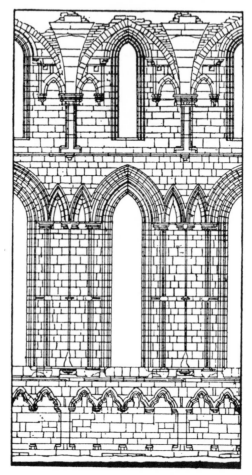

FIG. 13. *Fountains: Bay of Choir*

effect is spoiled by the loss of the original centre bays. When this Gothic ruin is seen from the hill which divides the valley from Ripon, across the parkland of the eighteenth century, it is easy to understand why it was acceptable to the lovers of Greek temples. Although carving of capitals was rejected by the builders of Fountains, the introduction of the rich trefoiled arcade and of

shafting, for which the local dark, white-speckled Nidderdale marble was used in place of imported Purbeck marble, showed them beguiled by the richer charms of the 'episcopal' style.

Besides the refashioning of churches, there was one field of building in which the larger and wealthier monastic houses, especially those of the Cistercian order, were particularly active: the improvement of their domestic quarters. Actual need for larger accommodation for monks and lay brethren or servants, and better care for their physical health, combined with the wish to live more pleasantly and the desire for social prestige. The traditional way of arranging the required main rooms along the three sides of the cloistered walk had to be given up. The refectories (fraters), built as spacious and stately halls as at Fountains[1] and Furness, faced the cloisters with only a narrow eastern entrance side, while the main body of the hall, frequently built upon an under-storey, extended at right angles towards the south. Larger kitchens provided for more ample food, and the frater itself, well lighted by tall lancet windows, was made more attractive by the main architectural inner feature: the elegant stairs which led to the reading-pulpit, built with marble shafts as at Beaulieu and Chester. The western range at Fountains with its cellar, the vault of which was upheld by a small forest of columns, the dormitory above it for the lay brethren, and the guest house, proclaimed the prosperity of the economic activities carried out by a small army of lay brethren, and the generous hospitality supplied by the monastery. From the nucleus of the cloister the monastic settlement grew large offshoots in rear dorters and infirmaries, well fitted to the higher standards of sanitation and health. Finally the abbot's lodgings became commodious apartments that could compete with episcopal palaces.[2]

More significant than any monastic rebuilding were the improvements and the raising of the standard in the parish churches. The reform movement resulting from the Lateran Council and the growing maturity of the English church were bound to have a strong effect on the relations between the parish clergy and the

[1] See air view in D. Knowles and J. K. S. St. Joseph, *Monastic Sites from the Air* (1952), 95.

[2] H. Brakspear, 'The Abbot's House at Battle', *Archaeol.* lxxxiii (1933), 139.

common people, which in turn affected the appearance of the parish church. With the weakening of the monastic power and its spiritual hold over the people, with the consciousness of the secular clergy and the bishops of their duties towards the common man, with the increasing interest of the laity in things spiritual, parish life in country and town grew in strength. Great prelates like Hugh of Wells, Walter Cantilupe of Worcester, Robert Grosseteste, and Walter de Gray and Edmund Rich, did not tire in their efforts to carry into practice the decrees of the Lateran Council for the organizing of a proper and healthy parish clergy, economically secure and ritually well equipped to look after the souls in their care.

During the first half of the century there was, in the great secular dioceses, a general stock-taking of existing parishes, a defining of boundaries and an inquiry into the responsibilities of patronage. It was only natural, for parish corruption endangered the roots of Christian life in the country, that the complaints were more vociferous than the statements of the healthy conditions that could be found. Matthew Paris's marginal drawing in the *Chronica Majora* (C.C.C. MS. 16, f. 79) is a visual record of the growing violence of the resentment against the increasing number of foreigners who were given English livings for an income without regard to their duties. 'Where there used to be noble and generous clergy,' he wrote, 'guardians and patrons of the churches, by their opulence bringing renown to the district, giving hospitality to wayfarers and feeding the hungry, now they are wretched men without manners, full of cunning';[1] but this implies that, although in some cases the situation had deteriorated through the abuses of pluralities and absenteeism, there were still elsewhere the good parish priests whom he had praised.

The bishops saw to it that the parish was given into the hands of those who were well equipped, even if they were only in minor orders, to fulfil their spiritual duties, and whom an adequate stipend freed from worldly worry and a lowering of social respect. The Lateran Council had insisted that parish priests be given a reasonable competence and security of tenure. It was the duty of the bishop to put these decrees into operation by instituting vicarages

[1] Matthew Paris, *Chronica Majora*, R.S. lvii (1876), iii. 389.

or, when they already existed, by watching over the competence of the vicars. Hugh of Wells instituted more than three hundred vicarages in his vast diocese of Lincoln and gave to the vicars an adequate income. Bishop Grosseteste was untiring in his care for the dignity and the fitness of the parish clergy. 'In 1247, in order to promote better teaching the bishop obtained papal permission for one of his clergy to leave his parish in charge of a deputy in order to pursue a course of theological study.'[1] He especially impressed upon the parish priest the duty of instructing the people in the meaning of the religious rites and of preaching to them in the vernacular as he himself did frequently.[2]

The rebuilding or remodelling of a great number of parish churches is positive evidence of this growth of a new religious life. Increase in population and in prosperity due to expanding agricultural and commercial activity, and abundance of good building stone such as in the band of oolite in the dioceses of Wells, Salisbury, and Lincoln, provided the material background. The remains of Early English work in parish churches are now found in greatest frequency in three main groups: in the south and south-east from Wiltshire to Hampshire, Sussex and Kent; in the north-east between the Humber and the Tyne; and most of all in the midlands. There remodelled churches follow each other in a broad belt which stretches from Hereford, Worcestershire, and Shropshire through central Staffordshire and south Derbyshire, Nottinghamshire, and Lincolnshire, where it is joined by another which starts at the border between the dioceses of Salisbury and Lincoln. From the upper Thames, church succeeds church all through the county of Oxford and north Berkshire, through the Vale of Aylesbury and along the valleys of the Ouse, the Nene, and the Welland to the Wash. The north-western counties from Cheshire to Cumberland were too far from the main building centres and did not share sufficiently in the prosperity which benefited most of the country to play an important part in the remodelling of parish churches. In

[1] J. H. Srawley, *Robert Grosseteste*, Lincoln Minster Pamphlets, No. 7 (1953), 12.

[2] *Robert Grosseteste, Letters*, ed. H. R. Luard, R.S. xxv (1861), 154–66: No. 52. 'Constitutiones Roberti Ep. Linc. rectoribus ecclesiarum, vicariis, sacerdotibus parochialibus ejusdem dioecesis directae.'

districts such as East Anglia and the south-western counties later rebuilding was to be too thorough to have spared many traces of the Early English period. This may account for the fact that there is very little influence from Glastonbury and Wells to be found in the parish churches of Somerset. In East Anglia, dotted with monasteries and with a dense population which was scattered over small villages, the need for enlargement of the rural church was probably not felt. Besides, neither Bury St. Edmunds nor Norwich, where no large building was undertaken at this time, could gather masons in large numbers who might disperse their skill through the countryside. But many of the places which received grants of markets and fairs under Henry III must have enlarged their churches as a consequence of a growing prosperity and swelling population. Along the south and east coast, the Cinque Ports, Yarmouth, Lynn, Grimsby, Hedon, and Scarborough testify to the share that the vigorous commercial life of the ports had in the religious life of the community.

Although parish church building consisted mostly of additions and alterations to existing fabrics, there are plenty of smaller churches and a few large structures that are more or less completely of this period, although these may still incorporate portions of older structures which stood on the site. The small church at Skelton (North Riding),[1] the large cruciform churches at Filey (East Riding) and Witney (Oxon.) are excellent examples of uniform design.

The two main portions of the churches most deeply affected by the trend of rebuilding were the east and west ends: the chancel and the tower. The care of the chancel was the responsibility of the patron or his representative, rector or vicar. New, deep chancels lit splendidly by rows of lancet windows and properly fitted with piscina and sedilia provided a beautiful setting for the celebration of the mass. Grosseteste's constitutions forbade lay people to enter the chancel with the possible exception of the patron, and the custom arose of separating chancel from nave by screens of which all wooden examples of the period have disappeared. But the

[1] There is a tradition that Skelton church was built with unused stones prepared for the south transept of York minster before 1247. See *Register of Walter Gray*, Surtees Soc. lvi (1870), 102.

triple stone structure at Westwell (Kent) is a magnificent and unique transparent screen through which the people could watch the altar and the celebrants (Pl. 19 *a*). The dogma of transubstantiation, decreed by the Lateran Council, the growing custom of the elevation of the Host and the withholding of the chalice from the lay people, lent to the service of the Mass a greater solemnity, assisted by the dignity of the new structures. Many parish churches received the present dimensions of their chancels at this time. Downton (Wilts.) and Alconbury (Hunts.) are examples of Norman east ends completely rebuilt. Perhaps the greatest height in chancel building was achieved at Cherry Hinton (Cambs.), Stanton Harcourt (Oxon.) and Hythe (Kent) where the chancel was built with aisles, triforium, and clerestory.

At the western end towers with or without spires were used more and more, although the tower of the crossing in the cruciform plan such as at Uffington (Berks.) and Potterne (Wilts.) did not disappear. In rare cases as at West Walton, Sutton St. Mary and Tydd St. Giles, all in the area of the Wash, where the marshy nature of the ground made it impossible to attach them to the main fabric, detached towers were built just as at Salisbury and Chichester and later at Westminster abbey and Old St. Paul's. The tower at West Walton is the most elaborate example. Open on all four sides at the base and with delicate arcading above, it is strengthened by buttresses at the corners and lightened by windows with plate tracery. From the second quarter of the century onward, the Northamptonshire masons elaborated the brooch type of stone spire and the method spread first to the neighbouring counties and then to many other parts of England. The Barnack stone provided an excellent material for high and slender brooch spires in which the transition from the square angles of the tower to the octagonal shape of the spire was done smoothly without a break, with the steep sides of the spires pierced by ranges of gabled lights. High and slender, in harmony with the high-pitched roofs, the spires became sometimes even loftier than the towers beneath, as at Polebrook (Northants.).[1]

[1] Polebrook church was granted to Peterborough in 1232. See *V.C.H. Northamptonshire*, iii (1930), 107.

As to the nave, the fabric and its upkeep were the responsibility of the community as a whole. The greatest variety prevailed in the planning, but the general trend was towards the enlarging of the nave area by the addition of aisles. In the south-eastern counties a number of examples still exist where the Early English aisles were covered by the extension of the nave roof which caused the interiors to be very dark, as at Bury (Sussex). But gradually aisles were tending to become wider, covered by lean-to roofs, and the nave received its own clerestory. The pillars, commonly round or octagonal, were built in exceptional cases with groups of shafting and, while the capitals consisted commonly of plain moulding, often, and especially in the churches of the Nene valley and near the Wash, they were enriched with conventional foliage.[1] Beautiful specimens of skill in carving foliated capitals are to be found at Eaton Bray (Beds.), Studham (Beds.), and Ivinghoe (Bucks.). But, in the majority of cases, the beauty of the church was in the smoothness of the masonry, the elegance of its proportions, and the brightness of its lighting. It is again at West Walton (Norfolk) that the most perfect example of an aisled nave of this period is to be found. The piers of the arcade are round, each with four Purbeck marble shafts, and the foliage design of the capitals is exceptionally beautiful (Pl. 19 b). The arches are elaborately moulded and above them, set off by a string course, appears a clerestory, one of the earliest examples of a high clerestory in a parish church.

[1] For stiff-leaf foliage in parish churches, see P. Wynn Reeves, *English Stiff Leaf Sculpture* (dissertation for London Univ., 1952, unpublished).

V

BIBLES AND PSALTERS BETWEEN
1220 AND 1245

AS the building style of Salisbury and Lincoln had been preceded by the first Gothic of Canterbury and Wells, so the basic changes in the illustration of books had been made in the bibles and psalters of the late twelfth century. But while the development of architecture and sculpture was tied locally to the places where the buildings were erected, it is almost impossible to find any clear evidence as to where the books of the period were produced. There are signs that, at least in the first half of the thirteenth century, some of the important monastic scriptoria like that of Winchester or St. Albans continued to be active, but very little is known about the scriptoria of the secular cathedrals and the catalogues of their libraries do not furnish proof whether the books were produced there or acquired elsewhere. In any case, two main factors determine the book production in this period: the increasing activity of the professional scribe or of the stationers' guild, who produced books to order; and the increasing demand by lay people who gave the orders. The latter affected chiefly the production of illustrated psalters; the type of bible was largely governed by the needs of students and scholars, and the intensive biblical studies pursued at the universities required a great number of written editions of small size, which would be less costly and more easily handled by readers.[1]

The early decades of the thirteenth century saw a great activity

[1] H. H. Glunz, *History of the Vulgate in England* (1933), 269: 'The technical innovation of the stationers consisted in the art of producing small and convenient volumes which comprised the whole Bible. The vellum of these books is very thin, and the writing small, but in most cases clear. Paris, which at first led in the making of these books, was soon followed by Oxford. The document dating from about 1180, according to which Oxford scribes, binders, and illuminators were pursuing their trade in Cat Street, witnesses not only to the existence of the University at that date, but also to the fact that its book trade was already organized. The first products of the Oxford stationers that have remained date from the first decade of the thirteenth century.'

in the revision of the Vulgate, which was divided into chapters by Stephen Langton. The work of theologians does not as a rule affect immediately that of the artist, but there is no doubt that the illustrators and those who directed their work read the bible in a new spirit. The large folio bible, produced during the twelfth century, revered as a sacramental book full of divine mysteries and provided with sumptuous, full-page illustrations, went out of fashion during the transitional period. Instead of a large historiated initial one of much smaller size opened each of the books of the bible. The content of such initials was partly provided by an older tradition, but gradually and systematically a standard scheme of illustrations was devised, most likely at the universities, with a minimum of figures and settings in which a few changes allowed the use of the same initial for more than one book. For most of the Minor Prophets, as well as for the New Testament, the single figure of prophet or evangelist sufficed as an appropriate opening, just as the Prologue was normally opened by the seated figure of St. Jerome. For the Book of Isaiah the scene where the prophet is sawn in two, and for Ezekiel an abbreviated version of his Vision, were frequently used. For the historical books of the Old Testament, a scene was chosen which epitomized their content: Judith cutting off the head of Holofernes, Esther with Haman hanging below, Job lying on the dung-hill conversing with his friends. For the Book of Ezra, a lively scene of building refers to the re-erection of the Temple, and for the Book of Maccabees a fighting scene between men in coat of mail is common.

But there is no rigid uniformity as to the choice and the composition of scenes, at least not in the first half of the century, and the statement made by M. R. James[1] still holds good that 'anyone who faced the task of collecting lists of them and tabulating the variants would elicit some interesting results as to the places of production and the local fashions.' In this way it may become easier to distinguish between English and French work, especially at a time when stylistic differences are obscured by the close contact between England and north-west France across the Channel.

[1] *The Pictorial Illustration of the Old Testament from the Fourth to the Sixteenth Century*, Cambridge, Sanders Lectures (1923), 55.

The initial letters, with the exception of that for the Book of Genesis, are usually set within a square with a short extension in scroll work, their shape clearly and precisely drawn and often strengthened by coloured patterns. The whole design grows organically out of the transitional work, with the use of the same ornamental motifs, although the acanthus and its derivatives are gradually replaced by the trefoil leaf. The process which reached its height in the twenties of the century was begun during the 'Classical Revival' as described by T. S. R. Boase: 'As the security of massive walls and pillars, almost defensive in their solidity, is abandoned for a more daring slenderness of construction, so men's minds seemed to shake off some of the nightmare images that had exercised their skill in carving, and to observe with new confidence and new exactitude the world around them'.[1] As the framework of the initial becomes more slender and light like trellis or tendrils, so the figures, fitting admirably into the tiny space allotted to them, move nimbly and gracefully with a clear consciousness of the role they have to play. The humanizing process, begun during the Classical Revival but there still connected with a certain stiff immobility, grows at the same time as the historical concept of the biblical stories. These are enacted no longer by people who seem to move as in a trance, governed by a power from without, their eyes staring as if obsessed, their bodies intersected by an abstract pattern of folds, but by ordinary human beings who in a world of their own carry out their prescribed actions in the quickest and most efficient way. Without self-consciousness or gloomy seriousness, they express vigorously and often joyfully the basic human emotions in the most natural and direct manner. The gold, the blue, and the red as prevailing colours contribute to the joyous effect.

The great bible, once in the possession of Lord Lothian (New York, Pierpont Morgan Library MS. 791), is an excellent stylistic link between the opening years of the century and the twenties and thirties.[2] Of folio size, it has as a frontispiece a full-page illustration of the Creation which by its design conveys the effect of order

[1] O.H.E.A. iii. 276.

[2] J. H. Plummer, *The Lothian Morgan Bible: A Study in English Illumination of the Early Thirteenth Century* (unpublished dissertation for Columbia University).

established by the Trinity in the beginning of the world (Pl. 20). The top half of the page is dominated by the group of the Trinity set in a quatrefoil and represented in a unique manner.[1] God the Father, young but bearded, sits upon a broad throne. His right hand touches the frame, as does the left hand of His Son, who is shown as a boy on His Father's knee, His legs concealed by the mantle of the Father which encircles Them both. The angelic host is arranged in five tiers on either side. Four fallen angels, who change into devils as they fall, are beneath the Throne, between the four rivers of Paradise encircling different lands on one side and the round disk of the world surrounded by water and by six angels' heads on the other. The dove, representing the Spirit of God, moves over the waters, while the Dove of the Holy Spirit joins the heads of Father and Son. In six roundels below, the Creation is told from that of the angels to that of man.

The design of the initials to the individual books is as original as that of the frontispiece. Not satisfied with limiting himself to a single incident, the artist divides with great skill the whole area of the letter, which is sometimes formed by the bodies of dragons or beasts, by scrolls or pieces of architecture, into smaller medallion-like fields. These are then filled with a sequence of scenes from the text which follows, as for instance in the initial for the Book of Job (f. 281) where Job not only appears at the climax of his trials, but at different stages of his misfortunes, and where his fate is discussed between God and Satan (Pl. 22 b).

A large bible (Cambridge, University Library, MS. Dd. 8. 12), in which all initials but one are ornamental with the gold letter on pink or blue ground enclosing blue or pink acanthus patterns, contains a magnificent initial to Genesis (Pl. 21 b). It extends the whole length of the page (unfortunately clipped at the top and bottom) and is designed like a metal belt framed by a gold and green border. In the round medallions six Creation scenes and God enthroned stand out with fresh colours against the burnished gold ground, and the beardless Creator moves with swiftness and power. In its style it is close to the Lothian Bible. A more typical bible of the

[1] See A. Heinemann, 'Trinitas Creator Mundi', *Journal of Warburg Institute*, ii (1938), 49, n. 4, Pl. 7 c.

period, produced about 1240 under French influence, is that in the Dyson Perrins Collection (MS. 6). Here the initials contain one single scene which is fitted very neatly into the letter. In the foliated base of the initial which shows the death of Joshua (f. 77 *b*)[1] a stag is pursued by two hounds and a horseman blowing his horn, one of the earliest examples of a 'drollery', here still confined within the frame.[2] In most bibles of the period the initials for the Book of Genesis are the most extensive, forming a long upright bar with medallions containing Creation scenes and ending at the bottom sometimes with the Crucifixion (Trinity Coll. MS. B. 10, 1; Dyson Perrins MS. 5), sometimes with other scenes like Jacob's Dream (Chester Beatty Coll. MS. 50), or Abraham's Sacrifice (B.M. MS. Burney 3). This last bible has a magnificent and unusually large Genesis initial in shape of an L,[3] which leaves only room for part of one of the two text columns in which bibles are usually written. In the medallions of the upright bar the Creation is told from the fall of the angels, ending with a representation of the Trinity in which the Dove touches with the tip of each wing the mouths of Father and Son. In the horizontal bar the medallions contain scenes from the Fall to Abraham's Sacrifice. This bible was owned by Robert de Bello, abbot of St. Augustine's, Canterbury (1224–53). It must have been written near the middle of the century, because the initial letters have broad bar-extensions with a tendency to cusping, the colouring is rather heavy, the dresses richly patterned with white dots, and the few folds often marked with a white line. Some of the initials have either elongated figures, which are like the elongated statues on the front of Wells cathedral, or are divided in tiers (Pl. 21). The initial for the Book of Ruth (f. 112*v*.) has at the top Elimelech walking with an iron-shod staff, Naomi in the

[1] Reproduced in G. F. Warner, *Catalogue of Dyson Perrins Collection*, ii (1920), Pl. vii *b*.

[2] Ibid. i. 27. 'The order of Books is most irregular.' It appears to have been written before the revised text had become generally established. The modern chapter numbers due to Stephen Langton are given in the margins throughout. A rubric to Genesis says: 'expliciunt capitula secundum S. Geronimum presb. in libro sequentis Genesis, sed non ita distinguuntur secundum doctores modernos theologie sicut infra apparebit notatum in marginibus'.

[3] Reproduced in E. G. Miller, *Eng. Ill. MSS.*, Pl. 76.

middle, and the two sons at the bottom. And the initial for the Gospel of St. John has in tiers the Marriage at Cana, Christ addressing the Virgin and St. John, John lying on the breast of the Lord, and an eagle-headed standing figure (Pl. 21 a).

The enormous demand for bibles tended to standardize the illuminations, but the production of psalters gave more scope to the originality of the artists. Some of the richest psalters were produced in the first decades of the century and are described in the previous volume of this history. Their style lingers on for a short time. Two psalters from the same workshop (Cambridge, St. John's Coll. MS. D. 6; Berlin, Kupferstichkab. MS. 78 A 8) have illustrations still in the transitional manner. The St. John's College manuscript has all the typical features of a fashionable psalter: roundels with the signs of the zodiac in the calendar; a series of New Testament pictures, two to a page; the figurated initials for the ten psalms which mark the main liturgical portions of the psalter. In addition it contains the Hours of the Virgin which open with an initial of the Virgin crowned, holding the Child on her knee and a flower in her right hand. The stocky figures are drawn with strong black outlines, without much modelling, and coloured heavily in dull blue, green, and brown. Their immobility is matched by a rather vacant expression.

Robert of Lindesey, abbot of Peterborough (1214-22) is known to have owned a glossed and an unglossed psalter, and if Cockerell's suggestion[1] is accepted that the first was the one mentioned above and the second the psalter which is now with the Society of Antiquaries, he had before his eyes two books which were widely different in style, the one already belonging to the past, the other pointing to the future. The Lindesey Psalter (London, Soc. of Antiquaries) is an outstanding example of the new trends. The three preliminary pages with six New Testament scenes, two to a page, are outline drawings in sepia, red and green, and show traces of the older tradition with ovoid patterns in the folds and in the ugly,

[1] M. R. James, *A Descriptive Catalogue of the Manuscripts in the Library of St. John's College, Cambridge* (1913), 109: 'On f. IIa, erased, Psalterium Abbatis Roberti de l . . d . . ye glosatum. Mr. S. C. [now Sir Sydney] Cockerell suggests that this should read Roberti de Lindeseye.'

grotesque faces. On the other hand they are alive with the stirring of a new sentiment in the lively and dramatic actions of the slender figures (Pl. 24 b). But they have nothing of the clarity and beauty of the two coloured full-page illustrations: the Crucifixion (Pl. 24 a) and the Christ in Majesty (ff. 35v, 36). In the former the slender curved body of Christ with thin long arms and legs is affixed to the cross by three nails. The weightless figures of Mary and John who shrink away towards the frame, yet bend gently towards the cross, are suspended in space. Graceful in their movements, they are controlled in their emotion, meditative, with eyes calm and clear. The artist is not afraid to leave ample empty space around the figures because it is filled with the radiance of the burnished gold ground against which the bright colours, especially the vermilion of John's mantle, stand out cheerfully. Greens, reds, and whites are repeated in the trefoil leaves which grow delicately on long stems out of the trunk of the cross. The same brightness and light emanate from the Christ in Majesty in whom the awful remoteness of the earlier periods is replaced by serene mildness.

Closely related to the Lindesey Psalter is the added leaf of Christ in Majesty in B.M. Cotton MS. Vespasian A. 1 and the Fitzwilliam Psalter (MS. 12), which has a similar Crucifixion but one more vigorously treated with St. John striding forward. Both psalters have beautiful initials to the main psalms (Pl. 26 b). Some of them are purely ornamental: slender scrolls in blue, red, and green with tendrils ending in trefoil leaves on burnished gold set upon a blue or red patterned or diapered ground in a square frame. In the Lindesey Psalter the artist with his delight in gay colours lets young David ride on a blue-dappled horse which rears and turns its head against a white lion (Ps. 51) and Goliath wears a red surcoat over blue mail, with pink and blue taken up again in the frame (Ps. 52).[1] The 'B' in the Beatus page of the Fitzwilliam Psalter is unique in its decoration: in its upper circle it holds Christ in Majesty, blessing and holding the chalice, while two female crowned figures face each other in the lower one.[2] As in metopes of fifth century Greek art, or as in the quatrefoils of the front at Wells, the figures together

[1] Reproduced in E. G. Millar, *Engl. Ill. MSS.*, Pl. 70.
[2] Reproduced in M. R. James, *Cat. of MSS. in the Fitzwilliam Museum* (1895).

with a tree or a building are fitted admirably and harmoniously
into their round fields. A reference to the owner of the psalter is
probably made in the initial to Psalm 101 where a Benedictine
abbot, attended by a monk, kneels in front of an altar.

It is part of the charm and the interest of the psalter in this period
that there is no monotonous uniformity in the motifs which are
chosen to mark its divisions. By 1220 the custom was well estab-
lished of marking the beginning of ten psalms with large and usually
historiated initials.[1] The text of the psalms did not make it always
easy to select a subject as an appropriate illustration. But with the
interest in biblical history in this period the choice was suggested
either by the title of the psalm or by a name or incident which
occurred in the text and seemed to refer to an incident in another
biblical book, far-fetched as it often may seem. For the opening
psalm an old tradition prescribed a capital B of the 'Beatus' which
was either filled with ornament or contained the Tree of Jesse or
some representation which showed David as the author, playing
the harp.

For most of the other psalms motifs most frequently used were
the following: for Ps. 26 (Dominus illuminatio mea) the Anoint-
ing or Crowning of David because it was sung by him before this
event; for Ps. 38 (Dixi: Custodiam vias meas) the Judgement of
Solomon although there is no direct reference to this in the text;
for Ps. 51 (Quid gloriaris in malitia) Doeg killing Ahimelech as
mentioned in the title; for Ps. 68 (Salvum me fac) Jonah and the
Whale since the text in the beginning refers to the sinking into
deep waters; for Ps. 80 (Exsultate Deo) Jacob's Ladder and Jacob
wrestling with the Angel as the first verse mentions him; for Ps.
97 (Cantate Domino canticum novum) the Annunciation to the
Shepherds referring to the Gloria in Excelsis; for Ps. 109 (Dixit
Dominus Domino Meo: Sede a dextris meis) Christ in Majesty or
the Trinity. For Ps. 52 (Dixit insipiens in corde suo: Non est Deus),

[1] The psalms were the following: 1, 26, 38, 51, 52, 68, 80, 97, 101, 109. The selection
of these was the result of a combination of an old Anglo-Saxon tradition of dividing
the psalter into three sections of fifty psalms and of the liturgical usage of reading the
whole psalter in the course of the week in sections, one at matins each day and an
additional one at vespers on Sunday. The numbering used here is that of the Vulgate.

no early agreement was reached and a great variety reigns in the illustrations as well as in those for Ps. 101 (Domine, exaudi orationem meam).[1]

On the whole one can say that the earlier the date of execution of the psalter the greater the deviations from the scheme. The most original in choice of subjects is a large glossed psalter (Cambridge, C.C.C., MS. M. 2), written in a hand of St. Albans type of which the 'B' still has small lions in its scrolls and three-lobed acanthus leaves and where the figures in the initials are just beginning to shake off the solidity and slowness of the preceding period. The initial for Ps. 26 has the Noli me tangere scene (Pl. 26 a), that for Ps. 50 Noah's shame, that for Ps. 51 Balaam's Ass, and that for Ps. 109 the Annunciation.

Two other early examples are the Psalters B.M. Lansdowne MS. 431 and Lambeth Palace Library MS. 563, the latter very small and possibly with a Peterborough connexion. In both the decoration is of average quality, but the first has a large 'B' taking up three-quarters of the page and exceptionally detailed. The letter is filled with finely meshed scrolls into which naked men and animals are intertwined, with the gold ground shimmering through. The four evangelist symbols and incidents from David's life are fitted into the vacant spaces between the letter and the frame, and prophets, musicians, the Church and the Synagogue are set into the roundels of the frame. In the second psalter a dancing or drunken man facing a tonsured cleric is one of the earliest English representations of the Fool (Ps. 52), and the Creation of Eve serves for Ps. 101.

With the small psalter in the collection of Sir Sydney Cockerell we approach the only illuminator of this period who is known by name and whose work is the best and most characteristic of the 1230's and 40's. The psalter has a London kalendar, but a Peterborough litany.[2] Seven of the historiated initials and the calendar pictures were done by a good but anonymous artist, but the eighth,

[1] G. Haseloff, Die Psalterillustration im 13. Jahrhundert (1938).

[2] Cockerell refers to a small bible in the Peterborough cathedral library which contains forty historiated initials of the same hand which did most of the decoration on this psalter.

to Ps. 109, showing the Trinity in which Father and Son sit side by side in scarlet tunics and blue mantles, is by de Brailes.[1]

Unfortunately, of W. de Brailes nothing more is known than his name, itself no certain basis for the assumption that he came from Brailes in south Warwickshire. In two manuscripts his name is mentioned as that of the illuminator, in one in Latin (Cambridge, Fitzwilliam Museum, formerly Chester Beatty Coll. MS. 38), in the other in French (Malvern, Dyson Perrins Coll. MS. 9), and the inscription refers to a picture of a tonsured man from which it can be concluded that he was an ecclesiastic, but whether monastic or secular cannot be said. The character of his art however tempts one to think of him as a secular, especially if one considers that in the great Last Judgement scene (Fitzwilliam MS.) St. Michael separates one little naked soul with tonsured head from the damned and that it is this figure which holds the scroll with the legend: 'W. De Brail. Me F(e)cit'. If this act of salvation should really refer to the author himself as an indication of his pious hope —and it could not be more than that—it is a remarkable sign of individual optimism, hardly permissible for a member of a monastic community.

Illuminations in five manuscripts and a number of loose pages have been ascribed to him,[2] although differences in quality of execution suggest that he had assistants working for him. His style grows organically out of that which is found in the Beatus page of the Huntingfield Psalter (New York, Pierpont Morgan MS. 16)[3] but shows contact also with contemporary French productions such as the psalter of St. Louis and Blanche of Castille (Paris, Arsenal MS. 1186). On the other hand there are indications that he was acquainted with older Winchester books such as the St. Swithun's

[1] Reproduced in M. Rickert, *Painting in Britain: The Middle Ages* (1954), Pl. 99 c.

[2] See S. C. Cockerell, *The Work of W. de Brailes* (Roxburghe Club, 1930); H. Swarzenski, 'Unknown Bible Pictures by W. de Brailes and Some Notes on early English Bible Illustration', *Journ. of the Walters Art Gallery, Baltimore*, i (1938), 55; E. G. Millar, 'Additional miniatures by W. de Brailes', ibid. ii (1939), 106. The ascribed works are: bible, Dyson Perrins Coll. MS. 5; 'Richard Smartford's Bible' (present owner unknown); psalter, Coll. Sir S. Cockerell; six leaves from a psalter, Cambridge, Fitzwilliam Museum; Book of Hours, Dyson Perrins Coll. MS. 4; leaves in Walters Art Gallery, Baltimore, MS. 500; leaves in Coll. G. Wildenstein; psalter, Oxford, New College, MS. 322. [3] See T. S. R. Boase, *O.H.E.A.* iii, 281-2, Pl. 87.

Psalter. His rendering of devils with 'fringed waistbands or kilts' (Cockerell) and the two thieves curiously fastened to the T-shaped cross point in that direction. These last are clad in drawers with knee-bands such as occur later in manuscripts connected with Westminster.

De Brailes's lively and inventive mind is at its best in the six leaves which probably preceded a psalter (Cambridge, Fitzwilliam Museum), with the Fall of the Angels, the Last Judgement, the Tree of Jesse, Christ and David playing the harp, six incidents from the story of Adam and Eve and their sons, and the Wheel of Fortune. The Fall of the Angels is a magnificent elaboration of the incident shown on the frontispiece of the Lothian Bible, told in much greater detail with an impressive Mouth of Hell facing Christ enthroned. It is filled with the fallen who have paid for their rebellion with the change from angelic forms to those of horrible monsters. Two lively jeering demons have hooked their long staffs around the neck of two of their future companions in order to pull them down. A similar hell-mouth in the Last Judgement is full to the brim with densely serrated rows and rows of damned, a wavy sea of heads, some with crowns or ladies' caps with straight sides, some only seen with the top of their shaven heads. It is in this scene, in the half-medallion in the lower right, that St. Michael separates the single soul which holds the scroll with the legend, mentioned above. The Judgement proceeds in perfect order with each of its component parts tidily enclosed by a circular or elliptic frame, and it is exactly this clear and stable order, this statement of facts, tangible as to form and lucid as to content, which robs the scene of doom of its menacing horror and makes it basically one of comfort.

The calligraphic complex patterns of the twelfth century have been replaced by simple geometric shapes, the square or the circle or other equally clear configurations achieved by the use of the compass. All the illustrations are built up from the parchment ground of the page with metallic precision as if carved in relief like the Wells quatrefoils, of which the six scenes of Adam and Eve are reminiscent. First come the square outer frame of gold and patterned coloured strips, then the roundels in the corners and the

half-roundels in between, then the main medallions which contain the important figural scenes which seem pushed forward by the solid gold ground. This geometric order, which creates the effect of a just but inescapable course of human destiny, is particularly appropriate in the Wheel of Fortune (Pl. 22 *a*). The hub of the wheel lies in the lap of Dame Fortune, and its spokes are continued into the frames of the half-medallions, containing eight scenes from the story of Theophilus, which enjoyed such popularity at this period, with its all too human struggle between the fallen priest, the devil, and the Virgin.[1] Other medallions on the outer circumference enclose scenes which illustrate in a charming and naive manner the rise and decline of man from the cradle to the grave.[2]

De Brailes's eagerness to tell a lively story found full scope in the Book of Hours of Sarum Use (Dyson Perrins MS. 4), one of the earliest books of private devotion of the kind that was to have such vogue in later times. It was probably written for a lady who is represented in three of its initials and it must have been for her benefit that a brief description in French of each subject was written by a neat hand into the margins, made necessary as the illustrations have rarely any connexion with the text. The book is so exceptionally rich and diverse in the content of its illuminations that it is difficult to render due justice to it in a limited space. Five almost full-page illustrations remain of those which introduced the Hours of the Virgin. They contain nineteen incidents from Christ's passion, all with the exception of the Crucifixion, set four to a page in medallions. The rendering of the figures, which occupy the given space with a minimum of stage properties, is a good example of de Brailes's style: neat and well proportioned, usually in tight-fitting garments, often a sleeveless surcoat which ends in an almost

[1] A. C. Freyer, 'Theophilus, the Penitent in Art', *Arch. Journ.* xcii (1935), 287.

[2] A Wheel of Fortune was painted on the walls of the King's Hall at Winchester (1235-6) and at Clarendon (1247). A later wall-painting of the subject (*c.* 1250-60), and the only one of which at least half is preserved, is on the north wall of the choir above the site of the prior's stall in Rochester cathedral (Tristram, *Wall Painting,* ii, Pl. 133). Here the composition is more dramatic than in de Brailes's work, Dame Fortune standing and turning the wheel and a single active man illustrating the rise of his fortune.

A 'Tree of Jesse' was painted in the Queen's Chamber at Windsor (1236-7) and in the King's Hall at Clarendon (1247).

straight hem. Feet and well articulated legs are left free, so that the
quick action is not impeded. Hip-lines are marked by a belt when
not concealed by a mantle falling in a few, chiefly V-shaped folds,
strongly marked by the deepening of colours or by black. The
tightly modelled, wide-eyed faces and the precise gestures express
the appropriate emotions in a simple, direct manner. In twenty-
seven initials the life of the Virgin is told, beginning with the story
of Joachim and Anna. Not less than seven are devoted to her end,
her death and burial, with the Jews in one unusually extended
initial trying to upset the bier. But interspersed are legends and
biblical stories. The legends tell of Theophilus, of the priest who was
suspended by Archbishop Thomas Becket because he could only
chant the mass of the Virgin and was reinstated and honoured by
her intervention, and of the burgess who gave a chalice to the
'church of St. Lawrence'. Of Old Testament subjects the story of
Susanna and the Elders occurs and some incidents of David's life
are connected with the penitential psalms, the most remarkable
being the one in which the king, chastised by a priest, has his cloak
pulled up to his neck, revealing bare back, drawers, and stockings
(f. 72).

It has been thought possible that this book was once even richer
in pictures, because a series of bible pictures which are now separate
and not connected with any text, may have formed part of it. This
series (Baltimore, Walters Art Gallery, MS. 500) consists of twenty-
seven full-page miniatures, eight of which are arranged two to
each page (Pl. 28). Only five are from the New Testament. The
Old Testament cycle has an exceptionally detailed account of the
plagues in Egypt, its gaps partly filled by some additional minia-
tures in the G. Wildenstein collection in Paris. Most of the scenes
represented occur also in the psalters at Munich (Cod. lat. 835) and
at Paris (Bibl. Nat. lat. 8846),[1] and there is a close similarity to the
Paris Psalter in the scene of the Drowning of Pharaoh's army in

[1] See Swarzenski in *Journ. of Walters Art Gallery* (1938), 65: 'With the exception of
the Stoning of Achan and of Samuel serving the Priest with meat (otherwise only in
the Bible Moralisée), all the Old Testament scenes are also in the Munich Psalter.
Both mss. include even so rare a scene as that of the kinsman who draws off his shoe
as a token that he renounces his property rights in favour of Boaz.'

the Red Sea, in both cases mostly done in outline, besides the fact that rare subjects like the Death of Herod and 'Foxes have Holes' occur in both.[1] Figures and properties are set off by black lines from the gold background, ornamented as in the Dyson Perrins Book of Hours, and the frogs in one of the Plagues or the cattle of Israel crossing the Red Sea are rendered in the characteristically de Brailes manner with overlapping heads. There are also French *tituli* written below, which have been clipped in binding. Some of the figures overstep the frame into the margins, as for instance those of Lot and his daughters who are leaving the burning and crumbling Sodom. The elongation of figures and an attempt at sophistication bring the leaves close to French work though the manner is cruder than, for instance, in the illuminations of the *Vie et Histoire de St. Denis* (Paris, Bibl. Nat. MS. r. nouv. arg. 1098), with which they have otherwise much in common.

De Brailes's intimate knowledge of legends that were not generally familiar until after the *Legenda Aurea* was written, might have been due to contacts with men of the new orders. In the Dyson Perrins Book of Hours a memorandum written in French, referring to persons to be prayed for, mentions the name of three English friars as well as all brothers, Preachers and Minors (f. 102*b*). The small Bible Dyson Perrins MS. 5, which has historiated initials closely resembling the style of de Brailes, was probably of Dominican origin and the Psalter Oxford, New College, MS. 322 has in the calendar an original entry referring to St. Francis, the 'first minister of the order of the Minors'.

This psalter is the most advanced and most sensitive of all the works ascribed to de Brailes. The ten large initials and three smaller psalm initials are by the same hand, four of the large initials painted on a thin piece of vellum which has been pasted on to the space left free. The Beatus page has a Jesse Tree: Jesse lifts himself from an elaborate bedstead covered by a large blue coverlet, carefully arranged in deep V-shaped folds partly in front and partly behind the bars of the bed. The horizontal bar of the letter is eliminated so that the tree which springs from his loins rises freely, broadening into three ellipses which enclose David, Mary, and Jesus. One of

[1] T. S. R. Boase, *O.H.E.A.* iii. 289.

the ten prophets in the subordinate medallions is not only un-
nimbed, but looks strangely secular with his hooded cloak and cap
of contemporary fashion. Lions' heads are used as joints between
the bar and the curves of the letter.

Many of the main initials follow the convention: the Judgement
of Solomon for Psalm 38, David slaying Goliath for Psalm 51,
Jonah and the Whale for Psalm 68, Jacob's Dream for Psalm 80,
but the subjects are rendered in a very spirited way. Not only are
the figures more slender and agile, but the colouring is of a special
kind: deep blues and maroons with deep grooves for folds which
are marked heavily by darker colour and sometimes with red on
white. The ridges are relieved by white, and a white line frequently
marks the hem. Hardly any other colour is used except a spot of
scarlet and in the last pictures some bright green. The heavy colour-
ing and strong contours contrast with the delicate drawing of faces
and hair.

Many features indicate an original mind at work: for instance
when a little devil, who perches on Goliath's shoulders, pushes
against his helmet, or when Jonah is pushed head downward into
the whale's mouth by a man who, holding his legs, stands up in the
crowded boat. Nineveh is an elegant little building with spires and
pinnacles, like the little temple upon whose spire Christ sits perched
in the scene of the Temptation (Ps. 52). The initial for Psalm 97
is divided into two halves with the Nativity below and the Angel
and Shepherds above. The most original is the initial for Psalm 101
which contains in four round medallions God sitting on a bench;
Bathsheba, bathing her bare feet, watched by David from the
battlements of a gatehouse; David reproached by Nathan; and
David in supplication 'out of the deep' (Pl. 27 b).[1] In the initial for
Psalm 26, King Saul lies in bed while the crowned and bearded
David, seated upon a throne, plays the harp (Pl. 27 a); and in the
initial for Psalm 109 a very elongated figure of God the Father in a
blue mantle holds the green cross with the Crucified.[2]

[1] The scalloped waves and the half-submerged figure are characteristic of the
prayer 'Salvum me fac' (Ps. 68), but here the waves are coloured brown.

[2] The kalendar roundels and over a hundred small initials, which usually contain
single figures, are by a different hand.

But two features have still to be mentioned which form an essential part of the ornamentation of de Brailes's work: dragons and coloured ornamental penwork. His dragons are lithe and slim like lizards, with a strong body on muscular legs and with feathered wings. These wings with rounded tops and pointed tips poised, spread or folded back, increase the effect of graceful agility caused also by the incredibly long and twisted neck and tail, creating a smooth link between the main initial and the marginal ornament. This ornament of leafy scrolls is always set against a gold or coloured background within an enclosing frame like a metal hinge. Such are most of the line-endings, filling the empty spaces in such a way that the lines of the text form firm columns without frayed edges. But all the more freedom is allowed to the delicate penwork in the lower margins: feather patterns in blue, red, and gold, sometimes shooting like a breath of fire from the mouth of men and animals. In most of de Brailes's work this penwork is well controlled and limited to the lower margins. But in the Cockerell Psalter it spreads in 'firework' ornaments and invades all empty spaces.

No less important than the New College Psalter and even more characteristic of the end of this period is the remarkable Psalter Cambridge, Trinity College, MS. B. 11. 4, once owned by 'Dame Ide de Ralegh' who lent it to the abbot of Newnham for life, to be left finally to a noble nun at St. Mary's abbey, Winchester.[1] Its calendar points to London and one of the artists employed in its decoration had an intimate knowledge of the illustrations which preceded the psalter in Munich (MS. Cod. lat. 835). The twenty-four roundels in the calendar with the Signs of the Zodiac and the Labours of the Months on gold ground have some most charming scenes of farm and domestic life and nude figures of remarkably detailed anatomy. The decoration of the text pages is unusually rich with small coloured and gold initials for every line and larger initials with scrolls and beasts for every psalm. In the first portion of the book coloured and patterned ribbons form line-endings, but as a new feature not only fighting monsters and animals, but

[1] M. R. James, *The Western Manuscripts in the Library of Trinity College, Cambridge*, i (1900), 333.

hunting scenes, are introduced into them. The nine large initials (the Beatus page is missing) have very dramatic scenes enacted by large figures with a minimum of settings and contain a number of unusual subjects: the Suicide of Saul with a devil grabbing the soul which escapes from his mouth (Ps. 52); the Crucified, His feet affixed separately, between lance and sponge-bearer with the three women at the tomb below (Ps. 68); a Benedictine abbess with an attendant nun kneeling before an altar with the Christ of the Last Judgement between angels carrying the signs of the Passion (Ps. 101); two nuns kneel on either side of the Trinity below two half-figures of angels carrying sun and moon, and the face of God the Father, who holds the Crucified between His knees, is hidden by a golden radiance contained within a quatrefoil (Ps. 109) (Pl. 25).

Another artist made the five leaves with a series of bible pictures which preceded the psalter and is now incomplete with the surviving pages bound in the wrong sequence. On each page six scenes are set in squares framed by gold and thin green borders and the colour of the backgrounds, powdered with white star-patterns, alternates regularly from pink to blue. Sometimes blue and pink are used side by side in the same square to set off the protagonists against each other as in the scene of Joseph and Potiphar's wife (Pl. 23 b). With the bible series ascribed to de Brailes this cycle is the second, and much the better one, derived in this period from an earlier model. It is in fact a Gothic version of the Munich Psalter, but variations occur which suggest not only a change in style, but also in spirit. The quietly sorrowful scene of the Entombment has been added and the Virgin, missing in the Munich Psalter, has joined the Apostles in the Ascension and the Pentecost. The heavy stolid compositions of the earlier psalter with their horizontal stratification have been transformed, not only by anatomical changes and quicker movements of the figures, but by more fluent rhythms throughout, which stress the diagonals. The figural scenes are really outline drawings done with a very agile light line, hairpin folds, and delicate facial expressions. They are tinted lightly with green and the gold of the border is taken up in the nimbi, crowns, and vessels. Only in the large Last Judgement,[1] in two scenes one

[1] Reproduced in E. G. Millar, *Engl. Ill. MSS.*, Pl. 68.

above the other, red and gold provide a richer note which contrasts with the red and black in the twelve panels which describe in great detail the tortures of the damned. In spite of its debt to the older model, this psalter points in style and sentiment towards the next phase in the development of Gothic art.

It is stated frequently by writers on medieval art that the illuminators of books were influenced by the designers of stained glass windows in the use of medallions of varying shape as a framework for figural scenes. But it seems more accurate to say that in both branches of the arts the geometrical order of circles and semicircles, foils and vesicae was employed contemporaneously. The remains of stained glass windows of this period are scanty with the exception of the series of windows in the choir of Canterbury cathedral, begun late in the twelfth and continued into the third decade of the thirteenth century (Pl. 23 a). In contrast to France there seems to have been a preference for windows in grisaille with ornamental patterns and insets of small coloured panels, such as were used at Salisbury cathedral and later at Westminster abbey. The most beautiful and most extensive example of the grisaille window is to be found in the 'Five Sisters' window in the north transept of York minster, made later in the century. Of the stained glass windows which decorated St. Hugh's choir at Lincoln, very little is left. The Dean's Eye in the north transept contains some panels, much pieced together, with Christ surrounded by saints and angels. In the *Metrical Life of St. Hugh* the two circular windows are said to have been emblazoned with the citizens of the Heavenly City and the weapons with which they overcame the tyrant of Hell. Their lights are compared to that of the sun and the moon while the other windows are like the common stars. Their variegated colour not only imitates the rainbow, but excels it, because while the rainbow is made by the splitting of the sunlight through the clouds, those two shine without a sun and glitter without a cloud. The other windows arranged in a lower and an upper order are compared to the noble army of the clergy illuminating the world with the divine light. The lower represents the order of the vicars, the upper the order of the canons, handling the business of the world, and they are decorated with a garnishing of flowers which

signifies the diverse beauty of the world. Some scenes from the life of St. Hugh set in medallions are preserved in the east windows of the north and south aisles designed in the manner of the windows in the aisles of the Trinity chapel at Canterbury cathedral, the most detailed cycle of miracles performed by an English saint. There can be no doubt that technical considerations recommended for large glass windows, which were not yet supported by stone mullions of tracery, the use of a metal framework (armature) designed in a variety of geometric patterns, into which the figural scenes were fitted with the same minimum of setting and the same clarity of composition as are found in the contemporary illuminations by de Brailes and others. But if the illuminators used the same patterns and model books, it is not simply because they followed the example of the window designers, but because the geometric order establishing sequences and relations was the natural and logical as well as the aesthetically appropriate one to be used by artists, who were taught to visualize human and divine relations in terms of eternal validity, satisfying reason and faith and independent of change in time and space.

VI

SHRINES AND TOMBS

DURING the first twenty-five years of his reign, King Henry had seen one church after another rise in the new splendour of the 'episcopal' style. He had given most generous assistance and had missed only a few of the splendid consecrations or dedications of the new works. But he himself had not built on a large scale, and had directed most of his personal efforts to the improvement of his residences. He finally came into his own when he concentrated all his energies and funds upon the rebuilding of Westminster abbey.

However erratic in politics, emotionally unstable, and unreliable in personal relations except in those with his family, Henry was one of the most distinguished patrons of the arts. His patronage was not only motivated by a genuine interest and almost sensuous delight in things beautiful, but it was the main mode of expressing his religious sentiments. No one can distinguish between religious zeal and love of the arts in a man whose devotion was only satisfied by the most lavish display in works of art, where the richness of the materials vied with the exquisite craftsmanship to the glory of God and his chosen saint. His contact with God was established through the medium of the eyes and the senses, through emotions which he had to express in a somewhat flamboyant fashion. Not content with hearing three masses daily, he assisted assiduously at private masses and 'when the priest elevated the body of Our Lord he usually held the hand of the priest and kissed it'. King Louis of France once warned him not to neglect sermons for the hearing of masses, but Henry maintained that 'he would rather see his friend often than hear speak of him, even though good was spoken'.[1]

[1] Chronica S. Albani, *Will. Rishanger*, R.S. xxviii. 2 (1865), 75. E. Kantorowicz (*Laudes Regiae*, Berkeley and Los Angeles (1946), 175 ff.) explains the multiplication of laudes days when the 'Christus vinxit' was chanted, at Henry III's order, as an indication of the progress of his religious zeal and his desire 'to borrow from this victory song the self-confidence which in many respects he lacked'.

Wherever he went on pilgrimages to shrines, his reactions required expression in visible form. His wish to go on a crusade was never realized, but though he could not visit the holy places himself he sought to find at home evidence of Christ's Ministry and Passion. The famous relic, the 'Rood of Bromholm', in the form of a patriarchal cross with one long and one short arm to the beam, had come to the Augustinian priory at Bromholm in Norfolk through an English priest, a native of Norfolk, who, on returning from a pilgrimage to the Holy Land, became keeper of relics under Emperor Baldwin I in Constantinople. After Baldwin's defeat by the Bulgarians in 1205, the priest had escaped to England where he finally sold the cross to the canons of Bromholm, probably in 1220.[1] According to Roger of Wendover, miracles at Bromholm increased from 1223 and the high reputation of the Rood lasted until 1251, after which references to it became scanty. On 5 April 1226 Henry went on his first pilgrimage to Bromholm, and he repeated his visits frequently between 1232 and 1248. In 1234 he ordered that his own image should be made without delay in silver-gilt to be presented to Bromholm.[2] At his last visit he went also to the priory of Walsingham near by, where according to a legend a noble lady had placed a copy of the house at Nazareth at the time of King Edward the Confessor.

In the meantime Louis IX had acquired the Crown of Thorns and the Lance for which he had begun to build the most exquisite of Gothic chapels, the Sainte Chapelle. Matthew Paris not only illustrated the relics but drew King Louis exhibiting them on a raised platform. It must have given deep satisfaction to Henry that he could acquire an even more precious relic. In 1247 a portion of the Lord's Blood was brought from the Holy Land via Constantinople to England, one year after the bishop of Liége had established the Feast of Corpus Christi in his diocese. In 1264, the bull 'Transiturus' by Pope Urban IV fixed the new feast on the Thursday after the octave of Pentecost for the whole Church, and St. Thomas Aquinas wrote the hymn, 'Pange, lingua gloriosi'. A society which was well acquainted with the stories of the Grail and

[1] F. Wormald, 'The Rood of Bromholm', *Journal of the Warburg and Courtauld Institutes*, i (1937–8), 31. [2] *Cal. Close Rolls, 1231–4*, 382, 413.

its connexion with the Passion, as they had taken final shape by
1230,[1] must have fully appreciated the preciousness of Henry's new
acquisition. At the king's special command, Matthew Paris was a
witness of the solemn procession in which the king carried the
Holy Blood to Westminster in 1247. As he recorded in writing[2]
and drawing (Pl. 44 *b*):

the king then gave orders that all the priests of London, vested in
surplices and copes, with their clerks seemly vested and with their
banners, crosses and lighted candles, should assemble in all due order
and reverence early in the morning on St. Edward's Day at St. Paul's,
whither the king himself came and bore the relic before his face, with
all honour, reverence and awe, going on foot and wearing a humble
dress, to wit a cope without a hood, preceding the vested clerics as far
as the church of Westminster which is about a mile distant from the
church of St. Paul. Nor shall it be omitted that he carried it with both
hands when he came to any rugged or uneven part of the road, but
always kept his eyes fixed on heaven or on the vessel itself. The pall was
borne on four spears and two assistants supported the king's arms lest
his strength failed him. On his arriving at the gate of the bishop of
Durham's court he was met by the conventual assembly of West-
minster accompanied by all the bishops, abbots, and monks which
had assembled, more than a hundred in number, singing, weeping,
and exulting in the Holy Spirit. The king, unwearyingly carrying the
vessel as before, made the circuit of church, palace and his own
chamber.

The vessel with the Blood together with a stone which carried
the imprint made by the Lord's foot at His Ascension, the latter
presented to Henry in 1249 by the Dominicans, was later placed
behind the shrine of St. Edward.

The temper of Henry's devotion was strongly influenced by the
new orders, especially by the Franciscans. Three years after the first
delegates of the Dominican order had been presented by Peter des
Roches to Archbishop Stephen Langton, eight Minors with their
leader, Agnellus of Pisa, had arrived at Dover in 1224. Very soon

[1] C. Williams, *Arthurian Torso*, ed. C. S. Lewis (1948), 62.

[2] *Chronica Majora*, R.S. lvii (1877), iv, 641. Matthew Paris had a good view of the
succeeding ceremonies from the step near the royal seat.

both orders won the active support of some of the secular bishops, especially of Grosseteste, Roger Niger, and Richard Wych, and were taken into positions of confidence at the royal court. Adam Marsh, respected by Henry, exchanged letters with the queen, who had another friar in her household. In 1250 a chapel was constructed for the Minors near the queen's lodgings at Clarendon. Quite apart from their contributions to intellectual life, the Franciscans brought a new warmth and a new concept of holiness into religious life in England. Even though the average Englishman did not know much of St. Francis, he saw the pattern of life which he had set in that of his followers. Thomas of Eccleston, the chronicler of the Minors, told of the death of Agnellus the first provincial minister, who 'crying through three whole days before he died, Come, sweetest Jesus, at the last having absolved his community ... closed his eyes with his own hands, crossed his hands on his breast and so died'. And he told of Vincent of Worcester who 'was so gentle and generous to others that he was loved by all as if he were an angel'.[1]

As a result the number of saints of the English Church venerated locally suddenly increased. To the officially established shrines there were added the tombs of some of the great English bishops, some of whom had been warm supporters of the new orders and who died in the forties and fifties of that century, leaving a reputation of holiness. The body of St. Edmund of Abingdon, the successor of Stephen Langton as archbishop of Canterbury and canonized in 1246, was lost to England. But many Englishmen, amongst them King Henry, did not fail to visit his tomb at the abbey of Pontigny, and miracles were recorded at the nunnery of Catesby where one of his sisters kept his pall.[2] Though not officially canonized, men like Roger Niger of London (d. 1241), Walter Suffield, bishop of Norwich (d. 1257), who added the lady chapel to Norwich choir, Robert Grosseteste (d. 1253), Richard Wych of Chichester (d. 1253), who was canonized in 1262, attracted pilgrims through the miracles which occurred at their tombs.[3] Such

[1] D. Knowles, *The Religious Orders in England* (1948), 141.
[2] Matthew Paris, *Chronica Majora*, R.S. lvii (1877), iv, 103 and 324.
[3] D. Knowles, *Religious Orders in England*, 4: 'It is not wholly accidental that the greatest ecclesiastic and the three canonised saints of the thirteenth century should all

popular recognition of Englishmen, the memory of whom was still fresh in the minds of the people, proved that the new concept of saintliness formulated by St. Francis had taken root in England. The claim of these men was not based upon the old traditions that supported the Anglo-Saxon saints, but their life represented a new ideal in which holiness was not seen in monastic austerity, in the grim fight against the powers of darkness, in the flight from life, but in their humane qualities, in their wisdom and kindness which was still active in miracles after their death and which made their shrines look bright and beautiful.

The shrines erected at this time, like that of St. Swithun at Winchester,[1] or that of St. Edward, had, probably in a free copy of the Holy Sepulchre in Jerusalem and following an old tradition, their base fitted with apertures or niches through which sick or maimed pilgrims could insert parts of their bodies, or into which they could crawl, to be healed not only by faith but by direct physical contact with the remains of the saints. Shrines of saints in the Church calendar had no effigies, but some of the new episcopal tombs were made to resemble shrines and some of the effigies were of men popularly sanctified.

Until 1240 by far the majority of tomb slabs, with effigies stretched out upon them, were those of bishops and abbots, for which a tradition was established at the end of the twelfth and in the early thirteenth century in a series of episcopal tombs at Wells and Peterborough. In style and conception these tombs followed on the whole the formula of the bishop figures on the Wells front. In the tomb of Richard Poore of Salisbury (d. 1237; Salisbury cathedral) and of Simon of Apulia (d. 1223; Exeter, lady chapel) the well-rounded effigy is boldly blocked out and encased in a niche or small mansion with a dragon under foot and angels beside the head. The solid figure is made to fit tightly into the niche with the arms clasped to the body, with hands holding a book or

have been diocesan bishops with distinguished university careers behind them, and that more than half a dozen others from among the *magistri* bishops should have left behind them a name for sanctity sufficient to acquire for their tombs a reputation as places of pilgrimage and miraculous cure.'

[1] J. D. Le Couteur and D. H. M. Carter, 'Notes on the Shrine of St. Swithun formerly in Winchester Cathedral', *Antiq. Journ.* iv (1924), 360.

the crozier thrust into the dragon's mouth or raised in blessing. All this gives an impression of immobility, which is increased by the shallow patterned folds of the vestments. But by the middle of the century the episcopal effigies have lost all traces of Romanesque compactness and severity. It has been generally accepted that this new style was formulated in London, in workshops which developed high skills in the carving of Purbeck marble imported in blocks from Dorset. The style of the London workshops, however, spread quickly through the country with effigies sent from the capital to the cathedrals and was copied locally in effigies carved in various types of stone.

An early and the most important example of this phase is the Purbeck effigy of King John at Worcester. This first royal effigy in England bears no relation to the royal tombs of the Plantagenets at Fontevrault. The simple order of dense, vertical, and V-shaped folds of his regal robes is reminiscent of Wells, but the figure, as well as those of St. Wulfstan and St. Oswald, who appear holding censers in place of the customary angels above his shoulders, has a distinct character of its own. The marble was painted and cavities in hems and belt, crown, sword, and gloves, suggest the use of inset stones (Pl. 29 a).

A new concept is illustrated by a number of effigies of the 1250's and 60's. Unfortunately, the tombs of Bishop Grosseteste and of Robert Niger are not preserved, but the effigies of Bishop Hugh of Northwold (d. 1254) and of Bishop William of Kilkenny (d. 1256) at Ely (Pl. 29 b), of Archbishop de Gray at York, of Bishop Giles of Bridport (d. 1262) at Salisbury, show a freedom of pose, a perfect poise in motion suggested by flexible bodies modelled by their drapery, and an idealized face in which spirituality is blended with the suave grace of a man of the world. In this last respect they resemble the figure of the archbishop in the additional drawings of the Westminster Psalter.[1] Even where a pillow is placed beneath the head, no suggestion of the dead corruptible body laid out on the bier is conveyed, but the effigy represents the heavenly body of the life hereafter. The sculptors did not see any inconsistency in combining the suggestion of resting in eternal peace in death and

[1] B.M. MS. Royal 2 A. xxii, f. 221.

standing in eternal life in heaven. The mansions which enclose these figures have a new richness of ornament, with slender detached columns and undercut foliage, and the resemblance to shrines is fully realized. In the tombs of de Gray, Bridport, and Peter of Aigueblanche (Hereford) the shallow niche of the slab has been developed into a full three-dimensional canopy standing above the tomb.

In the first half of the century the majority of tombs were freestanding low stone coffins covered by a slab which supported the effigy. A group of early tombs showed sculptural decoration on the sides similar to that of the screens upon walls and façades. The tomb of Archbishop Hubert Walter (d. 1205) in Canterbury and that of Bishop Gilbert Glanville (d. 1214) at Rochester were surrounded by arcades with small mitred heads set in the quatrefoils upon the roof-shaped lids. In Bishop Henry Marshall's tomb at Exeter (d. 1206) such heads alternate with seated bishops in larger foils, while flat scrolls with stiff-leaf foliage spread over the spandrels. But fifty years later the tomb becomes enshrined within a small chapel. The rich enclosure of the tomb of Bishop Giles of Bridport (d. 1262) at Salisbury is designed in the delicate and rich forms of the later florid Salisbury manner, under the influence of Westminster, with stiff-leaf and naturalistic foliage appearing side by side. The similarity to a saint's shrine is even more marked by the addition of figural scenes from the bishop's life, rather clumsily inserted between the gables of the Wells tradition, and by the shafts which rise with their heavy cross flowers like plumes above the moulding of the sloping roofs (Pl. 32).

In the tomb of Archbishop Walter de Gray at York (d. 1255),[1] the affinity to a shrine is even more pronounced as it is built in two storeys. Through an open arcade of sturdy Purbeck columns and trefoiled arches, the sarcophagus with the effigy can be viewed. In the second stage the trefoiled arcades are repeated set within steep crocketed gables which are surmounted by curved finials. The gay faces of little angels used as head stops are French in character, but the effigy has a physical vigour and an expressive power of its own. The breadth of the whole figure, as well as the width of the shallow

[1] Reproduced in A. Gardner, *Eng. Med. Sculpture*, Fig. 298.

folds in vestments laid thinly, one above the other, have nothing in common with either the Wells or London tradition. Though a pillow supports the head, the figure steps forward over the prostrate writhing monster and thrusts the crozier into the rearing dragon's mouth, lifting his right hand in blessing. The crozier, almost as thick as the shafts of the canopy, runs diagonally across the rectangle of the niche, breaking through the gable and half obscuring the censing angel perched above. The effigy of de Gray is a perfect illustration of the exalted concept of the English prelate who creates order in his diocese and defends the rights of the Church in all matters, even if need be against the pope as Bishop Grosseteste did at the Council of Lyon.

On the whole the attitude towards death now shows a more personal and sentimental trend. The origin of the custom of separating the heart of the deceased from the body and giving it a separate burial-place is not fully known.[1] King Richard, while buried at Fontevrault, left his heart to Rouen cathedral. By the middle of the thirteenth century the custom had found widespread favour in royal and episcopal circles. Bishop Poore and Bishop Niger bequeathed their hearts, the one to Tarrant, the other to Beeleigh abbey.[2] Special monuments for the heart burial were made, such as that at Winchester to Bishop Aymer de Valence (d. 1260), half-brother to Henry III, in which the half-length figure of the bishop, holding his heart before his chest in both hands, is set in a trefoiled niche within a mandorla, decorated with stiff-leaf and three coats of arms. Richard of Cornwall wished to have his heart buried in the Minors' church in London, as did Queen Eleanor also. In 1291 the abbess of Fontevrault received the heart of Henry III in Westminster abbey to take it with her to the old Plantagenet burial place.

[1] The first case of a heart burial the record of which can be accepted without doubt, is that of Robert d'Arbrissel, the founder of the order of Fontevrault (d. 1117). His body was interred in the abbey church, but the heart was given by the bishop of Bourges to the monastery of Orsan where it was preserved in a silver case of heart-shape. See Charles A. Bradford, *Heart Burial* (1933). The golden cup containing the heart of Henry of Almain, slain at Viterbo, is mentioned by Dante in the *Inferno* (xii, 115–20).

[2] J. H. Round, 'The Heart of St. Roger', *Trans. Essex Archaeol. Soc.* xvi (1923), 1.

About the same time a demand arose from lay patrons to be commemorated by effigies. The knightly effigy seems to have been inspired by the figures of knights on the Wells front and many of the earliest examples follow the pattern of Wells with a sloping belt, loose surcoat without sleeves, a kite-shaped shield, and even the peculiar feature of the seams in the coat of mail running lengthwise from shoulder to hand.[1] The effigy of William Longespée (d. 1226), earl of Salisbury, in the cathedral rests quietly on the slab, around the edge of which runs a delicate frieze of simple curving stiff-leaves. With his head on a flat square pillow, his legs apart but covered to the knees by the surcoat which spreads over the edge of the slab, his feet pointing downwards, and his right hand resting on the side, the earl reclines in noble calm (Pl. 30 a). This composure is maintained by all the early knightly effigies, whether made of freestone or marble, such as the heavily restored effigies in the Temple Church in London.[2] They follow the concept of the Christian knight, so beautifully represented in the drawing of the Westminster Psalter[3] (Pl. 37 b), whose faith and service for the church has gained for him entrance into the heavenly society, with the armour and weapon which marked him as a member of a noble class.

Very soon, however, this composure gives way to a new attitude which is exclusively English, where the figure suggests by its position keen alertness and vigorous life. The 'cross-legged' knight, of which the first known examples are to be found in the neighbourhood of Wells and in the Temple Church, has been explained in different ways. From the technical point of view the position gave more substance across the weakest point of the legs above the ankles and avoided the sagging of the lower part of the body between the head high on the pillow and the feet planted upon the back of a fully rounded lion.[4] The assumption that the crossing of legs indicated a crusader, or at least one who had taken the crusad-

[1] For a discussion of this motif see A. Andersson, *English Influence in Norwegian and Swedish Figure Sculpture in Wood 1220–70* (1949), 46.

[2] These suffered severely when the church was hit during an air raid in 1941.

[3] B.M. Royal MS. 2 A. XXII, f. 220.

[4] See W. R. Lethaby, *Westminster Abbey and the King's Craftsmen* (1906), 249.

ing vow, is as doubtful as the alternative theory that the pose has some judicial significance. May it not merely express the vigour and strength felt by the class as a whole in times when it played a most forceful role in the national life, and played it with many religious sanctions? Henry III took the religious ceremony of conferring knighthood seriously and delighted in the solemn procedure such as in the knighting of William of Valence and a number of his companions at the occasion of the translation of the relic of the Holy Blood;[1] and Ela, abbess of Lacock, the day before her son, William Longespée, was slain in Palestine saw in a vision his spirit, clad in his familiar armour, received by angels into paradise.[2]

[1] *Chronica Majora*, R.S. lvii (1877), iv, 644.
[2] *Flores Historiarum*, R.S. xcv (1890), ii, 365.

VII

HENRY III AND WESTMINSTER

ENRY'S decision to rebuild the choir of Westminster abbey was caused by various motives, political as well as religious and highly personal. When he was thirteen, in 1220, he was witness to the solemn translation of St. Thomas into his new chapel at Canterbury, one of the most impressive ceremonies in the then newest and richest of choirs. He must have remembered it when he decided to build a shrine for his favourite saint. His fervent devotion to St. Edward, 'Anglo-Saxon by birth and Norman by upbringing', was partly motivated by political reasons. The Plantagenet king saw in Edward a link between his immediate Norman predecessors and the long line of Anglo-Saxon kings. In the old choir of the abbey near the tomb of St. Edward was that of Matilda, queen of Henry I and granddaughter of Edmund Ironside, who by her marriage had formed a link between the Anglo-Saxon dynasty and that of the Conqueror. Besides, his devotion to St. Edward, a saint who had been canonized before St. Thomas, may have unconsciously contained a bias against the great opponent of his grandfather. There were to be many features of Canterbury choir which Henry copied in a grander manner at the abbey, and his impressions of the new chapel of St. Thomas may have inspired him with the wish to make the chapel of the royal saint outshine that of the bishop-martyr.

The church of the Benedictine abbey of St. Peter, which according to the legend had been consecrated by the apostle himself, recommended itself also by its site. It was close to the palace of Westminster, the king's residence when near London, only a mile away from St. Paul's, the cathedral within the city, which had been remodelled and solemnly rededicated in 1240. Henry's generosity to the abbey, to which he granted special privileges, was a great annoyance to the citizens of London, who many times had been a thorn in the royal flesh. Right in front of the Londoners,

Henry could express in the rebuilding and fitting of the new church his exalted idea of his role as king, which political circumstances and his unstable nature prevented him from playing in real life. The abbey stood then on its island in the Thames, as it had been built by King Edward, an *avant-garde* of the Norman style which was to take possession of England with the Conquest. The first step in the rebuilding was made, not at Henry's instigation, but with his knowledge. On the day before he was crowned by Archbishop Stephen Langton, on Whitsunday, 17 May 1220, the young boy had laid the foundation stone for a new lady chapel to be added to the east end of the Norman choir.[1] This chapel, now wholly replaced by that of Henry VII, must have been of considerable size, of six bays deep, to judge by its scanty remains: the start of its side walls at the west end, and the foundations of the three-sided apse found in 1876.[2] In 1234 Henry gave twenty-one oaks from the forest at Tunbridge Wells, presumably for its timber roof, and at the beginning of 1240 he gave five and a half marks for a glass window. The chapel must have been completed when Abbot Barking, its builder, was buried before its high altar in 1246. Its connexion with the main ambulatory must have been the same as that of Henry VII's chapel, which is only joined to the present ambulatory by its vestibule, while it is separated in the upper part by a well. The chapel presumably had a west wall detached in the upper part which allowed a large west window to bring light into the chapel. Moreover the well between it and the choir made it possible to place a window in the east head of the ambulatory and one in the centre bay of the triforium above, that shines like a beacon over the saint's chapel.

But it took more than twenty years after the founding of the lady chapel for the main rebuilding to start. In 1243-4 a mandate was issued to the sheriff of Kent to provide a hundred barges of grey stone for the new work to be undertaken at Westminster. Under the year 1245, Matthew Paris notes that a week after the

[1] *Chronica Majora*, R.S. lvii (1877), iii, 59; ibid. iv. 427.

[2] H. F. Westlake, 'Westminster Abbey: the Old Lady Chapel and its Relation to the Romanesque and Gothic Churches', *Archaeol.* lxix (1920), 31; and *Westminster Abbey* (1923).

Feast of the Apostle St. Paul, the beginning was made of the pulling down of the eastern limb and the tower of the Confessor's church. For the following thirteen years the work was pressed forward without apparent interruption until 1258 when the whole of the eastern limb, the crossing and the first bay to the west were completed. A second phase of construction from 1258–60 until 1269 took care of the rest of the choir. Henry of Reynes and John of Gloucester were in charge of the works during this period.[1]

There is no other building of this time or of preceding centuries for which so many data have been preserved as to wages, workmen, materials, and details of expenditure.[2] In 1250–1 for instance the king ordered that 600 or 800 men should work at the church and the following year 78 white-stone cutters, 49 marblers, 15 polishers, and 14 setters were engaged.[3] The king was utterly reckless in his expenditure. Although 'there seems to have been no particular office or servant of the king generally responsible for the king's building and their maintenance', an organization was set up to handle the funds assigned to the building of the abbey,

[1] Master Henry is not mentioned after 1253 and John of Gloucester is called the King's Mason of Westminster in that year. Three years later he was in charge of all the king's works. See J. H. Harvey, 'The King's Chief Carpenters', *Journ. Brit. Arch. Ass.*, 3rd ser., xi (1948), 20; *Cal. Close Rolls, 1256–9*, 11: 'Because the King has suffered much damage through causing his works to be carried on by Sheriffs and other officers, the King provides that Master John (of Gloucester) the King's mason, and Master Alexander the King's carpenter shall cause those works to be done for the future by task or otherwise and shall see to them and dispose of them personally to the better commodity of the King. And because they cannot labour at this at their own expense, the King wishes their wages, while journeying in connexion with the said works, to be doubled'. Alexander had built with William the spire of the detached belfry in 1248–9.

[2] F. M. Powicke, *King Henry III and the Lord Edward* (1947), 572. Here the work is described as partly 'the outcome of a social activity which engaged the interests of thousands of people and meant more to them than all the political and ecclesiastical issues of the day. At one period in the course of the work some 800 men were engaged upon it, but these 800 had behind them the quarrymen who dug out the stone in Caen and Purbeck and many other places, the sailors and wagoners who brought it to Westminster, the woodmen in the forests who felled the oaks for timbers, the merchants who collected the materials for work in cloth and jewellery, in mosaic and metal, the tilers at Chertsey and other places where men made tiles, the financiers who advanced money for wages.'

[3] For fluctuations in the numbers of workmen employed see L. F. Salzman, *Building in England* (1952), 35: *Cal. Close Rolls, 1247–51*, 423.

a new 'exchequer' of which Edward of Westminster, son of Odo the goldsmith, was one of the treasurers until his death in 1264–5.[1]

But all this information does not provide certainty about the artist who was responsible for the planning and the design as a whole. Six or seven weeks after the king's return from France, a Master Henry received a gown of office as master of the king's masons.[2] This same Henry may have been responsible for masonry details at the chapel of Windsor castle and also may be identical with the Henry of Reynes in charge of the new work at Westminster, but his exact function as master mason still remains uncertain. 'We may agree', writes Noppen, 'that he had charge of a body of masons engaged in that work; that he was expected to see that his men were of good skill, and that they exercised it; that he would have the responsibility in respect of supply and quality of stone, and share, with the wardens of the works, the executive tasks connected with his job'; whether or not he was the artistic creator of the church which so especially represents the fusion of the French and English manner is a harder question. Further, unless new evidence be discovered, it will remain an open question whether Henry of Reynes was an Englishman, a member of an Essex family of this name who had been sent to study in France, or whether he was a Frenchman, who had played a leading role in the building of Rheims cathedral and had been enlisted by Henry for the new work at Westminster.[3]

In 1241 Henry had been in France and he must have been impressed by what he heard of the new buildings carried out in the reign of his brother-in-law, King Louis. Louis had a new coronation church at Rheims, the choir of which was nearly completed

[1] J. G. Noppen, 'Building by King Henry III and Edward, son of Odo', *Antiq. Journ.* xxviii (1948), 138; xxix (1949), 13–25. There are constant references to Edward of Westminster in the Close Rolls of the period; up to the vol. 1245–7 they are indexed under 'Odo the Goldsmith, Edward son of'; afterwards under 'Westmonasterio, Edward de'. [2] *Cal. Close Rolls, 1242–7*, 141.

[3] F. M. Powicke, *King Henry III and the Lord Edward* (1947), 571, n. 1. 'It is not true, as Westlake has suggested, that King Henry saw Rheims in 1242 or that Master Henry, the architect, came from Rheims. The king left Gascony by sea in September 1243 and was never north of the Charente during his long stay in Gascony. He first saw the Sainte Chapelle in December 1254, but he did not visit Rheims until November 1262. He had opportunity to study Amiens in December 1254, July 1262, and January 1264.'

in 1242; he planned a splendid royal mausoleum at St. Denis, and he had begun the Sainte Chapelle within his palace. The new Westminster abbey was to combine all three functions: a royal chapel and a church for coronation and burial, where the old king was laid to rest and the new one crowned near St. Edward's shrine. The design was an adaptation of the high Gothic of the Ile de France to English traditional taste. It was the result of a new impact of French Gothic upon English building which had developed on its own lines after the first importation of French ideas seventy years earlier at Canterbury. Just as there, tradition, taste, and workmanship had turned the work of William of Sens into an English version of early Gothic, so at Westminster French features became assimilated and fused with English into an effect as unique as that of Canterbury choir.

For the new church the style of the bishops' churches in its chastity and its insular character was not adequate in Henry's eyes. Not even the new choir which was added to the round church of the Templars in London about 1240, with its richness of marble and its light-filled space, was beautiful enough.[1] His church was to be built in the newest French manner. Though in politics matters might not always run smoothly, the personal and cultural relations with the French court were of the closest. Of the four daughters of Raymond Berengar, count of Provence, the last of the Provençal poets, two had come to England, the two others stayed in France. Henry's bride, Eleanor, came to be married in 1236, and her sister Sanchia married the king's brother, Richard of Cornwall. Margaret became the wife of Louis, and queen of France, while Beatrice married Charles of Anjou, who later obtained the crown of Sicily which Henry had tried strenuously to win for his second son Edmund. With these connexions English art was bound to become more cosmopolitan. Furthermore the solid strength of the 'episcopal' style was softened by graceful refinement, acquiring an element of the exquisite and the feminine where an almost sensuous delight in aesthetic pleasure mingled with a devotion almost amounting to fervour.

The basic elements of the 'episcopal' style were retained, but they

[1] The choir suffered severe damage through air raids, but is now rebuilt.

were mingled with French Gothic features. The sharp definitions of the individual parts set against a solid ground were softened and the lines blurred. Blank surfaces were broken up by trellis, rosette patterns or blind foils, and arches and circles became cusped. The sharply cut patterns of the previous periods became richly embroidered and the contrasts between dark and light were replaced by gentle blending in soft transitions through a more complex mode of lighting. The lancet window gave way to the broad traceried window through which a flood of diffused light played gently over broken planes and delicate shapes.

Most French in character was the main entrance front of the new building, which was not at the west, where the front of St. Edward's church remained intact. The front of the north transept, approached from King Street, a short way to the south but parallel to present Whitehall, was the state entrance. Though it is in its present state almost entirely of the nineteenth century, one can still see that it was modelled after the main front of Amiens cathedral, but without its towers. Three similar steeply gabled porches stood out flush with the lower parts of the dividing buttresses, the fronts of these buttresses being divided in each case into two-arched recesses for statues standing on corbels. 'Above the lateral porches at Amiens the western windows of the aisles are deeply set in recesses like a similar curious arrangement at Westminster, and still higher the extended wall arcade of coupled lights runs right across the front beneath the rose window.'[1] Much more impressively than the Dean's Eye at Lincoln, the large traceried rose window (now restored like the rest of the front and all of the exterior) dominated the whole front and the gable was filled with blind tracery of three circles containing cinquefoils in a pattern similar to that of the cloister.

Above this cloister the second main French feature appears in its most extravagant form: pinnacled buttresses and flying arches (Pl. 35). The aversion of the English builders to the French open

[1] For the successive restorations of the north transept front, see W. R. Lethaby, *Westminster Abbey and the King's Craftsmen* (1906), 69, 123. Also S. H. Seager, 'Westminster Abbey; An Endeavour to Read the Story of the North Transept Façades', *Journ. of R.I.B.A.*, 3rd ser. xxviii (1921), 93.

skeleton framework was swept aside and the elastic construction was developed proudly, even beyond French common usage with three rows of flying arches swinging from the tall buttresses across towards the walls. Four low storeys follow each other in quick succession on the south side of the church as seen from the cloisters: the north walk of the cloister, the aisles with their second storey, the triforium and the clerestory above. The tracery of the cloister apertures and of the windows is designed as variations of a very simple theme of pure geometry. But at the same time the complex pattern made of flying arches and tracery is much more intricate and agitated than is common in France, and is reminiscent of the interplay of animated lines beloved by the Celts and Anglo-Saxons.

The most obvious French feature in the planning of the choir was the choice of the chevet plan (Fig. 14). In contrast to the square east end which had formed such a conspicuous feature of the 'episcopal' style, the architect used a variation of the chevet customary for the French cathedrals, in particular of that at Rheims, which had been finished by 1242.[1] But although copied from Rheims, the chapels at Westminster are more fully developed, more boldly detached as independent units, partly because they are built in two storeys, which is not common in France. This second storey corresponds in height to the triforium inside and is lighted by those round windows which, set within segmental or triangular heads, are such a distinctive feature of Westminster. With these windows, French window tracery becomes established in England. It is that of Rheims, as drawn by Villard de Honnecourt. No working drawings for Westminster abbey are in existence, but we must assume that drawings like those of Villard[2] had been made for Westminster to instruct English masons in the French ways of building.

In laying out the new choir, the architect was not free in his planning, but was bound by the building which he was to replace. The new work had to be fitted in between the lady chapel, built about twenty years before, and the nave of the Confessor's church,

[1] For the setting out of the chevet see G. G. Scott, *Gleanings from Westminster Abbey* (1863), 23. [2] H. R. Hahnloser, *Villard de Honnecourt* (1935), Pls. 60, 61.

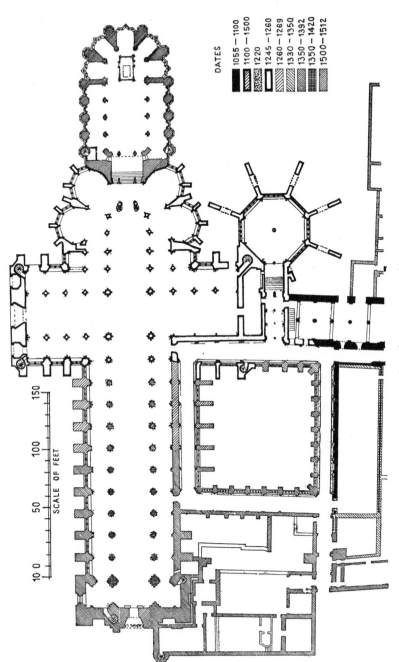

DATES

1055 — 1100
1100 — 1500
1220
1245 — 1260
1260 — 1269
1330 — 1350
1350 — 1392
1350 — 1420
1500 — 1512

SCALE OF FEET

10 0 50 100 150

FIG. 14. *Plan of Westminster Abbey*

the place of the crossing being determined by the position of the cloister. The new walls could not grow up round the older choir, the method customarily employed in new eastern extensions, but were laid out upon the lines of the old choir. This left, for sanctuary and chapel, only three bays east of the crossing, a wide one corresponding to the eastern aisle of the transept and two narrow ones preceding the apse. Such a short sanctuary was uncommon even in France, and was against all English habits. The limitations affected further the layout of apse and chapels. The sanctuary, raised by three steps, occupies the first two bays east of the crossing. The high altar stood on the line of the square chapels of St. Benedict and the corresponding one on the north side. Towards the east the chapel of St. Edward had one oblong bay followed by the apse marked by six supports and five intervals; although the sides of the apse are the same in number as at Rheims where they form a portion of a decagon, at Westminster the first two incline but slightly and the three eastern ones form the sides of an octagon.[1] The resulting effect in the elevation is quite different from that found commonly in France.

The ambulatory of five bays in regular trapeze shape is wider than was common in France, but the greatest difference lies in the disposition of the radiating chapels. Only two chapels on either side found room between the two square ones east of the transept and the lady chapel. The width of the latter may have determined their unusual width as the wall passage half-way up the wall in front of the window may have been taken over from the lady chapel.[2] The thrust from the six ribs of the main apse is taken by the pillars of the apse, by the transverse arches between the ambulatory bays and by the main buttresses wedged in between the

[1] The mathematical calculations which governed the architect seem to have been the same which were observed in laying out the octagonal chapter-house in contrast to the French custom of approximating the shape of the apse to a circular design. Of the five sides of the octagon the two westernmost ones however are slightly splayed. The off-chord position of the keystone of the apse vault corresponds logically to the position of the centre of the chapter-house vault.

[2] H. F. Westlake, *Westminster Abbey* (1923), i. 62: 'The width of the Lady Chapel made inevitable the widening of the angle between the axes of the north east and south east chapel. At Rheims this angle is 72°, at Westminster 90°.'

chapels. In the ground plan a straight line leads from the keystone of the apse to those of the ambulatory bay and of the chapel and finally to the middle of the minor buttresses, which number three in contrast to the two customary in French radiating chapels. Thus a rather awkward space is left between the first square chapels, which are in line with the high altar, and the first pair of radiating chapels. This gap is filled with a heavy block of masonry that provides a buttress of quite unnecessary strength, an arrangement that suggests an 'over-anxiety for the stability of the vaults' and thus a 'designer not altogether familiar with this type of structure'.[1] On the other hand, as Sir Gilbert Scott has pointed out, the setting out of the chevet is remarkable for its regularity and exactness. The chapels themselves are unusually deep and spacious with six canted sides and seven ribs of the vault meeting in the centre. The first two chapels of the north and south have three blank sides with three windows between them while the next have four windows between two blanks. The easternmost windows nearest to the lady chapel are placed so that they stand at the end of the vista along the aisles towards the east. The transepts of four bays jut out emphatically north and south in the English manner, which even in this period does not follow the French tendency to hold shortened transepts within a more concentrated contour.

Upon this plan the new work at Westminster rose higher than any other English church previously built, with a new feeling for fluid graceful growth (Pl. 34). To one proceeding through the transept, with its east and west aisles, a multitude of views is offered through the main arcades where the pillars of choir and sanctuary appear between and behind those of the transept, with the mould arches giving the impression of a steady rise and fall. The inner transept faces, but especially that of the south, are most beautifully composed in a geometric pattern. Three storeys of arcades follow one other. The first two, which are blind, are decorated with wall paintings at ground level, then with diapered spandrels and reach up to the height of the main pillars. In the third storey which rises to the triforium sill the thickness of the wall is gradually worked

[1] G. Webb, 'The Decorative Character of Westminster Abbey', *Journ. of the Warburg and Courtauld Institutes*, xii (1949), 16.

away with a base sloping back to the six lancets framed by trefoiled arches. Then follows a storey which corresponds to the triforium where six tracery windows of the triforium design are arranged in groups of three, their spandrels enriched with sculptured figures. The clerestory is taken up wholly by the pierced tracery of the rose window. This rose window, its circle inscribed in a square and its design accommodated to the vault, is but a restored copy of a fifteenth-century design but, Sir Gilbert Scott suggested,[1] this was most likely a translation of the original window, the shape of which one can guess from the contours of a rose found on a tile in the chapter-house (Pl. 36). Compared with the transept faces at York and at Lincoln, with its Dean's Eye, the design is much more delicate and unified, originally blazing in colour, very similar in its effect to the page in the Trinity College Apocalypse (f. 17) where the multitude adore the Lamb.

Sanctuary and chapel, however, give the climax of the whole effect. They rise smoothly and lightly with their high slender columns, their sharply pointed arches, their thin vaulting shafts. These start from the capitals of the main pillars, are encircled by the triforium sill, but are unhampered after until, at one-third of clerestory height, they receive the ribs. The inner kernel of the sanctuary is enmantled by an outer shell. Between the main pillars the eye can penetrate into ambulatory and chapels; the outer walls, never wholly visible, form a resilient enclosure contracting and expanding, alternately light and dark. Above it the chapel rises triumphantly, brightly lit through its high clerestory windows above the dimness below.

The main pillars of the eastern limb are not the many Purbeck shafted ones of Lincoln or Worcester. Only four slender shafts attached to the cardinal sides accompany the centre cylinder in French fashion, but still they are not like those at Rheims but those of Salisbury with their plain, bell-shaped capitals repeating the lines of the main moulded abaci and twice banded. The triforium above avoids the awkward proportions of that in Salisbury. Although, contrary to French custom, there is a deep triforium chamber, it has, for the first time in English Gothic architecture,

[1] G. G. Scott, *Gleanings from Westminster Abbey* (1863), 30.

been given satisfactory height in relation to the other storeys. Ground storey, triforium, and clerestory follow each other in the proportion of 3: 1: 2, the first a half, the second a sixth, the third a third, of the total height.[1] 'The normal width of the bays is about 19 ft. from centre to centre. The side bays of the clerestory are only about 17·0, and the height is thus six times the dimensions.'[2] The arches rise lightly, secured by ties, wooden or iron 'the varieties of which may possibly indicate the order in which the arches were built'.[3]

In the triforium the double arcade appears for the third time in an English building after Beverley minster and Worcester cathedral, but it is entirely different in its effects. Each bay has a transparent double screen, though the rear screen is more simple with chamfered sides. Double Purbeck colonnettes and carefully moulded arches make a rich pattern in front, with a colourful sequence of mouldings, stiff-leaf foliage, and diapers. The two pointed arches in the first three bays in the apse are all subdivided again by one slender colonnette with trefoiled heads, cinquefoils above, and pierced spandrels. If one faces exactly the centre of each bay, the rear screen is hidden by the one in front, but seen from an oblique angle the second screen appears in delightfully changing vistas slightly raised on steps above the triforium sill. Instead of the solid wall of Beverley and Worcester, soft darkness fills the empty spaces of the screen making the triforium a dark band between the luminous dimness of the ground and the brilliancy of the clerestory above. The triforium chamber is of surprising spaciousness. A whole upper church which could house thousands of people is made to extend into the chapels where it is lighted by triangular windows with segmented sides enclosing an octafoil circle or by windows of two pointed lights with a quatrefoil circle. These spherical windows, although they occur in France, give to Westminster abbey a personal note. Little light reaches the

[1] See F. Bond, *Westminster Abbey* (1909), 82.

[2] W. R. Lethaby, *Westminster Abbey and the King's Craftsmen* (1906), 128.

[3] R.C.H.M., *Westminster Abbey* (1924), 32. 'The three northern and the eastern bay of the apse with the adjoining cross arches and all arches opening into the polygonal chapels have wooden ties, the remaining southern bays of the apse have plain iron ties and all the rest of the work of Henry III has iron ties with hooks and staples.'

triforium arcade as the windows are not visible from below, except in the easternmost bay, where the triforium is only of the depth of the ambulatory and stained glass could be lit from the well behind.

The clerestory above seems purely French, lofty without a wall passage, since the architect by now dared to make the walls thin. The intervals are filled completely by tall slender windows of two plain pointed lights, a cinquefoiled circle with pierced spandrels, framed by circular shafts with moulded bases and foliated capitals, instead of the plain lancet so popular in the architecture of the first half of the century. The vaulting throughout the eastern portion is constructed with full mastery over Gothic wall construction. The courses of the stones in the webs, however, are arranged in English fashion. The quadripartite vault sections are divided by transverse ribs which are larger than the diagonals and have a ridge rib running through all, which is more ornate than the others and which may be a later addition.[1] As mentioned before, the six ribs from six piers meet as at Rheims in a keystone which is east of the chord but the effect of the apse is not that of Rheims or Amiens, that of half a polygonal building. As the sides of the first bay north and south are only slightly canted so that one is hardly aware of their curving in, and as the curve of the east end of the apse proper is rather flat, there are moments when in a certain light the east wall does not seem to be curved at all. Thus a compromise is reached between the French chevet and the English square end. The three pointed arches of the apse seem a more fully developed version of the east wall of Salisbury, with a softening of angles and a blending of its parts. The more complex pattern of the triforium tracery, the breaking up of the stone surfaces in the spandrels into a tapestry pattern of diapers seem with the 'reliance on colour and texture to point the way to the development at the end of the century'.[2] This tendency is even more pronounced in the portions which belong to the second work. From the second to the fifth bay west of the crossing, extended the actual choir with the stalls

[1] R.C.H.M., *Westminster Abbey* (1924), 19.

[2] G. Webb, 'The Decorative Character of Westminster Abbey', *Journal of the Warburg and Courtauld Institutes*, xii (1949), 20.

for the monastic chapter, and here, under the guidance of Robert of Beverley, who took over after the death of John of Gloucester in 1260–1, the French Gothic features become even less distinct. The main pillars have a more lively contour surrounded by eight shafts, four detached and four attached by marble bands or by bronze fillets, and the vault has the complex form of that of Lincoln nave with its multiplication of ribs.

King Henry had prepared for himself a royal pew, the 'Muniment Room' in the west aisle of the southern transept. This had been partly walled in in order to accommodate the east walk of the cloister. The vacant space above this walk between the arches and the vault of the aisle was used as an intermediate gallery from where Henry could take part at any time in the choir services without disturbing them, entering the church through the door in the south-east corner of the transept which was nearest to his palace, and mounting a staircase, space for which could be spared out of the thickness of the transept wall. From here he could look down into the sanctuary and the chapel, and feast his eyes on the splendour of the fittings: pavement, high altar, rood, and shrine. So that the rood should be visible from the pew, it was placed not above the pulpitum in the nave, but above the high altar. This rood, which can still be seen in the illumination representing Abbot Islip's funeral in the Islip Roll, consisted not only of the customary group of the Crucified between St. Mary and St. John but also of two cherubim standing on wheels on each side. About two hundred years before, Archbishop Lanfranc had placed such an enlarged version of the rood over the entrance into the choir of Canterbury as a witness of his belief in the transubstantiation upheld against Berengar of Tours. When Henry ordered a similar rood for Westminster, Lanfranc's belief had become a dogma.

The pavement in front of the high altar,[1] again a reminder of Canterbury, where a marble pavement in the Roman manner of Opus Alexandrinum had been placed immediately westward of St. Thomas's shrine, was made of material which was imported from abroad but put together by an English workman. For the pavement at the abbey, Abbot Ware had brought in 1260 from Rome,

[1] J. Perkins, *Westminster Abbey: its Worship and Ornaments* (1938), i. 18.

where he had been staying for two years, not only materials but also craftsmen to lay it down. The Roman artist Odericus, who, together with king and abbot, is mentioned in a long inscription in the border of the pavement, had to accommodate himself to the local requirements and the material available, employing in addition to the imported porphyry and serpentine a considerable amount of glass mosaic and Purbeck marble. The pavement seems to have been in place in 1268. Its pattern of inter-woven circles and squares in rich colour was more than mere decoration. The border round the middle circle carried originally a brass inscription saying that the pavement showed the plan of the universe and its duration. The central globe contained symbols representing the four elements: red for fire, blue for water, brown for earth, white for air, similar to the plan of the universe in one of Matthew Paris's drawings for which he had received instructions from Elias of Dereham.

The high altar[1] had a frontal of Opus Anglicanum, made by three women working on it for nearly four years, of gold cloth stiff with pearls, garnets, and enamels; behind it rose the shrine of St. Edward, raised upon a marble base, another work of a Roman artist, Peter, presumably the son of Odericus, who signed himself as *Petrus Romanus civis* on the ledge. The base of Opus Alexandrinum had twisted inlaid marble columns similar to those found in some cloisters at Rome, and deep recesses with blind window tracery for the pilgrims. The illustration of the shrine in the *Life of St. Edward* shows on two columns in front of it the figures of St. John as a pilgrim and St. Edward.[2] This illustration is the only evidence for the precious shrine which contained the body of the saint. Already in 1241 Henry had given the order for a shrine of gold and marble to be made by picked workmen.[3] From time to time gifts of jewels and money were made and the queen presented an emerald and ruby in 1253. Only two years before the great

[1] Abbot Richard de Berkyng bequeathed two dorsals for the choir upon which the stories of the Saviour and of St. Edward were told. See John Flete, *The History of Westminster Abbey*, ed. J. Armitage Robinson (1909), 24 and 105.

[2] Cambridge, Univ. Libr. MS. Ee. 3. 59, f. 30.

[3] *Cal. Lib. Rolls*, 1240–5, 83, 134. See J. Perkins, op. cit. iii. 32.

ceremony of translation, in 1267, Henry was forced to pawn the metal and the jewels to help him through the most critical period of his reign, but at last in 1269 all was well, and the shrine was 'placed high like a candle upon a candlestick so that all who enter into the House of the Lord may behold its light'.[1] Elaborate arrangements were made for brilliant illumination. Henry gave a corona for a great number of candles and four silver basins for lamps: two over the shrine, one on the south side over the un-marked grave of Queen Matilda, another in a corresponding position over that of Edith, wife of Edward the Confessor. All five bosses of the vault were pierced and in addition nine holes in the cells of the vault permitted the lowering of chains for the sus-pension of lights.[2]

On the day of St. Edward's first translation, 13 October 1269, Henry gathered all his family around him. The vigil was spent in strict fasting and on the feast day solemn mass was sung in the church. The chest with the body of St. Edward was carried by Henry and his brother Richard of Cornwall, while his two sons Edward and Edmund, both called after Anglo-Saxon kings and saints, and the earl of Warenne and Philip Basset, with as many nobles as could come near to touch it, supported it. As a permanent reminder of those who had been present at the ceremony or had contributed to the building and its fitting, armorial shields carved in stone and painted and gilded were attached to the spandrels of the wall arcade in the choir aisles: the first use of heraldry in the decoration of a building. Beside the shields of Edward the Con-fessor and of Henry III, there were the shields of the earls of Win-chester, Lincoln, Ross, Gloucester, Norfolk, Warenne, and others, among them that of Simon de Montfort, the king's brother-in-law. Other shields proclaimed the position which the English crown held under Henry III: those of the count of Provence, father of the queen; of St. Louis, who had married the queen's sister; of

[1] *Annales Monastici: Thos. Wykes*, R.S. xxxvi (1869), iv. 226.

[2] R. P. Howgrave-Graham, 'Various Bosses, Capitals, and Corbels of the Thirteenth Century', *Journ. Brit. Arch. Assoc.*, 3rd ser. viii (1943), 1: 'The central longitudinal ridge-rib between these bosses is pierced by several large holes which open into the upper space under the roof . . . one or more of them is likely to have been connected with the elevation of the canopy (over the shrine).'

the Emperor Frederick II, who had married Henry's sister; of Alexander III, king of Scotland, who had married the king's daughter; and of Richard, earl of Cornwall, brother of the king and husband of the queen's sister, who for ten years had been German king and candidate for the Imperial crown.

Under 1250 Matthew Paris recorded that the king built an 'incomparable' chapter-house. It was reached by the east walk of the cloister which was rebuilt together with the greater part of the north walk. The cloister arcades were designed as a most beautiful and rich variation of the classical two-light window with three lights under one arch and four foils in the head. For the chapter-house Henry chose a shape which was not the normal oblong one of monastic houses, but one which had been designed for the secular chapter of Lincoln not long before. The increased wealth and the administrative strength of the chapters, monastic or secular, led in the first half of the century to the building of chapter-houses, which by their size and the sumptuousness of their decoration went far beyond the customs of the preceding century. The height of the monastic chapter-houses was normally limited because the dormitory above it had to connect directly with the transept and the night stairs into it. But at St. Frideswide's at Oxford and at Chester, lofty chapter-houses were built, lighted by tall lancets behind the graceful screen of shafts supporting the rear arches, both under the influence of the design for the eastern transepts at Worcester.

In secular establishments, where the canons lived in separate houses and where no cloisters or other communal buildings were a necessity, the chapter-houses were free-standing and could rise to any chosen height. Not only were they built as lofty chambers of state, entered by a richly decorated vestibule and through an elaborate double-arched doorway, but they were detached central buildings. It seems unlikely that the rather remote polygonal chapter-houses at Margam and Abbey Dore of the late twelfth century could have served as prototypes for the new design, for they were small and no other Cistercian house, not even the largest, used this form. The circular chapter-house at Worcester, vaulted by ten arches to a central pillar (c. 1160), may have served

as a source of inspiration, though there was a gap of more than sixty years between it and the first great polygonal chapter-house at Lincoln.

It seems appropriate that such a magnificent chamber was built by the chapter of Lincoln, which was so conscious of its dignity and its rights that it refused to Bishop Grosseteste entrance to it. The early thirteenth century saw the final organization of the secular chapters and their officers. No other plan than that of the central building, in which all seats were of equal rank, could have expressed more clearly the concept of the chapter as a corporate body of canons who had entrusted some dignitaries with special duties, but who remained a society of equals. In this respect, their gatherings in the chapter-house resembled those of King Arthur's Knights of the Round Table. The seating of the canons corresponded to that of Arthur's Knights in which, according to Wace: 'It was ordained that when this fair fellowship sat to meat, their chairs should be alike high, their service equal, none before or behind his companions; and none could brag that he was exalted above any, for all alike were gathered round the board, and none was alien at the breaking of Arthur's bread.'[1]

Abbot Ware called the chapter-house at Westminster 'the work-shop of the Holy Spirit in which the sons of God are gathered together. It was the house of confession, the house of obedience, mercy, and forgiveness, the house of unity, peace, and tranquillity, where the brethren made satisfaction for their faults.'[2] In pictorial representations of the coming of the Holy Spirit at Pentecost, the apostles were usually seated in a circle, none of them presiding, but with the Virgin Mary in the centre. Ideas of this kind may well have recommended to the secular chapters the polygonal plan which pleased Henry so much that he chose it for his Benedictine abbey.

The chapter-house at Lincoln, begun before 1250, still retained the simplicity of the 'episcopal' style in its walls, which resemble the aisles of Lincoln nave, with the coupled lancets in each side of the

[1] C. Williams, *Arthurian Torso* (1948), 41.
[2] Ware, p. 311, quoted from A. P. Stanley, *Historical Memorials of Westminster Abbey* (1868), 388.

decagon. The wall arcade round its inner base which forms the individual seats seems applied to the solid wall, and the central column with its ten Purbeck shafts is heavy and low. But the complex structure of the vault is not in harmony with the clear-cut design of walls and windows. Its richly foliated corbels, with the bundles of slender shafts joined to the windows by acutely pointed corbelled arches, and the pattern made by the many ribs of the vault, springing from corners and centre to spread and meet at the ridge rib, must have been added at the time when the nave vault was designed. The chapter-house which was given to the cathedral at Lichfield between 1240 and 1250 resembles that at Lincoln, though it was built in two storeys and was slightly abnormal in plan, octagonal but oblong round a central pillar surrounded by ten shafts which branch out into sixteen ribs without a ridge rib.

Only at Westminster and later at Salisbury was the full charm of the central shape achieved. The chapter-house at Westminster[1] is approached through a vestibule which had to be low, dark, and divided into aisles because the dormitory of the monks reached across it from south to north towards the transept. Beyond the vestibule, the steps leading into the chapter-house, which was raised above a crypt, could be placed in a higher and lighter ante-room. In the end the full effect of the height and brightness of the main chamber is felt all the more strongly by the contrast with the dark approach. At Lincoln one is chiefly aware of the shapes of columns, shafts, and ribs. At Westminster it is the open void, radiant with light, held in by the transparent screen of the large traceried windows and covered with the springing vault which creates the main effect.

It was perhaps the unkindness of the English climate that led to most of the sculptural decoration of Westminster abbey being placed inside. This arrangement conformed to an English tradition, and sculpture so placed could be better enjoyed by the king and the chapter. The effects of climate caused in part the disappearance

[1] G. G. Scott, *The Chapter House of Westminster Abbey* (1867). The height of the crown of the vaulting (now modern) is 54 feet. The outer flying arches were built in the fourteenth century.

of the only outdoor sculpture which decorated the portals of the
north transept. Here, for the first time, after the abortive attempts
at Rochester cathedral and the portal of St. Mary's abbey, York,[1]
a portal in the manner of that of the great French cathedrals was
produced. In 1683, in spite of north wind, moisture, and sea-coal
smoke, it could still be described as having the statues of the twelve
apostles 'at full proportion, besides the multitude of lesser saints
and martyrs to adorn it with several intaglios, devices, and fret-
works'.[2] If this description suggests a portal with jamb figures in
the French fashion, the tympana of the three portals were treated
in a different manner. Those at the sides were decorated with an
overlaid pattern of foils, but in the centre the quatrefoils, arranged
in a pattern of blind tracery, are known to have contained figure
sculpture. This most likely represented the Last Judgement, but
quite differently from the French arrangement where the field of
the tympana was divided in horizontal strips. The Westminster
arrangement of quatrefoils must have been similar to that of the
Judgement porch at Lincoln, to be discussed later.

The outer doorway, leading from the cloister into the vestibule
of the chapter-house, did not fare much better than the abbey
portals. Here the pictorial programme was in honour of the Virgin.
A Tree of Jesse was carved out of the arch-moulding which framed
the large tympana above the twin doorway. The order in which
the figures of the Virgin and of two angels were fitted against the
tympana above indicates that they did not form an integral part
of the architectural order as in France, but were merely attached
and supported by splendid foliated corbels and stood out against
a richly coloured background of blue with gold and vermilion
scrolls. The headless angel on the right suggests a high quality of
carving with its slender grace. The English taste for interweaving
of figures and scrolls, so much indulged in illuminated manu-
scripts, affects the sculpture which was carved out of the jambs of
doorways and windows. Figures of this kind appear around the
inner doorway which leads from the dark and low vestibule to the

[1] T. S. R. Boase, *O.H.E.A.* iii (1953), 206 and 241.

[2] Thus described by Keepe in 1683: quoted G. G. Scott, *Gleanings from Westminster
Abbey* (1863), 35.

high inner chamber. The inner face of the doorway towards the chamber on either side of the arch was originally filled with open tracery,[1] the design of which was repeated in variation in the trefoils and heads of the niches which contain the archangel Gabriel and the Virgin. In the trefoils upon the diapered ground of the spandrels, censing angels bend towards the main figures and help to tie the composition together. Thus, trefoils and niches are not conceived as solid architectural, limiting frames, but as parts of an ornamental surface design which can be transgressed, as it was by the now missing wings of the angel.

The Annunciation group represents the most outstanding link between the sculpture at Wells and that at the abbey. But its style is similar also to that of the female torso in the feretory of Winchester cathedral which is, next to the transept angels in the abbey, the most beautiful piece of thirteenth-century English sculpture (Pl. 41 a). Her mantle hangs down from the shoulders and is draped over the left hip, forming a shell for the slender figure, whose dress is covered by the fine pleats of the Wells tradition. She floats with freedom and proud carriage, her body bent backward in a graceful curve, and the bottom folds sweep around her feet in a calligraphic pattern. The chapter-house Virgin and Angel, completed about 1250, seem slightly more rigid, owing possibly to the hardness of the stone (Pl. 40). If movement and gestures are restrained and almost awkward, the graceful flow of folds is vastly richer and more complex than that found at Wells, just as the sentiment is softer and suggests an interplay of emotions of a more feminine quality. The deeper carving with shallow convex planes embedded between sharp ridges reduces the weight of the body, and the spidery web of the drapery circumscribes the willowy shapes. While the vertical folds of the gowns stress the fragile growth, the V-shaped and rounded folds of the loose mantle converge towards the heads and hands. The shy joyfulness of the youthful angel, who bends back and reaches out with his hands, contains a promise of the censing angels in the transepts.

The sculptural decoration of Henry III's new choir did not

[1] G. Webb in *Journ. of Warburg and Courtauld Institutes*, xii (1949), Pl. 15 *b*, shows a reconstruction of the doorway without the modern additions.

follow a consistent plan and shows a variety of hands. Although one French sculptor seems to have been active, the majority of the craftsmen were English, apparently gathered from various parts of the country. While links can be found with Ely and Lincoln, the western influences predominate especially after Henry of Reynes was succeeded by John of Gloucester. The carving of the arcade spandrels in some of the radiating chapels and aisles, with figural subjects now largely destroyed or damaged, points to Worcester. The bosses of the high vaults of choir and transept are almost all decorated with trefoil foliage though in some in the transepts leaves are treated in a more naturalistic manner. A few of the bosses, however, which were more easily visible than those in the high vaults, are carved with figure subjects. The introduction of biblical subjects into carved bosses seems to have been made first at Worcester. Following this example the vaults of the lady chapel at Chester received bosses with the Trinity, the Virgin and Child (Pl. 39 a), and the Martyrdom of St. Thomas, and four bosses in the chapter-house of Christ Church, Oxford, are carved with Christ in Glory, the Virgin and Child, St. Frideswide, and with four lions whose bodies are joined in one head.[1] Of the bosses in the west aisle of the north transept at Westminster abbey, that with the Annunciation is the most beautiful, but the most magnificent series is that in the Muniment Room, different in style from all the others. They decorate the small rear vaults of the beautiful south window and represent allegorical combat scenes between men and monsters (Pl. 39 b).[2]

The most important scheme of sculptural decoration, however, was that of the angelic choir which extended from the ambulatory chapels into the transept. The presence of angels as participants in the celebration of the mass, leading the human voices, was not a particularly English invention, but the belief in the presence

[1] Illustrations of most of these bosses are to be found in C. J. P. Cave, *Roof Bosses in Medieval Churches* (1948).

[2] An historical sequence of the carvings of capitals and bosses has been attempted by R. P. Howgrave-Graham, 'Westminster Abbey: The Sequence and Dates of the Transepts and Nave', *Journ. Brit. Arch. Assoc.*, 3rd ser. xi (1948), 60–79. For the discussion of the foliage treatment see P. Wynn Reeves, *English Stiff Leaf Sculpture*, London Univ. (dissertation for London Univ., 1952, unpublished), 247.

of angels was frequently expressed in Anglo-Saxon theological writing and there are remains of Anglo-Saxon sculpture inside the churches which suggest a well-established tradition. The concept thus seems to be particularly dear to the English, and in the course of the thirteenth century such angelic choirs appear on the façade of Wells, in St. Hugh's choir in Lincoln, on the choir screen at Salisbury cathedral. Members of an angelic choir were added to the quatrefoils in the gallery of Chichester choir, probably at the occasion of the translation of St. Richard in 1276; and the most elaborate version is that in the Angel Choir at Lincoln. In the abbey, on the soffits of the lancet windows in the inner face of the north transept, the busts of twenty-four angels are fitted into the circles which are made by slender stalks out of which stiff leaves grow and curve against the motion of the circle. Most of these angels hold musical instruments and are carved in low relief more softly and roundly than the angels in the quatrefoils at Wells.[1] Most beautiful of all are the four angels in the spandrels of both triforium arcades. These pairs of censing angels originally flanked groups of two figures in the central spandrels. Those on the north side are largely gone and unidentifiable; on the south side St. Edward faces the seated Pilgrim. All these figures are slightly less than life-size but only just visible from the floor of the church. The angels are all in a half-leaning position, their torsos slightly bent back, and framed by their pointed wings. While the one wing, which is folded, strengthens their backs, the other is lifted to accompany the mighty power of the arm which swings the censer. The angels of the north transept are of sturdier build, with simpler drapery and of a more serious mien. In the two on the south side the grace of the slender, supple bodies is emphasized by the easy flow of the richly pleated gowns, and the curves and the points of the wings suggest a swift, swallow-like flight. Traces of colour have been found which suggest that 'their wings had been picked out with gold, green, red and black, and that their vestments had been brightly coloured and patterned with red and black spots and with little red crosses with green spots at

[1] C. J. P. Cave, 'A Thirteenth Century Choir of Angels in the North Transept of Westminster Abbey', *Archaeol.* lxxxiv (1935), 63.

their extremities'.[1] Though it may be that the sculptor derived his concept of angelic beauty from a French prototype of the time of St. Louis, such as the famous 'Smiling Angels' at Rheims, the Westminster abbey angels seem to represent a typically English ideal of beauty. The animated face, with its square jaw and high cheek bones, with a smile lurking in mouth and eyes, gives to them a peculiarly mischievous charm (Pl. 33).

In various places in the new choir, one finds head stops and corbels of high quality. The employment of carved heads in such a position developed with Early English architecture, and examples can be found at Wells, Salisbury, Rochester, Boxgrove, Chichester, and Lincoln. Heads of kings and bishops, of knights and ladies, were placed at structurally important points of articulation, and like the figures at Wells, show predominantly an ideal concept of noble humanity, though deformations of the human physiognomy occur, as in some heads at the east end of the triforium chamber in Westminster abbey. In no other country are such heads found in such quantities, a fact that indicates the English interest in physiognomy, an interest which in the future was to lead to the prominence of portrait painting. The heads at the abbey[2] are treated with greater softness and delicacy than the earlier heads, which merely show the solid round shape of the skull with a superimposed pattern of incised lines to mark the main facial features and hair and beard. A head from Clarendon, one of the few remaining pieces of sculptural decoration of the royal palace,[3] can perhaps be interpreted as that of a typical Englishman, but there is no way to prove that the heads in the abbey portray the royal patron, the abbots, and the masons of the time. It is chiefly the softer and subtler treatment, endowing them with greater inner life, that is responsible for the impression that they are portraits of individuals (Pl. 38).

All the stained glass of Henry's church has disappeared. Probably

[1] L. E. Tanner, *Unknown Westminster Abbey* (1948), 15, where the suggestion is made that the angels were probably by Master John of St. Albans and his School.

[2] See illustrations in Tanner, op. cit., Pls. 14–17.

[3] T. Borenius, 'An English Early Gothic Head', *Burl. Mag.* lxviii (1936), 157; reproduced in L. Stone, *Sculpture in Britain* (1955), Pl. 92.

all the windows were done in grisaille with coloured insets of heraldry and figure subjects.[1] In the Jerusalem Chamber seven panels with religious scenes, work of the thirteenth century, have been preserved which may have come from the lady chapel.[2] With so much of the walls of the church replaced by windows, little space was left for a wall painter and most of the painting in the new work was purely decorative.

It was in Henry's residences, on the other hand, that painters found full scope. The royal accounts are full of orders and payments for the embellishment of them, in many cases so specific that they allow one to form an opinion of the king's taste and interests. Of the actual buildings, the halls and chambers which served as living quarters for the king and his family, very little was left standing after the destruction of the Palace of Westminster in the great fire of 1834, the decay of Clarendon and Winchester and the restoration of Windsor castle.[3] Of the new halls which were built at Westminster, Scarborough, Newcastle, Dublin, and elsewhere, the only one preserved in its main parts is the hall of Winchester castle,[4] the building of which was supervised by Elias of Dereham. In 1233 Peter des Roches, bishop of Winchester, lent the king two hundred pounds 'for the works of the hall of Winchester castle'. The large hall is divided into three aisles by elegant clustered marble columns with high-pointed arches and was lighted by large traceried windows. Orders were given[5] for the capitals and bosses to be gilded and for the whitening and lining of the walls and a Wheel of Fortune was painted in the eastern gable.

[1] W. R. Lethaby, *Westminster Abbey Re-examined* (1925), 69, 71.

[2] Illustrated in *R.C.H.M.*, I. *Westminster Abbey* (1924), Pls. 17–19.

[3] Evidence that Henry did not spare money or labour in improving the residential quarters is found in a letter which he wrote to his treasurer, William of Haverhull, and to Edward FitzOtho, his clerk of the works in 1244: *Cal. Lib. Rolls, 1240–45*, 239. See L. F. Salzman, *Building in England* (1952), 36: 'We command you, as you wish our love towards you to be continued, that you in no wise fail that the chambers which we ordered to be made at Westminster for the use of the knights be finished on this side of Easter, even though it should be necessary to hire a thousand workmen a day for it.'

[4] *V.C.H. Hampshire*, v (1912), 9.

[5] E. W. Tristram, *Engl. Med. Wall Painting: The Thirteenth Century* (1950), 180, 610. See also E. Smirke, 'On the Hall and Round Table at Winchester', *Proc. Arch. Inst. Winchester* (1845), 54.

For the porch of the hall, four images were to be bought and a map of the world was to be painted inside the hall.[1]

In 1237 the wainscot of the chamber at Winchester was to be coloured in green and starred with gold, and in circles on the wainscot stories of the Old and New Testament were to be painted. A similar series for which a first-class painter (*optimum pictorem*) was required was to be executed in the chapel at Windsor (1242).[2] One cannot help wondering whether the remarkable series of scripture subjects in medallions which is prefixed to the Eton College Apocalypse (MS. 177) and is of such superior quality was not connected with these wall paintings. There types and prophecies surround an anti-type in the centre medallion, which is supported by a seated Virtue with one of the commandments written in the lower margin[3] (Pl. 37 a). This manuscript series would allow us to form an idea of the style of the lost wall paintings, just as the kalendar roundels in the psalters can serve as a reminder of the paintings of Labours of the Months which were done at the queen's hall at Clarendon (1251) and in the king's chamber at Kempton (1265). Very appropriately for its fire-side position, the chimney of the queen's chamber at Westminster was to have a painted figure 'which by its sad looks and other miserable portrayals of the body may be justly likened to Winter' (1240).[4]

The most important room in Westminster palace was the king's private chamber, the Painted Chamber, the destruction of which is an irreparable loss. The chamber, raised above a Norman undercroft and remodelled in 1230, was of a noble size (eighty feet six inches long, twenty-six feet wide, thirty-one feet high).[5] Its flat boarded ceiling had large quatrefoil bosses. The decoration of the

[1] *Cal. Lib. Rolls H. III, 1226–40*, 405.

[2] *Cal. Close Rolls H. III, 1237–42*, 514.

[3] These are said to have been copied from paintings in Worcester chapter-house. Iconographically they are of exceptional interest and are the closest an English artist ever came to the concept of the French *Bible Moralisée*. See M. R. James, 'On Fine Art as Applied to the Illustration of the Bible', *Proc. of Cambridge Antiquarian Soc.* vii (1891), 31; and Henrik Cornell, *Biblia Pauperum* (Stockholm, 1925), 133.

[4] *Cal. Lib. Rolls H. III, 1226–40*, 444.

[5] For a drawing of the reconstructed chamber, see W. R. Lethaby, 'The Painted Chamber and the Early Masters of the Westminster School', *Burl. Mag.* vii (1905), 258, Figs. 1 and 2.

chamber seems to have been completed on the whole in 1236–7 under the direction of William of Westminster. In its great gable the following motto was to be painted in French:[1] 'Ke Ne Dune Ke Ne Tine Ne Prent Ke Desire' (he who does not give what he holds does not receive what he wishes), a fitting motto for a king who set such high store on generosity and charity, though a precept of somewhat practical implication.[2] Since the main wall paintings in the chamber were repainted at a later date, they will be discussed in another chapter.

Although Henry owned a 'great book of romances', his piety apparently made him prefer biblical history and legend to romance. Subjects taken from romances were only used in rooms of a more private character. At Clarendon mention is made of an Alexander chamber (1230) and the story of Alexander was to be painted all about the queen's chamber at Nottingham castle (1252).[3] The hundred-and-fifty-two illustrations of one of the earliest illuminated manuscripts of the *Romance of Alexander* (Cambridge, Trinity Coll. MS. O. 9. 34) may give an idea of the content and perhaps even the style of these paintings. The illustrations are in outline, lightly tinted with green, and have other features which may justify M. R. James's conjecture that the book was produced at

[1] *Cal. Close Rolls H. III, 1234–7, 271.*

[2] The same motto but in Latin was repeated at Woodstock in 1240. The lesson it contained is basically the same as that of the story of Dives and Lazarus which in later years was represented in the gable opposite the dais in the hall at Ludgershall (1246), in a window in the great hall of Northampton castle (1253), and in the hall at Guildford opposite the king's seat (1256). For evidence of Henry's charity, see J. Harvey, *The Plantagenets* (1948), 59. For evidence and description of the wall paintings in Henry's palaces, see E. W. Tristram, *Engl. Med. Wall Painting: the Thirteenth Century* (1950), and T. Borenius, 'The Cycle of Images in the Palaces and Castles of Henry III', *Journ. of the Warburg and Courtauld Institutes*, vi (1943), 40–50.

[3] Tristram, op. cit. 18: 'The "Life of Alexander" offered as much of the martial and heroic aspect of life, something too of the chivalrous, and far more of the fantastic; and it is easy to imagine the painter's relish as his inventive mind conceived renderings of its rich and varied elements, comprising, apart from sorceries and magic, Alexander's numerous conquests and adventures in Persia and India, his visits to strange temples and stranger palaces, his descent into the depth of the sea in a glazed cage of iron, and his ascent to the skies in a chariot drawn by griffins, not to mention the multitude of weird creatures to be met with in its pages, such as dragons, griffins, elephants, rhinoceroses breathing fire, the basilisk, the phoenix, and caladrius.'

St. Albans. As an early example and as at least an iconographical parallel to the wall paintings this manuscript deserves closer study.

Two rooms in Dover castle may have been called 'Arthur's Hall' and 'Guinevere's Chamber' from subjects painted on their walls, but the only remaining illustration of such a cycle and the earliest preserved in a book, apart from the marginal sketch in the *Chronica Majora* (C.C.C., MS. 26, f. 66), is a drawing (B.M. Cotton Claudius B. VII, f. 224). Delicately tinted with green and blue-grey, it shows in a hall, suggested by an arcade of two trefoiled arches and a now truncated roof, King Vortigern sitting upon a throne while young Merlin stands in front of him on a piece of rock, his short mantle tossed up and a long empty scroll hanging from his right hand. Below the floor in three arches there are the white and the red dragons divided by water.[1] The two dragons appear also underneath the half-length figure of Merlin in the *Chronica Majora*, with the wild boar below them.

In 1250 the master of the Knights Templar in England was asked to lend a book containing the *Gestes of Antioch*, meaning a history of the crusades, so that Edward de Westminster could paint in the queen's room certain murals after which the room was called 'the Antioch Chamber'. In the year following at Clarendon and at the Tower paintings of the same subjects were carried out. The picture of at least one incident from this cycle is preserved in a floor-tile.

The most important centre for the manufacture of such glazed and figurated tiles seems to have been Chertsey abbey, between Windsor and Westminster, favoured by royal patronage. But the only tiled floor still complete and in its original position is that of Westminster chapter-house, which must have been laid down shortly after 1255, and which was probably designed by William of Westminster.[2] A great many of the tiles were merely decorated with floriated design, others show an archer shooting a stag, a riding huntsman, minstrels, and large shields of England with

[1] R. S. Loomis, *Arthurian Legends in Medieval Art* (1938), 138, Fig. 384.

[2] P. B. Clayton, 'The Inlaid Tiles of Westminster Abbey', *Arch. Journ.* lxix (1912), 36; W. R. Lethaby, *Burl. Mag.* xxx (1917), 133. For the Chertsey abbey tiles, see W. R. Lethaby, *Walpole Soc.* ii (1913), 69; R. S. Loomis, op. cit. 44. See also Lloyd Haberley, *Medieval English Paving Tiles* (1937) and 'English Medieval Embossed Tiles', *Arch. Journ.* xciv (1937), 128.

monsters and centaurs in the spandrels. But there are also more important figures of a seated king and a queen and the scene of St. Edward and the Pilgrim.

The Chertsey tiles, the most important fragments of which are now at the British Museum, others at the Victoria and Albert Museum, at Oxford and Guildford, are later in date (about 1260). Copies of them were made for Halesowen abbey and fragments were also found at Hayles.[1] One of the Chertsey tiles has the combat of Richard and Saladin from the Antioch cycle, but the most remarkable set is that drawn from the romance of Tristan and Iseult.[2] The designs for these tiles must have been made by an artist of no mean gifts, who could select from the epic the most telling scenes and represent them in a condensed and lucid manner, using only two actors and little setting for each scene. The style of line drawing is that which had developed at St. Albans and is connected with Matthew Paris (Pl. 54 c).

[1] The manufacture of paving tiles was widespread amongst monastic houses and specimens can be found in many plans. See for instance G. E. C. Knapp, 'The Mediaeval Paving Tiles of the Alton Area', *Hampshire Field Club and Archaeological Soc.* xviii (1954), Pl. 3, and J. B. Ward-Perkins, 'A Late Thirteenth Century Tile Pavement at Cleeve Abbey', *Somerset Arch. and Nat. Hist. Soc. Trans.* lxxxviii (1941), 39.

[2] The source for the Chertsey tiles was the Romance of Tristan, composed by the Anglo-Norman cleric, Thomas, between 1170 and 1200. A sword of Tristan ('ensis Tristrami') was among the regalia of King John in 1207, of which the present sword Curtana is a modified replica. It was handed over to Henry's treasurer in 1220 by Peter de Roches.

VIII

MATTHEW PARIS AND HIS SCHOOL

WHILE W. de Brailes is now no more than a name to which a number of works have been attached on the ground of similarity of style, Matthew Paris is a rare example of a medieval artist whose personality stands out strongly and vividly amongst the mass of anonymous artists of his time. Born about 1200, he became a monk in 1217 at St. Albans, where he may have been a novice four years previously, and where he followed Roger of Wendover as an historiographer in 1235. The scriptorium of the abbey, already famous in the past, was raised by him to the highest status in the kingdom. He left the reputation of having been creative in many fields, not only as a writer and author of one of the liveliest of chronicles, but as a versatile artist. Unfortunately, with the exception of the line drawings which illustrate a number of manuscripts produced at St. Albans, there is no evidence left for his meriting the extravagant praise of the continuator of the *Gesta Abbatum*[1] that there was no second to him left in the Latin world as to skill in metalwork, in sculpture, and in painting.

His knowledge and influence were widened by his contacts with the highest in the land, with Henry III and Richard of Cornwall and many of the leading clergy. Strongly biased in favour of English right and custom and antagonistic to foreigners, his life seems to have been limited to St. Albans and London with the exception of a journey to Norway (1248–9), where he stayed almost a year to reform the monastery of St. Benet-Holme near Trondhjem, a cell of St. Albans, and where he was in touch with King Haakon.[2]

[1] *Chronica S. Albani: Gesta Abbatum*, I, R.S. xxviii. 4 (1867), 395: 'Inerat ei tanta subtilitas in auro et argento, caeteroque metallo, in sculpendo et in picturis depingendo, ut nullum post se in Latino orbe creditur reliquisse secundum.'

[2] The opinion that his stay caused the emergence of a school of painting in Norway is merely based upon the badly preserved painted panel of St. Peter at Faaberg (now

Of all the manuscripts which have line drawings produced at St. Albans, either by Matthew Paris himself or by assistants under his influence, those of his *Chronicle* have to be considered first if one wants a firm basis for the definition of his style.[1] The first two volumes of the *Chronica Majora* are now in Cambridge (C.C.C., MSS. 26 and 16), and a third part bound together with the *Chronica Minora* or *Historia Anglorum* is in the British Museum (MS. Royal 14 C. VII). These manuscripts have separate pages bound in, which have no connexion with the text, but are decorated with large drawings. The British Museum manuscript contains the famous drawing of the Madonna and Child seated on a throne at whose feet, outside the frame, a monk is prostrated, identified by an inscription as Matthew Paris himself.[2] This is a most monumental and expressive work that marks the artist as one whose style, almost archaic in 1250, owes much to the art of the first half of the century. It still retains traces of the 'Classical Revival' and of the spirit and form of the sculpture of Wells and of the north French cathedrals before the maturity of St. Louis. This is evident in the solid shape of the throne and the figures, drawn with firm contours, and in their regal poise and tranquillity,[3] but over the core of strength there plays a vivid liveliness in the sketched-in folds, tinted with light blue and rose in the hollows, and in the zigzag and turned-up hems. The soft tints go well with the sentiment, which combines warm affection with solemn meditation in the rapt gaze which unites Mother and Child (Pl. 42 *a*). Drawing and expression here are much more sensitive than in another large drawing on a single sheet bound into the Cambridge MS. 26

in Oslo) which is attributed to him and upon the fact that Norwegian painting developed under English influence. But there is no real evidence that his mission allowed him time to act as an artist. For references to literature on Paris's influence on Norwegian art, see A. Andersson, op. cit. 97, n. 8.

[1] Most of the drawings attributed to Matthew Paris are illustrated in the article by M. R. James, 'The Drawings of Matthew Paris', *Walpole Society*, xiv (1926), 1–26.

[2] As to the doubts about the authenticity of the inscription, see R. Vaughan, 'The Handwriting of Matthew Paris', *Camb. Bibliographical Society Transactions*, i (1949–53), 380: 'Sufficient to point out that these words are written in ornate capitals, a fact which adds considerably to the chances of errors in orthography, and also makes them irrelevant to a discussion of the *handwriting* of Matthew Paris.'

[3] Cf. Virgin and Child, Westminster Psalter. T. S. R. Boase, *O.H.E.A.* iii, Pl. 85 *b*.

which shows on its top half the crowned head of the Madonna with a nimbed head of the manikin Child, both emerging from a band of cloud. This and the two heads of Christ on the lower half of the page seem to be models for wall painting. Of the two heads of Christ, that with closed eyes and sorrowful mouth is the more successful; the other, staring straight ahead, is still strongly in the monumental Byzantine tradition and quite different from the body of drawings in the text. Of these another portrait of Christ, the so-called 'Veronica' (C.C.C., MS. 16, f. 49 b), is similar in type, but is drawn much more crisply with a wiry strength in the curls and the beard; an English translation of a Byzantine model, serious without sadness (Pl. 52 b). The 'Veronica', in contrast to all the other text drawings, is painted separately on vellum and pasted on to the page within a square frame. Head and cross-nimbus stand light against the dark background, which is marked with white dots in groups of three and with the Alpha and Omega in the top corners.[1]

There are two other full-page drawings of eight seated kings, four to each page,[2] in MS. Royal 14 C. VII, which have much in common with the great Madonna and Child as to the shape of the throne and the arrangement of the draperies, although the kings

[1] Paris inserts this head in order to illustrate his report of the procession in which Pope Innocent III, worried by the insecure state of the Church, carried in 1216 'effigiem vultus Domini' from St. Peter's to the Hospital of Santo Spirito. Paris seems to accept two of the traditions current at the time with regard to this relic: that the image itself was called 'veron ikon', but that at the same time the name refers to that of a certain woman at whose petition Christ made the impression of His face some time during His ministry. But this picture seems to have no link with the Passion and the road to Golgotha, although this third tradition, which prevailed in the later middle ages, was known in England through the *Joseph* of Robert de Boron. There it is related that Veronica wiped Christ's face at the request of the Jews and thus received the likeness of Him suffering. (J. D. Bruce, *The Evolution of Arthurian Romance from the Beginnings down to the Year 1300*, i (1923), 233.) The deep impression which the 'Veronica' head made upon contemporaries is indicated by the numerous copies of it in other manuscripts.

[2] That this set of kings is fragmentary is suggested by the set of thirty-two seated kings (B.M. Cotton MS. Claudius D. VI. ff. 2r.–5v.), again four to a page, in similar but simpler niches, from Brutus to Henry III including Uther Pendragon and Arthur. They are derived from the eight kings mentioned above, but the work is crude, though very interesting in its iconography.

are much more vivacious in pose and expression. They are eight variations of the same theme, that of royal power and duty, chiefly distinguished by the way in which they hold the model of a church in one hand while the other holds sceptre or sword or rests on one knee. The solid, square figures fitted into the dark niches, standing out against the dark ground as against shadow, are related to the sculptural tradition of Wells (Pl. 42 b).[1]

The bulk of the drawings, however, in the Chronicles are marginal and are the most outstanding examples of this type in the thirteenth century. Although they show an extraordinary power of invention and keenness of observation, they owe a great debt to a previous tradition which reaches back into Anglo-Saxon times. Tristram is of the opinion that Matthew Paris's 'researches in the field of history would have led him to the consultation of Anglo-Saxon books, many without doubt enriched with line drawings. . . . It may not be fanciful to trace in this quarter [St. Albans] a potent source of national sentiment, productive of a fresh interest in pre-Conquest art'.[2] Immediate predecessors in the twelfth century can be seen in the marginal drawings of Irish life in Giraldus Cambrensis's *Topographia Hibernica* (MS. Royal 13 B. VIII) soon after 1188.[3]

But the actual style of Paris's drawings is very similar to that

[1] The representation of a 'king' seated in royal dignity was a favourite one around the middle of the century. The Cartulary of Abingdon abbey (B.M. Cotton MS. Claudius B. VI) contains a series of single figures of kings and queens of England seated on thrones rendered in a style which is a link between that of W. de Brailes and that of Matthew Paris. The head of a king, usually attributed to Master William, is still preserved on the wall of the cloister of St. George's chapel, Windsor. The royal seat in the hall at Windsor was to be painted with an image of a king holding a sceptre (*Cal. Lib. Rolls H. III, 1240-5,* 29). 'A king and a queen sitting with their baronage' was to be painted over the dais in the hall of Dublin castle (*Close Rolls H. III, 1242-7,* 23). It must have been in a state of anger or depression when 'lately at Winchester, the King, in the presence of Master William the monk of Westminster, provided for the making in the wardrobe where the king is wont to wash his head, at Westminster, of a picture of the king who was rescued by his dogs from the sedition plotted against him by his subjects'. (*Cal. Close Rolls H. III, 1254-6,* 326).

[2] *Engl. Med. Painting: Thirteenth Century,* 7. See examples in F. Wormald, *English Drawings of the Tenth and Eleventh Centuries* (1953), especially the psalter illustrations in Vatican MS. Regina, lat. 12.

[3] See T. S. R. Boase, *O.H.E.A.* iii (1953), 197, Pl. 31 e.

which is found in France between 1230 and 1250. It is interesting
to note that in two cases motifs, which can be found also in the
sketch-book of the French architect Villard de Honnecourt, are
used in the *Chronica Majora*, although the connexion with the text
seems forced. The 'man threshing with a flail', an illustration to
the popular uprising against the extortions of the Italians and the
burning of barns in Kent (C.C.C., MS. 16, f. 79), is a motif used
frequently in scenes of the Labours of the Months, and is also found
sketched into a geometrical scheme in Villard's sketch-book.[1] One
wonders also whether the rather unimportant event of a wrestling
competition which led to riots in London in 1222 would have been
illustrated if there had not been a stock motif on hand of two men
wrestling that was used also by Villard in more than one case,
partly as an example of the relation between the proportion of the
human figure and geometry.[2] The same motif was the formula
for the scene of Jacob wrestling with the Angel found in so many
psalters of the time.

The full narrative drawings in the *Chronica Majora* fall roughly
into two distinct groups: those which have the free character of
a marginal illustration done like a cartoon in a fluid quick manner
and with a free disposition of space; and those which approach the
closed picture-like composition which could be fitted into a frame.
The latter are drawn more stiffly and are more heavily tinted; the
faces are more conventional with red cheeks and a red dot below
the mouth, and dots and crescents scattered over the robes. The
former type is most frequent in the first part of the *Chronica
Majora*, but it cannot be stated that at any definite place one artist
took over from the other. The illustrator of the *Chronica Minora*
uses almost exclusively the second type.

But even though many of the drawings were carried out by
different assistants, we have the right to assume that it was Matthew
Paris who decided which passage should be illustrated, and that it
was he who created the image. In many cases he may have drawn
the main outlines which were to be strengthened and tinted by

[1] H. R. Hahnloser, *Villard de Honnecourt* (1935), Pl. 35 *g*. See also B. Kurth, 'Matthew
Paris and Villard de Honnecourt', *Burl. Mag.* lxxxi (1942), 227.
[2] Hahnloser, op. cit., Pls. 28 *a* and 37 *b* and *i*.

others. Such a sketch of the original idea is that of the two Templars seated on one horse, because their poverty did not allow them more than one horse for two men (B.M. MS. Royal 14 C. VII, f. 42v.). On the same page, beside the sketch, is the finished drawing in which the fresh liveliness of the advancing horse, with one leg lifted high, and the natural pose of the riders are somewhat lost.[1]

The clearest evidence that more than one hand carried out the illustrations can be found in the fact that the identical scene is represented in a different style in two different manuscripts. There are seven such pairs in the *Chronica Majora* and *Minora* relating to events between 1230 and 1245.[2] In all cases the drawings in the *Chronica Majora* are infinitely superior in quality. Here the 'man threshing with a flail' seems efficient and capable compared with his counterpart, who seems merely to go through the motions. In the pictures showing the king crossing the sea on his return, the flow of the waves, the steering of the ship with its rich carvings on its stern and bow, the quick action of the bearded king, stepping into the skiff supported by the oarsman: all these features are either absent or rendered stiffly in the *Chronica Minora*. Thus in Griffin's fatal attempt to escape from the Tower keep by means of a rope tied to its battlements, the drawing in the latter does not show any factual connexion between the knotted sheets and the figure of the man who seems to dive into the water. But in the drawing of the *Chronica Majora* the cautious descent of Griffin doubled up and with the rope tied around his middle, the shock caused by its break and the fear of death, his awareness of falling into empty space in front of a rounded keep and curved lower wall, are all most vividly portrayed (Pl. 45 *a* and *b*).[3] The best of the marginal drawings have

[1] The same picture of the two Templars shown from the shield side (C.C.C., MS. 26, f. 220) is treated more like a symbol or sign, as is the hospital founded by Queen Matilda which is drawn beside them.

[2] King Henry sailing to Brittany (75v. and 116v.); the Plundering of Barns (79 and 118); the Council of London (107 and 126); the king sailing back (163v. and 134v.); Griffin's escape (169 and 136); St. Louis's illness (182 and 137v.); the Council of Lyons (186v. and 138v.).

[3] The contrast between these two sets of illustrations may help to clear up the problem whether the manuscripts in Cambridge are a transcript of a lost original executed at the same time or even later than the *Chronica Minora*. See Sir F. M. Powicke, 'The Compilation of the Chronica Majora of Matthew Paris', *Proc. of Brit.*

this accurate literary connexion with the event described in the text and this lively psychological interpretation, as for instance that of Gilbert Marshall, his foot caught in the stirrup, dragged to death by his spirited horse, which has broken the reins (C.C.C., MS. 16, f. 147v.) (Pl. 46 b) or that of Engelram of Coucy, who falls over his horse's head into the water, pierced by his own sword (ibid., f. 177v.). In both cases a stock motif has been adapted with great skill to fit the requirements of the story.

On the whole Matthew Paris is unpredictable as to the selection of any event he considered worthy of illustration and as to the degree of completeness. Again and again the illustration is limited to a sign language: crowns, shields, hands holding a sceptre, and hands joined, as for instance to indicate the marriage of Richard of Cornwall and Isabel of Gloucester. The Interdict is merely indicated by a church bell with a rope thrown over the gudgeon making it silent, and its relaxation by two bells the ropes of which are pulled by two hands below. Offa's entering the monastery is shown by a bearded and tonsured head with a cowl around his shoulders and with his crown toppling off, and a black bird flying out of their mouth suffices for the death of heathens like Saladin or Saphadin. Wherever a setting is given in the fuller scenic drawings, be it church or castle, sea or land, traditional symbols are used, but with a greater feeling for roundness, achieved by shadows and fore-shortening, and for organic life. Churches, even Westminster abbey as rebuilt by Henry, are compact little buildings with aisles and clerestory, their sides and roofs marked by straight lines, and with long slits of windows and quatrefoils, and with towers placed campanile-fashion. Castles are more elaborate with curved battle-mented curtains, surmounted by a round keep and towers. All these features, with the addition of domes, are combined in the magnificent picture of Damascus (ibid., f. 134). Soil and waves are suggested by scalloped shapes and wavy lines, and vegetation

Academy, xxix (1949). The better quality of the drawings in the Cambridge manu-scripts seems to support the opinion that these manuscripts were written and illus-trated first. See V. H. Galbraith, *Roger Wendover and Matthew Paris* (1944), and R. Vaughan, op. cit., who states that they were written mainly before 1250 and finished up to that year in that year.

is limited to a few vigorous trunks with masses of trefoiled foliage. On the other hand, animals are rendered with great understanding and almost affection, especially the horses, which appear so frequently in a great variety of movements. With this interest in animals, it is not surprising that so much importance is given to the elephant sent by St. Louis to his brother-in-law in 1255 that it is represented three times in different manuscripts, usually occupying a page of its own. The human figures are drawn with an elastic contour, with quick lively strokes and hooks for folds. Most expressive in their gestures and particularly in their profiles, they are certainly not stereotyped but drawn from observation. The artist was well aware of how the curve of the brow or of the mouth can change the expression, and the profile is used chiefly to bring out the deviation from the normal shape as indicative of lowliness of caste or evilness of mind.

The main body of illustrations (about thirty-eight) covers the period from 1230 to 1251, that is, the time of Matthew Paris's prime. About twenty occur in the section between the battle of Bouvines and 1230, while only about twenty-two are scattered over all the preceding centuries. The pre-medieval scenes are rendered with an extraordinary liveliness, whether pagan or Christian, all treated in the same manner of historical reporting. In this vein are the very original scenes of Brutus worshipping Diana (C.C.C., MS. 26, f. 7) and King Lear with his three daughters (ibid., f. 11). There is nothing comparable in contemporary art to the swift journey of the Magi seated on their dromedaries which gallop along on horses' feet (ibid., f. 32). With the reins and the gifts in their hands, the kings look like illustrations of the Three Ages of Man, and a warm human touch is introduced by the suggestion of paternal concern with which the one in the centre looks back at the youngest in the rear (Pl. 44 a). Matthew Paris's concept of antiquity is unburdened by archaeological concern. The figure which combines Roman imperial features with the attributes of Aesculapius in the illustrated catalogue of rings and gems in the possession of St. Albans abbey (B.M. Cotton MS. Nero D. I, f. 146) is a rare and presumably faithful copy of a late Roman cameo, such as those used on the shrine of St.

Edward.[1] But the image of Diana, to whom Brutus sacrifices a kid, is more like that of Actaeon, having the antlers and ears of a deer and the wings of Mercury or of the Devil fixed to the ankle.

That Matthew Paris is chiefly a reporter of interesting and somewhat sensational events comes out strongly in the few scenes from the lives of saints. They do not express a particularly devout spirit but the best of them catch the mood of the particular anecdote, as that of the Wandering Jew (C.C.C., MS. 16, f. 70v.) (Pl. 46a) or the 'Maiden in Burgundy molested by a Young Man' (ibid., f. 61v.).[2] In spite of his rather sceptical and sometimes openly antagonistic attitude towards the friars, he still devotes some illustrations to them and their founder. The portrait of Brother William (ibid., f. 67) is not too markedly different from that of an unknown, typical friar, who stands with a knotted cord and long sleeves covering his crossed wrists in an attitude suggestive of humility. Twice St. Francis himself appears: in the episode of his preaching to the birds, and lying asleep on a piece of ground beside a magnificent rendering of a seraph (ibid., f. 66).[3] The latter is much more prominent than the saint and is a copy of those elaborate images of seraphim, with descriptions of their wings and their allegorical meaning, that were quite common in the late twelfth and early

[1] The names of St. Alban and King Ethelred who are reputed to have given the cameo to the abbey are engraved in niello on the silver setting.

[2] A. L. Smith, *Church and State in the Middle Ages* (1913), 167: 'In fact the loftier side of medieval thought hardly appears at all in him. Its idealism, its mysticism, its tenderness, its grandiose aims . . . must all be sought elsewhere.' D. Knowles, *Religious Orders in England* (1948), 294: 'Perhaps it is not fanciful to see in Paris, not only a typical conservative of the age, but a medieval embodiment of many of the elements that have always distinguished the national character—a love of old custom and a fear of being dragooned into the unfamiliar; an instinctive dislike of foreign ways; and an interest in persons and events rather than in principles and movements.'

[3] See *Franciscan History and Legend in English Medieval Art*, ed. A. G. Little (1937), and F. D. Klingender, 'St. Francis and the Birds of the Apocalypse', *Journ. of Warburg and Courtauld Institutes*, xvi (1953), 13. St. Francis preaching to the birds seems to have been especially popular in England. In a drawing (Eton Coll. MS. 96) which is perhaps slightly earlier, St. Francis preaches with much greater power, but the birds are rendered schematically. There is another early drawing of the preaching in the Bodleian bible MS. Auct. D. 3. 2 (reproduced *Eng. Illumination of the 13th and 14th Centuries*, Bodleian Picture Books, no. 10, 1954). The most expressive drawing of St. Francis with a companion is on a leaf inserted into the Florilegium of Alexander Neckham (Camb. Univ. Libr. MS. Gg. 6. 42).

thirteenth century.[1] But in this case the traditional image is placed against a roughly hewn cross to indicate the transmission of the stigmata (Pl. 46 c). Tribute is paid to St. Edmund and St. Roger, bishop of London (MS. Royal 14 C. VII, f. 122), the murder of St. Thomas is recorded in one drawing (C.C.C., MS. 26, f. 263), and of course the martyrdom of St. Alban and his Invention together with that of Amphibalus are illustrated (ibid., ff. 116, 117, 270).

The contacts of Matthew with the royal house produced comparatively few illustrations. With the exception of the elephant, and the king carrying the Holy Blood to Westminster abbey (ibid., f. 215) (Pl. 44 b), scenes from Henry's life are limited to his sailings between England and the Continent; his birth, illustrated by a baby in a cradle (MS. Royal 14 C. VII, f. 90), a symbol which was also used for the birth of his son Edmund (ibid., f. 138); his second coronation (1236); and his marriage to Eleanor (ibid., f. 124v.), the latter identical with that of the marriage of his sister to the Emperor Frederick in the same manuscript (f. 123v.). Henry's care for Westminster abbey is only indicated by a conventional symbol for a church and a shrine; but the relic of the Stone of the Ascension is shown (ibid., f. 146) and Henry's acquisitions of relics can be compared with those of St. Louis, who shows the crown of thorns and the cross from a raised platform (C.C.C., MS. 16, f. 141v.).

Earl Richard, however, must have given to Paris a lively account of his journey to the Holy Land (1240/2) because no less than seven drawings deal with it, amongst them that of the two Saracen girls walking on balls of metal whom he saw at the Emperor Frederick's court in Sicily (C.C.C., MS. 16, f. 149), and the elephant which carries a band of musicians on a wooden platform which was one of the features of Richard's reception at Cremona (ibid., f. 151v.). This drawing antedates that of the elephant sent by St. Louis in 1255, as it is still drawn in the tradition of the bestiaries. Some of the most lively and original drawings in cartoon style refer to Earl Richard's dealings with the Saracens and the events leading up to them as, for instance, the defeat of the French at Damascus (ibid.,

[1] See, for instance, C.C.C., MS. 29, f. viiiv.

f. 133v.). In the scene of the treaty between Richard and the leader of the Saracens (ibid., f. 138v.), Richard and Nazar kneel and join hands between Acon held by the Christians on the left and Castle Crac held by the Saracens (Pl. 44 c). The release at Richard's intervention of French prisoners (ibid., f. 148), who issue from a castle with their fetters unloosed, haggard and ragged but full of gratitude, is one of the most sensitive of the series. To this also belongs the remarkable sea fight between the Pisans and the Genoese, drawn from a report in a letter from Emperor Frederick (ibid., f. 146), and the report in another letter written by the archbishop of Bordeaux in 1243 on the habits of the Tartars gave the material for the drastic scene of their cannibal customs, where the ferocious expressions of the caricature-like profiles well befit the act (ibid., f. 166). Although confined by his monastic vows, the artist cannot suppress his insatiable curiosity in the events of his time and seems to have taken special delight in battle scenes, of which a great variety occur in the drawings recalling the tournaments or mock battles which Henry found so difficult to suppress amongst his barons. In the scene of the capture of the cross by Saladin (C.C.C., MS. 26, f. 279), with all the terrific clash and pull of the opposing forces, a tight and balanced composition has been achieved, hardly to be surpassed till Leonardo's Battle of Anghiari, two hundred and fifty years later (Pl. 45 c).

Besides the historical illustrations, there are three other types of drawings in Paris's manuscripts in which he displayed special interests and through which he exerted an influence in wider circles. Seven of his manuscripts contain maps:[1] maps of the world, maps of England, and maps with an itinerary from England to the Holy Land. The important role which the author of these maps plays in the history of cartography lies outside the field of art.[2] But

[1] Cambridge, C.C.C., MS. 16: map of Palestine; map of England. B. M. Cotton MS. Nero D. 1: portion of itinerary to Italy. B.M. MS. Royal 14 C. VII: itinerary to Holy Land, map of England. B.M. Cotton MS. Claudius D. VI: map of England. Oxford, C.C.C., MS. 2: map of Palestine. Cambridge, C.C.C., MS. 26: world map; itinerary from London to Jerusalem. B. M. Cotton MS. Nero D. V.: world map. For reproductions see *Four Maps of Great Britain drawn by Matthew Paris about 1250* (1928).

[2] See K. Miller, *Die ältesten Bildkarten* (Stuttgart, 1895–8); L. Bagrow, *Die Geschichte der Kartographie* (Berlin, 1951); G. R. Crone, *Maps and their Makers* (1953).

that the drawing of them required considerable artistic skill is evident in their colouring with yellow for mountains, green for the sea and blue for the rivers, and in the drawing of symbols for cities with walls and towers and a dromedary with his driver or a turtle and other animals. The *Mappa Mundi* which was painted in the 'manner of Matthew Paris' in one of the king's rooms at Westminster is lost, but the world map at Hereford cathedral (*c.* 1260–70) and the map in the psalter (B.M. MS. Add. 28681, f. 9) may give an idea of its character. They further show that such maps were appreciated not only for their geographical information but for the imaginative display of the wonders of the world which they contained.

The second matter of interest is indicated by the many shields with coats of arms which are scattered over the pages of the chronicles upright, or reversed to indicate the death of the owner, and beautiful in colour. In addition to these the *Liber Additamentorum* has two pages (B.M. Cotton MS. Nero D. I, ff. 170–170v.) covered with rows of shields of a few sovereigns and English earls and lords. Made about the same time as *Glover's Roll* which contains 218 English coats with blazon, Matthew Paris's efforts represent one of the earliest attempts at a systematic heraldry. In this

M. H. Marshall, 'Thirteenth Century Culture as Illustrated by Matthew Paris', *Speculum* xiv (1939), 465: 'The itinerary, beginning at London and ending at Jerusalem, was accompanied by a French text, including a description of Rome, Acre, and Jerusalem and detailed information concerning the inhabitants of Syria and Palestine. It was, so Madden and Hardy too for that matter declared, the first such map executed since the fourth century. The information therein set down, with relatively few inaccuracies, was so extensive as to raise at once the question of the source from which Paris obtained his information—if Paris it was who drew it. We can but remark at this point that, though Matthew Paris may not, as Hardy so emphatically asserts, have been the author of any of these maps, he was certainly more familiar with the geography of Europe than the ordinary chronicler. He shows throughout the *Chronica Majora* a knowledge of cities and feudal divisions that could have been acquired in some instances only at first hand. One feels, therefore, that Paris's claim to skill in the field of cartography is not an idle one.' For Paris's share in the making of the maps, see R. Vaughan, op. cit. 383. K. Miller (op. cit., Heft iii, 84) has pointed out that the big itinerary consists of two independent parts: (1) the itinerary from London to Rome followed by a cartographic representation of Apulia and Sicily. He connects this, as the legend of the map (B.M. MS. Royal 14 C. VII) says, with the offer of the kingdom of Apulia made to Earl Richard in 1252. (2) The map of Palestine made in the traditional way of the *Mappa Mundi* with east at the top of the map.

way the material was prepared for the artists who carved the shields in the aisles of Westminster abbey or those of Kirkham gatehouse or who needed heraldic devices for their tombs, windows, embroideries, and illuminations.[1]

The third field of interest lies in diagrammatic drawings which are based on simple geometric shapes of circles and half-circles. They are used whenever certain basic matters were to be put down in a clear, concise manner to explain their relationship or their sequence, as for instance for genealogies, be they biblical or historical.[2] The *Situs Britanniae* which shows the seven kingdoms of the Heptarchy or the similar scheme with Offa seated in the centre (B.M. Cotton MS. Claudius D. VI, f. 1*v*.) are shaped like a rose window. The circular scheme of the winds (B.M. Cotton MS. Nero D. 1, ff. 184, 184*v*.) claims to be drawn after Elias of Dereham, while another (B.M. Cotton MS. Julius D. VII, f. 51*v*.) is supposed to be after Robert Grosseteste. The *Dragmaticon Philosophiae* of W. de Conches (Cambridge, C.C.C., MS. 385) contains twenty-three diagrams, the captions of which, according to Vaughan, were written by Matthew Paris. The paschal tables in Cambridge, C.C.C., MS. 26 are very close to the spheres in the *Liber Experimentarius* ascribed to Bernardus Silvester (Bodleian, MS. Ashmole 304) only that in the latter the spandrels are filled, not with foliated scrolls, but with cities, beasts, birds, and fruit (Pl. 43 *b*).

With the discussion of maps, heraldry, and diagrams we have already gone beyond the *Chronicles* to other manuscripts which have drawings by Matthew Paris. The manuscript which contains the *Liber Experimentarius* mentioned above has four miniatures which have been ascribed to him. Euclid and Herman, Plato and

[1] See A. R. Wagner, *A Catalogue of Medieval Rolls of Arms* (1950); W. H. St. John Hope, *A Grammar of Heraldry*, 2nd ed. rev. by A. R. Wagner (1953). One wonders whether these attempts to put heraldry on a systematic basis were a conscious revival of Plantagenet tradition. The enamel plaque for Geoffrey Plantagenet, count of Anjou and Le Mans (d. 1151) is one of the first to make use of heraldry with a shield of golden lions. A similar shield was hung about the neck of his son-in-law by Henry I at the knighting in 1127. The same plaque shows the mantle lined with vair which became the popular device of the court school a hundred years later.

[2] A similar genealogical diagram is found in the 'Aurora' by Petrus de Riga (Cambridge, C.C.C., MS. E. 1).

Socrates, Pythagoras, and the Twelve Patriarchs are drawn in brown ink, tinted with green with a fluid curving outline and an almost fierce absorption in their task whether it is discussion or writing. Plato stands behind the seated, bearded Socrates and tries to make his point emphatically with a gesture of his hand while Socrates is writing[1] (Pl. 43 a). 'Euclid and Herman are certainly of the dialogue type in which two scholars or philosophers sit side by side engaged in disputation.'[2] Pythagoras as a single figure is rendered in the traditional manner of the evangelist portrait.

Of this same type is the portrait of Brother Wallingford in the small tome which contains his chronicle (B.M. Cotton MS. Julius D. VII, f. 60v.). With the long sleeves which conceal his hands and with his humble attitude, he is very similar to the drawings of the friar in the *Chronica Majora*. The reddish elephant in the same volume, however, is a school work, as well as the rather dry Christ in Majesty who, seated on a square throne, holds the chalice in His left hand and plants His feet on lion and dragon.

Closer to the marginal drawings is the first of the remarkable series of coronation scenes in the *Flores Historiarum* (Chetham Libr., Manchester, MS. 6712).[3] The ten drawings represent the coronations of Arthur and Edward the Confessor and of the Norman kings from William I to Edward I, though that of Henry III is missing. The coronation of Arthur (col. 185) is by far the best and establishes the prototype copied in the others. The king is seated upright upon the throne, full face and beardless, holding a sceptre with a three-foiled head. The fingers of his left hand pull down the cord of his mantle which is laid across his knees, a belt marking the hip-line. Two mitred bishops, placed

[1] F. Saxl and R. Wittkower, *British Art and the Mediterranean* (1948), 29: 'Socrates and Plato were known to the Middle Ages as Greek sages, and mystical wisdom of all kinds was transmitted under the authority of their names. They appear here as soothsayers and the table opposite the picture contains Prognostics according to "King Socrates".'

[2] F. Wormald, 'More Matthew Paris Drawings', *Walpole Soc.* xxxi (1946), 109, Pls. xxvii–ix.

[3] A. Holländer, 'The Pictorial Work in the "Flores Historiarum" of the so-called Matthew of Westminster (MS. Chetham 6712),' *Bull. of the John Rylands Libr.* xxviii (1944), 361. Richard Vaughan (*Matthew Paris*; Cambridge, 1958, p. 225) is of the opinion that the artist must have worked in close collaboration with Matthew Paris, for this manuscript has certainly been produced under Matthew's supervision.

symmetrically on either side, place the crown upon his head with their right hands, while their left hands are raised in blessing. Three clerics attend, one holding crozier and maniple. The vestments are tinted blue and green and the cheeks are reddened (Pl. 47 *a*). The same composition is used for all the others but one, but the drawing is weak and stilted, particularly in the coronation of Henry I and Henry II who both are seated with legs crossed. The most elaborate ceremony, however, is that of Edward the Confessor, done rather weakly and untidily, in a manner which is closer to that of the *Life of St. Edward* to be discussed later. It contains seventeen figures. The archbishop of Canterbury pours the oil out of the ampulla over the king's head, while the archbishop of York on the king's left places the bird-headed sceptre in the king's left hand. The magnates present their swords holding them with hilt on top and point downwards. While these coronation scenes illustrate how an original idea of the master was copied by minor scribes, another set of drawings in a collective volume at Cambridge (Univ. Libr. MS. Kk. iv. 25) shows the hand of a master through the retouching and heavy tinting which partly obscure the original drawing. The tract on the *Nature of the Angels* is illustrated with three drawings of the archangels in their specific missions: Michael fighting the dragon, which is partly finished, Gabriel in the Annunciation, and Raphael curing blind Tobias. They are most impressive examples of Matthew Paris's style, the Annunciation group similar to, but more powerful than, the sculptured group of Westminster chapterhouse (Pl. 41 *b*). On another page at the end of an epistle from Aristotle to Alexander, a youthful king with crown and floriated sceptre sits straight upon the throne with his right leg bent in a sharp angle to be supported by his left knee (f. 18*v*.) (Pl. 50). The significance of this pose still lacks a full explanation, but it occurs with increasing frequency from the second half of the twelfth century in the art north of the Alps.[1] The position is given so frequently to kings or those of kingly power acting in judgement that it seems justifiable to assume that it is a formal pose of the judge, not merely a means to give greater liveliness to the seated

[1] J. S. Tikkanen, *Die Beinstellungen in der Kunstgeschichte* (Helsingfors, 1912, 163), has not found an example in Byzantine art and considers it rare in Italian art.

figure.[1] It is in England, especially between 1240 and 1270, that the pose is rendered in its most pronounced and rigid manner as in the Alexander figure.[2] This is the case in manuscripts close to St. Albans and the court as in the *Life of St. Alban*, the *Life of St. Edward*, and in the Trinity Apocalypse as well as others, but it is chiefly used and with apparent purpose not for the king as the impartial judge but for bad rulers like Herod or the Antichrist, who give vent to their wrath.

A short Latin poem on the same page explains the figure of Alexander as that of the invincible warrior who wrought destruction and terror through his whole world and who, finally overcome by poison, sank into the depth of hell. In his case, as in that of Herod and the Antichrist, the pose might indicate the oriental despot in contrast to the nobler concept of kingship elaborated by Bracton and Grosseteste and very much in the mind of Englishmen under John and Henry III. On the other hand the most splendid example of this pose is to be found in a full-page illustration of a psalter which now forms a part of the Glazier Collection at the Pierpont Morgan Library, and which has not yet been published. Here King David sits in the manner described, and in this case it can only represent the general posture of an oriental ruler (Pl. 51).

The three manuscripts mentioned have been commonly connected with the scriptorium of St. Albans, although they lead progressively away from Matthew Paris and towards the development of a new phase affected by the increasing French influence in court circles. Matthew Paris is reputed to have written and at least to have directed the illustration of the lives of men who in Anglo-Saxon

[1] That the crossing of the feet was recognized in Germany at least in the later thirteenth century as a judicial pose is indicated by the ordinance of the Soester Recht: 'es soll der Richter auf seinem Richterstuhl sitzen als ein griesgrimmender Löwe, den rechten Fuß über den linken schlagen'. See Jacob Grimm, *Deutsche Rechtsaltertümer*, 4th ed. ii, 375. Also Hahnloser, loc. cit. 61, with reference to a drawing by Villard de Honnecourt.

[2] H. Martin, 'Les Enseignements des Miniatures: Attitudes Royales', *Gaz. des Beaux-Arts*, ix (1913), 173. 'En voyant cette attitude, rare avant le XII sc., se vulgariser aux siècles suivants; en constatant, d'autre part, qu'en aucun pays le geste n'a été plus en faveur que dans la Grand-Bretagne, on serait tenté de penser que la mode, venue d'Angleterre, c'est introduite sur le continent à la suite des triomphes des Normands.'

times and in his own time were guides of English spiritual life: St. Alban and Offa, St. Guthlac, St. Wulfstan, and St. Edward, and of the three archbishops of Canterbury, St. Thomas, St. Edmund, and Stephen Langton. Three of these hagiographies exist now in important illustrated manuscripts,[1] but only the illustrations of the *Life of St. Alban* (Dublin, Trinity Coll. MS. E. i. 40)[2] are close to the style of the marginal drawings in the *Chronica Majora* (Pl. 48 a). They may even represent the early work of Matthew Paris preceding the *Chronicles*.[3] On the first fly-leaf (f. 23v.) there is a drawing of the Madonna and Child which is unfortunately damaged so that the head of the Child and the head and the shoulders of the Madonna are destroyed. This drawing, although in many respects similar to the tinted drawing in the *Chronicle*, shows the Child seated in the normal position and the execution is fresh and sensitive.[4] Not all the pictures fill the space of the two columns of the text; some are smaller, and there are certain incongruities where parts of the pictures are cut off by the frame. But the rather solid figures are drawn with a firm contour which emphasizes rounded curves and makes a sparing use of zigzag and fluttering ends. Robes are frequently dotted with crescents and cheeks have red patches; the architecture is shown frontally or from the side, and there are many other features like the animals in the scene of the eagle and wolf guarding the dead bodies (f. 42) which recur in the marginal drawings of the *Chronicle*.

The second portion of the volume, which contains the *Visit of SS. Germanus and Lupus to Britain* and the *Invention and Translation of St. Alban's Relics and the Foundation of the Abbey by Offa*, is done in

[1] The fragments of a 'Life of St. Thomas' in the private collection in Belgium (Paul Meyer, *Fragment d'une Vie de St. Thomas*, Soc. des Anc. Textes français, 1885) have rather crude illustrations in the Matthew Paris manner. The Guthlac Roll seems closely connected with the Offa cycle which would, as suggested by Lethaby (*Burl. Mag.* xxxi (1917), 147), bring its date down to the middle of the thirteenth century. In this case it would have a direct connexion with the reliefs in roundels on the tympanum of Crowland abbey.

[2] Ed. M. R. James, Roxburghe Club (1924).

[3] R. Vaughan, op. cit. 387: 'The text of the *Vita S. Albani* is beautifully written, and therefore probably comparatively early in Paris's life.'

[4] Reproduced in M. R. James, *La Estoire de St. Aedward le Rei*, Roxburghe Club (1920).

a different style with more Gothic forms and the use of gold in the colouring (Pl. 48 *b*). A scene like that of Offa's Vision (f. 56*v*.), with the king lying in bed and a beautiful angel appearing from behind, points toward the drawing in the *Lives of the Offas*. In this second part all the pictures are fitted into an oblong frame in the new manner of a picture-book that seems to have become popular in lay circles at that time. In these books, whether they were lives of saints or apocalypses, a framed picture was placed on the top half of the page to be followed by the text, frequently in French, written in double columns below. In the *Life of St. Alban*, Latin rhymed hexameters were added to the French text. Though this may have been suitable for a monastic library—and the Dublin manuscript belonged to the abbey library—a draft of a short letter or message in Latin on the second fly-leaf proves its popularity amongst noble ladies: 'G. send, please, to the lady countess of Arundel, Isabel, that she is to send you the book about St. Thomas the Martyr and St. Edward which I translated and illustrated, and which the lady countess of Cornwall may keep till Whitsuntide.'[1]

The Lives of the Offas, which forms a part of a collective volume (B.M. Cotton MS. Nero D. I), provides an example of one method of making such a picture-book. Writing and illustrations were not executed simultaneously. Only the first seven of the drawings, outlined only and without tinting, were made at the time by an artist who tried to infuse into the Matthew Paris manner of objective reporting a stronger note of emotionalism, slightly tempered by an elegance inspired by French manuscripts such as for example the beautiful Pierpont Morgan book of Old Testament illustrations (MS. 638).[2] The battle scenes are tinged with a spirit of chivalrous gaiety suggested by the covering of the horses

[1] M. R. James, op. cit. 15.

[2] In the following century the attempt was made to complete the rest of the illustrations. The whole series, however, must have been sketched in lightly at the same time as the first seven scenes because composition as well as individual features such as trees or buildings are almost identical with those in the *Life of St. Alban*. This enterprise in the field of manuscript illustration is thus a close parallel to the completion of the nave of Westminster abbey in the fourteenth century in the style of the original preceding work.

and the display of heraldry. But the will to dramatize, to bring out forcibly the clash between good and evil, was not to be checked by French influence, just as the figures refuse to be confined by the frame. If not partially cut off by it they transgress it and the lively vigour of contours and the little hooks of the folds explode in wild gestures and in the curvature of the scrolls (Pl. 49 *a*).

In the *Life of St. Edward* (Camb. Univ. Libr. MS. Ee. iii. 59)[1] the Matthew Paris tradition is fully absorbed into the new current of the Court School. The life of Henry's patron is the most carefully and richly decorated manuscript of all the lives produced at the time (Pl. 47 *b*). In place of tinting, more solid colours fill the spaces between the suave and elegant outlines and, blending into each other, they form a splendid texture with silver and gold. Slender figures move without contortion, smoothly and with poise, in settings which are of the Gothic style of Westminster abbey. The buildings are no longer shown in front and side view projected flatly side by side, but by foreshortening a shallow stage is produced sufficient for the figures to move easily in all directions. One is made aware of distances in depth: King Harthacnut, seated behind the table, steps with one foot over it (p. 9), or in the remarkable group of scribes in the scene of the bishops at Rome (p. 24) some are placed in front of a draped rail while two others appear behind seen from the back (Pl. 49 *b*). Of the horses of the three knights in the 'Oppression of the English' (p. 7), one is seen from the side while the other is shown from the front in the manner used by Villard, though the abruptness of the frontal view is lessened by the turning of the neck. While shading and blending of colours suggest texture, vine leaves and grapes replace trefoil foliage. The pictures express a new warmth of affection and of devotion as in the scenes of the Flight of Queen Emma (p. 3), reminiscent of the Flight into Egypt, or of the Vision of King Edward, or the Miracle of the Eucharist (p. 37) where St. Wulfstan stands in front of the altar with chalice and corporal and holds up in both hands, not the Host, but the naked Christ Child. Gestures of adoration are more fervent, while those of wrath are more controlled, and the artist shows sympathetic understanding of human

[1] Ed. M. R. James, *La Estoire de St. Aedward le Rei*, Roxburghe Club (1920).

states and feelings as for instance in the group of the Four Blind Men (p. 42).

The whole character of the book makes it plausible that this French versification of the Latin prose life of St. Edward by Ailred of Rievaulx was produced for Queen Eleanor some time before 1264 and the final translation of St. Edward's relics at the order of the king, of whom the dedication says that 'he has filled [the royal stock of England] with his favour and throughout the kingdom gives both light and clear brightness everywhere, as the sun and the moon. Now are king, now are barons, and the kingdom, of a common blood of England and Normandy'. In spite of traces of the St. Albans tradition in the illustrations of the life of St. Edward, there can be no doubt that they were made by artists who were amongst those employed by the king and who contributed essentially to the formation of the Court School. In 1245 Henry paid Master Henry the Versemaker (Henry of Avranches) a sum for a poem based upon the life of St. Edward and in 1253 an order was issued that the history of the saint should be represented in a wall-painting in Westminster.[1] By this time Henry's patronage had brought so many artists from various centres to his court that the local traditions of the monastic scriptoria, be it Winchester or St. Albans, merged together. William of Westminster was active at Westminster, Windsor, Winchester, and perhaps Gloucester. From St. Albans there came Walter of Colchester, and Henry III was so impressed by the quality of the metalwork produced at St. Albans that he ordered a lectern to be made at St. Albans for the chapter-house of Westminster abbey. Other important work seems to have been entrusted to Nigel the Chaplain, William Florentin, and Peter of Spain.[2]

But just as in the case of the architectural style of the abbey, so in the painting produced for the court, French influences play an

[1] By 1266 a scriptorium had been provided for the monastery at Westminster according to the Customary of Westminster begun under Abbot Ware. See J. Armitage Robinson and M. R. James, The Manuscripts of Westminster Abbey (1909), 2.

[2] In addition to the painters mentioned, of whom it is known that they produced important work, the following who were probably chiefly assistants have to be added: John of Reading, Thomas of Chertsey, John of Carlisle, John of Nottingham, Thomas of Worcester, William of Oxford, Roger of Winchester.

increasingly strong part. This applies in particular to the paintings
in the Painted Chamber at Westminster palace, which were carried
out in the 1260's and early 70's to replace an earlier scheme of
decoration mentioned above. Unfortunately, this second and most
extensive scheme of decoration was destroyed in the fire of 1834.
The only visual evidence of its appearance in existence is provided
by coloured drawings made by Edward Crocker in 1819 (now in
the Victoria and Albert Museum, and in the Ashmolean), and
coloured engravings made after drawings by C. A. Stothard in
1819 and published with a description by John Gage Rokewode in
1842 through the Society of Antiquaries.[1]

From the royal accounts referring to an almost continuous
activity in the Painted Chamber, three main periods can be dis-
tinguished during which decorations were carried out. The first
falls in the early part of Henry III's reign, about 1236–7, when the
inscription in the gable was painted, which was mentioned above.[2]
In the years 1243 and 1244 an additional order was given for two
large lions to be painted face to face in the other gable and for the
images of the four Evangelists. Further the chamber was to be
wainscoted and the pillars about the king's bed were to be painted
green and gold.

The second and most important period must have been that of
the years 1263–7 after a great fire in 1262, and it must have been
then that the paintings recorded by Crocker and Stothard were
executed. Lethaby suggests that an order for a load of charcoal for
drying the paintings in the king's chamber in 1277 may mark the
completion of the work or better perhaps an extensive retouching
in order that the chamber might be in its full splendour when
Alexander, 'late king of Scotland', took the oath there to 'become
the liege-man of Sir Edward, king of England'.[3] On the walls of

[1] *Vetusta Monumenta*, vi (1885), Pls. xxvi–xxxiv.

[2] Some historical paintings must have existed then, because 'in 1236 Odo the Gold-
smith was ordered to remove the painting, containing panels with figures of lions,
birds, and beasts, which had been begun in the King's great chamber at Westminster
below "the great history", and to paint it green in the fashion of a curtain'. See L. F.
Salzman, *Building in England* (1952), 160.

[3] W. R. Lethaby, *Burl. Mag.* vii (1905), 257. For a comprehensive bibliography on
all Westminster paintings, see E. W. Tristram, op. cit. i. 65, 561.

the chamber an extensive pictured cycle of Old Testament stories was arranged in a succession of six tiers with French inscriptions in narrow bands between them. In the selection of the stories, a certain preference seems to have been given to warlike scenes in which the fighting men are all clad in chain-mail. The scenes may have been suggested by the windows of the Sainte Chapelle which contain the most extensive of all Old Testament cycles, and the architectural setting, as well as the treatment of hair and beards and the style of drapery, is much more Gothic than anything in the *Life of St. Edward*.

This applies in particular to the beautiful female figures of Virtues which were painted in the window jambs. They were noble and graceful (seven feet high) and retained their feminine charm and serenity in spite of their military garb of mail, various weapons, and magnificent shields, and in spite of the almost merciless determination with which they overcame the figures of Vices, who crouched below their feet. Their softly coloured mantles were arranged in a few rounded folds, their crowns had natural leaves like those in the spandrels. The Virtue of Largesse is trampling down Covetousness, represented as a man who is weighed down by many money-bags, and pouring gold into his throat from a cornucopia (Pl. 54 a).[1]

On the splays of the easternmost window, St. Edward and the Pilgrim were painted with stiff-leaf foliage of the late Westminster type above their shoulders. This scene was immediately opposite the king's bed. Above the bed, the famous large scene of the Coronation of St. Edward was painted (10·8 by *c.* 6 feet). It is a strictly symmetrical and solemn composition, rhythmically divided by a canopy of five three-foiled arches, two narrow ones set between wide and shallow arches. King Edward is seated majestically facing frontally and holding the sceptre with the dove, between the two archbishops who support the crown. The archbishop on the left holds a golden chrismatory in his left hand. Sixteen bishops or mitred abbots attend. The canopy was painted so as to suggest inlays of glass and natural foliage in gold on blue

[1] On the border, around the figure, lions of England and an eagle displayed sable, the arms of Frederick II, are painted alternately.

glass.[1] The flat ceiling was painted with various figures of angels, saints, and kings in compartments of different shapes, uniting into one regular and beautiful pattern, the whole coloured and enriched with stucco ornaments.[2] Gold upon raised gesso work was used lavishly to increase the sparkling effect, and 'the first impression must have been of the active stimulus of colour from these painted stories all as clear and bright as stained glass. The walls were a romantic illuminated book of great deeds'.[3]

If these paintings represent the most perfect example of the absorption of the St. Louis style in the field of wall painting, the large bible written by William of Devon (B.M. MS. Royal 1 D. I) occupies a similar place in the field of illumination. At the end of the Prologue, an almost full-page illustration is divided into compartments by delicate architecture with pierced and foiled arches on blue, red, or diapered grounds. In the first tier, St. Paul and St. Peter, the patron saints of St. Augustine's, Canterbury, and at the same time of Westminster abbey and the cathedral of London, flank the Madonna and Child enthroned with the small scene of St. Martin sharing his cloak with the beggar inserted below the throne. The picture in the next tier is the only contemporary representation in existence of a rood similar to that set up by Henry III in the choir of the abbey. The Crucified with St. Mary and St. John is flanked by two seraphs standing in their own compartments against a bright red ground.[4] A small steeple rises above the cross and the Coronation of the Virgin is placed in a small compartment beside it. The figure of a praying monk kneels below in the margin (Pl. 66 a).[5]

[1] In the right lower corner of the Coronation picture, an elaborately foiled window was pierced through the wall, probably in order to enable the king to see from his bed the altar which stood in the oratory attached to the chamber.

[2] *Gentleman's Magazine*, lxxxix, Part 2 (1819), 389. [3] Lethaby, op. cit. 266.

[4] In 1237 a sculptured rood with two angels was ordered for the Chapel of St. Thomas at Winchester. A similar rood was to be painted in the king's great chapel at Woodstock in 1244. In 1248 a sculptured rood with two cherubim on each side of the great cross with 'joyous countenances' was ordered for St. Peter's in the Tower of London.

[5] G. F. Warner, *Illuminated Manuscripts in the British Museum*, 1st ser. (1899), thought that the scene of St. Martin indicated that the bible was written in or for a religious house dedicated to that saint and that the kneeling figure of the monk might be that

The Genesis initial (f. 5) has in its vertical bar the scenes of the Creation and Fall in minute and elegant figures, God the Father holding only a small disk of the universe in the various stages of creation in His hand. The third large illustration (f. 231*v*.), which fills almost all of one of the half-columns of the text, is again divided into four tiers within an architectural frame, showing incidents from the life of St. Thomas, his murder, and the Crucifixion.

Small historiated initials, especially those of the Psalms, show strongly Parisian influence. Elegant smooth contours and a few flowing folds are accompanied by the delicate pen drawing of faces and hair, and the colours include soft greens, greys, and silver, gently blended. The borders which grow out of the initials are now made of thin and flexible bars with an occasional cusp, which stretch out until, on the Genesis page, they enclose the text on all sides. They are enriched with grotesques and birds, and here and there they end in vine or maple leaves. Sometimes in the place of these bars, which tend to take on the character of shoots or branches, long slender shafts occur strengthened by gold rings and knobs which, on the first page, carry the tiny figures of friars. In the Bible of William of Devon and the murals of the Painted Chamber, one finds the beginning of the Court School which will reach full maturity under Edward I.[1]

of Laurence de St. Martin, chaplain to Henry III and bishop of Rochester (1251–74). He also saw a possible connexion between William of Devon and the order (*Cal. Close Rolls H. III, 1251–3,* 57) to the 'custos librorum regis' for colours to be given to 'Mag. Willelmus, pictor regis'. But of all the subjects in the large initials examples could be found in paintings ordered by the king in his residences and chapels.

[1] A small, dainty Book of Hours (B.M. MS. Egerton 1151), executed for a lady, who kneels before the Virgin in the first initial, is close to the Bible of William of Devon. The Hours of the Virgin and the Office of the Dead are of the same Use as those in the Rutland Psalter, which contains also similar Hours of the Holy Spirit and the Passion.

THE ILLUSTRATED APOCALYPSES

THE close contact between St. Albans and the Court School is nowhere more obvious than in the apocalypses. The revival of the illustrated apocalypse about the middle of the thirteenth century in England is one of the most problematical and fascinating features in the history of the illustrated book, for England does not seem to have had any share in the previous development of the apocalyptic picture cycle, which occurred on the one hand in Spain and on the other in the centre of Charlemagne's empire. The Spanish tradition, which continued unbroken into the thirteenth century, was formulated in the seventh century and based upon the commentary of Beatus. The other, stemming either from Italy or Gaul, led to the production of a number of text illustrations between the ninth and eleventh centuries.[1] Why then this sudden popularity in England of what is essentially a picture-book with accompanying text, a popularity which transcended clerical or monastic circles to reach the educated layman, for whom must have been written the French text that replaces or accompanies the Latin in so many English apocalypses of the time?

The style and the spirit of the English illustrated apocalypse are the result of a new understanding and a new interpretation of the Revelation of St. John that dates back to the close of the twelfth century. Shortly before the first English apocalypse appeared, an illustrated commentary was written in Germany by Brother Alexander, a Franciscan in Bremen, which must have been known in England at least in Franciscan circles. It was first completed in 1232, but was extended in the later edition to cover events up to 1249.[2] Alexander's commentary is the first in existence which

[1] See W. Neuss, *Die Apocalypse des heiligen Johannes in der altspanischen und altchristlichen Buchillustration* (1931).

[2] The commentary exists in a number of manuscripts. The oldest copy of the lost original, written before 1250, was in Dresden. The copy in the University Library in Cambridge (MS. Mm. 5. 31) is an enlarged edition written later in the thirteenth century, its pictures faithful though weak copies of earlier originals.

explains the events described in the Revelation by a systematic historical method, each vision related to an actual event in history, beginning with the first Coming of Christ and the foundation of the Church and leading up to the author's own time. There are four main directive thoughts which guide Alexander through the Revelation. 1. The contents of the Apocalypse refer, with the exception of the last chapters, to the past. 2. The author sees the main dangers to the Church, after the first persecution and the attacks of the heretics, as coming from the east. In this he shows himself to be as well informed about the relations between the eastern and the western Church, about the Moslems and the crusades, as Matthew Paris. 3. He believes in the harmony between the universal church and the universal state, between pope and emperor, and does not share the anti-papal views of the Spirituals, the radical wing of the Franciscans. 4. In the struggle between the forces of Christ and the devil which make the content of human history, the *religiosi* or monastic orders play a decisive role until, with the coming of the Franciscans and the Dominicans, the victory is achieved and the New Jerusalem is realized.[1]

For this interpretation the most important source is to be found in Joachim of Fiore, who had prophesied the coming of the two new orders before they had been founded. Joachim (d. 1202) preceded Alexander by about fifty years. His commentary on the apocalypse written after 1195 still followed the 'recapitulation' method which interpreted at least the events introduced by the seven vials as a recapitulation of those preceded by the seven trumpets, but it also connected actual historical events with the vision of the apocalypse. It was he who set the tone for the new optimistic interpretation, since he predicted that the third and last era of human history would begin in 1260, ushered in by the two new orders. His reputation for prophetic gifts and his views on the apocalypse reached England during his lifetime. Two English chroniclers[2]

[1] For literature on the Commentary and detailed description, see A. Wächtel, *Die weltgeschichtliche Apokalypse-Auslegung des Minoriten Alexander von Bremen* (1937).

[2] *Roger of Hoveden*, iii, R.S. li (1870), 75–79; *Gesta Henrici II et Riccardi I*, R.S. xlix, 2 (1867), 151. These accounts are based on common material. See H. Grundmann, 'Neue Forschungen über Joachim von Fiore', *Münsterische Forschungen* (1950), 48.

tell of the meeting of Joachim and Richard I at Messina. The king hoped to learn Joachim's views about the outcome of the crusade, but he asked him also about the seven-headed dragon and the Antichrist. Joachim is reported to have identified the heads of the dragon with a series of persecutors, beginning with Herod and Nero and leading through Mahomet and Saladin to Antichrist. Joachim's written works were known in England and aroused great interest. Adam Marsh sent some identified writings of his to Bishop Grosseteste.

If the commentary of Brother Alexander has been discussed at some length above, it is not because there is a direct stylistic relation between its illustrations and those of the English apocalypses, but because it explains the spiritual ground out of which they grew. In contrast to all previous types of illustrations, the tenor of those in the thirteenth-century editions is an optimistic one with the accent shifted from the dread and fear of the tribulations to come to the positive, the triumph over Satan. It is still a warning to men, but even more a comfort to the heart with its promise of salvation. If the apocalyptic visions of strife and woe referred mainly to the past, they could be visualized and represented with much greater detachment. That the Franciscans were concerned in the revived interest in the apocalypse in England is proved by the beautiful drawing of Christ among the Candlesticks which is bound in with Matthew Paris's collective volume (B.M. Cotton MS. Nero D. I, f. 156) (Pl. 55 a). This drawing, done in pencil and partly with the pen, is different from Matthew Paris's style. An inscription on the left of the haloed head says that it is the work of Brother William of the order of the Minors, the companion of St. Francis, second in that order, holy in conversation, English by birth. On the back of the sheet is written the warning that 'Nothing more is to be written on this page lest the image be injured, as the parchment is transparent, and it can be seen better if held up to the light'. For the same reason only light yellow wash was used for the hair and the garments, with red for the flames of the candles and black for the pupils of the eyes.[1]

The first and a most sumptuous representative of the new type of

[1] See A. G. Little, *Collectanea Franciscana*, i (1914), 1–8.

apocalypse is the Trinity College Apocalypse (Cambridge, Trin. Coll. MS. R. 16. 2).[1] In its illustrations three outstanding features may provide a clue to its origin. The new Franciscan concept was known to the authority who outlined the programme to the artists. In at least three of its pictures which mark decisive moments of the final triumph (in the Glassy Sea in front of the throne, f. 17v., in the Fall of Babylon, f. 20v., and in the Final Judgement, f. 24v.), representatives of the new orders are shown.[2] Another new feature introduced by the author of the Trinity Apocalypse which was then taken over by most of the others, but seldom in such completeness, is the scenes from the life of St. John. Their content is drawn from the same sources which were used later in the *Legenda Aurea*, but scenes of his life occur in late twelfth and early thirteenth century editions of the *Liber Floridus* by Lambert.[3] In the Trinity Apocalypse these scenes form an introduction and a closing chapter, in harmony with the historical method of interpretation as the Revelation is thus seen anchored historically, without exclusive stress on the timelessness of the vision.

In the selection and the arrangement of the scenes, the Trinity Apocalypse follows on the whole the non-Spanish tradition. But there are signs of influence from illustrated copies of the *Beatus Commentary* as they were still produced in the thirteenth century, in a style quite different from that of the eleventh century.[4] Most of its text illustrations are not yet uniform in size. The scenes from the life of St. John are arranged in three tiers and usually fill one page with a short explanatory text written upon bands between the tiers, while scrolls and tablets provide additional explanation. Such scrolls and tablets inserted between the figures occur fre-

[1] Ed. M. R. James, Roxburghe Club (1909).

[2] That the Franciscan view was known in royal circles is proved by the illustrations to the apocalypse in the *Bible Moralisée* (Pierpont Morgan Libr. MS. 240) made for Blanche of Castille and her son, King Louis, where friars appear frequently in the medallions explaining the meaning of the text.

[3] For the sources of the life of St. John, see M. R. James, ibid. 16.

[4] There is a strong possibility that a new Spanish commentary had been written early in the century, from which Brother Alexander took over into his enlarged edition the prophecy that the faith of Mahomet was to be exterminated soon in Spain, 666 years after his appearance. The same reckoning was made by Innocent III when he called for a new crusade. See M. Huggler, *Antonianum*, ix (1934), 119.

quently also in the text illustrations. Most of these are oblong, of the same width as the double columns of the text, but sometimes two oblongs are set one above the other, and some take up the greater part of the page. Two are set in small squares with the text written around on three sides. The clearest evidence of Spanish influence, however, is to be found in the representation of the Heavenly Jerusalem (Pl. 55 b). In the manuscripts outside Spain, Jerusalem is shown in elevation, and this is the way in which it appears in all other thirteenth-century manuscripts except in the Trinity Apocalypse and some of its dependants. Here Jerusalem is shown in projection with its walls and gates flattened out enclosing a centre square with the angel, the tree, the river, and Christ.

The text of the Trinity Apocalypse is in French with a commentary in French based upon that of Berengaudus, who wrote after the destruction of the Lombard Kingdom in the eighth century. Partly derived from Bede, Berengaudus's interpretation had already elements of the historical method and a Franciscan may have been the author of the French text and the gloss.[1] The French version further suggests that the book was destined for a lay person and from its splendour one may suspect a person of high rank, possibly Queen Eleanor,[2] who may well have known an illustrated copy of a *Beatus Commentary* before she left Provence. The Trinity Apocalypse is exceptionally rich and detailed in its illustrations, with the unique scenes of St. John tasting the bitterness of the Book after having swallowed it, the four dark-faced Angels of the Euphrates after their release, and the whole of Creation represented by man, fowls, birds, beasts, and trees in the great Adoration. The heavy rich colouring, which varies in its strength according to the four different artists employed in the execution, the solidly coloured background and garments, frequently covered with red and white dots or other patterns, the use of gold, all features which are reminiscent of the Spanish tradition, stress the transcendental aspect. The backgrounds are divided alternately into broad blue or pink-brown borders enclosing pink-brown or blue fields within a golden border, and figures and objects are projected flatly upon it.

[1] See P. Meyer in L. Delisle and P. Meyer, *L'Apocalypse en Français au XIII^e siècle* (1901), ccxvii. [2] See M. R. James, op. cit. 25.

With wildly staring eyes, prominent eyeballs, and hectic red cheeks, the slightly elongated figures move jerkily as if under compulsion, their garments tossed with zigzag hems and fluttering ends. A faint trace of ovoid folds, especially around the hips, still appears, and the sloping feet which are sometimes supported by the scalloped ground but more often dangle in the air, the over-accentuation of leg-muscles, and the disregard of anatomy in strong movements when hip and shoulder seem out of joint, are all archaic features (Pl. 56). Christ in the Vision of the Candlesticks has a golden face with ruby eyes, but a green face when He holds the Book of the Seven Seals. A circlet of roses frequently surrounds the over-large heads. Trees are entirely ornamental, with trefoil foliage, and the buildings are of that Gothic phase when square or round layers and sections are used without foreshortening. Each individual part of the composition remains a separate entity, arranged in orderly fashion side by side. The abstract order in geometric compartments is particularly obvious in the heavenly visions, where Christ, angels, elders, and elect are set in their own sections (Pl. 55 b). In the beautiful scene of the Angels holding the winds, an outer red circle encloses a concentric wavy belt of water, and the twelve tribes are fitted into a large square box subdivided into twelve little cells. When the order is upset, when the earth quakes and buildings break and crumble, the severed parts float like suspended building blocks. Thus even the most dramatic action seems somehow unreal, suspended in time and outside ordinary human conditions, and in spite of the great excitement, the total effect is that of solemn quietness, retaining to a large extent the character of a revelation through vision.

It is not known where this apocalypse was written, Westminster, Salisbury, and even St. Albans being credited with the authorship. But as to the last, it seems doubtful whether a Benedictine scriptorium would have allowed such a prominent share to the new orders, and artists employed by the royal circle seem more likely. The winged helmets and the drawers tied below the knee are Winchester and not St. Albans features. On the other hand a St. Albans origin seems more likely in the case of the great rival of the Trinity Apocalypse: the Paris Apocalypse (Bibl. Nat. MS.

403),[1] which according to M. R. James forms, together with two others at Oxford and New York, the first family group.[2] This version has ninety-two pictures (two missing), all the same size, set in frames on the top half of the page, above the text and the non-Berengaudus gloss in French, except in the scenes from the life of St. John where two, set one above the other, occupy the whole page. Instead of the full colouring of the Trinity Apocalypse, the illustrations here are drawn in outline and slightly tinted, with a plain parchment as a background and a circle of tiny rings marking the nimbi. Iconographically the most important difference from the Trinity Apocalypse lies in the absence of all pictorial reference to the Preachers or, as a matter of fact, to any monastic order, and the introduction of the Antichrist. The two Witnesses, instead of being slain by the Beast, which bites the hand of one of them, are summoned to appear before the Antichrist. He orders their execution, seated in the crossed-leg position, like Domitian when he orders the torture of St. John. The following scenes develop the Antichrist theme ending with his destruction and the ascent of the Witnesses to Heaven. Twice St. John is lifted up and carried by the angel, when he faces the Woman on the Beast and the Heavenly Jerusalem.

In spite of traces of ovoid shapes, dislocation of joints, and fluttering folds, there is a greater feeling for organic movement in the slender pliable figures, which are modelled with shadows and by the flow of garments rendered with hairpin folds. A fiery breath animates the scenes, and they are more unified in their dramatization (Pl. 57 b). Almost all the figures stand upon a continuous strip of ground and the scalloped soil carries a suggestion of texture with deep pools of shadow. The architectural settings in an advanced Gothic are more delicate in structure with turrets and gables and six-foiled arches. Trees, though still trefoiled, seem to grow out of the ground, with knotted branches, and loving care is given to the various birds and other animals, especially to the little dogs, which seem to partake in the action. There are a great number of realistic features, like the man who fans with

[1] Delisle and Meyer, L'Apocalypse en Français.
[2] See M. R. James, The Apocalypse in Art (1931).

bellows the fire under the drum of oil in which St. John was to be boiled.

The most complex movements are now made to converge from all points of the circumference to the centre. Openings through which minor actors look may still be flat projections, but the men who watch St. John's torture are piled up one upon the other to peep through three holes at different levels with a fiendish absorption.[1] In no other illustrated apocalypse do the actors contribute their utmost to a concerted action. The eyes under the triple line of lid, socket, and brow are well embedded above high cheeks, made more prominent by red spots, and do not merely stare into vacant space but tell of a surprising variety of emotions. Fury and anger and the power of evil are expressed most powerfully by grotesque profiles in the English tradition. The terse, dramatic style of drawing and the clear and simple text of the gloss make this apocalypse an admirable book for the spiritual instruction of lay people, and the artists possessed an exceptional gift for realizing the visions, which were still remote in the Trinity Apocalypse, as close to human life and human passions.[2]

The strength and the power of these two great apocalypses was never reached again. The development leads to a progressive secularization where the pathos of the greatest vision is gradually replaced by sentiment and charm, suitable for courtly readers. The Revelation pictures seem to become merely marvellous incidents, in which a pleasing contrast exists between almost humorous beasts and gentle angels, between the ugliness of the mouth of Hell and the radiant beauty of the Heavenly Jerusalem, between the wicked charms of the Woman who sits on the Leopard, as if ready for the hunt, and the purity of the Woman on the Moon to whom the angel lends the wings.

With this trend one would expect a French text, but the two

[1] Reproduced in E. G. Millar, *Engl. Ill. MSS.*, Pl. 181.

[2] The two sister manuscripts (Bodleian, MS. Auct. D. 4. 17 and Pierpont Morgan, MS. 524) are weaker variants, less powerful with minor iconographic differences. They have more the character of mere picture-books with sentences from the Latin text and the Berengaudus gloss written upon the scrolls or into the empty spaces in a manner which disrupts or overcrowds the compositions. The Oxford MS. was edited for the Roxburghe Club by H. O. Coxe, *The Apocalypse of St. John the Divine* (1876).

most outstanding examples of the second phase of apocalypse illustrations (Malvern, Dyson Perrins Coll. MS. 10[1] and B.M. Add. MS. 35166) have a Latin text with gloss in red below the half-page pictures. With the absence of the Antichrist scenes, these two follow the Trinity Apocalypse, but on the other hand no reference is made to the Preachers and the pictures are outline drawings. They are tinted in the same subtle manner as the illustrations to the *Life of St. Edward*. Altogether there is the closest connexion between these manuscripts in manner and mood, with the same style of costumes (vair is used) and drapery folds which suggest soft and rich textures. Although there are still fluttering and tossed-up ends, all has become calmer with lines less tense and with soft blending of light, shadow, and tints. The line flows suavely and softly, and the movement of the supple figures is of quiet grace. The apocalyptic riders issue forth with ease and speed, even the beasts assume an elegance and courtliness of manner (on f. 24*v*. the second beast sits upon the altar with crossed legs), and the angels have the charm of those at the abbey. The settings are greatly reduced, but air seems to fill the empty spaces, floating around the figures, and the suggestion of space is supported by a new feature: St. John standing outside the frame and looking through a window at the stage (Pl. 58 *a*). This figure expresses a wide range of feeling by a surprising variety of poses, in, however, a lyrical vein with little dramatic pathos. St. John thus inserts himself between the spectator and his visions which thereby are moved into a greater distance without the direct impact of those in the earlier apocalypses. Spatially and emotionally he has the function of the middle-man between vision and spectator, so that emotional reactions are directed gently without being strongly aroused.

It is impossible in this volume to describe the many apocalypses which follow more or less closely the great models and to define their relationships.[2] Their illustrators never show great originality, at least as far as the text illustrations are concerned, but draw freely from the greater predecessors. It is only in the additional matter, with which in many cases the manuscripts are enlarged, that some

[1] Ed. M. R. James (1927).

[2] They are listed in M. R. James, *The Apocalypse in Art* (1931).

rise to a higher level. This applies to a group which is more ornate and copious than the rest, and which has been connected with St. Augustine, Canterbury, although in two of the manuscripts Franciscans play an important role. In these two (the Abingdon Apocalypse, B.M. MS. Add. 42555, and H. Y. Thompson MS. 55, which was bought in 1920 for C. S. Gulbenkian) an illustration to the Commentary of Berengaudus (in French in the first, in Latin in the second) has been added on each page opposite to the apocalyptic picture, and it is in those that Franciscans appear frequently. The Abingdon Apocalypse seems to have been given by Giles of Bridport, bishop of Salisbury (1257–63), to Abingdon abbey, but if so it must have been in an unfinished state.[1] Four leaves at the beginning and three at the end were obviously prepared for scenes from the life of St. John, two of which were roughly sketched in and all the other pictures were carried out as line drawings. Only a few (ff. 8v.–10r.) were coloured at the time, but to most of the others unpleasant chalky colours and gold were later applied rather carelessly.[2] In the scene of the killing of the Witnesses, the artist chose to combine the two traditions. The Antichrist sits partly outside the frame ordering and watching the execution, while from the other side the Beast presses forward, trampling down the victims (Pl. 59 a). In general there are faint similarities to the *Life of St. Edward*. In the illustrations to the gloss, a figure representing the Church resembles that of St. Faith at Westminster abbey though earlier in style, and the Martyrdom of St. Edmund occurs in two others (ff. 37r. and 36r.).

A similar figure, this time as St. Margaret (f. 50), and the same martyrdom (f. 51) are found in the infinitely superior De Quincey Apocalypse (Lambeth Palace Library, MS. 209).[3] It opens with a figurated initial which contains the seated Evangelist, and which ends in an ornament and a peacock very much like that in the

[1] R. E. W. Flower, *B.M. Quarterly*, vi (1931), 71.

[2] Strangely the same was done to the second apocalypse (H. Y. Thompson MS. 55) in which the colouring was done at a later stage by an Italian artist. See *Cat. of H. Y. Thompson Coll.* ii, no. 55.

[3] Its Latin text with extracts from Berengaudus is very close to that of H. Y. Thompson MS. 55. See M. R. James and C. Jenkins, *Descriptive Catalogue of the MSS. in the Library of Lambeth Palace*, 331–6.

Abingdon Apocalypse. This is also a composite work derived from the three earlier versions (the Trinity Apocalypse; Paris; and Dyson Perrins). But it recalls the Trinity Apocalypse by the sumptuousness of its colouring and by the manner in which the now fully Gothic figures stand out against the coloured frames and the patterned or golden background (Pl. 58 b). Although in one of the main illustrations the Beast kills the Witnesses, biting the hand, six Antichrist scenes are inserted, as if by an afterthought, in the margin as tinted drawings by a different hand. A note of chivalry characteristic of the whole work is provided by the Second Rider with the sword, who wears a yellow surcoat with black lions rampant over his coat of mail, and in the scene 'Beati Mortui' two angels lift the souls which they have gathered in a shroud with fluttering ends.[1]

Twenty scenes from the Life of St. John are followed by two from the Life of St. George who is raised by the Virgin and slays Julian, and by six most unusual and dramatic scenes from the Theophilus Legend. Theophilus' prayer before the statue of the Virgin and Child, which stands beside a crucifix upon an altar placed against the foreshortened external view of a church, shows an original power of invention and that almost neurotic sensitiveness which is found in all the additional full-page tinted drawings (Pl. 60). In the beginning a Benedictine monk in his heavy black cowl is shown applying colour to a statue of the Virgin and Child raised on a short column. He has the thin elongated figure and small bony head with tiny pointed chin which occur in all the drawings, together with sharply broken metallic folds and brittle lines. After the Theophilus cycle, follows the unusual representation of St. John on Patmos, where he is seated in the traditional Evangelist pose, writing in front of a lectern, while water flows all around him with four islands in the corners.

Style and temperament suggest that all the drawings which are not illustrations of the apocalypse are of the last quarter of the

[1] This group is similar to that of the two angels who lift the soul of the prioress in the *Obituary Roll* (B.M. MS. Egerton 2849) which Lethaby (*Burl. Mag.* xxix (1916), 190, pl. ii) dates, probably too early, about 1230, and attributes to Master Walter of Colchester or one of his colleagues at St. Albans. In addition the Roll has two other tinted drawings of the Crucifixion and the Virgin and Child side by side and of the Last Offices of the Prioress who lies in an open coffin surrounded by priests, clerics, and nuns.

century. This is evident if one compares the figure of St. Christopher or that of an archbishop, and most of all the 'Veronica' head (Pl. 52 *a*) with the additional drawings in the Westminster Psalter,[1] or the drawing of the Madonna and the Child (Pl. 64 *b*) in its Gothic setting with that of the Matthew Paris Madonna. The Crucifixion scene on one hand, into which are crowded all the incidents of physical and mental suffering and shame, and the remarkable and elaborate Allegory of Christian life on the other, show how dry theoretical thinking is now combined with an overheated emotionalism and a worldly charm. The wimple worn by the lady in the Allegory, similar to that worn by the Virgin and by St. Mary Magdalene in the Noli Me Tangere, is an additional evidence that the drawings belong to a later period.[2]

Besides these elaborate editions of apocalypses which must have been produced for patrons in high society, there is another group which represents a simpler, more popular version in abbreviated form and with tinted outline drawings. For them a Benedictine origin and possible destination have been suggested. The Eton College Apocalypse (MS. 177), which has a sister book in the Lambeth Palace Apocalypse (MS. 434), comes from Worcester. Both were owned by nunneries and are chiefly picture-books with an abridged text in French. The Witnesses are executed at the order of the Antichrist, but the Heavenly Jerusalem is shown in a peculiar combination of flat projection and of elevation (Pl. 59 *b*). In both the Second Beast is like a goat. The pictures have the effect of coloured wood-cuts with their narrow coloured frames, plain backgrounds, dull tints within strong black outlines, the sparing use of gold, and the hectic red cheeks. They have the tenor of a popular sermon as is suggested in the opening picture, where St. John stands preaching before a crowd composed of both sexes and all social ranks. The closing phase of the illustration of apocalypses will be discussed in a later chapter.

[1] B.M. MS. Royal 2 A. XXII.

[2] The small figure of a lady with a wimple who kneels at the foot of the Madonna (f. 48) bearing the arms of the De Quinceys might be Eleanor, wife of Roger De Quincey, earl of Winchester, who later married Sir Roger de Leybourne of Leybourne and Leeds castle, who died in 1271.

X

BIBLES AND PSALTERS BETWEEN
1250 AND 1275

THE growth of private and personal devotion amongst lay
people in high society not only increased the demand for
illuminated psalters, but caused changes in the manner of
their decoration, choice of subject-matter, and the spirit they
express. Private ownership and the wish to show closer personal
contact with the sacred figures caused the frequent appearance of
the owner's portrait at the feet of Christ or the Virgin. First these
figures were usually added outside the frame, like that of Matthew
Paris or that of the abbot in the Evesham Psalter, but gradually
they were included in the main composition.[1] Further the full-page
illustrations preceding the psalter, now generally limited to the
lives of Christ, the Virgin, and the Saints, became more devotional
than historical in character and indicated the deepening emotional
participation in the events described, very likely as the result of the
influence of confessors chosen from the new orders upon the mind
of patron and scribe. On the other hand, a growing awareness of
the sensuous pleasures of the world, together with the conscious-
ness of the temptations which they hold, lay behind the popularity
of the grotesques or 'drolleries' which now take possession of the
margins.

Not only does the peacock become more frequent than the
dragon, but a world of little figures, human and animal or a mix-
ture of both, plays around the text invading the empty spaces as if
demonstrating that the world with its pleasures and its evils is full
of snares for the mind whose concentration escapes from the words
of the sacred text. The rendering of animals, especially that of
birds, of which such charming examples can be found in the 'Bird'

[1] In a window in the queen's chamber at Clarendon a child and a queen were to be
placed at the feet of the Virgin and the Child, holding jointly an Ave Maria (1250).
(*Cal. Lib. Rolls. H. III, 1245–51, 25.*)

Psalter (Cambridge, Fitzwilliam Museum, formerly coll. Lord Lee of Fareham), shows an extraordinary knowledge and affection, but all too often they are hunted or chased and their apparent innocence becomes spoiled by human faces growing out of their bodies and by the indelicacies and tricks which they commit.

Most of these books show the effect of the process which had started at Westminster abbey and which has been discussed previously in connexion with its architecture and sculpture: elongation of figures with an S curve and long, softly rounded, flowing folds, and careful drawing of heads and hands. But there exists a wide range of variety in style which cannot be explained on the basis of local tastes and traditions since the places of origin are not known. The only fact which is certain is that many were produced at a distance from London. But even so, the Parisian scheme of psalm illustration, based upon the words of the psalm and not upon historical associations attributed to it, gradually gained ground. This supplanting of the English manner, so vigorously creative in the earlier psalters, started with the psalter illustration in the bibles, which were naturally more open to directions from University circles. Thus, the theme of the Fool for Psalm 52, the Chanting Priests for the 'Cantate', and the figure of David in a variety of actions for others became more and more common.

The change which had taken place in the course of fifty years is clearly illustrated by the contrast between the earlier illustrations of the Westminster Psalter (B.M. MS. Roy. 2 A. XXII)[1] and the set of five tinted drawings, added c. 1250, of a king, a kneeling knight, an archbishop, St. Christopher, and a 'Veronica' head. Although without doubt influenced by the St. Albans manner, they are firmer and more courtly, and the 'Veronica' especially is full of fire in the crisp drawing and the spirited expression of mouth and eyes, which go far beyond the stoic 'Veronica' of the *Chronica Majora* (Pl. 53). The St. Christopher has the drawers tied below the knee worn by figures of de Brailes but not by figures in St. Albans manuscripts, and the archbishop's mantle is lined with vair, a feature which was to become a hallmark of the Court School.

[1] See T. S. R. Boase, *O.H.E.A.* iii, Pl. 85 *b*.

A rather weak example of the St. Albans tradition is found in the tinted drawings attached to a psalter (B.M. MS. Royal 2 B. VI).[1] They form an abbreviated cycle of the life of Christ with five scenes from the Annunciation to the Presentation and four scenes from the Flagellation to the Ascension, followed by three scenes of martyrdoms, amongst them that of St. Edmund and of St. Alban, and one page with seated saints in pairs. The page with the Madonna and Child (f. 16v.) is reminiscent of the seated kings in the *Chronica Minora* in its general arrangement of arcade and solid blue background, but more Gothic in its slenderness, in the delicate floriated sceptre, and in the trefoiled arch.

The character of the tinted drawing is maintained in the Evesham Psalter (B.M. MS. Add. 44874) which was probably given to that abbey by Abbot Henry of Worcester (d. 1263) but went soon to Earl Richard's foundation at Hayles.[2] In the full-page Crucifixion (f. 6) the green of the cross, made of a tree with chopped-off branches, is backed by a bright red border dotted with small white patterns. This in turn is set off from the patterned gold ground, the whole enclosed by a blue, gold, black, and red border. The pose and expression of St. Mary and St. John have an almost late-Romanesque quality, found also in the arrangement of the lightly tinted folds which combines smooth ovoid areas with hairpin folds and turned-up hems, but the face of Christ is exceedingly tender. Below the cross, partly outside the border, an abbot kneels in adoration (Pl. 62). The 'Veronica' head (f. 6v.) is closer to that in the *Chronica Majora* than that in the Westminster Psalter, although it is coloured.[3] The beautiful clear 'B' of the Beatus page is balanced against the

[1] A psalter in Venice (Marciana lat. class. I. 77) with a series of full-page illustrations belongs to this period.

[2] T. Borenius, 'A Masterpiece of English Illumination', Sotheby's Catalogue, 19 May 1936. The kalendar has an entry for the deposition of St. Edmund Rich but none for Richard Wich. The erasure of the kalendar entry for the deposition of St. Egwin, founder of Evesham abbey, may have been caused by the removal to Hayles. On f. 162 in the margin a shield has the arms of Richard of Cornwall.

[3] A much coarser coloured copy of the 'Veronica' head on gold ground within a blue frame is found in the psalter (Lambeth Palace Libr. MS. 368), on f. 95v. On the opposite page a reference in French is made to Pope Innocent's Prayer which is quoted in Latin. The psalter contains six full-page pictures from the Annunciation to Christ in Majesty which are crude.

opposite page on which in the older tradition the beginning words of Psalm I are written in large, gold letters on solid coloured ground. Further signs of an early date are the dragons with human heads and lions fixed to the main initials (Pl. 65 a), the simple line endings in coloured ink, and a grotesque of a man wearing a winged helmet (f. 159r.).

Tinted drawings such as those mentioned above are, however, an exception. All others of the numerous psalters have fully coloured illuminations. A group of manuscripts of distinct character probably had its origin at Salisbury.[1] The Amesbury Psalter (Oxford, All Souls MS. 6), the most beautiful work in this group, must have been made for a member of this most aristocratic of all nunneries. The nuns and monks, found in some of the illustrations, are cloaked in blue over green, the colours of the Order of Fontevrault, and two entries in the calendar refer to St. Melorius. Four full-page illustrations precede the psalter, the three of the Annunciation, Mary Enthroned, and Christ in Majesty in straight frames, the fourth of the Crucifixion with roundels at the corners and half-roundels in between. Not only the choice of the four subjects, but their emotional character with their highly strung drawing, rich glow of colours on burnished gold, and tense expressions seem apt to stir the devotion of a noble lady withdrawn into retirement. Vermilion, white and green break out in startling vividness in contrast with the paleness of the women's faces with their small red mouths and the red spots on their cheeks. White and red star patterns dot the closely fitting robes, which flutter and toss. The roundness of the figures is achieved with barely any shadows, chiefly by lines: strong contours and V-shaped or hairpin folds circumscribe the shape of the body underneath and at the same time have an expression and a most dramatic life of their own. Long slim bodies which twist and sway, thin fingers and long curling toes, large ovoid eyes with dark pupils and a curved brow, a slightly aquiline nose and a small mouth with well-shaped lips, all serve to emphasize the deep feelings which the figures express by strong gestures, but which they still control by an inner pondering and self-meditation.

[1] A. Holländer, 'The Sarum Illuminator and his School', *Wilts. Arch. and Nat. Hist. Magazine*, l (1943), 230.

The Crucifixion scene has kneeling and censing angels in the roundels at the corners. Old Adam and two other naked men rising from their tombs and reached by the trickles of blood from the wounds, and God the Father between angels holding the Dove between His hands are balanced against each other at the foot and the head of the cross, just as are the Church and the Synagogue on either side of it in the foiled half-medallions of the frame. The body of Christ is nailed with three nails to the green knotted cross with a green band around His head, the anatomy of His torso marked over-sharply, His thinness contrasting with the ample loin-cloth rolled and knotted around His hips. The Christ in Majesty hovers majestically in front of an elaborate throne-bench in an eight-foiled frame, holding the chalice in His left hand, the fingers of which are visible under the cloth of the mantle. A richly foiled arcade encloses the figures in the Annunciation and the Madonna Enthroned who suckles the Child at her breast (Pl. 64 a).

The text of the psalter is richly decorated; all the psalms begin with initials on a gold ground, mostly ornamental, but some with small figures like that of a man shading himself beneath his large foot, a mermaid suckling her child, a monkey playing the harp, a hare beating the drum, and many others of this kind. Line endings are made of square borders or with animals mostly in gold, blue, and red. The ten large historiated initials are still linked with the de Brailes tradition, but the figures are much more ponderous and the action much more dramatic (Pl. 65 b). The Temptation is used for Psalm 52, and the Resurrection for Psalm 101. The B of the Beatus page with the Tree of Jesse is enclosed by a straight border which contains in round or lozenge medallions six Old Testament scenes from Cain's murder to the Ark. In the scene of the Anointing, Samuel advances, as does St. John in the large Crucifixion, like a cross-legged knight; and in the scene of Jonah and the Whale, Jonah wearing drawers is immersed in a mountain of lightly tinted water surrounded by fish.

The Wilton Psalter (London, Royal College of Physicians) contains in its Litany prayers for the abbess and the congregation of the church of St. Mary and St. Editha, but Franciscans occur in some of the smaller initials. Two only of the large historiated

initials are preserved; Pentecost for Psalm 26, where the Virgin in a blue mantle with white dots sits between St. Paul with a sword and St. Peter with the keys, and the Fool disputing with David for Psalm 52. These were possibly made by a pupil of the Sarum Master.

The master himself, however, illustrated the beautiful Sarum Missal (Manchester, John Rylands Libr. MS. 24) which has on its fly-leaf in a later thirteenth-century hand a memorial to Henry of Chichester, canon of Exeter, and belonged to Exeter cathedral at a very early date.[1] The historiated initials for the introits and collects contain some unusual scenes which are of great liturgical interest. That for the First Sunday in Advent (f. 16) shows a kneeling bearded man who holds up a small nude figure towards Christ in the clouds ('Ad te levavi'), and the initial to the canon of the mass (f. 153) has the Crucified between the Church and the Synagogue (Pl. 61 a) as in the Amesbury Psalter and as in the large Crucifixion scene which forms part of a series of eight full-page illustrations. The Annunciation (Pl. 63), the Nativity, the Virgin Enthroned, the Betrayal, the Scourging, Christ bearing the Cross, and the Resurrection, are set in frames of patterned bands edged with blue, gold, and red. A certain stiffness, the strong black lines in contours and folds, a difficulty in fitting the scenes into the frame and other features, betray a connexion with an earlier style such as that of the wall-paintings in the chapel of the Holy Sepulchre in Winchester cathedral. This applies especially to the overcrowded scene of the Betrayal with the prominent ugly faces of the soldiers, but less to the Nativity and the Madonna Enthroned. In the Nativity, the hieratic and the natural are charmingly blended, with the Madonna suckling the Child and a maidservant adjusting the coverlet with loving concern. The Madonna and Child, who receive the prayer for mercy from a priest kneeling in blue cope over white at the foot of the throne, have no longer the monumental remoteness still maintained by Matthew Paris's Madonna. Seated on an elaborate throne, the curved back of which is treated almost as if it were made of

[1] M. R. James, *A Descriptive Catalogue of the Latin Manuscripts in the John Rylands Library at Manchester*, i. 73–75; ii, Pls. 51–57; J. Wickham Legg, *The Sarum Missal* (1916).

wickerwork and forms a niche behind her, the Virgin bends her head full of sweet but serious charm to her Child and the priest, and the animation of the human relationship is even shared by the three little lions which play like lap-dogs at the foot of the throne. With her human charm the Madonna is close to the loveliest of all wall paintings preserved from the thirteenth century: the Chichester Roundel. On the south wall of the chapel in the Bishop's palace a quatrefoil is painted within a round medallion (32 inches in diameter) with foliage filling the spandrels; it encloses the Madonna who sits upon a throne-bench with eagle ends and a curiously shaped triangular back. The blue background is powdered with golden fleur-de-lys which are also embroidered upon the Virgin's rose mantle lined with vair. She is flanked by two angels emerging from coloured cloud bands and vigorously swinging their (once) silver censers. While the jewelled crown and the floriated sceptre, which grows out of the apple in her right hand, mark her as the Queen of Heaven, the girlish figure of the young Mother, with narrow shoulders turned sideways, looking down at the Child who stands in a long embroidered tunic on her knee and enfolds her neck with His hands, is very human in feeling (Pl. 61 b). There is nothing of the tense excitement, the fluttering of folds, and the twisting of bodies found in the Salisbury group, but a sweet gentleness and calm elegance close to the Westminster style.

The bible written by William of Hales for Thomas de la Wyle, head of the school at Salisbury cathedral in 1254 (B.M. MS. Royal 1 B. XII), is a typical English example of the stylistic development in the third quarter of the century, growing out of the style represented by the bible B.M. MS. Burney 3. The extension of the cusped bars of its small initials is still limited and the backgrounds are still plain though usually decorated with white dots. The Genesis initial is purely ornamental, but with a small grotesque man at the bottom, and that for Paralipomena (Chronicles) i (f. 124) is unusual with its long bar with twelve tiny heads which spring from it like buds. The decoration of the many other bibles of this period follows the conventional pattern with variations and different degrees of quality and illustrates a gradual progress towards

the style which developed in Paris under St. Louis.[1] A Bible at Trinity College, Cambridge (MS. B. 10. 1), has a most intricate and elaborate initial to the Book of Genesis with thirteen figural scenes set in quatrefoils. God seated upon the throne is followed by six acts of creation and six Old Testament events, the last being Abraham's Sacrifice set immediately above the Crucifixion. In addition New Testament stories beginning with the Annunciation and ending with Pentecost are fitted into the spandrels in admirable abbreviation and a grotesque tournament is balanced gracefully upon the extended bar at the bottom.

Without known place of origin, the Rutland Psalter (Belvoir castle, duke of Rutland) has a certain kinship with the Salisbury group, but its illustrations have a distinct character of their own and it abounds in drolleries.[2] An obit added to the calendar might refer to Edmund de Lacey, earl of Lincoln (d. 1258) and, although Edmund Rich is absent from the calendar, it has the Octave of the Nativity of the Virgin introduced in 1252. Six full-page illustrations are so arranged that one precedes each of the main psalms, which have their own large historiated initials with subjects that suggest individual choice outside the convention. Not only is the draughtsmanship sharper, with certain peculiarities like white hatchings on the garments, but the type and actions are more virile than in the Amesbury Psalter, as in the scene where Saul thrusts his long javelin toward the small David sitting on a footstool with his harp. The Beatus page combines David playing the harp with the Judgement of Solomon in the roundels of the letter, while Creation scenes are added, also in roundels. Balaam's Ass and the Healing of the Blind are unusual scenes, and when David plays the organ small angels' heads floating above form a pattern as of notes, while the man

[1] Some of these bibles are: B.M. MS. Royal 1. C. I (c. 1250); London, Coll. Emery Walker; Coll. Sir S. Cockerell (c. 1260–80); Durham, Cathedral Libr. A. ii. 3 and A. ii. 10. A typical Cistercian bible (Holkham Hall, MS. 9) has only ornamental initials with the exception of that for the Prologue. For a group of bibles in the Bodleian Library see *Eng. Illumination of the Thirteenth and Fourteenth Centuries*, Bodleian Picture Book No. 10 (1954).

[2] E. G. Millar, *The Rutland Psalter*, Roxburghe Club (1937). Here it is suggested that the death of the earl of Lincoln may have caused the greater simplicity of the later section.

manipulating the bellows is realistically treated. The psalm initials in the glossed psalter at Durham (MS. A. II. 10; Pl. 68 *a*) are drawn with a similar tense and excited liveliness.

In some psalters, though their English origin is clearly evident, style and method of illustration are closely related to the famous *Bible Moralisée* produced for St. Louis in Paris. This is the case of a psalter (now in possession of E. G. Millar) probably produced at York or in its neighbourhood, since special prominence is given to St. William of York and to St. Wilfrid in the kalendar.[1] It has nine large historiated initials for the main psalms (Beatus page missing), a large decorative initial for the beginning of the canticles, all on burnished gold, and smaller psalm initials. The illuminations have certain distinctive characteristics as pointed out by Millar: extensive use of brown instead of black outlines for many of the figures especially the faces; a marked facial type, often with a slightly surprised expression, a curious bulbous nose with a deep indentation just below the forehead, a remarkable pattern of matt gold foliage on a lake ground in the frames and in the bows of all the large initials except the first. The novel feature of the psalm initials is the combination of two or more scenes divided by arcades with irregularly foiled arches as they occur in the actual architecture of this time, and the linking of Old and New Testament scenes as types and anti-types. Thus for Psalm 26, the Anointing of David and his Coronation are set against the Presentation in the Temple and the Baptism; for Psalm 51, David and Goliath, the latter with a grey face, are combined with the Temptation in which the Devil half disappears into a hole; for Psalm 52, the hooded Fool with his bladder is set below the scene of the Jews stoning Christ; for Psalm 68, Jonah issuing from the mouth of a green whale with vermilion fins appears below the Resurrection. The two scenes for Psalm 38 are based upon pure word illustration: David, closing his lips with his right hand, faces the Devil with a dark grey body and light green head ('I will keep my mouth with a bridle while the wicked is before me') and on the right a dying man whose treasures are

[1] E. G. Millar, *A Thirteenth Century York Psalter*, Roxburghe Club (1952). According to Millar, the psalter (London, Sion Coll.) written for the use of the diocese of York and the bible (Coll. Sir S. Cockerell) are related in style to the York Psalter.

carried away by three men ('For he heapeth up riches, and knows not who shall gather them'). The 'Hear my Prayer' of Psalm 101 is illustrated by Judith, in a green robe and lake mantle with a flat cap tied under her chin, kneeling in prayer, while the story is continued in the next compartment where a maid receives from her the head of Holofernes, whose decapitated trunk lies on a couch. (Pl. 68 *b*).

A reassertion of English taste against French influence is particularly strong in the remarkable Oscott Psalter (Dyson Perrins Coll. MS. 11).[1] This book is exceptionally rich in content and decoration. It contains, besides a kalendar and a psalter, the canticles, collects, office of the dead, and a psalter of the Virgin. In the French metrical paraphrase written in six-line stanzas on the right of the Latin text, William is mentioned as the author (f. 215) and he may also have been the scribe. A connexion with Polesworth (Warwick) on account of two entries in the kalendar to St. Modwenna, foundress of the famous nunnery, is most doubtful, for in some of the smaller initials figures of friars appear. Between the kalendar and the psalter, twenty-two full-page illustrations have been inserted which form a unique sequence: twelve single figures, mostly of apostles, two of which originally alternated with two of the ten pages with scenes from the life of Christ (two on a page). They stand on bare feet with large toes upon a piece of scalloped ground in front of a dark blue or pink diapered background and under a richly foiled arch with foreshortened buildings in the spandrels. A flat-gold tunic which falls in straight folds is partly covered by a mantle, sometimes brown lined with green or blue lined with red or grey lined with red. The mantle is arranged in deep key- or V-shaped folds, as rich and diverse in their patterns as are the poses and facial expressions. All serve to bring out the individuality of each figure with a startling vividness and with a vast scale of emotion ranging from gentle resignation to feverish obsession. Some stand quietly in the centre of the niche, some sway to one side leaving half of the ground uncovered, others are bending or almost doubled up. The degree of tension in their mood

[1] G. Warner, *Descriptive Cat. of Illuminated MSS. in the Library of C. W. Dyson Perrins* (1920), 40, Pls. xi–xv.

can always be measured by the relation of the curves to the frame and the diapered ground. The drawing of facial features and hair is remarkably detailed, though over-sharp, marked by a peculiar bone-formation with high and broad upper portions and quickly narrowing lower parts (Pl. 75 a). These single figures have their nearest parallel in the apostles which are painted in medallions on the vault of Oxford chapter-house around the figure of Christ in Majesty.[1]

The scenes from the Birth and Passion of Christ are set in roundels upon diapered grounds. In the corners in quarter-medallions, single heads usually supplement the main action, such as the horses' heads where the Magi are warned in their sleep by the angel. The connexion with the *Bible Historiée* is indicated by the subjects of the half-medallions which are scenes from the Creation to Abraham's Sacrifice. In one of them, between Adam's Creation and that of Eve, a strange scene is inserted in which God the Father carries the sleeping Adam like a babe in His arms (Pl. 67 a). The Last Judgement scene is divided between Christ as the Judge in the upper roundel and the scene of dispute between St. Michael and the Devil, between souls in the Mouth of Hell and souls carried upwards in a sheet by angels. St. Michael holds the scales, as commonly in French art but rarely in English. All these scenes are told in a highly excited manner, the actors throwing themselves with full absorption and vivacity into their roles; the three Magi, for instance, fit so well into the circular frame that the motion rotates in a continuous circle. The main psalm initials (Beatus page missing) are by a different hand, following in their subject-matter on the whole the French convention, and there is a bewildering wealth of smaller initials, drolleries and line-endings, which suggest that an important and wealthy patron stood behind the artists.

There seems to be a relationship, not so much in style but in temperament, between the Oscott Psalter and the curious Old

[1] E. W. Tristram, *Engl. Med. Wall Painting: the Thirteenth Century* (1950), Pls. 83–93. The close connexion between the sculptured bosses in the chapter-house and those in the abbey muniment room has already been mentioned above, p. 127. A Westminster connexion has also been suggested for the Oscott Psalter. See O. E. Saunders, *Engl. Illumination*, i (1928), 67.

Testament illustrations which precede the psalter (MS. K. 26 of St. John's Coll., Cambridge). If one compares the full-page illustrations of David playing the harp, it is clear that the Oscott painting is of finer quality, but in both the same excited animation spreads from the figure to the ornamental ends of harp and chair, and even to the little fat white dog which sits beside David in the latter psalter. The twenty-nine illustrations of the life of Christ and the Virgin are by later and weaker hands, but the Old Testament scenes have an almost barbaric power in the splendour of the patterned backgrounds and the shrill tones of the colours. Faces and folds are drawn harshly, the anatomy of the nude parts is over-accentuated and the gestures are strangely emphatic. Animals appear in great numbers, not only in the scene of their creation, and a surprising realism, as in Noah building the Ark, where he leans his chest on the auger and turns it with both hands, is combined with a weird imagination. The three angels visiting Abraham (Gen. xviii) are, according to the Latin *titulus*, the Lord in the figure of the Trinity, and are thus shown with one body and one pair of uplifted wings but with three beardless heads growing out of one long neck (Pl. 67 *b*).

XI

THE INFLUENCE OF WESTMINSTER

THE mingling of the influence from Westminster and local taste and traditions, so difficult to determine in manuscript illuminations, of which the place of production is generally uncertain, can be traced more easily in buildings raised after 1250 in various parts of the country. Masons from the abbey must have been directly responsible for the exquisite and rich work in the small church at Stone (Kent). Of the cathedrals, Salisbury was the first to be touched by the style of the Abbey, receiving a rich reward for its contributions to Henry's work. The cloisters and the chapter-house, added between 1263 and 1284, were a close copy of those at Westminster. The north walk of the cloisters was not built as usual against the south aisle of the church, but separated from it by an open space, the 'plumbery', of considerable width. In this way it did not cut off the light which came through the aisle windows into the church. The cloisters were after all not a necessary require-ment for a secular chapter, not linking common living quarters together as in monastic establishments. Spacious walks covered with four-part vaults open into the quadrangle with the most beautiful traceried arcades, originally enriched with Purbeck marble shafts. The only building opening out of the cloisters is the chapter-house. Like that at Westminster, it has a high slender central pillar with eight shafts and geometric tracery set in its broad four-light windows (Pl. 72 a). The wall arcades, which break the surface of the plain wall below, have a richer decoration of six-foiled arches, labels, and head stops and their spandrels are filled with carved reliefs. These reliefs represent an exceptionally detailed cycle of Old Testament stories, from the Creation to Moses receiving the tablets of the Law.[1] In spite of recutting and the replacing of most of the heads during a devastating restoration, the smooth flow of the narration and the softness of overlapping

[1] See W. Burges, *The Iconography of the Chapter-house* (1859).

draperies can still be discerned. Even richer than the design of the wall arcades was that of the choir screen, portions of which have been re-erected in the north choir transept. Its spandrels hold the most charming of angel choirs, in which small half-length figures of angels with beautifully curved and pointed wings express their jubilation with graceful movements and radiant faces (Pl. 12 b). The west front of the cathedral is its least successful addition. Its designer tried to combine the effect of a broad screen and niches filled with statuary, on the Wells model, with gabled porches and gradated lancets as on the north transept of Westminster abbey.[1]

At Chichester the Norman nave and aisles were widened by the addition of chapels on the north and south. Those on the north were turned into a second aisle with traceried windows and open flying arches. By these additions the church became the widest of all cathedrals except that at York. The north aisle with its slender piers and bright light forms an impressive contrast to the dark Norman nave. But much more thorough and remarkable was the work carried out at Lichfield and Hereford, both under bishops closely connected with the court. The remodelling of the Norman cathedral at Lichfield, which became the recognized seat of the bishop over St. John's, Chester in this period of ascendancy of the seculars, was begun late in the twelfth century. A new choir was built by masons in contact with the western school of early Gothic. Before 1250 the two transepts with eastern aisles were completed (south transept begun about 1220; north transept about 1240). Henry III was interested in the new work; he granted in 1235 and 1238 licences to dig stone from the royal forest of Hopwas for the new fabric for the church at Lichfield.[2] In 1243 he ordered Archbishop de Gray to have a lofty wooden roof, like the roof of the new work at Lichfield so that it seemed stonework, constructed at the king's chapel at Windsor.[3]

[1] For the few remaining mutilated statues of the west front and the style of their drapery, see E. S. Prior and A. Gardner, *Medieval Figure Sculpture in England* (1912), 345. [2] *Cal. Close Rolls H. III, 1234–7*, 103; *1237–42*, 46.
[3] *Cal. Close Rolls H. III, 1242–7*, 39. The wooden vault with moulded ribs and carved bosses in the manner of a stone vault which was put over the presbytery at St. Albans late in the century is the only remaining example of this kind.

This earliest example of a wooden roof pretending to be of stone exists no longer, as both transepts have been heavily restored and the vaults reconstructed. But the vaulting shafts against the transept walls remain and rise from the ground upwards to the spring of the vault which must have been higher originally, since the wheel window in the south transept is now above the present groining. Though the five lancets of the north transept have been reconstructed in the nineteenth century, largely with the original stone, and are lower than intended, the arrangement forecasts the effect of the Five Sisters at York.

In 1258 Roger Longespée was elected bishop. He was the natural son of the earl of Salisbury and nephew of the king. He had spent a long period of his life in France and owed his selection to the notorious influence of the king and queen and Richard of Cornwall. The architect whom Roger employed to design the new nave blended features of the twelfth-century western school with the elegance of Westminster abbey. The new nave was of the same length as the late twelfth-century choir, of seven bays with an eighth forming a vestibule between the towers. No other design, not even that at Westminster, rises so vigorously with its sequence of vertical bays and its smooth fluidity of upward movement; and this in spite of the short pillars which follow the pattern of the older presbytery piers, with groups of stone shafts, alternating between one and three, and with richly foliated capitals. As at Beverley and Westminster, the ground storey occupies one-half of the total height, but triforium and clerestory divide the remaining half equally between them. This excessive height of the triforium chamber may be due to the assimilation of the new work to the older presbytery, but the effect of lowness in the ground arcade is counteracted by the three slender vaulting shafts in front of the lozenge-shaped pillars. They rise unchecked, cutting across the spandrels with their cusped five-foil decoration, to their heavily foliated capitals below the dog-toothed string course of the clerestory. Although the walls seem thin, the effect of relief has been heightened by arch labels on head stops, repeated in both storeys. The delicate screen of the triforium arcade with lozenged trefoils and completely pierced heads is outlined against the soft dark

shadows of the gallery chamber. All windows in aisles and clere-
story are filled with tracery and the Westminster influence is strongly
marked in the spherical triangles with their trefoiled circles in the
clerestory. The complex rib-vault of the nave is that of Lincoln, but
the transverse rib was omitted and a ridge rib made to extend the
whole length of nave and aisles (Pl. 73 a).

The front of Lichfield cathedral is the only main front built in
this second period, except the front of Salisbury. It was designed
as a truly twin-towered façade of the French type, a type for which
there was an earlier tradition only in the province of York. Bishop
Longespée may have procured the design for it from France, but
in the execution a compromise was achieved between the French
twin-towered high front and the broad sculptured screen of
the Lincoln type. Now heavily restored, it forms with the bays
behind it a rudimentary western transept, only slightly broader
than the nave. The rich screen of blind arcading runs across a flat
surface unbroken by buttresses, though these appear to have been
intended originally, and encircles the stair turrets at the angles.[1]
Between the portals with the heavy, lush leafage of their capitals
and archivolts, pointed arches, triangles, circles, and foils of white
sandstone make a shimmering blind screen against the reddish
stone of the walls. Cusps and crockets soften sharp lines and points,
and the trefoils within the arches are no longer made of sections of
a pure circle, but are extended by the addition of another pair of
foils which gives to the whole the effect of a flickering candle.

Even more sophisticated and singular in the peculiar refinement
of its design was the north transept of Hereford cathedral (Pl. 73 b).[2]
Peter of Aigueblanche (Peter Aquablanca, 1240–68) had come to
England in 1236 with William of Savoy, bishop-elect of Valence.
In 1239 he was special counsellor of Henry III, and Keeper of the
Wardrobe. The north transept of his cathedral, possibly never com-
pleted in the Norman building stage, was turned into a high chapel

[1] Only the portion up to the first gallery belonged to Longespée's time. It was only
under Bishop Langton, who built the lady chapel, and his successors that the whole
was completed. See J. T. Irvine, 'The West Front of Lichfield Cathedral', *Journ. Brit.
Arch.* xxxviii (1882), 349.

[2] See G. Marshall, *Hereford Cathedral, its Evolution and Growth* (1951).

sparkling with light, set in a thin framework of mincing elegance: the dream of a courtier with an exotic taste. On the west and north sides the walls were split up by enormously tall windows, similar to those of the Sainte Chapelle or of Narbonne. In the tracery of windows and triforium, delicate shafts or mullions divide the openings arranged in groups of three joined together to form a larger group of six. Three circles with foils inside pierce the heads framed by gable-like arches and the spandrels of the triforium are covered with a diaper pattern similar to that at Westminster abbey. The cusped circular windows of the clerestory set in spherical triangles stem from the same source. The slender marble shafts which seem to be turned by the lathe and the sharp mouldings are those of Aquablanca's own tomb, which was placed in one of the chapels of the transept (Pl. 31), and are more fitted for a shrine built delicately on a small scale than for a major piece of architecture.

While the influence of the abbey radiated where the taste of the court prevailed, the English tradition reasserted itself magnificently in the most consummate work of this phase: the Angel Choir at Lincoln. Work at the Angel Choir was begun about the time when the new choir of Ely cathedral was completed. Although Ely choir belongs partly to the previous period, it prepared the way for the full glory of Lincoln.[1] Not long after the Norman nave at Ely had been closed by its splendid western front, a Galilee, a porch of two vaulted bays, was added under Bishop Eustace (1198–1215). Two storeys high, it reached as far up as the triforium stage of the western transept, with four ranges of blind arcades and in the centre three lancet windows above the entrance. But though the wall-frame of the porch may be of Bishop Eustace's time, the graceful double screen of trefoiled arches which form an inner and outer portal must have been made by workmen who were employed in the rebuilding of the eastern limb. By 1234–5 it was decided to replace the Norman sanctuary by a new, well-lit presbytery and a spacious retro-choir for the shrines of St. Etheldreda and her companions. Bishop Hugh of Northwold (1229–54) provided most of the funds for the work, which was finished in 1252.

The retro-choir of four bays was built first outside the old

[1] See G. Webb, *Ely Cathedral* (1950).

Norman apse, increasing the eastern limb to nine bays. The high altar stood originally two bays farther west than it stands today. The two bays in front of it, which may well contain old Norman masonry, show a change in style which leads away from the simplicity of the first phase towards the richness of the second. In place of the crisp foliage and the twisted ribs and trefoils of the vaulting corbels in the retro-choir, fuller and riper foliage appears, with down-curving clusters of leaves hanging like full grapes (Pl. 16 b), and the cones of the corbels are shaped like sprouting stalks. The new work maintained throughout the elevation and the height of the Norman nave. The spacing of the main supports was the same as in the nave (17 feet), but their sharply pointed arches reached higher than the nave arches. This caused a reduction of the height of the triforium, which in the nave was equal in height to the lower storey, so that a different proportion was achieved. The triforium, however, still remained unusually lofty, well lit by coupled lancets in the outer wall (they still exist in two bays on the south side), with the internal flyers and their wooden roof visible from below. In no other building of the time are the parts which make the whole so clearly articulated, so firmly independent and yet so submissive to the general plan. The Purbeck marble shafts which surround the marble cylinders, alternating in their thickness, are detached from the core to which they are tied by rings half-way up, and the four slender colonnettes, which divide the triforium arch into two smaller trefoiled units, let a strip of light shine through narrow gaps. The orders of the arches are clearly defined, moulding and hollow follow each other in quick succession. The walls are spliced in layers, trefoils and quatrefoils in spandrels and tympana are pierced though blind. The thickness of the masonry between the triforium openings was overcome magnificently in the sequence of four polished shafts, with deep hollows between, filled with trefoiled leaves. Even before the alteration of the windows, the choir must have been remarkably well lit, with rich contrasts of light and shade in the beautiful carvings. The bays of the choir are narrow and lofty, each bay a unit in which was set up a simple sequence of interspaces; of one in the arcade to two in the triforium to three in the gradated lancets of the clerestory. The triple

vaulting shafts, of triforium height, lead to bundles of ribs which, first running straight, suddenly bend and fan out to rush towards the centre ridge rib with which they are joined by sculptured bosses. For the east wall the architect chose the steep eastern front of the northern region, thus making Ely choir the southernmost representative of the straight east wall pierced by groups of lancets.

When the new choir at Lincoln was designed to replace the apse of St. Hugh's choir, it was the square end and steep eastern front as at Ely, and not the chevet of Westminster, which was chosen. Already in the bull which canonized St. Hugh in 1220 it was decreed that his body should be translated to a more worthy position than the small transeptal chapel which he had selected himself in his modesty. But it was more than thirty years later in 1256, that dean and chapter applied to Henry III for licence to remove portions of the city's eastern wall to extend the cathedral.[1] By 1280 the work on the new choir was sufficiently advanced to allow St. Hugh's translation in the presence of Edward I and his queen.

The new work extended by five bays eastward from the old eastern transept. It was to be the continuation of the older choir and its design was assimilated to that of the earlier portions as far as the fashion of the day allowed. Its height was to be the same, so that the long roof-line east of the central tower was farther extended without a break until it reached the steep drop at the east end. But the wish to replace walls by windows, and to extend the window space as much as structurally possible, led to a more elaborate framework of buttresses and open flying arches than in the western portions. Strong buttresses with crocketed pinnacles allowed the traceried windows to expand to the whole width of the bay, and the flyers swung in an elegant curve towards the clerestory walls. Although the general disposition in the interior was that of the nave with its three-storeyed elevation, an entirely different effect was achieved by subtle changes that increased the emphasis upon expanding breadth rather than rising height. The width between the pillars was made about five feet less than in the bays of the nave, and at the same time the main arches rose to a

[1] Cal. Patent Rolls H. III, 1247–58, 506.

slightly greater height, thus reducing the height of the triforium. The impression created was not that of a nave separated by columns from the attached aisles, but of one vast spacious hall expanding from the centre into the other parts. Prior's description of the piers applies to the whole:

The piers are sufficiently illustrative of the change of feeling which after 1250 required the soft modellings of breadth to take the place of the trenchant uprightness of the Purbeck monolith. The Corfe mason was still to supply Purbeck columns for the richest English Gothic in many parts of England, but they were now no longer the round turned shafts, but sheafs of modelled roll-sections. And the full round contours of the pier were echoed in the vault and arch members which it foreshadowed and carried. The deep-cut accent of the first thirteenth century masonry faded away before the multiplied expressions of a decorative breadth.[1]

In fact only the second and fourth pier pairs of pillars are wholly of marble, the rest of the yellow Lincoln stone with marble capitals. The fusing of all the parts into a coloured, richly woven pattern was assisted by the use of lobed trefoils in the spandrels, of rich corbels and delicate mouldings, of cusps and sculptured leaves between the Purbeck shafting. The pierced screen of the triforium was carried into the clerestory. While it stands out light against dark in the lower storey, it stands dark against light above. In place of the triplet of lancets, a four-light window fills the whole space between the caps of the vault, and its tracery is repeated in the open screen in front of it. It is most of all this new mode of lighting which creates the effect of brilliant luminosity, with the darkish band of the triforium set between the subdued light of the traceried triplets in the aisles and the brightness above, as at Westminster abbey. But instead of the narrow height of St. Edward's chapel with the mysterious shadowy depth of the ambulatory and chapels behind, the Angel Choir ends in a straight wall of luminous transparency. The pattern of the tracery of the great east window is a glorious variation of the main classical theme: the two-light window with the encircled foils in the head. Each of the two main lights between the jambs and the central post is subdivided again

[1] E. S. Prior, *A History of Gothic Art in England* (1900), 308.

into two, and with one more subdivision, eight narrow lights are comprised within the main order while the foiled circles in the head reduce in number, but increase in size, towards the top. The whole design is still one of architectural clarity and stability, though the main circle is allowed to cut into and merge with the arches below (Pl. 71). Flooded with brilliant light, the Angel Choir stands like a halo at the head of St. Hugh's darker sanctuary. With its radiance which seems to change the substance of stone to that of condensed light, and with the angelic choir in the triforium spandrels, it comes nearer than any other building to the poet's vision of the Temple of the Grail.

For the new choir an elaborate entrance was provided on the south side. The sculptural decoration of the Judgement Porch, which has suffered damage and drastic restoration, was carried out between the years 1255–80 by a number of artists who drew from the experiences acquired at Ely, at Westminster abbey, and in the north. In its general disposition it was probably inspired by the north transept portal of Westminster abbey, unless one presupposes a more direct French influence. The main theme is indicated in the tympanum over the main door where the Last Judgement is represented. Iconographically it follows the model of the French cathedrals, but as far as its design is concerned it conforms to an English tradition. At Higham Ferrers (Northamptonshire) and Crowland abbey, tympana had been carved earlier which were not divided into horizontal strips but covered by circles or foils containing figural scenes, in W. de Brailes's manner, an arrangement as already mentioned apparently used also in the main tympanum at Westminster. But at Lincoln the whole is filled by one scene. In a quick tempo a continuous flowing movement is carried by the hurrying angels, with flapping garments and pointed wings, to swirl around the pointed quatrefoil which contains the seated Judge and two kneeling angels (mainly nineteenth-century restorations). The struggle between the angels and the devils is represented dramatically with two demons feeding the mouth of Hell at the bottom. The relief is not as bold as those carved thirty years before at Wells, and the slender shapes seem to sink into the soft ground. The stiff-leaf foliage in the outer arches is so deeply undercut that

it stands out like filigree against the shadow of the hollow mould and forms oval bowers which shelter the nimble and elegant figures of the virtues on the left and the apostles on the right (Pl. 75 b). Seven full-size statues remain somewhat loosely connected with the portal, without heads and badly weathered and broken. Traces of the Wells style remain as in the figure of the Synagogue but ideals have changed.[1] The carvings of the draperies now give a suggestion of soft texture. Bodies with swelling breasts are covered by layers of garments with varying patterns of richer folds, and by bearing and dress suggest a society which has become more conscious of the social graces. Although the figures are fitted into the hollows of the moulding as part of a continuous series of portal figures, with a figurated corbel below and a nodding canopy above, they seem more detached and free from the architectural setting. Their position in relation to each other and to the porch comes very close to that of the figures on the Eleanor Crosses designed a little later.

Three statues placed against buttresses of the Angel Choir are of a different style. The single female figure, usually named 'Queen Margaret', second wife of Edward I, without justification, is a very controversial piece. Though the treatment of the hair is of the time, the main features of the face such as eyelids and lips seem to be recut.[2] The statues of the royal couple with modern heads, now called Edward I and Eleanor, have draperies treated in a manner quite different from that at Wells or Westminster. The breadth of the female figure which is the same at shoulders and base as well as the straight vertical folds seem related to the effigy of Archbishop de Gray at York, though later in date.

The theme of the Last Judgement extended from the porch into the interior, into the sculptural decoration of the two westernmost and latest bays of the Angel Choir. Here the spandrel figures in the triforium, at least on the north side, are usually connected with the

[1] A mutilated figure on the west front of Crowland abbey is carved in the same style. A connexion with Lincoln has also been suggested for the statue of a female saint in the west gable of Lanercost priory (Cumberland).

[2] A. Gardner and R. P. Howgrave-Graham, after careful and close study of the head, have reached the conclusion that the head is a 'genuine medieval work of the highest quality'. See A. Gardner, *English Medieval Sculpture* (1951), 149.

Last Judgement representation: the figure of Christ with a crown of thorns displaying the wound in His side, the angel with a scale weighing the souls, the angels with a crown of thorns, a spear, and a censer, and the angel expelling Adam and Eve. The iconography of the angels holding a human soul, a hawk, books, and scrolls, and the charming Madonna with the Child on the south side is less clear. Most of the angels in the three bays towards the east are part of a musical choir playing their instruments with boyish gusto and vigour. The two who blow trumpets or pipes cross one leg over the other in a position which seems more suitable for that familiar grotesque, the Lincoln 'Imp'. Although different hands can be distinguished in the execution of the spandrel figures, they all show an extraordinary freedom of action and pliability in fitting into their triangular fields. The rhythmical sequence of bays in the choir is accentuated by the placing of a figure with wings out-spread in the centre of each bay. Those angels who seem to be the earliest have short chubby bodies and round heads with crisp rows of curls and short stiff wings. The best have the charm and the elegance of the Westminster transept angels, but they go beyond even them in the sinuous movement, in the rich interplay of light and shadow in the full soft folds and in the expression of sentiment (Pl. 74). It is amongst these that one finds the remarkable features of the perspective rendering of the second wing which is bent and visible behind and below the first.[1] The same style as that of the later spandrel sculpture, though by a different hand, can be found in the rich series of roof bosses in the choir aisles and in the cloister. Religious scenes, full of tender and passionate expressions, are mingled here with secular and fabulous motifs which are drawn with the same liveliness and humour as are found in the drolleries of book illustration. Besides the latest type of stiff-leaf foliage, the oak and maple and other natural leaf forms are handled with an accomplished skill which is equal to that which produced slightly later the famous leaves of Southwell.[2]

[1] A. Gardner, ibid. 121, believes that 'certain misfits, especially in the wings' prove that the spandrel figures were carved before being put into position, but these 'misfits' may be intended perspective effects.

[2] See C. J. P. Cave, *Roof Bosses in Medieval Churches* (1948), 79, 189.

The influence of the architecture of the Angel Choir spread quickly towards the north, though it reached its full effect only in the last quarter of the century. The large window which was inserted into the north wall of the chapel of the Nine Altars at Durham in place of the original lancets was inspired by the windows of the Angel Choir (Pl. 18). Its basic design was a group of three two-light windows of the classical type, but the main arches over the main posts were carried through to the outer arch and made to intersect in the centre, while the main posts and arches were repeated in a screen and rear arch in a design that was even more complex than that of the double screen in the clerestory of the Angel Choir.

At York, however, the northern tradition of grouped lancets reached its final and greatest triumph. The north arm of Archbishop de Gray's transept was completed by the treasurer, John le Romain. While the east and west elevation remained that of de Gray's time, the north wall was slit by five huge lancets which rise fifty feet high from base wall arcade to the gable. The unique design of the 'Five Sisters' is a concession of the northern tradition to the novel fashion of the traceried window, for the strips of wall between the lancets are almost as thin as mullions and the five windows tend to merge into one. When after its completion the north surrendered its lancets and accepted tracery, it developed its own patterns which, like the 'Five Sisters', were based on the uneven number of lights (Pl. 69).

The influence of Westminster abbey was not limited to the cathedrals. Some of the abbeys, especially those which enjoyed the patronage of Henry III or members of his family, were affected by it. Waltham abbey received a clerestory of circular windows like those at the abbey, and at St. Albans the remodelling of the presbytery was begun under its influence. The Norman church of the Austin Canons at Dunstable to which an eastern chapel had been added in 1228 received a new west front. The remains, though badly damaged, show three tiers of wall arcading above the portals, of which the one leading into the north aisle was enriched with six orders of arches. But much more imposing was the new front at Binham (Pl. 70 a). In a peaceful corner of Norfolk, separated from

the sea only by a narrow belt of marsh, was the Norman church of this cell of St. Albans. Matthew Paris stated that Prior Richard de Parco (1226–44) built the new front of the church from the foundation to the roof.[1] But this date seems remarkably early for the magnificent tracery of the large window in the centre. There is a strong likelihood that the work at Binham was due to the presence of masons who must have been active at Bromholm near by. In 1226, marble which Richard de Marsh, bishop of Durham (1217–27), had cut in Weardale, was to be given to the prior and monks of Bromholm,[2] and Ralph of Coggeshall[3] mentioned the erection of beautiful buildings due to the increased prosperity of the priory. It would have been strange if Henry III had not provided an appropriate setting for the Rood of Bromholm, and its splendour can be gauged by what was built at Binham, the only remaining example on a large scale of thirteenth-century architecture in East Anglia.[4]

Too little evidence is left with regard to the famous nunneries in what was once Old Wessex, which had always been a favourite place of retirement for the ladies of the royal house.

The east end of Romsey abbey was rebuilt with two splendid traceried windows of three lights, which shed their brilliance above the dark Norman sanctuary. But there are no reports of large rebuilding at Amesbury, where Queen Eleanor retired in 1286, like Queen Guinevere, never to be seen again. The beautiful chapter-house at Lacock is the main remaining portion of the Augustinian nunnery which was founded by Lady Ela Longespée, countess of Salisbury, in 1232 on the same day as the Charterhouse at Hinton, and of which she became abbess in 1238.[5]

But at least three of the latest Cistercian foundations profited greatly from royal favour: the abbeys at Beaulieu, Netley, and Hayles. Early in the century at the first of all Cistercian houses in

[1] *Chron. Majora*, vi, R.S. lvii (1882), 90.

[2] *Rotuli litterarum clausarum*, ii, 1224–7 (1844), 140.

[3] Ralph de Coggeshall, *Chron. Angl.*, R.S. lxvi (1875), 203.

[4] In 1234 Henry III gave the order for a gilded silver image in the likeness of the king (*ad similitudinem regis*) to be made and sent to Bromholm in honour of the Holy Cross (*Cal. Close Rolls, 1231–4*, 382).

[5] See H. Brakspear in *Archaeol.* lvii (1900), 125.

England, at Waverley, rebuilding had started on a large scale. In 1231 the new presbytery of four bays, with a processional path and five eastern chapels against the straight east wall, was consecrated. The rest of the church was built slowly, to be consecrated in 1278. But only scanty ruins remain.[1] The abbey of St. Mary de Bello Loco had been founded by King John in 1204 on land in the New Forest close to Southampton Water, where an inlet facilitated the import of stone from Caen and Binstead (I.O.W.) for magnificent new building.[2] The new church was entered by the community of thirty monks who had come directly from Cîteaux, on the Vigil of the Assumption in 1227.[3] A solemn dedication took place on 17 June 1246, performed by the bishop of Winchester in the presence of King Henry, Queen Eleanor, the earl of Cornwall, and many prelates and nobles. The queen even spent three weeks at Beaulieu in violation of Cistercian rule, to nurse Prince Edward who had fallen ill, and Isabel of Gloucester, first wife of Richard of Cornwall (d. 1239), was buried before the high altar of the church, while her heart was sent to Tewkesbury. Built at the same time, at least in its major parts, as the choirs of Rievaulx and Fountains, the church at Beaulieu shared with them largeness of scale. It was 336 feet long, of which nine bays were given to an exceptionally spacious nave set between very shallow aisles. The northern transept was double-aisled with an elaborate porch in front of it. But the most unusual feature was the shape of the choir: a concealed chevet with ten chapels, six of which were enclosed within the continuous curve of the outer wall, broken only by buttresses. The plan may have been due to a mason, Durandus, from Rouen, who was recorded at Beaulieu between 1214 and 1254. The type of chevet, however, was that of Pontigny where St. Edmund was buried, though Beaulieu choir must have been a much more stately building, truly royal in its scale.[4]

[1] For plan and description, see H. Brakspear in *V.C.H. Surrey*, ii (1905), 621.

[2] See W. H. St. John Hope and H. Brakspear in *Arch. Journ.* lxiii (1906), 139, and *V.C.H. Hampshire*, iv (1911), 652.

[3] *Annales Monastici*, ii: *Waverley*, R.S. xxxvi (1865), 304.

[4] A more normal version of the chevet was used in building the choir of the church at Croxden abbey (Staffs.), built between 1180 and 1250 and dedicated in 1254. The new structure was probably due to the initiative of Abbot Walter London of whom the

Although Beaulieu church has been destroyed to its foundations, the extensive remains at Netley not far away, though more modest in scale, are an excellent illustration of the struggle between Cistercian simplicity and royal lavishness, with the Cistercian tradition winning through on the whole. Netley abbey was founded as a daughter house of Beaulieu in 1238–9, but building probably did not start before 1251 when Henry III, taking over the role of founder and patron, lent his assistance.[1] To his wish must have been due the additional unusual dedication to St. Edward (Sancte Mariae de Loco Sancti Edwardi). The base of the north-east pier of the crossing still bears an inscription: 'H.D.Gra Rex Angl.', with a shield of England and a cross for the king, while on the base of the north-west pier a crown surmounted by a cross was probably meant for the queen. The plan of the abbey church was the normal Cistercian one, but with slight and characteristic modifications. A nave of eight bays was divided from the aisled presbytery of four bays by a transept with eastern chapels. The absence of a processional path and chapels beyond, as well as the width of the nave which was three times that of the aisle, produced the effect of a spacious hall, continuing at the same height from east to west. The elevation was of two storeys in the Cistercian tradition with a wall passage between the nave arcade and the clerestory windows. The width of the nave between the shallow aisles was responsible for the beautiful effect of the east wall, where the narrow lancets of the small side-chapels flanked the traceried window above the high altar (Pl. 70 *b*). The shape of the windows, which changed from part to part, provide in themselves good illustrations of the development of the window in the course of the century: single lancets in the side-chapels, coupled lancets still

Chronicle reports that he wonderfully enlarged convent and church. Of the church only the steep western front is still standing. The foundations of the east end indicate that the apse was half a decagon, its supports planted on a semicircle, the radius of which was half the width of the choir. Lines radiating from a point in the centre of the chord went through the centres of the vaults and radiating chapels, and ran against the minor buttresses in the centre of each. See C. Wynam, *The Abbey of St. Mary, Croxden* (1911).

[1] See H. Brakspear in *V.C.H. Hampshire*, iii (1908), 472, and A. H. Thompson, *Netley Abbey* (1937).

comprised by a round arch on the outside in the aisles of the presby-
tery, triplets of lancets in the transept, triplets with foils in the
south aisle, and finally triplets with foils and pierced trefoils in
the later north aisle. All these windows were constructed in the
simplest form of plate tracery. Only in the inner face of the south
transept and in the east window did the Cistercians finally succumb
to the tastes of the royal founder.

A second daughter house of Beaulieu, the abbey of Hayles
(Glos.), owed its foundation to Richard of Cornwall.[1] On his way
back from Gascony in 1242, after his engagement to Sanchia of
Provence, Richard barely escaped shipwreck. His vow to build an
abbey was redeemed by the foundation of Hayles a few years later
on a site which his brother granted in 1245. The church, which was
dedicated by Bishop Walter Cantilupe in 1251 in the presence of
the royal couple, of Bishop Grosseteste and twelve other bishops,
became the burial church of Richard himself,[2] of Sanchia his wife
and of his two sons, Henry and Edmund. As then built it had a
presbytery of four bays, of which the westernmost was consider-
ably narrower than the rest. With a processional path and a row
of eastern chapels which were probably like those at Abbey Dore,
and with a nave of eight bays, the whole church was about 320 feet
long, as long as Gloucester cathedral. The simple early choir was
destroyed by fire in 1271. Three years before, in 1268, Edmund,
son of Richard, had brought back from Germany a portion of the
Blood of our Lord, which he gave to the abbey, except for a small
portion which he sent to his newly founded college at Ashridge
(Herts.). The new choir was laid out on a much grander scale. It
might have been drafted by Robert of Beverley, chief mason at
Westminster abbey at this time. To judge from the foundations,
which are preserved, it was in the form of a chevet, but even more
French in character than that at Westminster abbey, with five
sides of an apse, the ribs of which radiated from a point on the

[1] See H. Brakspear in *Arch. Journ.* lxiii (1906), 261.

[2] F. M. Powicke, *King Henry III and the Lord Edward* (1947), 721: 'Richard of
Cornwall told Matthew Paris, when the church of his new abbey at Hailes was dedi-
cated, that he had spent 10,000 marks on it, and he added "Would to God that I had
spent as wisely all the money that I have spent on Wallingford Castle".' *Chronica
Majora*, v. 262.

chord and were continued by the transverse ribs of the ambulatory meeting the buttresses between the five semi-octagonal chapels. Of the decoration of the church at Hayles only a few sculptured bosses are left. In 1300 Edmund was buried in the choir in the presence of his cousin Edward I, who had found solace in solitude at Edmund's College at Ashridge after Queen Eleanor's death.

XII

THE COURT SCHOOL UNDER
EDWARD I

THE change from an old to a new reign, the death of a king and the succession of his son, would not of necessity mean a change in the style of the arts, even when personalities and tastes were as different as those of Henry and of Edward. But a change occurred during the last quarter of the century which had already begun in the last ten years of Henry III's life and became fully effective under his son. Edward I, who was so close to his father that he said, when informed of his death in 1272, 'God may give me more sons, but not another father', saw to it that Henry received a splendid tomb in the Confessor's chapel at Westminster abbey. But a politically more important addition was the Coronation chair with the Stone of Scone, removed from Scotland to the abbey in 1296. Before this, in 1285, Edward had presented the crown of Arthur at the high altar. Thus he gave to the abbey the two symbols of his victory over the Scots and the Welsh. The making of the tomb and of the Coronation chair illustrate the two sides in Edward's character both of which had their influence on the arts: a shrewd realistic approach, and an almost extravagant sentimentality that clothed many of his actions in the garb of chivalry derived from Arthurian romance. He seems to have been a devout man, but without the religious enthusiasm of his father, punctilious in attending dedications of new churches or translations. He caused the appointment of a commission which, finally in 1320, secured the papal canonization of St. Thomas of Cantilupe, Simon de Montfort's chancellor, and attended his translation into his shrine at Hereford cathedral in 1282. He frequently visited the shrines of English saints, but in these visits piety mingled with either personal or political motives. He paid special honour to Our Lady of Walsingham, because she had saved him from being crushed by a huge stone which destroyed the chair occupied by

Edward while playing chess with a knight. In 1278 at Easter he and Queen Eleanor stood at the open grave of King Arthur and his queen at Glastonbury. Their remains, which had been discovered in 1191, were then placed in tombs in front of the high altar of the abbey and thus the seal was set upon any hope of the Welsh that Arthur would return.[1] When Edward stopped at Bury St. Edmunds in 1300 on his way to the north, he was not only generous to the monks and full of reverence for St. Edmund, but 'a few days after he sent his standard, begging the prior and convent that the mass of St. Edmund might be celebrated upon it, and that it might be touched by all the relics'.[2] His repeated visits to the shrine of St. John of Beverley were connected with the Scottish war. Like King Athelstan, Edward took the banner of St. John from Beverley to help him in securing another victory over the Scots.

In addition Edward's imagination was fired, not by the quest for the Grail, but by the chivalry of the Round Table.[3] When he accompanied the body of his beloved queen on its last journey to her tomb at Westminster abbey, he marked the places of rest on the way by the famous Eleanor Crosses. Though it has been shown that in this he copied what had been done for St. Louis of France on his last return to Paris in 1271,[4] there seems to be a great difference between the mourning of a nation over the death of its saintly king and that of a knightly king over his beloved lady.

Edward found in London a body of artists who had been active for his father and had developed a style in which lay the beginnings of the Court School. His first efforts as art patron after his return and coronation in August 1274 were concentrated upon Westminster. As early as 1246 Henry III and his queen had stated their desire to be buried in the abbey. But Henry's body was apparently at first laid to rest in the old tomb of Edward the Confessor as suggested by the letter written by the nobles to Edward I in the Holy

[1] F. M. Powicke, *King Henry III and the Lord Edward* (1947), 724: 'He would not allow Llewelyn and the Welsh to rely upon the memories of King Arthur and the belief in his return to save them.' [2] Ibid. 721.
[3] R. S. Loomis, 'Edward I, Arthurian Enthusiast', *Speculum*, xxviii (1953), 114: 'In his cult of Arthur Edward was influenced by a vogue not exclusively English but shared by most of the aristocracies of Christendom in his days.'
[4] J. Evans, 'A Prototype of the Eleanor Crosses', *Burl. Mag.* xci (1949), 96.

Land announcing the death and reporting that his father had been buried before the high altar. About twenty years later he was translated to the magnificent and unique tomb prepared by his son. In 1291 William Torel, the goldsmith, received payment for figures of the 'King and Queen' at Westminster and for another figure of the queen at Lincoln.[1] No greater recognition of Henry's closeness to Edward the Confessor and of his deeds for his sake could have been given than by making his tomb resemble St. Edward's shrine with the use of porphyry, mosaics, and delicate twisted columns.[2] Indulgences were granted by certain bishops who proclaimed a visit to the royal tomb and to the relics placed in niches in its base to be as beneficial as that to St. Edward's shrine. The bronze effigy, the first made in England, is stretched out upon the slab, which is scattered over with engraved leopards in lozenges. The canopy above his head and the two lions at his feet have disappeared as well as the two sceptres which he held in his slender sensitive hands. The replacing of the customary stone or marble effigy by one of bronze must have been due to the wish to render special honour to the king, to the influence from tombs at Saint-Denis which is further indicated by the use of a double pillow, and in general to the taste for more precious and warmer colour effects. Henry could not have wished for a finer image: the defect in the eyelid mentioned by Matthew Paris was omitted and the impression was conveyed of an almost frail and delicate figure. Gentleness and wisdom mark the finely cut face with its high brows and slightly aquiline nose, with the wavy curls of hair and beard and the thin mouth, the corners of which curl down with the end of the moustache (frontispiece). The two royal effigies of the thirteenth century, that of John at Worcester (Pl. 29 a) and that of his son, may represent the physical and mental differences between two individuals, but much more the two different concepts of royalty, the one still full of the bristling and barely controlled vigour of the

[1] E. S. Prior and A. Gardner, *Med. Figure Sculpture* (1912), 659.

[2] F. Saxl and R. Wittkower, *British Art and the Mediterranean* (1948), 32: 'Henry's tomb is a perfect example of the classical ideal of balanced proportions. The ornaments, such as guilloches, interlaced bands and panels of lozenges and crosses, are made of coloured stones which were imported for this purpose from the Continent.'

time of the Great Charter, the other expressing the gentle and devout spirit of kings who chose their advisers from among the followers of St. Francis.

The almost feminine grace of Henry's effigy comes close to that of the second statue which Edward I ordered from Torel, for Eleanor of Castile. A payment in the Issue Roll (17 Edw. I) to Hugh de Kendall for certain work 'in the burial place of the abbot of Westminster in which the statues of King Henry and Queen Eleanor are being made'[1] suggests that the queen's tomb was prepared in 1289, one year before her death. But even so Torel's second masterpiece cannot be considered as a portrait but merely an idealized figure of the queen. Perhaps under French influence there is less reference made to fashionable dress than commonly in English tombs of this period. No wimple or kerchief hides the slender neck and wavy curls which frame the smooth brow, high cheek-bones and square chin, and there is a timeless quality in her robes. Two long dresses and a cloak are made to flow so lightly and smoothly that the shapes of the left arm, whose hand holds the mantle strap, and the knee are barely discernible, and there is hardly a deviation from their straight and even course. The style and the skill of the Purbeck marble carver in mouldings and canopy seem even more delicate when transformed into metal by the goldsmith (Pl. 76 a).

In contrast to the Roman mosaic work of Henry's tomb, the altar tomb of Eleanor executed in Purbeck marble by Richard Crundale has on each side a shallow arcade of trefoiled niches below crocketed gables, which enclose the coats of arms of England, Castile, Leon, and Ponthieu.[2] Towards the ambulatory the effigy is screened off by a transparent, curving, wrought-iron grating by Thomas de Leighton, of whose work there exist about fifteen examples in England. Fragile tendrils with conventional foliage make an intricate pattern 'approximating to the carving on the crosses and hog-backed stones of Celtic art'.[3]

[1] G. G. Scott, *Gleanings from Westminster Abbey* (2nd ed. 1863), 154.

[2] For the remains of the painting at the base of the tomb towards the ambulatory, see E. W. Tristram, *English Medieval Wall Painting* (1950), 152.

[3] F. H. Crossley, *English Church Monuments, A.D. 1150–1550* (1921), 165.

Both effigies by Torel, for all their idealized beauty, are stamped with a seriousness almost amounting to sadness, as if overcast by the shadow of death. In spite of the sparkling splendour of gilt and enamel, of the trappings of chivalrous life and heraldry and the intricacy of costume, the Edwardian effigies do not radiate the same confidence and serenity as those which went before. They seem to carry the atmosphere of the funeral ceremony and of the hearse, that was to be conveyed particularly by the new motif of mourners or weepers. This comes from France where mourners appear in niches at the side of the tomb of Louis, son of St. Louis, about 1260 at Saint-Denis. In England they are reserved for tombs close to the court as for that of Aveline and Edmund Crouchback, of Lady FitzAlan at Chichester (c. 1275), and of Archbishop Peckham at Canterbury (c. 1292).

The effigies of Edmund Crouchback and William of Valence are the most elaborate and finest of the knightly effigies which reached a climax of popularity in Edward I's reign. These are scattered all over England, more frequently now in parish churches, an expression of private piety similar to that which led to the founding of chantries. Although few can be identified, it is evident that by now not only the earls and the great barons were com-memorated, but that the custom was eagerly taken up by the gentry as a whole, as a visible proof that they were conscious of the posi-tion they had gained in the social framework in the later part of Henry's reign and in that of his son. More attention is now paid to variations of armour and weapons, with the mail and accessories no longer carved, but shaped in gesso and coloured with paint. Purbeck marble no longer satisfies the demand for richer colour and realistic detail. It gradually disappears to be replaced almost entirely by freestone by the end of the century. Further, two new materials which allow for the full development of realistic repre-sentation make their first appearance: alabaster in the effigy at Hanbury (Staffs.), c. 1300, and incised brass, of which there are early examples at Stoke d'Abernon (Surrey), c. 1277; Chartham (Kent), c. 1300; and the most beautiful, that of Sir Roger de Trumpington at Trumpington (Cambs.), c. 1280.[1] Frequently oak

[1] Prior and Gardner, op. cit., Fig. 725. With the increased demand local schools of

is used for effigies which were covered after carving with canvas, gesso, and paint. These were first produced in London workshops but were soon executed locally as at Pitchford (Salop) *c.* 1285; Hildersham (Cambs.) *c.* 1300; Ousby (Cumb.) early fourteenth century; and the most vigorous of cross-legged knights, Robert, duke of Normandy (?) *c.* 1290 in Gloucester cathedral.[1]

During the later thirteenth and early fourteenth century the effigy type of the cross-legged knight reaches a peak of vigorous action. Hands may be crossed or folded in prayer, but most common between 1270 and 1290 is the alert pose of the right hand crossing the body to grasp the hilt of a sword to unsheath it (Dorchester, Oxon., *c.* 1310; Pl. 30 *b*), or more rarely clasping a horn (Pershore, *c.* 1280), or holding a small axe (Malvern, later thirteenth century). The whole figure with legs crossed and knees bent may be turned over on its side 'dancing with springy vigour', but the head, now regularly lifted upon a double pillow, remains normally in frontal position. The face, framed by helmet or mailed hood, retains a serene calmness in the regular features and the narrow oval open eyes. How little attention was paid to portraiture is particularly evident in those effigies where the whole head was encased in a flat-topped helmet with mere slits for the eyes, as at Walkern (Herts.), Kirkstead (Lincs.), Furness (Lancs.), and in a group of effigies in Durham county, all following a pattern originally set by some knights on Wells front.[2]

It seems characteristic of Edwardian society that beside the knightly effigies those of noble ladies gained in popularity. The few made earlier, like that at Worcester (*c.* 1240) and that at Romsey abbey (*c.* 1270), still show connexions with Wells, but on the whole the Westminster Abbey influence prevails. In the west (Axminster) and especially in the north (Bedale, Yorks.) about

effigy-making developed, classified by Prior and Gardner, which at first follow the pattern established in London, but eventually develop local features of their own. Some of the extensive literature on effigies in the counties is listed in A. Gardner, *English Medieval Sculpture* (1951), 346.

[1] See F. H. Crossley, op. cit. 237.

[2] All the examples mentioned are dated late by A. Andersson, *English Influence in Norwegian and Swedish Figure Sculpture* (1949), who is generally inclined to give later dates than Prior and Gardner.

1300, different and new versions appear. The Westminster model was provided by the tomb of Aveline, countess of Lancaster, daughter of the count of Aumâle, who would have been queen of Sicily if her husband Edmund, second son of Henry, could have gained the crown. In her effigy she wears, like all ladies of the time, kerchief and wimple, with the trailing folds of the mantle tucked up under each arm to frame the folds of the undergarment which swings in soft curves from side to side, 'the sculptor now losing himself in the frail charm of the new Parisian drapery style and excelling in the reproduction of the bulging surfaces and winding soft contours of the materials'.[1]

The two knightly effigies in the choir of the abbey form a contrast with each other. The effigy of William de Valence (d. 1296), half-brother of Henry III, now in the chapel of St. Edmund and St. Thomas the Martyr, is archaic in its pose, resting quietly on its back with straight legs, like the earliest Temple knight (Pl. 76 b). The altar tomb of Reigate stone, with octofoils enclosing coats of arms, supports an oak chest which was originally covered with enamel copper plates. The same treatment was given to the effigy. Instead of paint, copper-plates, engraved, gilded and enriched with champlevé enamel in the Limoges manner, produce a softly shimmering surface with blended colours similar to the effects of Opus Anglicanum. The effigy of Edmund Crouchback (d. 1296)[2] is a quiet version of the cross-legged knight, his head resting upon a double pillow, supported by nimble angels, his hands folded in prayer. The way, however, in which the figure seems to be turned on its side towards the altar makes it seem, not merely an isolated figure like the earlier tomb effigies, but one which is emotionally as well as artistically related to the surrounding space, just as the mourners at the base of the tomb are paired, turning towards each other. The magnificent tripartite canopy of which the side compartments are now empty is a most elaborate example of the 'seigneurial' style on a minor scale, much more complex than the canopy over the tomb of Aveline and copied in simpler form in the tomb of Bishop William of Louth (d. 1298) at Ely. The mounted knight in the trefoil of the main gable and the small crenellated

[1] A. Andersson, ibid. 69. [2] J. Evans, O.H.E.A. v, Pl. 3.

parapets of the pinnacles carry the social connotations of the effigy into the setting. With cusped crockets, diapers, gilt and inlaid glass and painting, the canopy is not only infinitely richer than that over the tomb of Bishop Aquablanca at Hereford, but it does more than merely enclose the tomb. Following the general trend of the time each sculptured shape merges into the other without the clear-cut division of the geometric design at Hereford, and the empty spaces, filled with luminous shadows, with suffused colours and their reflections, give a new sense of atmosphere to the setting.

Whether it is a tomb (Bishop Thomas de Cantilupe at Hereford),[1] a saint's shrine (St. Alban's about 1305 or St. Erkenwald's at St. Paul's), a cross for Queen Eleanor or pieces of furnishing like the Coronation chair and the sedilia in the abbey, the same basic style appears in all. It was apparently formulated at court and rendered in variations which depended on the personal imagination of the artist and on provincial traditions.[2] The cross at Geddington, for instance, with its needle-point slenderness, is as far apart from the broad, space-filling cross at Hardingstone as the different figures of the queen which fill the canopied niches. The statues of Waltham Cross have a suavity of pose, with bent knee, S-shaped curve, and quiet draperies suggestive of French and courtly society. Those at Hardingstone, on the other hand, are stocky and broad with full draperies hanging heavily in a manner which is close to the school of sculptors active in the north. Although the polygonal crosses stand free, facing in all directions, they are still designed in such a way that two or three niches together combine in a frontal view. At Hardingstone the effect is that of three graduated niches, set in a slightly curved plane with the queen represented three times and the side view of the outer statues supplementing the frontal figure in between.

Edward I employed so many artists, whose names figure in the

[1] G. Marshall, 'The Shrine of St. Thomas de Cantilupe', *Woolhope Naturalists' Field Club Trans.* (1930), 45.

[2] The Eleanor Crosses, of which eleven were erected at the king's command wherever her body rested on the way from Hardby (Lincs.) to London, are dealt with in volume V of *O.H.E.A.* as examples of the beginnings of the decorated style. See also S. M. Hastings, *St. Stephen's Chapel and its Place in the Development of Perpendicular Style in England* (1955).

accounts, to make monuments for his queen and his relations, that it is all the more surprising to find his own altar tomb in the abbey, beside that of his father, so austerely bare. When Edward died at Burgh-on-the-Sands (Cumb.) in 1307, his order that his body should be carried with the army until all Scotland was subdued, while his heart was to be sent to the Holy Land, attended by 140 knights, could not be fulfilled. Whatever his intentions were with regard to his tomb in the abbey, the absence of an effigy may perhaps be considered symbolic of this king, the elusiveness of whose character has stimulated the imagination of historians, who know of his deeds without being certain of having captured the inner man.[1]

When the tomb was opened in 1774, the body was discovered wrapped in regal robes: a

Dalmatic, or tunic, of red silk damask; upon which lay a stole of thick white tissue, about three inches in breadth, crossed over the breast . . . on this stole were placed, at about the distance of six inches from each other, quatrefoils, of philigree work, in metal gilt with gold, elegantly chased in figure, and ornamented with five pieces of beautiful transparent glass, or paste, some cut and others rough, set in raised sockets . . . These false stones differ in colour. Some are ruby; others a deep amethyst: some again are sapphire; others white; and some as sky-blue. The intervals between the quatrefoils on the stole are powdered with an immense quantity of very small white beads, resembling pearls, drilled and tacked down very near each other so as to compose an embroidery of most elegant form, and not much unlike that which is commonly called, the True-lover's Knot. . . . Over these habits is the royal mantle, or pall, of rich crimson satin, fastened on the left shoulder with a magnificent fibula of metal gilt with gold. . . . The corpse, from the waist downward, is covered with a large piece of rich figured cloth of gold, which lies loose over the lower part of the tunic.[2]

[1] Peter Langtoft (Chron. ii, p. 341) mentions a portrait:

> 'From Waltham before-said to Westminster thei him brought.
> Besides his fadre he is laid in a tomb well wrought,
> Of marble is the stone and purtreid there he lies.'

But this may refer to a temporary effigy lying upon the coffin during the funeral procession and the obsequies.

[2] Sir Joseph Ayloffe, 'An Account of the Body of King Edward I as it Appeared on Opening his Tomb in the Year 1774', *Archaeol.* iii (1775), 382.

This description may serve as a reminder of the high repute English embroidery, called 'Opus Anglicanum', had gained not only in England but on the Continent.

It is to such embroideries that a statement refers, made by Pope Innocent IV and quoted by Matthew Paris in a mixture of pride and annoyance in the *Chronica Majora* under the year 1246: 'England is for us surely a garden of delights, truly an inexhaustible well; and from there where so many things abound, many may be extorted.' Innocent wrote to all the abbots of the Cistercian order to send him embroideries in gold and the merchants of London were pleased with this export trade which apparently allowed them to make their own prices.[1] The papal interest was maintained by his successors since in a Vatican inventory of 1295 Opus Anglicanum is mentioned a hundred and thirteen times.[2] It is thanks to the large amount of English embroidery sent abroad at that time, that we know the quality and richness of the work, since very little has survived in England. The name of one of the needlewomen, that of Mabel of Bury St. Edmunds, has been handed down through the royal accounts (1239–44), and Isabel, sister of Henry III, when joining her husband, the Emperor Frederick, was accompanied by a woman experienced in needlework.[3] But of the most costly and precious work, the altar-frontal which Henry III gave to Westminster abbey, only records of payments for material and labour are preserved. It was probably designed by William of Gloucester, goldsmith to the king.[4]

Examples of Opus Anglicanum produced before 1250 are very rare. Vestments reputed to have come from the tomb of St. Edmund at Pontigny in the cathedral treasury at Sens, may be English work. Upon the stole of silk twill a series of oval panels framed by scrolls and joined by six-lobed rosettes, enclose a symbol for a castle and four winged seraphs on a ground powdered

[1] Matthew Paris, *Chron. Majora*, iv, R.S. lvii (1877), 546.

[2] See A. G. J. Christie, *English Medieval Embroidery* (1938), 3, which is the standard work on Opus Anglicanum and contains excellent reproductions. Also Victoria and Albert Museum, *Catalogue of English Ecclesiastical Embroideries of the Thirteenth to the Sixteenth Centuries* (1930).

[3] Matthew Paris, *Historia Anglorum*, ii, R.S. xliv (1866), 380.

[4] J. G. Noppen, *Burl. Mag.* li (1927), 189.

with crescents, stars, or spots. A pair of buskins and fragments of a vestment from the tomb of Bishop Walter Cantilupe (1236–66), now at the Victoria and Albert Museum, at Worcester and in the British Museum, are embroidered in the same simple fashion with half-figures of kings set in the manner of a Tree of Jesse in scrolls with three-foil buds, all ornament worked almost wholly in gold and clearly set off from the ground which has scattered small gold spottings singly or in groups of three.

Almost all important large specimens now found in collections outside England seem to date from the 'great period' of Opus Anglicanum in the last quarter of the century. But the gap could be filled if an earlier date could be given, as seems justified by its style, to a cope and a chasuble at Anagni, both made in the same workshop. The late date ascribed to them is merely based on the fact that they may be identical with vestments mentioned in an early-fourteenth-century inventory of the possessions of Pope Boniface VIII at Anagni. But the simplicity of the basic design, which consists of three rows of circular medallions framed by narrow bands of gold and coloured silk, as well as the style of the figural scenes, seem close to de Brailes. Scenes from the life of Christ and the Virgin, similar to those in the Dyson Perrins Book of Hours, are set in the roundels, while kneeling angels swinging censers fill the empty spaces between (Pl. 78 a). The only unusual scene is that of the Miracle of the Cornfield on the Flight to Egypt. 'Pale brown outlines that express the features give to the faces a character entirely different from that produced by the usual black line.'[1] The chasuble is decorated in the same manner with roundels enclosing scenes from the life of St. Nicholas.

A chasuble in the Victoria and Albert Museum must date from the late sixties or early seventies, since a shield with arms on its back connects it with Edmund of Cornwall and his wife, Margaret de Clare (b. 1250). It would thus reflect the style of the lost frontal of the abbey. Upon its blue ground thin and elastic foliated scrolls enclose lions and griffins, as elegantly lively as the animals on the Westminster tiles. On its centre-back, a broad orphrey is embroidered in gold, silver, and silk threads, with four quatrefoils

[1] A. G. J. Christie, op. cit. 99.

containing the Crucifixion, the Virgin and Child, St. Paul with a sword and St. Peter with two keys, and the Martyrdom of St. Stephen (Pl. 78 *b*). 'Faces are worked in split stitch, in lines following the contour of the features, and the cheeks are stitched in indented spirals. This is the earliest example of such treatment in existing English medieval embroidery, and it continued in use throughout the "great period" until the decline set in towards the middle of the fourteenth century.'[1]

Somewhat similar to it, but at the same time closely related to the style of the Lambeth Palace Apocalypse and of the Huth Psalter, is the cope at Ascoli Piceno.[2] The Registers of Pope Nicholas IV mention that he sent a cope and other presents in charge of a Franciscan to the cathedral of Ascoli, his native town, on 28 July 1288. Eight foiled panels within circles are set closely in three tiers. Three of the scenes which they enclose, embroidered in silk upon gold ground, refer to Christ and the Virgin. A 'Veronica' head is very close to that in the Lambeth Palace Apocalypse (Pl. 79 *a*), and in the Crucifixion scene the same realistic touches appear with men hammering in the nails as in the Huth Psalter. Ample use is made of vair lining of mantles and one of the executioners in the Martyrdom of Pope Clement wears a winged helmet. The unique subject-matter of most of the roundels suggests that the cope was made by special order, because they contain episodes from the lives of sixteen popes. The last four are of the thirteenth century; Innocent IV (1243–54), Alexander IV (1254–61), Urban IV (1261–64), and Clement IV (1265–68)—the last-named giving the date *post quem*. Instead of standing out boldly from the ground, the scenes are now subtly blended with the gold background by delicately coloured silks and heraldic patterns in gold upon the draperies. A cope at Rome (Vatican, Museo Cristiano) has the refined elegance of the Court Style in its single figures as well as in the framing pattern. A thin gold net of star-shaped dovetailed panels with eight or four points is spread over the rose silk ground. The scenes of the Virgin and the Child, the Crucifixion, and the Coronation of the Virgin (Pl. 79 *b*) are set

[1] Ibid. 78.
[2] See W. R. Lethaby, *Burl. Mag.* liv (1929), 304.

in the central panels, and single slender figures of apostles and saints have ample space in the others Six-winged seraphs standing on wheels fill the smaller panels. Such seraphs occur also in a similar arrangement on the Sion Cope (Victoria and Albert Museum) which is in many ways like the Vatican Cope, though less fine in workmanship.[1] An orphrey in the Victoria and Albert Museum coming from Marnhull priory in Dorset has figure scenes, embroidered in split stitch, which closely recall some contemporary manuscript drawings[2] and are amongst the most accomplished pieces in this medium that have come down to us.

If the frontal is lost, another of the abbey furnishings, the Coronation chair, retains its original design and even more than its original celebrity. Described in contemporary accounts as of gilt wood, it was made in 1300 to take the 'Stone of Scone'.[3] Two small leopards were to be placed on either side of it, and the figure of a king, probably that of Edward the Confessor, was to be painted on its back, following the pattern of a painted chair ordered by Henry III for his hall at Windsor in 1250. The chair seems to have been placed originally near the high altar before the feretory, thus in a position opposite to that of the sedilia. It was designed by Master Walter of Durham who was also active in the Painted Chamber in 1267 and in the last period of its restoration, 1292–4.[4] To him may also be due the most outstanding of the surviving paintings in the abbey: the famous and much disputed retable (10·11 by 3). If the murals in the Painted Chamber were still intact and if some at least of the many painted panels made for Henry III and mentioned in the Rolls were preserved, the retable would not seem so unique and so surprising as it seems now, even

[1] About the later phase in the development of Opus Anglicanum, of which the replacing of foils and stars by an elaborate architectural setting is one of the main characteristics, see J. Evans, O.H.E.A. v. 17–19.

[2] A psalter written for Hyde Abbey c. 1300, Bodleian Library, MS. Gough Liturg. 8, is an example.

[3] M. Hastings suggests that the present Coronation chair was copied after a bronze chair which had been ordered by the king in 1296 after his return from Scotland, and that it is in the style of 1296. He compares it with St. Erkenwald's shrine of 1313, and the Prior's Throne at Canterbury c. 1304. See M. Hastings, St. Stephen's Chapel (1955).

[4] W. R. Lethaby, 'Master Walter of Durham, King's Painter c. 1230–1305', Burl. Mag. xxxiii (1918), 3.

in its battered state.[1] Some of its peculiar features—the use of painted glass and embossed gilding, the inset of gold plaques and jewels in imitation of enamel work—were also employed in the canopy work of the great Coronation panel and in the decoration of the Coronation chair. It will probably never be possible to know the actual purpose for which the retable was made. Its iconography and the fact that gesso and coloured glass served in place of precious metal, gems, and genuine cameos make it doubtful whether it was connected with the high altar, even as an antependium, and the suggested alternative that it was part of the cover of St. Edward's shrine cannot be proved, although the miracle scenes in its star-shaped panels could support such a view.

It is divided into five panels of different sizes. On the sides and in the centre, niches are framed by a delicate raised canopy of clustered shafts adorned with minute figures of lions and eagles and of fleurs-de-lys. The crocketed gables and intricate pinnacles are inset with blue glass. In the left outer panels, St. Peter is placed (Pl. 80), while in the centre St. Mary and St. John, both holding palms, flank the figure of the Deity as Creator who holds the small disk of the Universe in His hand. This is the same arrangement as that of the Creation scenes in the Bible of William of Devon. In the square fields between the outer and centre canopies four star-shaped panels are joined by quatrefoil bosses in a pattern which is like that on the Vatican Cope. Of these scriptural scenes inside the panels, only three on the left can be identified as representing miracles such as the Raising of Jairus's Daughter, the Healing of the Blind, and the Feeding of the Five Thousand. Even in their poor and fragmentary state, the paintings show not only a superb skill but a strong all-pervading sentiment (Pl. 83 a). It is shown by the telling gestures of the long sensitive hands and by the expression of the faces, which have such a peculiar formation, the high cranium, long nose, and quickly narrowing lower parts. A uniform soft rhythm, in gently undulating folds and carefully waved curls and hair, goes through the whole, and the figure of

[1] For literature on the retable, a thorough discussion of it and of related works see F. Wormald, 'Paintings in Westminster Abbey and Contemporary Paintings', in *Proceedings of the British Academy* (1949), 161.

St. Peter calls to mind the art of Duccio with its grace and gentle melancholy.[1]

The same features appear in the two important wall paintings in the lower blind arcades of the inner south transept front in the abbey: the Incredulity of St. Thomas and St. Christopher. In both the figures stand out with monumental strength from the coloured background. The aged St. Christopher, bent under the weight of the Child, is vastly different from the same figure in the Westminster Psalter and the Lambeth Palace Apocalypse. The voluminous mantle, which is arranged in convoluted folds, is drawn over his head, and there is something gravely touching in the manner in which he supports the Child, who puts His arm trustingly around his shoulder. The showing of one foot of the Child with its bare sole is a realistic touch which occurs also in the Douce Apocalypse. There is great majesty and compassion in the figure of Christ as He guides the hand of St. Thomas to His wound (Pl. 81).

The figure of St. Faith, in the St. Faith chapel entered from the south transept, although less well preserved, especially as to its face, has the same majestic quality. The tall figure of the saint stands quietly, framed by a painted canopy with crocketed gable and pinnacles, clad in a green tunic and a rose mantle lined with vair against a vermilion ground. The folds of the mantle are arranged in the new fashion found also in the Eleanor statue of Waltham Cross. Swathed around the figure, its ends fall down on either side from the arms in serpentine folds while in front it swings from hip to hip in a few concentric curves. Four star-shaped panels like those on the retable form a painted predella on either side of a square panel which contains the scene of the Crucifixion. Not only is the figure painted so as to suggest a stone

[1] In the Archivio Capitolare of the cathedral at Velletri, three pieces of what must have been once a roll are preserved. Below the trefoiled arches of the painted niches, scenes from the Passion, now beginning with the entry into Jerusalem and ending with half of an event after the Resurrection, are inserted. The star-shaped panels in the spandrels, containing single figures, as well as the style of the whole are close to the retable. See Ernesto Monaci, 'Un rotolo miniato d'arte francese a Velletri', *Mélanges offerts à M. Emile Chatelain* (Paris, 1910), 440–1, with plate, and G. de Francovich, 'Miniature inglesi a Velletri', *Bolletino d'Arte* (1930), 17.

statue on a pedestal, but the spatial connexion between her and the enclosing masonry arch of the niche is accentuated by the painting on the northern jamb, where a Benedictine monk kneels in prayer, the words of which are painted on the east wall as if rising towards the saint.

The retable and the other Westminster paintings are often compared with the Douce Apocalypse, and the figure of St. Faith seems to be preceded by similar figures in the Abingdon and the Lambeth Palace Apocalypses. The illustrated apocalypses produced in the last quarter of the thirteenth and early in the following century convey perhaps best the changed outlook in spiritual matters. They are weak descendants of a great tradition. Though still remarkable creations, they have nothing of the visionary or the historical mode of interpretation found a generation earlier, but rather have the character of the romance or even the fairy tale. The Douce Apocalypse (Bodleian, MS. Douce 180)[1] consists of two parts. The first of twelve leaves with the text of the apocalypse and an exposition in French has no illustration other than a large historiated initial in the beginning with cusped bar and a hunting scene in the lower margin of no outstanding quality. Its letter S contains in its lower curve two scenes divided by a small column supporting two trefoiled arches: St. John writing at a desk and St. John preaching to a seated audience. In the upper curve the Trinity is flanked by two kneeling figures, a knight in mail and a lady, who uphold shields with coats of arms of Edward I (as prince) and Eleanor. From this it has been concluded that the book was at least begun under their patronage, before their accession to the throne. It is in the pictures of the second and main portion, the apocalypse with a Latin gloss, that one finds the startling new approach which distinguishes the Douce Apocalypse from its immediate predecessors. These are two apocalypses (Bodleian, MS. Canon., lat. 62, and Cambridge, Magdalene Coll. MS. 5) for which a Peterborough origin has been suggested. Neither has scenes from the life of St. John, which are also absent from the Douce Apocalypse, in common with most later versions, where

[1] M. R. James, *The Apocalypse in Latin and French*, Roxburghe Club (1922). Also F. Wormald, op. cit. 171.

the Antichrist scenes are also omitted. In both, the seventy-eight half-page pictures are tinted outline drawings derived from an edition such as the Dyson Perrins Apocalypse, but with a later style of drapery, naturalistic foliage and emphatic, worried facial expressions.[1] Otherwise they do not prepare in any way for the novel manner in which the artist of the Douce Apocalypse gives new life to the by now traditional scenes.[2] Although traces of the style found in the *Life of St. Edward* can still be detected, the most revolutionary change lies in a new concept and treatment of space. This is partly created by a sense of freedom in the movement of the figures, despite their voluminous robes, falling about them in sweeping, convoluted and very various folds. The angel who carries the millstone on his shoulders so that it looks like a second larger halo behind the first, balances its weight most carefully and both wings are bent to one side, like those of some of the angels in the Angel Choir, of whom the angels in the apocalypse are the nearest relatives (Pl. 83 b.).[3] The effect of distance is created by rudimentary perspective in the buildings, and by the suggestion of a recession in successive grounds one behind the other. Thus the heavenly visions appear not only above the earth but farther away · above the horizon, and one feels the distance over which the angel has to carry St. John before they reach the broad steps which lead up to the elegant gates of the Heavenly Jerusalem. In the few pictures which are fully or partly coloured, strongly contrasting colours in the contemporary dresses and in the lush vegetation, silver for armour and weapons, pink faces and grey-skinned beasts, give a strong worldly character to the illustrations.[4]

[1] A third apocalypse grouped with those above by James (Bodleian, MS. Tanner 184, now Auct. D. 4. 16) is based mainly upon the earlier version (Auct. D. 4. 17).

[2] An original interpretation is given to the first Rider who resembles Christ with a cross-nimbus.

[3] In the apocalypse (Paris, Bibl. Nat. MS. lat. 10474) which is a sister book to the Douce Apocalypse and, like it, not French but English, the angel blowing a trumpet (f. 15v.) is even seen from the back, his wings in front of the frame. The illustrations on the whole show many variations, as for instance in the case of the witnesses, who are not, as in the Douce version, dressed in mendicant habits with knotted cords.

[4] The fighting scenes have a likeness to those in the Painted Chamber and to the 'Battle between Harold and William' contained in the composite volume of historical writings, including the Laws of St. Edward, B.M. Cotton MS. Vitellius A. XIII. In

While the Douce Apocalypse stands at the end of a long row which began with the apocalypses in Trinity College and Paris, the artist of the Dublin Apocalypse (Dublin, Trinity Coll. MS. K. 4. 31) tries to find a new and unique method of illustration.[1] The volume contains in addition to the apocalypse with commentary some directions for church services and the Meditations of St. Bernard, which are also added to the apocalypse in the Bodleian, MS. Canon, lat. 62. All the pictures are set in foils of varying shape upon a diapered or patterned ground, set in turn within a rectangular patterned frame. Within the foils the ground is usually coloured blue or pink and covered with delicate white flourishes. All the bolder appear the figural scenes which the artist fitted into the difficult shapes with an unerring sense of ingenious compression. With strong outlines and bold colouring and with an admirable economy of setting, the scenes stand out with precision and spatial implications are conveyed with surprising skill. In about half of the pictures St. John does not appear at all (Pl. 84 a). Where he is included he is beardless like all other figures except that of the Witnesses and of the Deity. The vision of the Deity is very often limited to the bust and a sad, nimbed head. 'The more obvious horrors are subordinated to the beauty of imagery' and the Beasts have the 'intimate formalised charm of heraldic creatures.'[2]

An intentional archaism is maintained in another group of late apocalypses of which the Greenfield Apocalypse (B.M. MS. Royal 15 D. II) is the best. The large folio volume which belonged once to Greenfield nunnery (Lincs.) contains the poem *La Lumière as*

this volume the illustrations, of considerable historical interest, consist chiefly of effigies of kings from St. Edward to Edward I with very brief descriptions in French in blue and gold below the pictures. In one, Richard I in prison stands in front of a castle gate and the text contains a reference to the sale of chalices to raise his ransom, in another John receives a poisoned cup from a monk of Swineshead priory. The text to the coronation of Henry III contains a reference to the battle of Evesham and the death of Simon de Montfort. On the whole these representations of kings make a characteristic contrast to those by Matthew Paris. See O. E. Saunders, *English Illuminations*, i (1928), 81.

[1] This apocalypse is later, by some dated in the early fourteenth century, and a Peterborough or East Anglian origin is suggested by James. See M. R. James, *The Dublin Apocalypse*, Roxburghe Club (1932).

[2] J. Wardrop in *Burl. Mag.* lvii (1930), 154.

Lais and the apocalypse in French with commentary.[1] The pictures, reverting in their varying size and position in the text to an earlier tradition, are on diapered, coloured backgrounds, drawn with long sinuous contours. A few strong black lines suffice to indicate folds, but faces and curls of hair are drawn exquisitely with the pen. The colouring shows a preference for blue-greens and purples, against which the ivory-white in the robes of angels and elders forms a highly sophisticated contrast. An archaic repetition of pose and gesture is chosen for the scenes of crowds in heaven, closely packed in alternating purple and blue garments with only heads appearing in the rows behind. But in order to reach this heaven, St. John has to climb a ladder, an artificially naïve motif which is repeated in many of the late apocalypses. Old features like the *Beatus* Jerusalem are revived in another manuscript (Oxford, New Coll. MS. D. LXV) and new realistic ones appear such as the representation of the fourth Rider as a skeleton in a shroud (B.M. MS. Add. 22493; Florence, Laurentiana, Cod. Ashburnham 415). Beautiful as all these later examples are in draughtsmanship and colour, something of the joyous certainty of earlier work has gone out of them. Their ornateness cannot conceal the underlying sombre mood, the sad eyes below sharply angled brows and the drooping mouths.

It seems most likely that it was Edward I's cousin, Edmund, earl of Cornwall, who gave to his foundation, Ashridge College, a bible with the commentary by Petrus Comestor, now B.M. MS. Royal 3 D. VI. In the manner of its decoration, it is the direct offspring of the Bible of William of Devon and the quality of the work is worthy of the most exacting patron. The first page of the New Testament (f. 234) is completely enclosed by a broad band with a most delicate pattern on blue and brown ground which expands into cusped scrolls ending in ivy and oak leaves.[2] Four shields contain the arms of Edward I and his son Edward, and of Richard of Cornwall and his son Edmund (d. 1300). Animals, and especially birds, are most carefully placed in the corners and in the centre of

[1] D. D. Egbert, 'The so-called "Greenfield" La Lumière as Lais and Apocalypse', *Speculum*, xi (1936), 446.

[2] Reproduced in E. G. Millar, *Engl. Ill. MSS.*, Pl. 95.

each bar, and a peacock with grey-blue body, sapphire-blue neck with emerald neckband, dove-grey back and golden headpiece and tail is so beautifully painted that the effect of soft texture and brilliant colour is achieved. The chapter initials do not always have the usual subjects. For Deuteronomy (f. 93) Church and Synagogue are given (Pl. 82 *b*), and for Esther (f. 210*v*.) a banqueting scene very similar to that of St. Edward with his queen and courtiers in the historical volume (B.M. Cotton MS. Vitellius A. XIII, f. 3).

Such rich and intricate decoration would not have been suitable for the ordinary bible, but a few biblical or patristic manuscripts have similar borders with natural leaves and initials executed with the same delicate penwork in the faces and hands and the same subtle colour harmonies. The bible (Cambridge, Sidney Sussex Coll. MS. 96),[1] the epistles of St. Paul (Cambridge, Trinity Coll. MS. B. 4. 1), the *Gregorii Moralia super Job* (Cambridge, Emmanuel Coll., MS. II. 1. 1)[2] are outstanding examples of this type. In the latter each book begins with a small historiated initial, many of which have been cut out. The delicate penwork is matched by an equally delicate colour scheme. On f. 154 two Benedictine monks kneel below Christ who stands in a small niche in the centre bar separated from them by one of the columns of the written text. Their black cowls make a beautiful contrast to the green, blue, and pink of the broad leaves of the bars (Pl. 89).

[1] M. R. James, *Cat. of MSS. at Sidney Sussex College*, no. 96.

[2] M. R. James, *Cat. of MSS. at Emmanuel College*, no. 112. James suggests a possible Norwich origin. But it is very questionable to what extent monastic scriptoria still produced books at this time. See N. R. Ker, 'Medieval Manuscripts from Norwich Cathedral Priory', *Cambridge Bibliographical Soc. Trans.* i (1949), 8: 'The payments to illuminators are much less than those to scribes. It is not surprising that the monks hired scribes to write books in this period, instead of doing the writing themselves. The difficulties in maintaining the monastic scriptoria during the thirteenth century for the production of literary manuscripts must have been very great. The scriptoria flourished just as long as the books of the old twelfth century kind were copied in the old way, as they still were, commonly, in the early part of the thirteenth century, but they were not able to adapt themselves so as to deal with the products of the new learning in the universities and the closely written books which are so typical of the century. . . . The decay of the scriptoria must have been encouraged also by palaeo-graphical developments during the thirteenth century, as a result of which the hand used for writing books became, for the first time in England, very different from the hand used for writing documents.'

As to psalters and books of hours, the 1270's and 80's are years of transition; while some books were produced with decorations in the style of the previous decade, others opened the way to entirely new developments. It became customary to insert into psalters leaves whose illustrations gave greater prominence to the saints. The tinted drawings in the psalter B.M. MS. Royal 2 B. VI[1] with scenes of martyrdoms, influenced by the illustrated lives of saints discussed in a previous chapter, are among the earliest examples. From the same source, though later, springs the much more complete cycle, Cambridge, Fitzwilliam Museum MS. 370, which originally may have preceded a psalter. The tinted drawings, however, have such strong contours and the manner of telling the legends is of such popular simplicity that the leaves may well represent a pattern-book, eminently suitable for wall paintings in smaller churches. Although its date must be late in the 1270's, the horse of St. Martin is still shown full front in the Matthew Paris manner (Pl. 84 b).[2]

In the Grandison Psalter (B.M. MS. Add. 21926), a provincial work, written possibly before 1276, as St. Richard is entered in the kalendar, but not his Translation, the cycle of saints and martyrs has been increased to fourteen, including not only the Martyrdoms of St. Edmund and St. Thomas, but also St. Edward and the Pilgrim, and, rare in English psalters, St. Francis preaching to the Birds.

The Huth Psalter (B.M. MS. Add. 38116) dates from the 1280's and its illustrations seem to be the result of a faint influence from Westminster upon a provincial artist. A full-page Majesty with six roundels containing creation scenes precedes one page with four Old Testament scenes and six with fifteen New Testament stories. The scenes are set in an architectural frame of foiled and pierced arches, alternately blue and pink, on gold or diapered coloured ground. Elegant little figures move vividly in robes the folds of which are drawn with quick, single strokes of the pen (Pl. 85 a). The full-page Last Judgement is arranged in three tiers in the

[1] See above, p. 173.
[2] M. R. James, 'An English Picture Book of the late Thirteenth Century', *Walpole Soc.* xxv (1936–7), 23, Pls. ix–xxviii.

manner of the French tympana, with dark-skinned devils stirring the cauldron filled with souls. Realistic details increase the liveliness, such as the midwife who touches the hand of the Virgin in the Nativity, the little Innocent speared upon the sword of a soldier and held up like a banner, the men who hammer in the nails and the drop of blood falling into the eye of Longinus in the Crucifixion. The full-page 'B' of the Beatus page holds a Tree of Jesse in which David and Goliath and two tilting knights are entwined in the subsidiary scrolls; and in the other full-page initial, for Psalm 109, four scenes are fitted into roundels and half-roundels suggesting a survival of an earlier tradition in circles not immediately touched by Westminster (Pl. 85 c).

The Huth Psalter has connexions with Lincoln, and to Lincoln point the Salvin Hours ($12\frac{3}{4}$ inches by $8\frac{3}{4}$ inches), a Book of Hours of Sarum Use which is closely related to it (formerly Yates Thompson Coll. no. lxxx, then Chester Beatty MS. 60).[1] The book contains the Hours of the Virgin, the Hours of the Holy Ghost and the Hours of the Trinity, with large historiated initials to the Hour Services, smaller initials, and elaborate line-endings (of the three full-page frontispieces to the Hours, two remain). The Hours of the Virgin open with a large 'D' in pink, blue, and vermilion on a patterned gold ground which encloses a Tree of Jesse. In the outer scrolls of the tree, eight scenes are inserted, beginning with the Betrothal of Joseph and Mary and ending with the Flight into Egypt. The 'D' of the Hours of the Holy Ghost, similar but much superior to that of the Huth Psalter, contains the Ascension and Pentecost in roundels and the Noli Me Tangere and the Doubting Thomas in half-roundels. The decorations are in many ways still close to those of the Salisbury group, with the solid frames for the letters, the bright red and blue of the colouring contrasting with the gold ground, the broad cusped bars with dragons ending in human faces such as that of a lady with a wimple. In the Passion scenes the executioners have grotesque ugly faces with prominent misshapen noses, and supplemental

[1] *Illustrations from 100 MSS. in the Yates Thompson Coll.* iv, Pls. xxiv–xxviii; E. G. Millar, *A Descriptive Catalogue of the Western Manuscripts in the Library of Chester Beatty*, ii. 70–75, Pls. cxxiii–cxxvi and coloured frontispiece.

scenes are added in the margins such as Pilate washing his hands (f. 32*v*.) or St. Peter weeping after his denial (f. 35) (Pl. 87). The smaller initials for the Hours of the Holy Ghost contain martyrdoms, among them the remarkable one of St. Catherine (f. 117*v*.), who sits high up on the axle between the green and white wheels spiked with knives; the upper part of the wheel falls off to hit and burn some of the people stricken to the ground (Pl. 82 *a*).

Another book of hours (Baltimore, Walters Art Gallery, MS. 102)[1] with thirty-four historiated initials, line-endings, and drolleries, has also certain old-fashioned features, although its main illustrations are later, towards the end of the century. Ornamental pen-drawings in blue, red, and gold go diagonally from the first letter of the last line across the lower margin and are still like those in the de Brailes manuscripts, although some have excrescences of the weirdest form. If the book was illustrated by two artists for a foundation of Austin Canons, as has been suggested, the drolleries reveal curious interests for a monastic community. The religious implications of earlier fancies have been forgotten and many of the new type are extraneous to the text, such as a pair of wrestlers reminiscent of Matthew Paris, and are decidedly secular, to the extent of frivolous mockery of the clerical state and church ceremonies. A family of monkeys, or an elephant and castle, stem from the bestiary, which as a number of late manuscripts witness, seems to have enjoyed a fresh popularity at this time. The Roman twins are suckled and licked by the wolf (f. 29*v*.) and a beautiful specimen of the first man is fitted as a large picture into the invocation of the saints (f. 28*v*.), but a new note is struck by the animals which either in their natural state or dressed up as priests or pilgrims seem to satirize the secular clergy.[2]

These provincial productions, which can hardly be called progressive, have led away from the main stream of development, the course of which is determined by the tastes of court and gentry. These are reflected in the illustrations of the Cuerdon Psalter

[1] *Illuminated Books of the Middle Ages and Renaissance*, The Walters Art Gallery (1949), 56.

[2] A line drawing of the Martyrdom of St. Laurence (f. 105*v*.) is close to the Fitzwilliam picture-book, only much coarser, and seems to be a throw-back with its grotesque faces and winged helmets of the soldiers.

(Pierpont Morgan MS. 756) which is still close to the style of the Bible of William of Devon. Some pages preceding the psalter contain small pictures, generally six to a page, of scenes from the lives of Christ and of saints and martyrs (Pl. 66 b). These are usually arranged in couples, amongst them two female saints in Benedictine habits, divided by a slender column and under trefoiled arches.[1] The Tenison Psalter (B.M. MS. Add. 24686) was probably commissioned as a wedding gift for Alphonso, son of Edward I, but before it was completed, the contemplated marriage with Margaret, daughter of the count of Holland, could not be celebrated as Alphonso died in 1284. The writing of the psalter had proceeded by then as far as f. 18; the first three leaves inserted at the beginning and the first eight leaves of the psalter were executed by an artist of the first rank, the rest was completed later in a less accomplished fashion. Three leaves at the beginning contain twelve single figures of saints on blue-diapered and gold burnished ground. These figures sway in S-curves, and the broad, sweeping folds of their mantles either hang down from each arm showing different coloured linings or swing across in softly rounded curves. The colours are delicately blended and their brightness is set off by contrast with the black habits of the Benedictine nuns of St. Frideswide and St. Barbara (Pl. 86 b).

The eighteen minute pictures of the Passion (six on a page) on gold ground, are pasted down in one corner of a carpet-like panel, alternately blue and lake, which are covered somewhat preciously with varying patterns, one of which is made by lions rampant, such as occur in the Arundel Psalter (Pl. 88 a). On the Beatus page the coats of arms of England and of the count of Holland are set in the border, an example of the growing use of heraldry in illuminated books. The border goes now all around the page holding birds and other drolleries which, however, form an integral part of the scheme. At the bottom, the tiny figure of David, poised lightly on a piece of green ground and holding the sling like a toy, faces Goliath, who steps toward the right away from David but turns his face back towards him. The biblical scene is turned almost

[1] *The Pierpont Morgan Library: Exhibition of Illuminated Manuscripts* (1934), 22–23, Pl. 40. After 1262, for the Feast of St. Richard is marked in the calendar.

into one of genre, like the beautiful hunting scene (f. 13 v.) with a lady in a blue robe and crouching dogs eager to pursue an elk and its young. Incidents such as this prepare the way for similar but more elaborate scenes in later psalters such as the Ormesby Psalter, and the parchment ground is no longer merely a neutral foil but carries a suggestion of airy space. In the Tenison Psalter the marginal figure of an angel blowing the trumpet (Pl. 85 b) has the freedom and power of action of some of the later angels in the Angel Choir and is similar in style to the figure of the Fool (f. 53v.) in the Windmill Psalter (New York, Pierpont Morgan Libr., MS. 102) (Pl. 86 a). Prior suggested that this latter psalter was produced at York,[1] because the full figures with their heavy robes reminded him of York sculpture at the end of the century. A comparison between the Tree of Jesse on its Beatus page with that of the Huntingfield Psalter illustrates the distance between the style at the beginning and that at the end of the thirteenth century. Instead of a formal pattern built up of neutral and abstract forms in relief, the Tree in the Windmill Psalter rises in luxuriant growth, its branches twisting forward and back sending out fleshy scrolls and lush broad leaves. The roundels are no longer separable but blend into each other, sometimes held together by woodland figures made of leaves, and the heavy figures of prophets and angels, some seen from the back, seem to be sucked in to a bower of stems and leaves.[2] Shades of the Lindisfarne Gospels seem to come alive again in the unique Beatus page with its incredibly intricate pattern drawn with a pen on a red ground.[3] But the free arrangement of figures in the Judgement of Solomon disregards all relation to geometric pattern, and the angel who swoops down boldly foreshortened, showing the soles of his feet and spreading his arms and wings, seems to move through a space such as architects were creating in the nave and the chapter-house of York minster.

Of all psalters the most extensive and splendid and the one that is most pregnant of the new trends is the Arundel Psalter (B.M. MS. Arundel 83). The large volume consists now of two psalters bound together (ff. 1–116v.; ff. 117–36) illustrated by different artists.

[1] See M. R. James, *Catalogue of the Pierpont Morgan Library*, No. 19 (1906), 41–43.
[2] E. G. Millar, *Engl. Ill. MSS.*, Pl. 99. [3] J. Evans, *O.H.E.A.* v, Pl. 6.

These must have been guided by a person well versed in scholastic theology who devised a most elaborate sequence of pictures illustrating scholastic themes, a reflection of the new dominance of the teaching of Aquinas. 'The idea of correspondences dominates them: in one each of the Ten Plagues represents a punishment for a breach of one of the Ten Commandments; in another the eight Beatitudes reach their reward in a grade of the celestial hierarchy; in a third the seven Offices of the Hours are related with the seven scenes of the Passion and with the curiously assorted gifts of sight, smell, taste, hearing, touch, agreement, and liberty of judgment.'[1]

The page with the table of the Twelve Articles of Faith (f. 12) has borders on the sides which are divided into square panels with gold, blue, and red diapered grounds, which contain the prophets on the left and the evangelists on the right. The centre panel contains correspondingly twelve figural scenes beginning with the figure of God the Father and ending with Christ seated beside the Virgin or the Church, inscribed 'vita aeterna'. Wavy scrolls with inscriptions connect a pair of prophets and apostles with each scene in the centre, crossing a red background which is decorated with yellow lions rampant like those in the Tenison Psalter. The Tree of Life (f. 13) taken from Bonaventura is a large green tree growing from a hill upon which sits St. John the Evangelist. St. Paul, Jeremiah, and Moses stand on its right, Daniel, Ezekiel, and St. Peter on its left. The figures of the apostles and evangelists are seated on the ends of thick branches which spread towards them carrying inscriptions. The figures of the Good Thief and of Nicodemus are placed above the straight branch which forms the horizontal bar of the cross which supports Christ, and the pelican feeding its young is placed on top. In the Tree of Jesse of the Beatus page (f. 14) the members of the genealogy are placed in star-shaped panels like those on the retable.

The second psalter is usually assumed to have been produced about thirty years later, as a note at the end of the second calendar mentions that Robert de Lyle gave the psalter to his daughter in 1339. It also is preceded by a series of full-page pictures illustrating theological systems of thought. The Sphere 'after Archbishop John

[1] Ibid. 8–9.

Peckham' (d. 1292) consists of concentric circles (f. 124*v*.). In the centre Hell is placed with a hell-mouth and flames on a black ground, surrounded by four circles in green, blue, yellow, and red for the four elements, and followed by the circles of planets and stars in blue. On the periphery the 'caelum empireum' encloses all, with God upon the Throne in a foiled medallion above. The whole design may serve as a reminder that the psalter was produced at the time of Dante. The Wheel of the Ages of Man (f. 127*v*.) with scenes descriptive of the ages in medallions on the periphery and with a sombre 'Veronica' head in the centre, is reminiscent of de Brailes's Wheel of Fortune (Pls. 22 and 88 *b*), but at the same time different, at least in feeling. It implies, as do all these illustrations in the psalter, that an increase of knowledge or at least its intricate classification did not necessarily induce happiness. All the elegance in dress and manner cannot lighten the sense of transitoriness which is so strongly expressed in the 'Three Living and Three Dead Kings' (f. 128) and which must have been felt by Edward I when sudden death took his wife and his young son. Between May 1302 and July 1303 Amadeus V of Savoy, cousin of Edward I, bought, while in England, two panels representing the same subject from Bernardo di Mercato.[1] It has been pointed out that a close relation in style exists between the picture in the Arundel Psalter and the figures on the sedilia in Westminster abbey, made about 1308, and furthermore that Walter of Durham had two assistants who came from East Anglia.[2] The new style of psalter illustration which blossomed forth so profusely in the last years of Edward I's reign and which is commonly called 'East Anglian' has without doubt its roots in the art of the Court School.[3]

[1] See E. Carleton-Williams, 'Mural paintings of the Three Living and the Three Dead in England', *Brit. Arch. Assoc. Journ.*, 3rd ser. (1942), 31: 'The form in which the legend was known to medieval artists was inspired by four short thirteenth century French poems. The best-known of these, "Li troi vif et li troi mors", was written by Baudouin de Condé, minstrel at the court of Margaret II, countess of Flanders, 1244–80.'

[2] F. Wormald, op. cit. 175. The short verses above the miniature and a French poem in the Arundel Psalter are quoted by W. F. Storck, 'Aspects of Death in English Art and Poetry', *Burl. Mag.* xxi (1912), 319.

[3] These psalters are discussed by Joan Evans in *O.H.E.A.* v. 8–16. A beautiful example has been recently discovered at Longleat (Wilts.) by Dr. G. Zarnecki, and has been photographed for the Courtauld Institute.

XIII

CHURCH AND CASTLE BUILDING UNDER EDWARD I

EDWARD I left no building such as Westminster abbey that could compare with the undertakings of his father or his uncle St. Louis. One large monastic church was built at his initiative and one royal chapel was begun at Westminster. But, even were they still in existence, they could not counterbalance his father's contributions in this field. There was in his reign less stimulus to build new churches, partly because so much had been done in the first half of the century, partly and perhaps even more because the spiritual need was no longer the same. The universal church under a Boniface VIII was not that of Innocent III. St. Thomas Aquinas and Bonaventura were dead in 1274. The English Church was not led by bishops as a united group, inspired by the same ideals as those who worked with Stephen Langton or with St. Edmund Rich. Archbishop Pecham (1279–92) acquired a reputation as a scientist and a poet, but he lacked the universality and idealism of a Grosseteste.[1] Most of the bishops were good administrators and disciplinarians, stern lords of their vineyards rather than gentle shepherds of their flocks. Some were untiring in the visitations of their dioceses of which there are ample records, with unfortunately little reference to building or the other arts. But the general tone in the field of the arts was set by men like Robert Burnell and Antony Bek.[2] Burnell, bishop of Bath and Wells (1275–92) and chancellor of Edward I, aimed at founding a baronial house in Shropshire, and owned at his death estates in fifteen

[1] See D. L. Douie, *Archbishop Pecham* (1952), 18: 'His significance in the history of medieval scholasticism is that his thought shows the beginning of the transition from the eclecticism of the early Franciscan thinkers towards Duns Scotus's subtle and penetrating criticism of the whole Thomist position.'

[2] For Robert Burnell, see F. M. Powicke, *The Thirteenth Century* (1953), 338–9. On Bek's episcopacy, see R. K. Richardson in *Archaeologia Aeliana*, 3rd ser. ix (1913), 89.

counties. Antony Bek, bishop of Durham (1284–1311), was a magnificent prelate who never showed to better advantage than when he went out hunting or warring against the Scots, with a retinue of 140 knights. He was the first bishop of Durham who dared to intrude into the chapel of Nine Altars at the cathedral, ordering his tomb to be near the shrine of St. Cuthbert. Both he and Burnell increased the scale of their episcopal residences. The few and fragmentary remains of episcopal palaces built in the first half of the thirteenth century indicate that they were of a fair size. Stephen Langton is credited with the building of a large hall at Canterbury, portions of which still exist in the present palace.[1] Those at Lincoln, said to have been begun by St. Hugh and completed by Hugh of Wells, and at Bishop Auckland (Durham) were smaller, aisled with two rows of pillars down the centre and thus similar to the King's Hall at Winchester.[2] At Lambeth palace the chapel remains as a beautiful example of episcopal taste about the middle of the century.[3] Raised upon a perhaps slightly earlier undercroft, its four bays are lit by triplets of gradated lancets in the side walls, with Purbeck shafts originally supporting the rear arches, and impressive groups of four lancets in the east and west walls. At Wells Bishop Jocelin had built a palace beside the cathedral, the vaulted basement of which still exists, retaining parts of its foliated windows. Above the basement were a hall and a small solar. But Burnell was not satisfied with such an unpretentious residence. He added a very large hall, chapel and other chambers at right angles to Jocelin's palace. Though now in ruins, the hall still shows the majestic size and the beauty of its traceried windows of exceptional height. Burnell treated his episcopal residence like a castle. After having received licence to crenellate in 1285 he gave to hall and chapel a crenellated parapet, and a battlemented wall enclosed an inner ward, raised upon a rampart and strengthened by four towers at the corners and half-towers between. A strong gatehouse

[1] See plan by A. W. Clapham in *Arch. Journ.* lxxxvi (1930), 239.

[2] See M. E. Wood, 'Thirteenth Century Domestic Architecture in England', *Arch. Journ.* cv. (Supplement 1950), 18, 44.

[3] R.C.H.M., *London: West* (1925), 79–80. The chapel has been restored after suffering heavy bomb damage.

faced towards the cathedral across the broad moat fed by the water of St. Andrew's Well.[1] In the north, at Durham castle, Bishop Bek built the great Hall, still 'one of the finest examples of a castle hall both for size and simple grandeur',[2] though little of the actual work of Bek's time is still visible.

Unfortunately there are no effigies left of either, but other funeral effigies of bishops from the last quarter of the century show a different spirit from that of the fifties. That of Peter of Aigueblanche (d. 1268) in his new transept at Hereford has still much in common with that of Archbishop de Gray at York, the figure carved as a massive block, the vestments rendered in strong relief with vertical or V-shaped folds.[3] But in the later tombs of Bishop Walter de la Wyle (d. 1271) at Salisbury, of Bishop Laurence of St. Martin (d. 1274), and Bishop Thomas Ingaldsthorpe (d. 1291) at Rochester, and of Archbishop Pecham (d. 1292) at Canterbury, the heroic concept of the bishop, robust in health, vigorous in action, radiant with spiritual life has disappeared. Frail bodies, which seem, with diminished relief projections, to have sunk partly into the supporting slab, are covered by soft vestments flattened down in smooth overlapping folds, which fall in undulating curves at the sides. The design of the canopies over their heads follows in intricacy and richness the lead of contemporary architecture, creating soft shadows and colouristic effects which must have been richer when the original painting of the effigies was still fresh. The canopy over the head of Bishop Laurence of St. Martin has ornaments similar to those of the retable at Westminster. The splendour of the apparel contrasts with the expression of the faces, which are those of older men resting peacefully in resignation and not reawakened to eternal life. One of the best-preserved and most sensitive of this type is the effigy of 'Chancellor Swinfield' (c. 1290), probably a member of the Swinfield family in Hereford,

[1] C. Oman, *Castles* (1926), 59.

[2] W. T. Jones in *V.C.H. Durham*, iii (1928), 73.

[3] The effigy of a priest at Clifford (Herefordshire) is similar to that of Peter of Aigueblanche, but carved in oak. According to G. Marshall, 'Wooden monumental effigies in Herefordshire', *Woolhope Naturalists' Field Club Trans.* (1920), 189, it is the earliest of its kind known at present (Pl. 77 a). See also A. Andersson, op. cit. 70, and A. C. Fryer, *Wooden Monumental Effigies in England and Wales* (1910), 10.

in alb and chasuble and with the doctor's cap on his head (Pl. 77 b).[1] The effigy of Bishop Walter Bronescombe (d. 1280) in the lady chapel at Exeter cathedral, which was perhaps carved at Salisbury, seems different in character, more stately not only because the figure is fuller and rounder, but because the original painting of the head in flesh-tones over green underpainting and of the gorgeous vestments with fine patterning partly of lions and endorsed doves is so well preserved.[2] It seems an appropriate monument for the builder of Exeter lady chapel with its lordly splendour. When Bishop Thomas Bytton, who carried on Bronescombe's work at the cathedral, granted forty days' indulgence for contributors, the tenor of his grant differed as much from those promised to pilgrims to shrines in the first half of the century as his cathedral differed from that of Salisbury or Lincoln, and indulgence was given to all who availed themselves of his spiritual ministrations or offered prayers for his prosperity during his life and after death.[3] Carved in relief on the side of the tomb of Archbishop Pecham bishops act as mourners, but on the lower part of the tomb-shrine ascribed to St. Thomas Cantilupe (d. 1282) at Hereford, the only bishop for whom a plea for canonization was made under Edward I, seated knights in long surcoats and with shields hold a permanent death watch, with exquisite naturalistic foliage filling the spandrels between the five-foiled arches.[4]

The few great buildings such as York minster nave and Exeter choir, constructed during this period, no longer seem to evoke ethereal visions of the Heavenly Jerusalem. On the contrary, the

[1] There are remains of a painting on the back of the recess 'formerly showing the kneeling figure of the doctor before the Virgin with attendant figures'. See *R.C.H.M. Hereford*, i (1931), 109. In the south aisle of the presbytery in the cathedral an interesting series of tombs was set up *c.* 1300 with effigies intended to represent former bishops of Hereford, chiefly of the twelfth century.

[2] E. W. Tristram, *English Medieval Wall-Painting* (1950), 385: 'So high a degree of skilled workmanship may reasonably be taken as pointing to the existence of a class of painters who specialized in this brand of painting, and were employed to decorate not only effigies, but perhaps also tabernacle-work such as that on the Westminster Panel or on the Prior's Seat in the chapter-house at Canterbury.'

[3] G. Oliver, *Lives of the Bishops of Exeter* (1861), 52.

[4] Such naturalistic foliage occurs also in the spandrels of St. Frideswide's shrine in Oxford cathedral, probably made for the Translation of 1289.

concept of heaven reflected by them seems to be coloured strongly by the desire for opulence and pageantry on earth. They seem to be built, not primarily for spiritual reasons, but in order to render homage to the highest liege lord by their splendour, while at the same time enhancing the social status and the prestige of the builder. The face of the gatehouse which led into the precinct of the Augustinian priory at Kirkham[1] (Pl. 91 b) was decorated between 1289 and 1296 with ten shields with coats of arms in three rows set against the wall surfaces between the straight gables above the entrance arch and the traceried windows and niches above. They proclaimed the priory's connexions with noble founders and benefactors past and present, amongst them William de Ros, an unsuccessful claimant of the crown of Scotland.

Edward I's main building in the capital was St. Stephen's chapel. The 'King's New Chapel', refounded in 1292, was the third of the main large buildings which belonged to Westminster palace, set between the Hall of Rufus and the Painted Chamber. Designed as a palace chapel as was the Sainte Chapelle in Paris, St. Stephen's was built in two storeys, the lower dedicated to the Virgin, the upper to St. Stephen. Begun in 1292 by the master mason, Michael of Canterbury, the lower chapel might have been completed at Edward's death.[2] Engaged piers with clusters of marble columns divided the vast single-aisled space (90 feet by 26 feet) into bays and carried the vault. The ogee-arch appeared and the 'most notable feature was possibly the cusped rear-arches of the windows'.[3] The chapel of St. Ethelreda, Holborn, possibly begun by Bishop William of Louth (d. 1292) as part of the town house of the bishops of Ely, may repeat the design of St. Stephen in a simpler form.

But the most important piece of building, both for its own sake

[1] Lord Hawkesbury, 'The Heraldry on the Gateway at Kirkham Abbey', *East Riding Antiq. Soc. Trans.* viii, 1.

[2] This is the only part of the chapel which still exists under the name of Crypt chapel, so heavily restored that the extent of original work is obscured. See *R.C.H.M., London*, ii (1925), 123.

[3] M. Hastings, *St. Stephen's Chapel and its Place in the Development of Perpendicular Style in England* (1955), where it is claimed that St. Stephen's chapel, completed under Edward's successors, was, with Old St. Paul's, the birthplace of the 'Perpendicular'. See also the same writer's *Parliament House* (1950), 54–76.

and because of its influence in shaping a new style, was the 'new work' at Old St. Paul's. The remodelling of the cathedral which dominated the city had been strangely slow. The Norman nave and transepts seem to have been left virtually intact, to judge from Wenzel Hollar's engraving.[1] But a quadripartite vault was erected on the old walls, causing a change in the clerestory zone. The upper part of the west front between its flanking towers was apparently rebuilt and at the same time a high lantern tower was raised on pointed arches over the crossing. The tower was completed in 1221[2] and its slender spire of timber and lead, with its four corner pinnacles and windows between, must have set a model followed by many churches on a smaller scale. It seems reasonable to suppose that the remodelling of the first four bays of the choir was undertaken then. Hollar's engraving shows irregularities in the triforium zone and an earlier type of tracery than is found in the rest of the choir farther east. The solemn dedication of the church performed by Bishop Roger in 1240 in the presence of the archbishop, several other bishops, the king, and the legate, may not have been connected with any important stage in the history of the structure, for shortly afterwards King Henry began the rebuilding of Westminster abbey, and in 1258 the 'new work' at St. Paul's was begun[3]—

[1] Since St. Paul's was destroyed in the Great Fire and completely replaced by Sir Christopher Wren's building, any attempt to reconstruct its medieval appearance has had to rely mainly on Wenzel Hollar's engravings in Dugdale's *St. Paul's Cathedral* (1st ed., 1658; 2nd and revised ed., 1716) and a plan and a drawing of three choir bays by Wren at All Souls, Oxford. W. Benham, *Old St. Paul's Cathedral* (1902), 5, states that 'an outer encasement covered the Norman, as Wren showed when he wrote his account of the ruined church'. In a series of articles in the *Builder*, v. cxxxix (1930) Lethaby discussed the thirteenth-century alterations. All previous writers followed Dugdale's opinion that St. Paul's received a new choir before the middle of the century which was replaced soon after by the 'new work'. Lethaby contends that no changes in the Norman building were carried out except those mentioned above and that the dedication of 1240 'signalised the first completion of the whole church including nave, central steeple and choir fittings'. In his opinion the first four bays east of the crossing were those of the old Norman choir, but remodelled at the time when the 'new work' was begun to take the place of the old Norman apse and chapels.

[2] *Annales Monastici*, iii, R.S. xxxvi (1866), 66.

[3] See Lethaby, loc. cit. Cf. *Chronicle of the Mayor and Sheriffs of London*, ed. H. T. Riley (1863): 'This year before Easter, was begun the New Work of the Church of St. Paul.' In 1255 Bishop Fulk Basset appealed for funds to repair the dangerous decay of the roof.

probably as a counter-move to the king's work—which was to give
to the cathedral within the walls an even larger choir than that of
the royal abbey and one designed in a more advanced style. The
cathedral within the walls, which protected a population known
not to harbour friendly feelings for the king, often witnessed
stormy scenes in the movement which tried to check the abuse of
royal power. Before the altar of St. Paul King John had made his
kingdom a fief of the Holy See. When the Council of London met
in 1237 the legate Otho took his seat before the same altar. The
king bowed before him, until his head almost touched his knees.
As the text for his sermon Otho chose Rev. iv. 6, and interpreted
the 'living creatures' as the bishops around his throne whose eyes
were to be everywhere. The damage done to the building by a
terrific storm which broke just then was repaired later by Bishop
Roger.[1] When Simon de Montfort took arms against Henry III,
the Londoners followed the call of the great bell of St. Paul's and
under Edward I Bishop Gravesend, at the demand of Archbishop
Winchelsey, called upon the clergy to protest against Edward's
claims on the clerical income for his war with Scotland, and read
Boniface VIII's bull 'clericis laicos' in the cathedral. Besides, the
citizens knew that the religious history of St. Paul's went back
much farther than that of Westminster abbey, back to the begin-
ning of Christianity in England. It housed the shrine of St.
Erkenwald, son of Offa, king of East Anglia, who had been con-
secrated bishop in 675 by Archbishop Theodore, and the tombs of
two Anglo-Saxon kings, Sebba and Ethelred, who were the first
to be converted by St. Augustine's mission. While a new shrine for
St. Erkenwald was set up behind the high altar, the tombs of the
two kings were inserted into the recesses of the wall arcade in the
new choir.

The 'new work', which was mainly completed by 1283, made
St. Paul's the largest church in Europe (Fig. 15). The crossing of
the double-aisled transept stood between the old nave of twelve
bays and the new choir, also of twelve bays, making the whole
length of the church 690 feet.[2] The new eastern extension

[1] Matthew Paris, *Chronica Majora*, iii, R.S. lviii (1876), 415 and 419.
[2] L. F. Salzman, *Building in England* (1952), 389: 'In 1314 the church was measured:

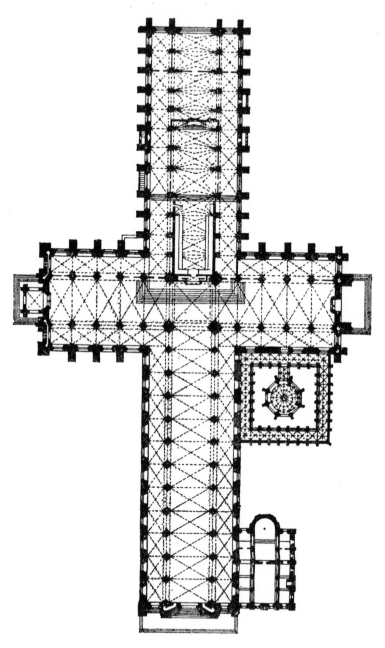

FIG. 15. *Plan of Old St. Paul's*

swallowed up the church of St. Faith which had stood east of the old church. The people of the parish, besides wanting a detached tower with a peal of bells east of the church, insisted on the use of the eastern part of the crypt as a parish church. The crypt below the eight easternmost bays was divided into the parish church of St. Faith and the chapel of Jesus. It was a spacious vaulted hall lighted by small windows below those of the upper church. Its broad centre aisle was subdivided into two by a row of smaller clustered pillars down the centre of the chapel creating rich and complex spatial effects as can be seen in Hollar's view. In the choir above, an eastern transept was merely suggested by the widening of the fifth bay, but otherwise the choir stretched as one majestic hall from the crossing to its eastern end. Its pillars were made of eight isolated shafts, most likely of Purbeck marble, around an eight-foiled core. Strong shafts rose in front of them to slightly below the clerestory sill from where the ribs started which supported the vaults in a much more complex pattern than that found in the nave vault.[1] The choice of the square eastern end represented a clear and emphatic rejection of the chevet of the royal abbey, and, after that at Ely, the southernmost penetration of the steep eastern front of northern custom. While the eastern front of the Angel Choir was the consummate expression of a pure geometric style, the eastern front of St. Paul's, perhaps under the influence of the new transept fronts of Notre Dame in Paris, developed features which were to start a new style. In contrast to the sequence of storeys below the rose in the transepts of West-minster abbey, a thin transparent screen of slender lancets is similar in effect to that of the Five Sisters at York, only enlarged to seven (Fig. 16). These windows occupied the whole space between the

its length contains 690 ft., breadth 130 ft., height of the western vault (testudinis) from the pavement 102 ft. The height of the vault of the new fabric contains 88 ft. The roof ridge (cumulus) of the church contains in height 150 ft.' *Chronicles of the Reigns of Edward I and Edward II*, i, R.S. (1882), 277. The length of the third church at Cluny, the largest in the twelfth century, was *c*. 615 feet.

[1] In Hollar's engraving the ribs spring from the level of the clerestory sill, but in Wren's drawing the springing point lies slightly below. The drawing reproduces the design of the triforium and of the window tracery. See M. Hastings, *St. Stephen's Chapel* (1955), where attention is drawn to the cusped, curved triangles in the tracery, as very characteristic of London and Canterbury work.

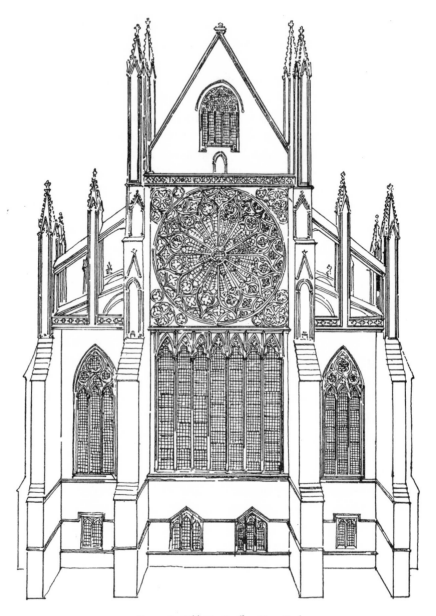

FIG. 16. *Old St. Paul's: East End*

wall arcade, which ran along all the walls below the aisle window-sill, and the horizontal moulding which divided them from the enormous rose, which here filled a wall space equal in height to that of triforium and clerestory combined. At Lincoln, the geometric tracery of the large east window is still an enlarged version of classical tracery, based on division by two, with circles filling the heads of the pointed arches. At St. Paul's the whole eastern front below the gable was turned into one flexible screen of thin sharp mullions, held together by trefoiled heads, with a multiplication of small patterns in the rose where the curved main line weaves its way to tie the smaller shapes together.

Outside London the main buildings of this period are to be found on the outer periphery of the realm in north and west. North of the Humber, in the West and especially in the East Riding, during the last quarter of the century, building activity revived with extraordinary energy after a pause following the efforts made in the first half. Almost simultaneously great building schemes were carried out by the Benedictines at Finchale, St. Mary's, York, and Selby, by the Austin Canons at Bridlington and Guisborough, by the seculars at Howden, Ripon, and York. The same school of masons must have been active in these places. Not only the style, but also the intentions, were the same: to build on a large scale and with a sumptuous grandeur.

Until the nave of York minster was begun, the decisive influence was that of the Angel Choir. It travelled northward to the Augustinian houses at Newstead and Thornton. At Newstead priory, north of Nottingham, the rebuilding of the nave was begun in the second half of the century and the beautiful west front was added between 1280 and 1290. Although the church had a north aisle only and the space of the south aisle was taken up by the cloister, the new façade was designed symmetrically. Its lower south section without a doorway merely screened the outer parlour of the convent. The side-sections, flanked by bold buttresses which were doubled at the corners by others set at right angles, were raised to the same height as the broader centre. Thus a wide screen front was achieved in which blind windows of four cinque-foil headed lights framed the large west window, originally of five

lights.[1] At Thornton a new choir was in building between 1260 and 1300 which extended the length of the church to 360 feet. It has perished, but the remains of an octagonal chapter-house show beautiful examples of geometric tracery.[2]

North of the Humber, at one of the richest of the Augustinian houses, Bridlington priory, where William of Newburgh had received his early education, rebuilding of the church was carried on from *c*. 1250 onwards, beginning with a twin-towered façade of northern tradition. The arcades of the existing nave with the exception of the three westernmost bays on the south side, together with the north aisle, the beautiful north porch and the lower part of the north-west tower, are of this period. The masons responsible for the design carried on from where those at Beverley had left off. But instead of Purbeck marble the hard limestone of the district was used throughout, with rich and subtle effects in the undulating surface of the piers with their twelve stone-shafts. The design of the triforium on the north side, of *c*. 1270, was still that of Whitby and York minster transepts, but the thinness of the shafts, the sharpness of the mouldings and the piercing of all the interstices gave to the triforium arcade the character of a traceried window similar to the large windows above (Pl. 93 *a*).[3]

The most important and monumental churches were built at York: the abbey of St. Mary and York minster nave.[4] Twenty years divided the beginnings of the two new fabrics. The first must have been the most grandiose representative of the style of the Angel Choir in the north, the other was designed in a new vein, which opened up a new development. The great Benedictine abbey outside York, which had once tried to stem progress by fighting some of its monks who had turned Cistercian and had founded Fountains abbey, had entered a great period of

[1] See A. H. Thompson, *Thoroton Soc. Trans.* xxiii (1919), 112.

[2] See A. W. Clapham, *Arch. Journ.* ciii (1946), 172.

[3] M. Prickett, *History and Architectural Description of the Priory Church at Bridlington* (1831).

[4] A large church and monastic buildings were erected at Finchale, founded *c*. 1195 as a dependent priory of Durham, between 1250 and 1300, of which extensive ruins remain. See D. Knowles and J. K. S. St. Joseph, *Monastic Sites from the Air* (1952), 42–43 and *V.C.H. Durham*, iii (1928), 73.

prosperity. In 1245 the abbot had received an indult by Innocent IV to use mitre, ring, and other pontifical insignia, with the right to bless vestments and give solemn benediction when no bishop or legate was present. The abbey became one of the richest houses in Yorkshire and accordingly a new church was begun in 1271 by Abbot Simon of Warwick. The plan of the church was that of Whitby abbey whence the first Norman abbot was said to have come.[1] A nave of eight bays was divided by a transept with eastern aisles and a high central tower from the choir of nine bays, which was even two bays longer than that at Whitby, ending in a steep eastern front. The ruins of the church still show its majestic size (c. 352 feet long) and the delicate beauty of arcading and tracery (Pl. 92 b). The wall arcade below the aisle windows, as well as the remains of the large windows in the north aisle, set in northern fashion between acutely pointed blind arches, follow a traditional tracery design. But the trefoiled arcading at the west front with its crocketed gables was designed under the influence of the new style of York minster.

On the 6th of April 1291 Archbishop John le Romeyn (1286–1296), son of the treasurer under whom the Five Sisters were built, laid the foundation stone for the new nave, the outer walls of which grew up outside the older Norman church. Though the width of the nave was determined by the older crossing, the new aisles were broader and thus necessitated the most ingenious alterations in de Gray's transepts. The new nave was made two and a half bays longer than the old, but it still remained shorter than the span of the transepts (45 feet in width and nearly 100 feet high). Thus it was more compact and, with the wide spacing of the nave pillars and the enormous height of the arcade, the side-aisles were drawn more towards the nave, the whole thus tending to give the impression of one vast hall (Fig. 17). This tendency to unification was felt everywhere. The twelve shafts, in three degrees of thickness, were sunk into the mass of the pier with polygonal bases and abaci; only shallow hollows formed a shadowy band between the convex arch moulds. The vaulting shafts rose from the ground tying the storeys together as at Old St. Paul's, and the five

[1] See Arch. Journ. xci (1935), 383.

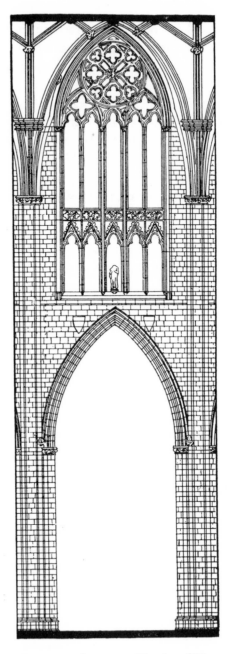

FIG. 17. *York Minster: Elevation of Nave*

gabled and trefoiled arches of the triforium were taken together with the clerestory above. This merging of the two storeys into one was copied later at Guisborough and became a general mark of the style. The arcading below the aisle windows and on the inner and outer faces of the west wall was as rich as that of the west front at Lichfield, but it no longer stood out boldly against the solid wall, it was sunk into it. Like miniature chapels, the polygonal niches flanked by thin buttresses and finials with a crocketed gable, pierced the lozenge-shaped trefoils used as a filling.

The most important fact, however, was that the new nave introduced a new concept of the relation of space and enclosure. Space was no longer a negative value as it had been previously, where the voids were only dark or bright foils for the tangible shapes of pillars, shafts, and ribs. It was now conceived as something concrete and positive, shaped by and at the same time sinking into the enclosing wall mass, fluctuating in terms of light and shadow between nave and aisles. It was chiefly this new concept that distinguished the chapter-house of York from those at Westminster and Salisbury. Its effect was prepared by the chapter-house given shortly before to Southwell minster (Pl. 72 b).[1] Both chapter-houses were octagonal, approached by beautiful vestibules; in both the architects created one undivided space by the omission of the central pillar. The smaller fabric at Southwell could be covered by a stone vault while at York a wooden vault, pretending to be of stone, covered the vast interior span. The new interlocking of space and enclosure was carried considerably farther in the later arrangement of the stalls in polygonal niches, with their own vaulted ceiling and the undulating line of their canopies. Capitals, corbels, and crockets are decorated with foliage slightly more developed than the more famous examples at Southwell,[2] where decorative carving reaches the highest achievement in the naturalistic foliage that had first appeared at Westminster abbey and had spread from there

[1] The only documentary evidence for the building of the chapter-house is an order by the Archbishop of York in 1293 that fines collected from canons for failure to repair their houses should be used 'ad fabricum novi capituli'. See A. F. Leach, *Visitations and Memorials of Southwell Minster*, Camden Soc. (1891), 211.

[2] See N. Pevsner, *The Leaves of Southwell* (1945).

throughout England. The fame of the leaves at Southwell is not only due to the quality of workmanship, to the accuracy and loving care in the rendering of actual plant forms, identifiable as oak and hawthorn, vine and hop, buttercup and ivy and others,[1] but even more to the masterly balance between stylization and naturalism, between the shadowy hollows and clearly defined detached shapes, between the apparent freedom and at the same time the discipline of growth. The twigs do not grow out of the stone bell, nor are the means of fastening them to it made obvious, but they cling to the bell because, through the manner in which the leaves curve, bend, or twist, they are subservient to the architectural order. They are individual specimens, just as the corbel heads display a great variety of faces which may or may not have been derived from the likenesses of members of the chapter or of masons. But neither heads nor leaves have become so free and particular in their individuality that they have lost their connexion with a supervising universal order (Pl. 16 c).[2]

The large windows of the chapter-house at Southwell were still beautiful examples of the pure geometric of the east window at Lincoln. In those at York new steps were taken which were to transform the basic simple pattern. Not only are mullions and arches much thinner, less tangible shapes than sharp lines, but the pairs of two-light windows are separated by a narrow intermediate window with acutely pointed arch, thus creating the uneven division of five instead of the traditional four. The general tendency in the design of tracery became to enlarge the area of the window-head, where above the thin upright mullions a most intricate pattern could be woven: a pattern no longer consisting of a circle or part of a circle, but of the more active shapes of the lozenge and the spheric triangle. When the choir at Ripon minster was rebuilt (c. 1280), it received a magnificent eastern front, filled by a large traceried window in which the development was carried one step

[1] For the identification of the leaves see A. C. Seward, *Cambridge Antiq. Soc. Proceedings*, xxxv (1935), 1.

[2] At its entrance an inscription gives high praise to the new chapter-house: as the rose is the flower of flowers, so this is the house of houses. ('Ut rosa flos florum sic est domus ista domorum.') See A. H. Thompson, *York Minster Historical Tracts* (1927).

farther than at York. The thin elegance of the window was stressed by the contrast with the massive projecting gabled buttresses. The tracery lost almost all reference to architectural construction: thin moulded mullions without base and capital are continued as arches. The centre light cuts with its sharp point into the circle in the head, where the trefoils, stable upon their twin base, alternate with lozenges that converge towards the centre, seemingly eager to rotate (Pl. 92 *a*).

Neither at Southwell nor at York was vaulting developed to the same degree of intricacy as in the south-west at Wells and Exeter. But in the vaults of the chapel of the Nine Altars at Durham the difficulties caused by the different spacing of the springing points of the ribs from the east wall of the chapel and from that of the choir with its aisles were overcome by a most ingenious modification of the normal four-part vault. In the centre bay divergent twin diagonals form a four-pointed star with an eyehole in the middle.[1] Its mouldings are decorated with the figures of the four evangelists (Pl. 39 *c*) and with vine leaves and grapes. At the junction of the choir with the chapel two figures of angels, about five feet high, stand on brackets above the choir triforium. They are the nearest relatives to the angels in the latest bays of the Angel Choir and to those in the Douce Apocalypse, with their robust build, their full bunched robes and mass of curls.

At the same time a fresh burst of building activity occurred in the south-western region. Exeter cathedral, the last of the secular cathedrals to be rebuilt, although completed long after Edward I's death, contains large and important portions dating from his reign.[2] Under Bishop Henry Marshall (1194–1206), brother of William Marshall, earl of Pembroke, the first steps had been taken to refashion the older Norman cathedral, which was distinguished from all others of its time by the two towers raised above the arms of the transepts. These were the only parts of the older cathedral which remained. The old Norman apse was taken down, and five

[1] The vault was built between *c.* 1274 and 1280. See *V.C.H. Durham*, iii (1928), 95. For an illustration see W. A. Pantin, *Durham Cathedral* (1948), Pl. 16.

[2] See H. E. Bishop and E. K. Prideaux, *Building of the Cathedral Church of St. Peter at Exeter* (1922).

bays were added to the three bays of the choir. After this a long pause occurred. Under Bishop William Brewer (1224–44) only a large chapter-house was added, of which the lower part still exists. As a stately, oblong chamber, it was built still in the older tradition before the polygonal chapter-house had become fashionable for secular cathedrals. A decisive change began under Bishop Walter Bronescombe (1258–80) between 1270 and 1280 and his successor Peter Quivil (1280–91). Bronescombe was largely re-

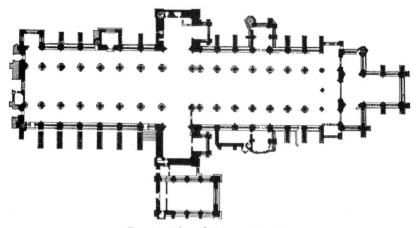

FIG. 18. *Plan of Exeter cathedral.*

sponsible for the low lady chapel of two bays, with an equally low transept in front of it and a narrow processional path (Fig. 18). The whole was designed in the Winchester tradition as a separate church at the eastern end of the cathedral, separated from the main east wall by one bay. Bronescombe's work was completed by Peter Quivil, who was praised as 'primus fundator novi operis'. His architect was responsible for a design which was carried through even into the later portions of the nave, though with certain modifications, especially in the flowing tracery of the windows. Quivil altered the lady chapel and gave to it its sedilia and its double piscina, its vault and its magnificent windows, which were similar to those at Merton College, Oxford. Then a new presbytery was laid out. Although the work could not have progressed very far at his death, the design and the rich material collected were handed over to his successor, Bishop Thomas

Bytton (1292–1307), who completed Quivil's work and in addition remodelled the three bays of the Norman choir.

One of the first steps in the alteration of the Norman cathedral had been the opening up of the lower storeys of the Norman towers in order to produce a broad western transept. But beyond this no eastern transept, as in Salisbury, interrupted the unbroken contour of the deep and broad eastern extension. The most distinctive features of the eastern wall of Quivil's presbytery were its two low and wide arches divided by a pillar in the centre, which also cut the view into the lady chapel. This singular arrangement was the same as that formerly devised at Winchester and Romsey, which was limited to this local area and not to be found elsewhere. The pillars had the characteristic multiplication of shafts which were developed into a massive cluster of sixteen in the centre pillar, set diamond-wise with undulating surfaces. These immense marble piers, which set a pattern for all the others in choir and nave, gave an impression of magnificence, and the blue-grey marble, the yellow sandstone of the arches and the white Caen stone above increased the colouristic effects of the gentle play of light and shadow over piers and arches. Since, owing to the transeptal towers, a central tower was omitted, the customary strengthening of the piers of the crossing was not required. The last pair of the nave pillars could be made the same as all the others. Thus an effect of the nave broadening smoothly and directly out into the transepts was achieved as in no other church, with no impediment to the view, which slides easily from nave to transept around the slanting sides of the pillars.

The fact that the builders retained the thick upper wall of the twelfth and early thirteenth century structure caused in the triforium a peculiar new treatment, in keeping with the trend of the time. It was reduced to a low, almost blind arcade of four trefoiled arches embedded in thick walls, and was thus almost eliminated as a separate storey, just as it had been, though in a different manner, in the nave of York minster. The balustrade of pierced quatrefoils in two rows merely formed a sill for the wide clerestory window of five lights, with their large traceried heads (Pl. 93 b). What the cathedral lost in height, it gained in stately breadth. The

low intermediate storey barely intervened between the complex design of pier and arch and the spreading richness of the vault, the multiple ribs of which fan out at clerestory level until they lean against the ridge rib. The vault is studded with carved bosses and the vaulting shafts start from sculptured corbels, the style of which changes west of the first four bays of the presbytery completed by 1307.[1] A school of masons skilled in the production of such work must have grown in this part of the country, having its centre most likely at Bristol, which by the end of the century held a position in the field of sculpture similar to that of Wells in the first half of the century.[2]

A new building period had commenced by this time in accordance with the wealth and importance of this great port in the west of England. St. Augustine's, church of the Augustinian canons, was to receive a new choir of five bays without an eastern transept, but with a projecting eastern chapel of two bays. The work was begun under Edmund Knowle when he was treasurer, in 1298, and, although it was completed only after his death in 1332, the plans must have been made not later than 1298. They represent a unique attempt to achieve new spatial effects. The choir was built as a hall church, its aisles, though narrower, of the same height as the nave. In order to dispense with flying arches on the outside, the thrust of the centre vault was transmitted to the outer buttresses by transoms between the aisle pillars and the outer wall, with pierced ogives inserted between the transom and the transverse arch. The vast broad hall was flooded with light from the high traceried windows in the aisle walls.[3] It is this search for new spatial effects which distinguishes the new chapter-house at Wells (c. 1290–1310) from those at Westminster abbey and Salisbury. The vestibule, slightly earlier in date, with the rise and bend of its staircase caused by the undercroft, creates charmingly complex vistas which serve as a preparation for the effect of the main

[1] See C. J. P. Cave, Roof Bosses in Medieval Churches (1948), 192. Also E. K. Prideaux and G. R. Holt Shafto, Bosses and Corbels of Exeter Cathedral (1910).

[2] The theory of the transference of the Wells workshop to Bristol after the completion of Wells front developed by Prior and Gardner, Medieval Figure Sculpture, 319 and 609, has been questioned by A. Andersson, English Influence in Swedish Sculpture (1949), 50. [3] See J. Evans, O.H.E.A. v, 66.

chamber. Though the central pillar was retained, its profile was made more undulating by sixteen marble shafts. The stately spatial effect, caused primarily by the wide and low proportions, was enhanced by the intricate design of the wall arcade, the almost curvilinear tracery, and, most of all, by the extraordinary richness and complexity of the vault. Eleven ribs were made to radiate from the angles of the polygon and the small space was vaulted by forty-four cross-ribs and eight radial ribs, all joined by a ridge rib (Pl. 96).[1] Similar effects, but without the central pillar, were achieved in the new lady chapel of the cathedral, which apparently was begun as a separate octagon until it was joined with the later presbytery (begun *c.* 1320) in a complexity of planning which goes far beyond anything attempted in the reign of Edward I.[2]

While the seculars, Benedictines, and Austin Canons all succumbed to the spell of lordly grandeur, the Cistercians succeeded in clinging more firmly to their traditions. At the southern and northern entrance into Wales, two churches represented the last of powerful patronage for the order. The monks of the abbey of Tintern, one of the earliest Cistercian foundations, had begun refashioning their modest house in 1220 with the claustral quarters.[3] By 1270 the eastern portion of a new church was in building, assisted by the patronage of Roger Bigod, fifth earl of Norfolk. Although mass could be celebrated in the new presbytery by 1287, the whole church was only completed early in the fourteenth century. The plan of the eastern part was similar to that of Netley abbey, but the nave with six bays was exceptionally short, and broad aisles increased the effect of lofty spaciousness (Fig. 11). Once more Cistercian austerity found expression in the simple two-storied elevation, where merely a blank wall covered the space of the aisle roofs and was crossed by the triple vaulting shafts (Pl. 91 *a*). But this sober frame with the purity of its proportions and the reticence of its carving was a foil for the magnificence of

[1] Ibid. 24. At Evesham a new chapter-house was built under Abbot John of Brocklehampton (1286–1316) with a fine vault without a central column, most likely inspired by the vaulting experiences made at Pershore abbey where the choir was revaulted after a fire in 1288. Illustration, ibid., Pl. 9 *a*.

[2] Ibid., Pl. 12.

[3] H. Brakspear, *Ministry of Works Guide* (1934).

the traceried windows which took up almost the whole width and height in all the fronts. While the windows of the transepts still retained the classical design of tracery like the east window at Netley, the west window above the elegant portal with its two flanking traceried niches was a most beautiful example of late geometric tracery. Two-thirds of this window are taken up by seven tall lancets between the slenderest of mullions, but the two outer ones are taken together under one larger pointed arch, as are the three in the centre, although the centre group could be read as consisting of two intersecting arches which share the middle lancet. Shapes like candle flames and like sharp daggers are held within the main curves, and the tense alertness of the lower portion becomes finally relaxed in the three traceried circles in the head.

Not a stone is left of the much larger church which was built at Edward I's initiative in the north, in the county of Chester. The foundation charter was issued in 1270, before Edward's departure on his crusade. 'It may be regarded, therefore, as a local and permanent expression of his devotion to God and the Blessed Virgin on the eve of his pious but dangerous enterprise.'[1] The site selected was at Ramhall, but seven years later Edward, assisted by the queen and many great nobles, laid the foundation stone on a new site four miles away, which he named Vale Royal. Just before his invasion of Wales, 'by this act of pious symbolism, the king put his war with Llewelyn under divine guidance'. The extraordinary length of the church (420 feet), the largest of all Cistercian churches in England, the enormous funds which were expected to rise to about a thousand pounds a year,[2] the army of workers from all parts of England under the master mason, Walter of Hereford, all indicate the scale of Edward's ambitions. In his efforts he must have been spurred on by those which Richard of Cornwall and his son had spent on their foundation at Hayles. Long after Edward's death, as late as 1359, the church at Vale Royal received a chevet like that of Hayles with twelve chapels round its choir.[3]

[1] F. M. Powicke, *King Henry III and the Lord Edward* (1947), 722.

[2] D. Knoop and G. P. Jones, 'The First Three Years of the Building of Vale Royal Abbey, 1278–1280', *Ars Quatuor Coronati Trans.* xliv (1934), 5.

[3] L. F. Salzman, *Building in England* (1952), 439.

Besides the king, the barons, and the higher clergy, other classes
of society began to assume the role of patrons. The lesser gentry
and the citizens of the larger towns developed increasingly a class-
consciousness and a religious zeal. The former was largely caused,
not only by increasing wealth, but by the growing awareness of
their role in the government of the realm through parliamentary
representation. The latter was the result of the reforming activities
of the bishops, of the improvement in religious instruction by a
better-educated clergy, and of the activity of the mendicant orders.
Unfortunately most of the churches which were built by the Fran-
ciscans and the Dominicans in the last quarter of the thirteenth
century have been destroyed. After the first adherence to utter
simplicity in building, restated in the rules of the Franciscan order
issued in 1260, a great building period started about 1270.[1] Larger
churches were required by the orders, who sought great con-
courses for their sermons: more sumptuous building was almost
forced upon them by the generous gifts of their devout followers
amongst the laity and by the popularity which their churches
gained as places of burial. The mendicant churches did not have
to suit the elaborate liturgical requirements of cathedrals and
churches of the older orders. Their services were essentially those
of the parish church, and their plans and structures were of the
same type only built on a larger scale. Though no complete
example has survived, the existing evidence indicates as a normal
type an unaisled nave and a narrower unaisled choir. Usually
there was no structural division between the two parts, unless
a high wooden steeple required the insertion of a space between
nave and choir with strong supporting walls. Usually the roof-
line ran straight and unbroken from west to east, to the straight
drop of the square east end. Exceptionally the Friars' church at
Winchelsea had a polygonal apse. The choir of the Friars' church
at Chichester, the only well-preserved example, was completed
probably by 1282 on the site of the old castle, given by Richard
of Cornwall to the Franciscans some time before 1269. The
long unaisled choir (82 feet by 31 feet) was of the utmost sim-
plicity. Its plain walls were pierced at the east end by five slender

[1] See A. R. Martin, *Franciscan Architecture in England* (1937).

gradated lancets and at the sides by five two-light windows with chamfered mullions and plain quatrefoils in the head, set between the shallow stepped buttresses on the outside and connected internally by a string-course forming a hood-mould around them.

Since all the mendicant churches were built in the centre of urban settlements, they were bound to influence, chiefly by their spaciousness, the parish churches in the towns. As to the rural parish churches, the growth which had started in the first half of the century continued, but more and more the village communities were stimulated to an active participation in the upkeep, the embellishment and the fitting of their churches. At the council at Merton in 1305, Archbishop Winchelsey decreed that all the following items should be provided by the parishioners: missal, chalice, and vestments; processional crosses, incense, and thurible, lights and bells, candlesticks, and the necessary liturgical books.[1] Wall-paintings, of which a considerable number have survived in parish churches from the second half of the century, contributed not only to the appearance of the church, but in addition to the sermons of the parish priest they spread knowledge and familiarity with Christian teaching amongst the lay people. Besides scenes connected with Christ and the Virgin and frequently a large 'Doom' figure, scenes from the lives of saints became more common. St. Christopher led in popularity, but at Cliffe-at-Hoo (Kent) the histories of St. Edmund, king and martyr, and of St. Margaret are shown, and at Little Missenden (Bucks.) that of St. Catherine. In the exceptionally detailed cycle at Black Bourton (Oxon.)[2] with gospel scenes, a Jesse Tree, St. Christopher and St. Peter and St. Paul, the single figure of St. Richard of Chichester appears. St. Francis preaching to the birds occurs at Wiston (Suffolk) and Little Kimble (Bucks.) and in a painting once at St. John the Baptist's church, Winchester, St. Francis and a layman occupied the place of St. Mary and St. John on either side of the

[1] See J. R. H. Moorman, *Church Life in England in the Thirteenth Century* (1945), 142.

[2] See E. W. Tristram, *English Medieval Wall Painting* (1950), 506, 530, 580; Pls. 97–110, 137–43, 194–9.

Crucified, with streams of blood from Christ's hands falling on both figures, and in the large Last Judgement St. Francis led the Blessed to Paradise.[1]

The chief element which contributed to the growth of the church from the last quarter of the century onwards was the increasing popularity of chantries, especially after the Statute of Mortmain had checked the alienation of land.[2] Instead of investing funds in monasteries, the lesser gentry and the merchants favoured more and more the local parish church, where, with the altars for private masses, the number of tombs with effigies increased steadily. From this time onward, the parish church ceased to emulate cathedrals and monastic churches, and began to acquire a more personal and intimate character. Aisles to the naves, and chapels to the chancels, increased the ground area of the churches, and made them more spacious. The designs of the new additions or alterations were still determined by those of the larger buildings. The influence of Westminster abbey and the Angel Choir at Lincoln made itself felt primarily in the introduction of delicate patterns of tracery within the enlarged windows. On the whole, geometric work in parish churches was rare and usually to be found in alterations of various parts of the building, such as the widening of aisles (Moulton, Lincolnshire), the extension of chancels, and the addition of transeptal chapels. Where nave arcades were built, the pillars were usually octagonal with profusely moulded capitals. Foliage carving was rare, but when it occurred it followed the naturalistic trend, and the arches were enriched by hood-moulds with carved human heads used as stops. In continuance of the trend to build high towers and spires, the Northamptonshire broach was gradually superseded by two types of spire, the one common in south Lincolnshire, the other in Oxfordshire. An early example of an Oxfordshire spire, inspired by that of St. Frideswide's, is that at Witney, which is a broach spire, but with pinnacles at the

[1] See *Franciscan History and Legend in English Medieval Art*, ed. A. G. Little (1937), 10. St. Francis held a book with the inscription: MIHI.AVTEM.ABSIT.GLORIARI.NISI.IN. CRVCE.DOMINI.NOSTRI.JESV.CHRISTI. Tristram, op. cit. 620.

[2] See G. H. Cook, *Medieval Chantries and Chantry Chapels* (1947); also A. H. Thompson, *The English Clergy and their Organisation in the later Middle Ages* (1947), 132.

four corners which smooth the transition from the square tower to the polygonal spire. Gradually the spire was set back behind the tower walls, and the pinnacles on the corners were joined by a parapet, and small delicate flying arches swung from pinnacle to spire. Ribbed, and sometimes crocketed, the spires became higher and more slender, and the gable lights increased in number, set in stages above one another. Instead of being set off by sharp contours and solid surface planes, the elegant spires merged into the surrounding air.

Perhaps the most glorious example of a parish church of this period was the church of St. Wulfram at Grantham.[1] Though a prebendal church of Salisbury, the merchants of the town who had become prosperous through the wool trade supplied much of the funds for the gradual enlargement of the church. First a great western tower, crowned later by a lofty spire, was built, which was then taken into the lengthened nave and flanked by the elongated aisles. Both the chapter-house at Salisbury and the Angel Choir at Lincoln have inspired the design of the traceried windows. The magnificent west window of the north aisle was an adaptation of the great east window of the Angel Choir, though reduced to six lights, and the west window of the south aisle is an illustration of the changing character of tracery near the end of the century, with a narrow centre light inserted between the two two-light windows at the sides (Pl. 94 b). Other towns which grew in prosperity through shipping trade remodelled and enlarged their parish churches such as Hedon in the East Riding and Great Yarmouth on the East Anglian coast. A completely new church was built at Winchelsea (Sussex) on a magnificent scale, dedicated to St. Thomas of Canterbury.[2] The choir, which is the only part left and has suffered considerable restoration, is a spacious hall church. Its aisles not only were nearly of the same width as the chancel, which projects one bay eastward, but were of the same height, with an arcade of lofty pillars formed by four stone columns and four Purbeck marble shafts (Pl. 94 a). The tracery of the wide windows and the canopied wall niches for the tombs of Stephen Allard,

[1] See A. H. Thompson in *Arch. Journ.* lxvi. 431.
[2] See S. Toy in *V.C.H. Sussex*, ix (1937), 71.

admiral of the Cinque Ports, and his relatives belong to the Decorated period.[1]

The building of the church at Winchelsea followed the laying out of the new town to replace the old port which had almost perished in the terrible flood of 1250. The planning of towns, the development of the fortified manor or residence, and the building of a new type of castle are all signs of the increasing importance of secular art during Edward I's reign. As a town-planner Edward followed a general European trend and the example set by St. Louis and Alphonse of Poitiers. His founding of new towns was the natural result of a wise and benevolent policy, concerned more with the welfare of the citizens and the security of the realm than with aesthetic qualities. But the layout of the streets in relation to the gates in the enclosing walls and to the main buildings within indicates a growing capacity to conceive and visualize a group of buildings as a well-ordered whole, together with its relation to the space in which it is set. Edward's English activities were preceded by the building of small urban settlements on the Garonne and Dordogne in his duchy of Gascony where 'part of his policy was the setting up of a class of new towns which were at once centres of expanding commerce, bulwarks of English power and refuges of country folk in time of war'.[2] In these *bastides* there was no rigidity in the planning, which tended naturally toward the chequer-board system, but modified it subtly in accordance with the nature of the ground. Libourne, the chief of the *bastides*, which rivalled Bordeaux in the wine trade, and was named after Edward's seneschal, Roger of Leybourne, a Kentish village, had eight straight streets radiating from a central square. At the little town of Beaumont, founded in 1272 in the hilly country between the Dordogne and the Lot, the longitudinal streets followed the gentle curve of the plateau so that the secondary streets could not be strictly parallel, and the main square was slightly irregular, aligned on the pattern of the streets. The main feature which distinguished the *bastides* from the new towns in Wales and England[3] was the market square with its fortified

[1] See J. Evans, *O.H.E.A.* v (1949), 166. [2] T. F. Tout, *Edward I* (1913), 101.
[3] P. Lavedan, *Histoire de l'Urbanisme*, i (1948), 402: 'En dépit de la lettre par laquelle

817203

church, its arcades to shelter the wares and the town hall which was customarily built with open sides on the ground level as at Montpazier, where the roof was supported by twenty-eight stone pillars. All *bastides* were protected by walls, and the building of the fortifications was usually a shared duty.[1]

Edward's continental experiences bore fruit in the new castle boroughs built after the conquest of Wales, towns which were open at Flint and Rhuddlan, but strongly fortified at Caernarvon, Beaumaris, and Conway.[2] At Conway, where the fortifications are well preserved, the stone wall around castle and town was about 1,400 yards in length with three great gates and twenty-two half-round towers, generally open at the back. The walled area was roughly triangular in shape with a broad base along the river and a sharp point at the opposite end from the castle, where a round tower, on rising ground, reached the same height as the castle's towers. Within the town was an old hall built mainly of timber, called 'Llewelyn's Hall', which was preserved and repaired until in 1316 its timber was sent to Caernarvon to build a shelter for victuals. Roughly in the town centre was the conventual church, which now became the parish church of the new town. The Cistercian abbey of Aberconway, founded *c*. 1186 and richly endowed by Llewelyn the Great, was removed, but the convent had to provide 'two honest English chaplains and one honest Welsh chaplain' for the town. On the whole, the layout of the streets was not rigidly chequer-board in fashion, though they were set roughly at right angles to each other, with long blocks between, nor was it governed by any relation to a main building or a square. Except at Flint, where all long streets led towards the castle, there was no formal market square in the new

Edward I demanda à l'Angleterre des architectes pour ses domaines du continent, les villes de Guyenne offrent un sens de l'ordre urbain, parfois même des recherches de rythme et d'harmonie auxquels demeurent étrangères les villes sur le sol de la Grande-Bretagne.'

[1] C. Shillaber, 'Edward I, Builder of Towns', *Speculum*, xxii (1947), 297: 'For seven years beginning in 1287 Edward stipulated that the duties on merchandise handled at the port of Libourne be applied to the expense of its fortifications and in turn required the inhabitants to fulfil their obligation of building homes.'

[2] See H. H. Hughes, 'The Edwardian Castle and Town Defences', *Arch. Cambr.* xciii (1938), 75 and 212.

boroughs, and at Conway there was only a widening at the crossing of the two main arteries in front of the church. Though Archbishop Pecham wanted Edward to move the Welsh into the towns, so that their children might be brought up in English ways, the Welsh towns remained outposts of English civilization, military and commercial centres to serve the English interest.

In England the main achievements in this field were at Winchelsea and Kingston-on-Hull. The site chosen for the new town at Winchelsea was upon a rock above the sea, selected principally for military reasons to guard the entrance of the Brede river. The work of surveying was done with great skill, with regular square blocks between the streets and four gates in the wall of which three still remain. 'The king took 149½ acres on which to lay out the town. Of this, 87½ acres were laid out as building sites; 45 acres were used for streets, markets, waste ground etc.; five acres were set aside for cemeteries and churches, twelve acres the king retained for his own use.'[1] Not all the blocks were ever fully built upon though the new foundation was fairly prosperous. But its growth and prosperity remained far behind that of the new port of Kingston-on-Hull, which was to replace the port of Ravenser already half swallowed by the sea. A new port was needed in connexion with the Scottish wars and as an outlet for the rich production of the Yorkshire area, the prosperity of which was witnessed by the energetic activity in building noted in the preceding pages. Edward's actions were limited to the granting of charters, the first of which was given in 1299, and to the improvement of protection and communication. But though the actual laying out of the town proceeded under his successor, his was the choice of the site. 'We may perhaps claim for Edward a touch of that instinct in choosing town sites which is a rarer gift for the town-planner than the mechanical measuring out of straight lines and right angles in

[1] W. M. Homan, 'The Founding of New Winchelsea', *Sussex Arch. Soc. Trans.* lxxxviii (1949), 22. See also G. E. Chambers in *V.C.H. Sussex*, ix (1937), 62, and T. F. Tout, 'Medieval Town-planning', *Collected Papers*, iii (1934), 81–84. Tout points out that one of the three men appointed in 1281 to make assessments was a Gascon of wide experience in *bastide*-building. In the directions given to a larger commission in 1284 Tout saw the 'most detailed evidence of conscious planning by royal authority that the age was to witness'.

plotting the roads and "burgages" within the walls.'[1] The procedure followed by Edward when he tried to transform Berwick-on-Tweed provides a good illustration of his methods. The order given to the City of London in 1296 to select 'four wise and knowing men to devise, order and array a new town for the profit of the king and the merchants' was followed by one issued to twenty-three other boroughs to send two representatives, and again in the beginning of 1297 Edward asked for representatives from Winchelsea and other boroughs.[2] This request for opinions from men living in different parts of the country was bound to make the new ideas of town planning known all over the country. Though the older towns could not easily make readjustments of their plans they developed and elaborated their walled enclosures. Practical considerations must have provided the main reasons, but the impressive walls with their towers and gates built in the newest fashion were symbols of the towns' growing importance in the framework of English society. Other units such as cathedrals and monasteries followed the towns, encircling their precincts by elaborate walls.[3] Licences from the king were required for the purpose and the demand for licences to crenellate increased steadily, sought not only by institutions but by individuals for their private residences.

Under Henry III the plan and appearance of the domestic residence suitable for king, bishop, and baron were on the whole still those of Norman times. Henry tried many ways of improving the comfort of his various residences. Orders for chimneys, the glazing of windows and other details were issued frequently and particular care was given to sanitation. An 'oriel' became a favourite addition, usually in connexion with the chapel, and a great porch was built at Westminster between the lavatory in front of the king's kitchens and the door into the lesser hall 'so that the king may

[1] T. F. Tout, ibid. 80.

[2] *Parl. Writs*, &c., ed. F. Palgrave (1827), i. 49–51. T. F. Tout, ibid. 84–86.

[3] Licences for enclosure were given to the cathedral priory of Norwich in 1276 (*Cal. Patent Rolls*, 4 E.I. m. 12), to the dean and chapter of Lincoln (ibid., 13 E.I. m. 22), to the dean and chapter of York, and to the dean and chapter of St. Paul's (ibid., m. 15) in 1285, to the dean and chapter of Exeter in the following year (ibid., 14 E.I. m. 24), to the priory of Tynemouth in 1295 (ibid., 24 E.I. m. 8). See A. H. Thompson, *Military Architecture in England during the Middle Ages* (1912), 298.

dismount from his palfrey in it at a handsome façade ("ad honestam frontem") and may be able to walk under it from between the door and the lavatory and also from the kitchen to the knights' chamber.'[1] But no basic changes were made in the planning. Westminster palace as all other palaces consisted of a loosely tied group of buildings varying in size and in material. In this it did not differ from one of the largest residences built by one of Henry's favourites at Toddington (Beds.) who, as Matthew Paris describes, 'so adorned his manor with a palace, chapel, bedchambers and other stone houses, covered with lead, with orchards and fishponds as to provoke the wonder of the beholders: for during many years the artificers of his buildings are said to have received weekly in wages one hundred shillings, and very often ten marks'.[2] But under Edward I one finds not only a greater demand for comfort and lordly splendour,[3] but the planning of the house as a unified block. Stokesay castle (Salop), a fortified manor house, still consists of a picturesque group of separate units. To the twelfth-century north tower there was added a hall of unusually wide span, without aisles and with tall traceried windows, a solar wing (c. 1260–80) and a polygonal south tower built after the licence to crenellate in 1291. But the houses at Aydon (Northumberland) (c. 1280) and Little Wenham Hall (Suffolk)[4] (c. 1270–80) are built with two regular blocks set in right angles to each other mainly of two storeys. The large palace which Bishop Robert Burnell built for himself at Acton Burnell (Salop) of the red sandstone of the district is the most regular in planning and elevation. He received licence to crenellate in 1284 and probably did not see the completion of the building. Four square towers marked the angles of the whole enclosure, and the west front of the palace, with two towers

[1] *Close Rolls, 1242–7*, 273; cf. L. F. Salzman, *Building in England* (1952), 95.

[2] *Chronica Majora*, v, R.S. lvii (1880), 242. Cf. T. Hudson Turner, *Some Account of Domestic Architecture in England*, i (1851), 62.

[3] The Pipe Rolls 13 E.I contain accounts for the building of a house for Edward I at Woolmer. Cf. Hudson Turner, op. cit. i. 60. In the hall at Langley a painter from London painted in 1292 54 shields and 4 knights 'seeking feats of arms'. Cf. Salzman, op. cit. 163.

[4] For Stokesay, Aydon, Little Wenham, and Acton Burnell see M. E. Wood, 'Thirteenth-Century Domestic Architecture in England', *Arch. Journ.* cv (Suppl. 1950), 64, 51, 76, 62. The walls of Little Wenham Hall are of brick.

flanking a third more massive one in the centre, is reminiscent of the gatehouses in the castles which his master had begun to build in Wales.

Even if the abbey of Vale Royal and St. Stephen's chapel had been completed in Edward's lifetime and were still standing, it would yet be fair to say that Edward's enthusiasm as a builder found more and greater scope in his castles. His father was not a castle-builder, partly because he was wholly absorbed by other tasks which appealed more to his love of the arts, partly because military science was outside his interests. Few entirely new castles were built by Henry, but, where security and political exigencies required, an existing castle was repaired or strengthened as for instance the Tower of London and the castles at Dover, Windsor, and elsewhere. It was only during political crises, such as that of the siege of Lincoln at the start of his reign and the critical one of Kenilworth at the end, that castles played an important role. They were, however, already an object of architectural experiment, where various new features were tried out which affected profoundly the two main portions of the traditional late twelfth century castle, the keep and the curtain, and prepared the way for the magnificent achievements of Henry's son.

The cylindrical or polygonal plan for the keep, which replaced the earlier one of Norman times, became generally accepted early in the century, actually at the time when this strong point was already losing its important function of chief defence, refuge, and residence. The keeps of Pontefract and York were merely more perfect examples of a dying form. Clifford's Tower at York, built probably between 1245 and 1259, was built like that of Pontefract on a quatrefoil plan with two vaulted storeys, the roofs of which were supported by a single pier in the centre and small, corbelled turrets were inserted between the four main curving towers. But the interest had already begun to shift from the keep to the encircling walls. The stone curtain, at intervals strengthened by projecting towers, for which the round shape became customary, received increasing attention from the builders. The appearance of the castle enclosure gained enormously by the rhythmical alternation of broad stretches of wall, crowned by a rampart walk,

and high bulky towers which represented the multiplication of the one single keep in the centre all around the curtain. The towers seem to activate the passive and stolid stretches of wall; as in the knightly effigies on their tombs the crossed legs and hands on swords preserve a tense alertness even in the stillness of death. Each curtain tower was a key to one section of the wall; each tower could be entered on the first floor from the rampart walk which it commanded. At Pembroke castle[1] the curtain around the inner bailey was amply provided with stairways and passages, which allowed the defence forces to rush from one part to the other, and each section of the continuous curtain could be closed off by means of barriers and the defence carried on even after other sections had been taken. The seizure of the defence of such a towered curtain was thus not a single action but a multiple one, where each tower and section of the wall between had to be taken one by one. The Tower of London and the castle at Dover received this strengthening of the curtain under Henry III and contributed to the development of the concentric plan, as along certain stretches the curtains were doubled.[2] A similar strengthening of the older nucleus was carried out at Middleham castle (Yorkshire).

Another feature which enhanced the effectiveness and the appearance of the castle was developed in the second half of the century: the broad expanse of water, more a lake than a moat, of which the most impressive example was that at Kenilworth.[3] There the great dam which produced a lake of a hundred and eleven acres was probably due to Henry III. The narrow crest of the dam which held in the water was the only approach towards the advance works and the gatehouse in the outer curtain, which was

[1] William Marshall, earl of Pembroke, and his successors were responsible for the modernization of this castle, which served as a point of embarkation and contact with Ireland. The original Norman castle was relatively small, occupying a triangular shaped area on the point of a promontory jutting out into the river Pembroke. By the end of the century its area was tripled and the weight shifted from the older circular keep to the massive gatehouse. See air view in W. D. Douglas, *Castles from the Air* (1949), 97.

[2] The building of the outer ward of the Tower under Henry III has been questioned: see below, p. 263, n. 1.

[3] For the plan of Kenilworth castle see S. Toy, *The Castles of Great Britain* (1953), 137; see also C. Oman, *Castles* (1926), 73.

strengthened by five mural towers. The test of the strength which three kings, Henry II, John, and Henry III, had given to Kenilworth came during the baronial war when Kenilworth was held by the irony of history against the king, and Simon de Montfort's son withstood in it a siege of seven months. Young Edward may have learned a hard lesson in military science when he fought in front of Kenilworth. But while Henry III had helped to turn the castle into a mighty fortress, it was typical of him that thirty years before the great siege he thought of the amenities of the sheet of water which his dam provided when, in 1237, he ordered 'a fair and beautiful pleasure boat' to be moored near the door of his private chamber. The greatest strength of the curtain was gathered in the gatehouse which protected the main approach. At Rockingham castle a magnificent gatehouse was built in the later part of Henry III's reign with two bulky round towers flanking the gateway, the timbered doors of which were protected by an iron portcullis. The 'Black Gate' at Newcastle, built in 1247, was of a more elaborate type.

But with all these improvements the castle during Henry III's reign still consisted of single, separate units: low stretches of flat wall and high cubic units of towers, gatehouse or keep, each conceived as a single part, each facing its own way. It was only at the time of Edward I that the castle became a living organic entity. If the Edwardian castles were merely the result of the development of military science, where new techniques of attack required the appropriate counter-measures of defence, they would play no great role in the history of art, but under Edward an increase of purely aesthetic values caused the castle not only to gain in massive strength in order to impress the enemy, but to grow in splendour so that all the features required by military science were turned into visual symbols, the trappings of the governing class. Basically as to plan in the arrangement of defences, these later castles were variations of a single type which was found, at its most splendid, in the castle of Le Crak des Chevaliers in Syria and was used also in western Europe. But it is part of their strength and all of their appeal that the Edwardian castles, though all designed on the same principles, show a marked adaptability to the geographical

condition of the chosen site. Their enclosure, single or, as more common now, double in two concentric rings, seemed full of elasticity with a general contour apparently advancing and retreating, alternately slack and tense, and with a skyline rising and falling. The castle was conceived from the beginning as a whole, its builders aiming at a balanced regularity in plan. With their symmetrical and axial planning and their terracing, they have the quality of strictly organized power of a Hellenistic or Roman fortress. The concentric plan was of cosmopolitan usage at this time, derived from Byzantine sources and used at Crak, Carcassonne, and English castles like the Tower, but the keep-gatehouse was a distinctively English feature. In castles like Caerphilly, Harlech, and Beaumaris, which were built on a fresh site upon a preconceived plan, unconnected with a town, the concentric plan implied a gradual widening of the surrounding rings from the keep-gatehouse to the inner and the outer ward within their curtains. They seem to be conceived as spatial compositions in a well-ordered organization in depth from the first approach to the centre and in height from the low outer curtain to the higher inner curtain wall, from low bastions to drum towers to the dominating keep. At certain points a more active advance from the centre towards the outside was provided by the barbicans in front of the main gate. These barbicans protected sorties by the garrison as well as making it exceedingly difficult for the attacker to approach the main entrance. The movements of the garrison were made more fluid and arranged in depth. The new conception of spatial depth was strengthened by axial planning with the main axis leading from the main gatehouse to a second one in the rear. In older castles posterns in the curtain had always provided means of retreat, but the posterns were placed at odd convenient spots without relation to keep, gatehouse or each other. In the new castles back and front were on the same axis which divides the whole symmetrically. At Chepstow the old castle was enlarged by the addition of an outer ward with curtain and gatehouse in front of the Norman castle and it extended backwards to a rear gate which could be used for a well-ordered final retreat. Since the outer curtain was usually lower than the inner, its defenders could

shoot at the same time as, but above the heads of, those in front. Loops and merlons were placed systematically and the whole defence was planned as a multiple action radiating in all directions in depth and height and governed from a centre. In giving the gatehouse the strength of a keep the 'weight and mass of the castle was brought forward and concentrated frontally'[1] with the drawbridge and portcullis under immediate control of the commander, who could direct the defence from the gatehouse as from a captain's bridge while using it as a spacious residence in peace time.

The castle of Kidwelly in South Wales, in a key position on the road to Carmarthen in the west and communicating with the sea, built by the Chaworth family, was a blend of the old and the new manner, a link between Chepstow and the castles built on a fully developed concentric plan. The castle was rebuilt about 1275, a typical mid-thirteenth-century structure, raised on the summit of a steep hill with a small inner ward enclosed by walls which were strengthened at the angles by four drum towers.[2] Front and rear entrances were provided merely by small doorways in the curtain. A semicircular outer bailey was protected only by ditch and palisade. But about twenty-five years later, the palisade was replaced by a curving stone curtain with three half-round towers, making the castle semi-concentric. The drum towers of the inner ward had to be raised in order to command the new curtain and a strong keep-gatehouse was built to protect the principal entrance into the outer ward. Elaborate outer works were added as well as a postern flanked by small drum towers which provided a rear gate at the opposite extremity. The full concentric plan on a large scale was used for the castle at Caerphilly (Fig. 19) begun about 1267 by Gilbert de Clare, 8th earl of Gloucester and 7th earl of Hereford, who, by deserting the Montfortian cause, became the strong supporter of the king. The Red Earl built the castle to protect the

[1] W. D. Simpson, 'Harlech Castle and the Edwardian Castle Plan', *Arch. Cambr.* xcv (1940), 153.

[2] J. C. Perks, 'The Plan of Kidwelly Castle', *Arch. Cambr.* xcviii (1943), 259, and C. Fox and C. A. R. Radford, 'Kidwelly Castle, Carmarthenshire', *Archaeol.* lxxxiii (1933), 93.

lower valley of the Rhymney and the coast around Cardiff against
Welsh attacks from the valleys which came down from Brecon
Beacon.[1] Like Kenilworth, the castle was reared on an island in a
lake. The outer curtain was low, with curved projections like
bastions in the four angles which were concentric to the four drum

FIG. 19. *Plan of Caerphilly castle.*

towers of the rectangular inner wall. Two large gatehouses flanked
by drum towers were provided, set in the middle of the east and
west walls of the inner ward, repeated on a smaller scale in the outer

[1] W. Rees, *Caerphilly Castle* (1937). The concentric design of Caerphilly castle may
have been developed gradually in connexion with that of Harlech. See J. H. Harvey,
English Medieval Architects (1954), 237: 'If it could be proved that the concentric
defences of Caerphilly were actually designed in the reign of Henry III, the English
concentric plan would have been introduced before the date of Edward I's crusade,
but . . . this is unproven and even improbable. The earliest concentric works with a
certain date are those added to the Tower of London by Edward after his return to
England in 1274; this makes the old tradition of the introduction of concentric works
by Edward directly from Palestine highly probable. . . .'

curtain which formed a resilient and elastic enclosure echoing the lines of the inner curtain. The lake, divided by a dam into an inner and outer moat, a large hornwork in the west and a formidable outer defence system in the east, with gatehouses, walled and turreted platforms and a wet ditch, completed the whole defensive system which, with about thirty acres, was second only to Windsor castle. 'The new castle of Caerphilly was a symbol of the force which was to overthrow the Prince of Wales.'[1]

Edward I had become well acquainted with the modern achievements in castle-building in the east and in France before he began to build the castles which sealed his conquest of Wales. The latter experience proved particularly fruitful since there are strong reasons to believe that Master James of St. George who was to direct the works on Edward's castles in Wales had gained his experience in the service of the counts of Savoy between 1261 and 1275. His name has been linked with that of the castle at St. Georges-d'Espéranche built on a concentric plan where Count Philip of Savoy paid homage to Edward I in June 1273.[2] The eight castles at Builth and Aberystwyth, Flint and Rhuddlan, Conway, Caernarvon, Harlech, and Beaumaris, built within twenty-five years, represent an increasing scale of magnificence, raised by an army of workmen 'sufficiently great to constitute a noticeable draught upon the total pool of mobile labour available in England'[3] and at the expense of about £80,000. It is tempting to believe that political and strategic reasons alone could not account for this enormous effort and that the imagination of the king and of his architects must have been set on fire, by the possibilities which the situation offered, to devise variations of the same theme out of love for the problem.

The four best-preserved castles in North Wales fall into two groups: the concentric castle centring in a keep-gatehouse and standing by itself, like Harlech and Beaumaris, and the castles with

[1] F. M. Powicke, *King Henry III and the Lord Edward* (1947), 581.

[2] For the relation between castles in Wales and that built for Peter of Savoy at Yverdon, see F. M. Powicke, *The Thirteenth Century* (1953), 431; A. J. Taylor, 'The Castle of St. Georges-d'Espéranche', *Antiq. Journ.* xxxiii (1953), 33.

[3] J. G. Edwards, 'Edward I's Castle-building in Wales', *Proc. Brit. Acad.* (1946), 15, which gives a full account of the building periods and costs.

irregular, elastic-flanked curtains built in connexion with town
fortifications, like Conway and Caernarvon.

Harlech castle[1] was begun after the fall of Llewelyn in 1282,
after an army under Otho de Grandison and John de Vesey had
reached the spot in their march along the coast from Caernarvon.
The building was substantially accomplished by the end of the

FIG. 20. *Plan of Harlech castle.*

season of 1285. In its plan it is similar to Caerphilly, but it is more
regular and strictly symmetrical (Fig. 20). A middle axis cuts through
the outer gate and the great gatehouse and continues through
the great hall to the postern in the middle bailey. The low outer
curtain surrounds the mighty inner curtain and serves as a terrace
for the lofty walls and drum towers, which rise to some forty feet
high, blank and forbidding. The square shape with angle-towers
was repeated in the huge keep-gatehouse which reaches with its
rear turrets deep into the inner bailey. The unusually thick curtain
walls provided ample space for a continuous rampart walk which
ran, as in Conway, round the inner faces of the angle towers,
supported by corbels, without passing through the towers. Its

[1] See C. R. Peers, *Harlech Castle* (1923).

dominating position high upon the rock, above shifting and changing sand and sea, its austere compactness and its symmetry make Harlech the most perfect castle of its kind. Were the builders conscious of the grandiose contrast of rock and sea, of the permanence of the massive bulk of stone and the changes of season and weather? Though the battle and the feasting have long ceased in the now

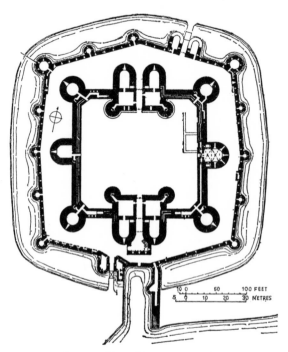

Fig. 21. *Plan of Beaumaris castle.*

empty shell of the castle, the change of light, the movement of wind and cloud, still seem to infuse it with vigorous life (Pl. 95 *b*).

The effect of the castle of Beaumaris[1] seems an anticlimax, partly due to its site on flat ground, partly to the almost monotonous abstract perfection of its plan and elevation. It was begun early in the season of 1295, but building still proceeded during the years 1309–23. It was planned on a series of concentric rings whose radii were on a ratio of 1, 2, 3, and 4, the plan being a square enclosed by an octagon (Fig. 21). Axial planning was carried through with

[1] R.C.H.M., *Anglesey* (1937), 3.

rigid consistency. Two gatehouses are standing back to back
balancing each other north and south. The cross axis was marked
by the drum-towers in the centre of the east and west walls and
four round towers marked the corners of the square. The only
divergence from symmetry is in the placing of the gates in the
outer curtain which were set off-centre in oblique angles to
the main gatehouses. Owing to the lack of natural defences on the

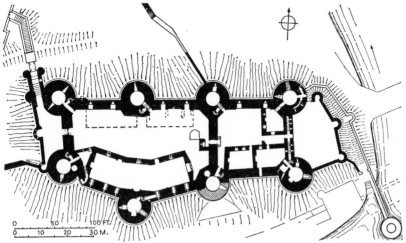

FIG. 22. *Plan of Conway castle.*

flat site with only an outer ditch which filled at high tide, the
outer curtain was made higher than at Harlech, but yielded to the
projection of the towers of the inner curtain. Its perfect geometrical
symmetry makes Beaumaris seem less alive than Harlech, an
exercise in castle-building suitable for any site which provided an
even flat surface to build upon.

The castles at Conway and Caernarvon formed a class of their
own. Both were built without a keep-gatehouse and without a
concentric curtain in a narrow, irregular shape on a tongue of land
between river and sea, with the curtain moulded to the contour of
the rock upon which they were raised. Conway castle was begun
in March 1283 and substantially completed by the end of 1287
(Fig. 22). The site was one of great natural strength upon a high
rock, protected on the east and south by the rivers Conway and
Gyffin and towards west and north, towards the town, by a deep

moat. The main points open to attack were the narrow fronts in east and west, and strong gateways with barbicans protected the approach. The western barbican had three bastion towers, the eastern three round towers, which, relatively small in scale, led up to the majestic scale of the castle's main towers. These, eight in number, were made to project beyond the high curtain, all carried up one stage above the level of the rampart walk, with the four eastern towers rising even higher with embattled stair-turrets. A continuous rampart walk ran along the top of the curtain, curving around the inner faces of the towers and crossing along the inner wall which divided the enclosed area into two wards, a long outer ward roughly hexagonal in shape with a sharp twist in the southern wall, and an almost square inner ward, considerably lower in level. Into the twist of the southern wall the great hall for the garrison was fitted, while the royal quarters took up almost three-quarters of the inner bailey. The great hall, now in ruins, was built on a sumptuous scale although the standing garrison was small. Besides the commandant and his household there were thirty men of whom '15 shall be cross-bowmen, a chaplain, an artillery crafts-man, a carpenter, a mason, a smith, and from the others there shall be made janitors, watchmen, and other ministers of the castle'.[1] The royal establishment in the inner ward contained a smaller hall, a chapel, and separate rooms. The remains of large windows with delicate tracery, the provision made for comfortable ladies' quarters, the splendour of the private chapel, added a note of pageantry to the stern music of battle, but it is the protective frame of these private quarters which creates the climax of the whole design. The skyline of the castle rises from west to east. While its face drops down precipitously towards the estuary it rises trium-phantly to its greatest height in the small round turrets, lofty observation posts, rising elegantly above their bulky companions (Pl. 95 a).

At Caernarvon the site, determined by earlier buildings, did not have the advantages of Conway, offering a relatively level ground between the river Saint on the south and the town on the north. But while Caernarvon castle lacks the compactness and the proud

[1] S. Toy, 'The Town and Castle of Conway', Archaeol. lxxxvi (1936), 163.

height of Conway, it exceeds it not only in size, but in the effect of
vivacity caused by the many angles in the curtain wall, each angle
marked by a tower (Pl. 90). The nine towers are not simple
cylinders, but polygons varying in number of angles (Fig. 23).
It seems proved that the vast irregular structure was conceived
from the beginning as a complete unit under the direction of
Master James of St. George, the 'magister operacionum regis in

FIG. 23. *Plan of Caernarvon castle.*

Wallia', for Walter of Hereford, master of the works at the abbey
of Vale Royal, did not take charge until 1295. The south wall from
the Eagle Tower to the north-east tower was built mainly between
1283 and 1292, the north wall with the Well Tower, the King's
Gate, and the Granary Tower, raised to a height of 12–24 feet, was
completed between 1296 and 1323. The plan was roughly a figure
8, the shape of the lower ward, built in five sections determined
by the earlier Norman motte which it contained. The sloping
apron which strengthens the base of the curtain at the east section
on the outside was probably necessitated by the artificial nature of
the ground of the earlier motte. The Eagle Tower, at the point of
juncture between castle and town wall, was built with the strength
of a keep, a witness of the versatility of Master James, who had
built the keep which is such a distinctive feature of Flint castle and

T

'to which a true English parallel has still to be found'.[1] The tower-flanked King's Gateway, facing the town, protected the entrance into the lower ward and was linked with the dividing portions between the wards. The Queen's Gateway, at the highest point in the east, was next to the joining of river and sea.

The most imposing front was that which spread in a broken line along the river, with the sharp salients of the curtain sections and its projecting towers, like finely cut diamonds in the long chain of the walls, and with the even surface of the finely grained limestone broken by bands of darker stone and triple rows of loops. Though a building caused by stern necessity, it was not only the bulwark and token of conquest, but was a stage for re-enacting the Arthurian tradition. To the earlier nineteenth century these Welsh castles in their lonely hills were to seem the quintessence of romance, but even to those who built them they spoke of a remote past, and the conquest of North Wales seemed a continuation of ancient adventures.[2] Edward celebrated it by holding a 'Round Table' in Nefyn (Caernarvon) at midsummer in 1284 'where the most famous knights of England and the Continent fought amidst the wilds of Snowdon'.[3] The year before he had sent the alleged crown of Arthur to Westminster abbey. Thus, as the writer of the Waverley Annals puts it, the glory of the Welsh was transferred to the English.[4] Edward's attitude towards Arthurian romances illustrates that mixture of intellectual acumen and sentimental romanticism or chivalry so characteristic of him and of the art of his time.

[1] A. J. Taylor, 'The Date of Caernarvon Castle', *Antiquity*, xxvi (1952), 33. See also A. J. Taylor, 'Master James of St. George', *Engl. Hist. Rev.* lxv (1950), 433.

[2] F. M. Powicke, *King Henry III and the Lord Edward* (1947), 724.

[3] T. F. Tout, *Edward I* (1913), 117. A Round Table meant apparently a special form of tournament fought on horseback with blunted lances in the presence of ladies between opponents who, it is presumed, figured as Arthurian knights. The first Round Table on record was held at Cyprus in 1223. In England the first, mentioned by Matthew Paris, was at Wallingford in 1252. In 1279 Edward was the guest of Roger Mortimer at Kenilworth. From the reports on that occasion it can be gathered that Mortimer invited 100 knights and 100 ladies and held a Round Table at which he won a prize of a golden lion. See R. S. Loomis, 'Edward I, Arthurian Enthusiast', *Speculum*, xxviii (1953), 114.

[4] In the same year the body of the father of the Emperor Constantine was discovered at Caernarvon and brought to the church at the king's command. See *Flores Historiarum*, iii, R.S. xcv (1890), 59.

CONCLUSION

SINCE Rickman and Sharpe, Prior and Bond evolved a classi-
fication of the phases of English Gothic art, it became gener-
ally accepted that the development in the thirteenth century
went through three stages—stages which are called with reference
to architecture and especially to window tracery the Early English
(*c.* 1225–45), the Geometric (*c.* 1245–70) and the Early Decorated
(*c.* 1270–1310). But, by enlarging the field so that all the arts are
taken into account and seen in relation to the cultural background
and the prevailing patronage, three other headings could well be
used under which to group the material discussed in this volume:
the 'Episcopal', the 'Regal', and the 'Seigneurial'. Of the years
between 1205 and 1215 it has been said that they are 'a watershed
in religious history' and that 'no other decade has such a signifi-
cance for the spiritual and constitutional life of the Church until
the early years of the sixteenth century are reached'.[1] This state-
ment applies equally to the arts. The period immediately following
1215, that of the 'episcopal' style, represents the stage of classical
perfection in English Gothic art.

It never gained the universal interest or high esteem allotted to
the arts of the Anglo-Saxon and Norman periods. That it 'lacks
the high finality of Durham and the Bury Bible' of the twelfth
century is partly due to a temporary isolation caused by the loss
of Normandy and the break-up of the Angevin Empire. But even
if English Gothic was not, as English Romanesque had been, a
'great, at moments supreme, exponent of a European style',[2] it
developed a characteristically national style during the 'episcopal'
phase. Norman Durham and Gloucester are more grandiose than
Salisbury and Lincoln, and these latter do not reach the same degree
of sublime perfection as Chartres and Rheims; but, besides possess-
ing a beauty of their own, they are 'English' to the last detail and
far more so than their Norman predecessors. The great Norman
cathedrals and abbeys in England are, it is true, different from those

[1] D. Knowles, *The Religious Orders in England* (1948), 1.
[2] T. S. R. Boase, *O.H.E.A.* iii. 299.

on the Continent, a difference which must have been caused by local taste and tradition and which cannot be easily defined; but it is only in the first half of the thirteenth century that an English style is clearly established. This applies in particular to architecture and sculpture, for in the field of illumination English and French production on either side of the channel can less easily be distinguished. It seemed more important in this volume of the History of English Art to define the main features which constitute the English element in the European Gothic style, than to discuss in detail the various continental influences.

The strength of the 'episcopal' style lies not only in its individual and national character, marked by order and clarity of planning, a preference for Purbeck marble and the use of stiff-leaf foliage, but also in the optimistic belief that the struggle between the temporal and the spiritual, to which St. Thomas had fallen a victim, could be solved peacefully and that a harmony could be established between reason and faith, between heaven and earth. From this comes the serenity of the statues of Wells. They lack the emotional tension and the personal expressions of earlier and later periods, but their faces shine with physical beauty, keen intelligence, and humane benevolence, not to be found again until the time of the High Renaissance. It is in this short span that 'the minds of men of that time, more perhaps than at any other moment of history, found their employment and exercise in dealing with formal and abstract truth, rather than with the concrete realities of human life or with the emotions and appreciations of individuals'.[1] From the middle of the century the realities of life become more and more the concern of artists and patrons. The 'regal' style under Henry III inclines towards a ripeness and a sophistication which carries in itself the seed of decay. The art of this period blossoms forth in the warm emotional climate largely produced by the two brothers-in-law, Henry III and St. Louis. They and their wives and nobles became the patrons of a new art appealing to a lay society who, partly under Franciscan influence, saw in the Christian knight and the society of the Grail an ideal standard of behaviour. In the third quarter of the thirteenth century

[1] D. Knowles, op. cit. 8.

England was in close contact with the cultural and political life of Europe. The Emperor Frederick II, who had married Henry III's sister, had died in 1250, but in 1257 Richard of Cornwall was elected king of Germany and Henry's eldest son, Edward, married the daughter of Alfonso of Castile, Richard's rival as king of the Romans. Henry's ambitions to gain the crown of the kingdom of Sicily for his second son, Edmund, were defeated, but Charles of Anjou, who succeeded, was the husband of the fourth daughter of Raymond of Provence, sister to the queens of England and France and to Earl Richard's wife. In the north English influence was strong in Norway under King Haakon. Westminster abbey is the finest flower of a courtly, cosmopolitan art which was deeply influenced by French manners and designs. In the Angel Choir at Lincoln English taste and tradition reasserted itself, but the freshness and the purity of the 'episcopal' style, which had retained in all its richness something of the budding firmness of early growth, was lost. Royal patronage was partly responsible for a self-conscious and emotional aestheticism which caused in the arts a rift between the senses, the heart and the mind.

The third phase, the 'seigneurial' style, during which patronage spreads in wider circles from the court to gentry and merchants, is not as clearly defined as a stylistic unit. It represents a phase of transition in which the sense of unity, in the spiritual order as in the arts, gradually dissolves. At the same time new elements of visual representation come into being; space becomes three-dimensional. Figures tend to become detached from architecture and to show their individual features just as the leaves of Southwell show the variety of natural forms. An intricate and complex intellectual play, be it in the configurations of window tracery or the elaborate patterns on the pages of the Arundel Psalter, goes hand in hand with the gorgeous and colourful splendour of chivalrous courtliness. And underneath it all there is an emotional insecurity and anxiety. The Heavenly Jerusalem that once seemed so close has become remote. The consciousness of this is either deadened by the enjoyment of all the richness of the world or assuaged by an elaborate funerary art. It increases the devotional dependence on the assistance of saints, whose faces in painting and sculpture

indicate that the youth and serenity, which shone from the statues at Wells, have fled and left the field to age and care. 'The fifty or sixty years after the death of St. Louis in 1270 (or, if we prefer, that of St. Bonaventure and St. Thomas in 1274) mark what is called the end-phase of High Scholasticism by the historians of philosophy, and the end-phase of High Gothic by the historians of art-phases in which the various developments, however important, do not as yet add up to a fundamental change in attitude but rather manifest themselves in a gradual decomposition of the existing system'.[1] Not till the Renaissance will the arts again reflect the optimistic confidence of the opening years of the thirteenth century.

[1] E. Panofsky, *Gothic Architecture and Scholasticism* (1951), 8.

BIBLIOGRAPHY

THIS selective bibliography may be supplemented by the exhaustive and critical bibliography for the period in all its aspects by Sir Maurice Powicke, *The Thirteenth Century, 1216–1307*, in the *Oxford History of England* (Oxford, 1953), 720–78, and by the *Bibliography of the History of British Art* published by the Courtauld Institute of Art (5 vols., Cambridge, 1934–51) covering the years 1934–45. Additional references can also be found in Vols. III and V of the *Oxford History of English Art* by T. S. R. Boase and J. Evans. The topographical card index of the Society of Antiquaries proved an invaluable aid.

Topographic alguides such as the *Victoria County History*, the volumes of the Royal Commission on Historical Monuments, the Little Guides published by Methuen & Co., and the Penguin *Buildings of England* edited by Nikolaus Pevsner have not been included, as they are general works and obvious sources of information. This applies equally to the catalogues listing and describing the illuminated manuscripts, such as those by M. R. James for the Cambridge Colleges, Eton College, and the Lambeth Palace Library; by G. F. Warner and J. P. Gilson for the Western Manuscripts in the Royal Collection in the British Museum; by F. Madan and H. H. E. Craster for the Bodleian Library. A card index of reproductions of illuminated manuscripts in the Conway Library of the Courtauld Institute is in preparation.

CONTEMPORARY SOURCES

Annales Monastici, ed. H. R. Luard (R.S. xxxvi, 5 vols., 1864–9).

BARTHOLOMAEUS DE COTTON, *Historia Anglicana*, ed. H. R. Luard (R.S. xvi, 1895).

Charter Rolls, Calendar of: Vol. i, *Henry III, 1226–57*; vol. ii, *Henry III–Edward I, 1257–1300*; vol. iii, *Edward I–Edward II, 1300–26* (Public Record Office, 1903–8).

Close Rolls, Calendar of: *Henry III, 1216–72* (14 vols., 1902–38); *Edward I, 1272–1307* (5 vols., 1900–8).

FLETE, J. *The History of Westminster Abbey*, ed. J. Armitage Robinson (Cambridge, 1909).

Flores Historiarum, ed. H. R. Luard (R.S. lxxxiv, 3 vols., 1890).

Fountains, Memorials of the Abbey of St. Mary, ed. J. R. Walbran (Surtees Soc., xlii, vol. i, 1863).

GIRALDUS CAMBRENSIS, *Opera*, ed. J. S. Brewer, J. F. Dimock, and G. F. Warner (R.S. xxi, 8 vols., 1861–91).

GROSSETESTE, ROBERT, *Epistolae*, ed. H. R. Luard (R.S. xxv, 1861).

Hugh of Lincoln, Metrical Life of, ed. J. F. Dimock (Lincoln, 1860).

LANGTOFT, PETER, *Chronicle*, ed. W. A. Wright (R.S. xlvii, 2 vols., 1846–8).
Liberate Rolls, Calendar of, 1226–51 (3 vols., 1916–37).
MARSH, ADAM, 'Epistòlae', ed. J. S. Brewer, in *Monumenta Franciscana*, i (R.S. 1858).
PARIS, MATTHEW, *Chronica Majora*, ed. H. R. Luard (R.S. lvii, 7 vols., 1872–83).
—— *Historia Anglorum*, ed. F. H. Madden (R.S. xliv, 3 vols., 1866–69).
Patent Rolls, Calendar of: Henry III, 1216–72 (6 vols., Public Record Office, 1901–13); *Edward I, 1272–1307* (4 vols., Public Record Office, 1893–1901).
RISHANGER, WILLIAM, *Chronica A.D. 1259–1307*, ed. H. T. Riley (R.S. xxviii, pt. 2, 1865).
Rotuli litterarum clausarum, 2 vols., Record Commission (1833, 1844).
THOMAS OF ECCLESTON, *De adventu Fratrum Minorum in Angliam*, ed. A. G. Little (Paris, 1904; 2nd ed. Manchester, 1951).
WALSINGHAM, THOMAS, *Gesta abbatum monasterii S. Albani*, ed. H. T. Riley (R.S. xxviii, pt. 4, 1867–9).
WENDOVER, ROGER OF, *Chronicle*, ed. H. O. Coxe (5 vols., English Historical Society, 1841–4), ed. H. G. Howlett (R.S. lxxxiv, 3 vols., 1886–9).

MODERN WORKS

ACKERMAN, R. W., 'The Knighting Ceremonies in the Middle Ages', *Speculum*, xix (1944), 285.
ADDY, S., *The Evolution of the English House*, ed. J. Summerson (1933).
ALLO, E. B., *St. Jean, l'Apocalypse* (Paris, 1921).
ANDERSON, M. D., *The Mediaeval Carver* (Cambridge, 1935).
ANDERSSON, A., *English Influence in Norwegian and Swedish Figure Sculpture in Wood, 1220–1270* (Stockholm, 1949).
ANDREWS, F. B., *The Benedictine Abbey of Pershore on the Eve of the Suppression* (1934).
ARNOLD-FORSTER, F., *Studies in Church Dedications of England's Patron Saints*, 3 vols. (1899).
ATKINSON, T. D., 'Medieval Figure Sculpture in Winchester Cathedral', *Archaeol.* lxxxv (1935), 159.
—— *A Glossary of Terms used in English Architecture*, 7th ed. (1948).
AUBERT, M., *La Cathédrale Notre Dame de Paris* (nouv. éd. 1945).

BAGELEY, W., 'Notes on the Early English Lady Chapel built at Gloucester in 1224', *Bristol and Glouc. Arch. Soc. Trans.* xvi, 196.
BAGROW, L., *Die Geschichte der Kartographie* (Berlin, 1951).
BATSFORD, H., and FRY, C., *The Cathedrals of England* (1945).
BEER, E. J., *Die Rose der Kathedrale von Lausanne und der kosmologische Bilderkreis des Mittelalters* (Bern, 1952).

BENHAM, W., *Old St. Paul's Cathedral* (1902).

BENTHAM, J., *The History and Antiquities of the Conventual and Cathedral Church of Ely, from the Foundation of the Monastery A.D. 63 to the Year 1771* (Cambridge, 1771); 2nd ed. (1812) and supplement by W. Stevenson (Norwich, 1817).

BILLINGS, R. W., *Carlisle Cathedral* (1840).

—— *Architectural Illustrations and Description of the Cathedral Church at Durham* (1843).

BISHOP, E., *Liturgica Historia* (Oxford, 1918).

BISHOP, H. E., and PRIDEAUX, E. K., *The Building of the Cathedral Church of St. Peter in Exeter* (Exeter, 1922).

BIVER, P., COUNT, 'Westminster Tombs', *Bulletin Monumental* (1909), 243.

—— 'Tombs of the School of London at the Beginning of the 14th Century', *Arch. Journ.* lxvii (1916), 51.

BLOXAM, M. H., 'The Sepulchral Remains and Effigies in the Cathedral Church of Worcester', *Arch. Journ.* xx (1863), 339.

BOASE, T. S. R., *English Art, 1100–1216* (Oxford, 1953).

BODLEIAN LIBRARY, *English Illumination of the Thirteenth and Fourteenth Centuries*, ed. T. S. R. Boase (Oxford, 1954).

BOND, F., *English Cathedrals, Illustrated* (3rd ed. 1901).

—— *Gothic Architecture in England* (1905).

—— *Screens and Galleries* (1908).

—— *Westminster Abbey* (1909).

—— *The Chancel of English Churches* (1910).

—— *An Introduction to English Church Architecture*, 2 vols. (Oxford, 1913).

—— *Dedications of English Churches* (Oxford, 1914).

BORENIUS, T., *St. Thomas Becket in Art* (1932).

—— 'The Cycle of Images in the Palaces and Castles of Henry III', *Journ. of the Warburg and Courtauld Institutes*, vi (1943), 40.

BORENIUS, T., and CHARLTON, J., 'Clarendon Palace', *Antiq. Journ.* xvi (1936), 55.

BORENIUS, T., and TRISTRAM, E., *English Medieval Painting* (Florence and Paris, 1927).

BRADFORD, C. A., *Heart Burial* (1933).

BRAKSPEAR, H., *Tintern Abbey* (1934).

BRAUN, H., *The English Castle* (1936).

—— *An Introduction to English Medieval Architecture* (1951).

BRAYLEY, E. W., and BRITTON, J., *The History of the Ancient Palace and Late Houses of Parliaments at Westminster* (1836).

BRAYLEY, E. W., and NEALE, J. P., *The History and Antiquities of the Abbey Church of St. Peter, Westminster*, 2 vols. (1818).

BREHIER, L., *La Cathédrale de Reims* (Paris, 1920).

BRIDGETT, T. E., *A History of the Holy Eucharist in Great Britain* (1908).
BRITISH MUSEUM, *Reproductions from Illuminated MSS.*, 4 vols. (1923–8).
BRITTON, J., *Architectural Antiquities*, 5 vols. (1807–26).
—— *Cathedral Antiquities*, 11 vols. (1814–35).
—— *The History and Antiquities of the See and Cathedral Church of Lichfield* (1836).
BROWNE, J., *The History of the Metropolitan Church of St. Peter, York*, 2 vols. (London, Oxford and York, 1847).
BRUCE, J. D., *The Evolution of Arthurian Romance from the Beginnings down to the Year 1300*, 2 vols. (Baltimore, 1923).
BUNIM, M., *Space in Medieval Painting and the Forerunners of Perspective* (New York, 1940).
BURGES, W., *The Iconography of the Chapter House at Salisbury* (1859).
BURLINGTON FINE ARTS CLUB, *Catalogue of an Exhibition of Illuminated MSS.* (1908).

CARPENTER, S. C., *The Church in England 597–1688* (1954).
CARTER, J., *Some Account of the Cathedral Church of Durham with Plates Illustrative of the Plans, Elevations and Sections of that Building* (1801).
CAUTLEY, H. M., *Suffolk Churches and their Treasures* (1937).
—— *Norfolk Churches* (1949).
CAVE, C. J. P., *Roof Bosses in Medieval Churches* (Cambridge, 1948).
CHAMBERS, E. K., *Arthur of Britain* (1927).
CHAMBERS, G. E., 'The French Bastides and the Town Plan of Winchelsea', *Arch. Journ.* xciv (1937), 177.
CHENEY, C. R., 'Church-Building in the Middle Ages', *Bulletin of the John Rylands Library*, xxxiv (1951–2), 20.
CHRISTIE, A. G. I., *English Medieval Embroidery* (Oxford, 1938).
CHURCH, C. M., 'Jocelin, Bishop of Bath, 1206–1242,' *Archaeol.* li, part 2 (1888), 281, 348.
CLAPHAM, A. W., 'The Architecture of the English Praemonstratensians', *Archaeol.* lxxiii (1922–3), 117.
CLAPHAM, A. W., and GODFREY, W. H., *Some Famous Buildings and their Story* (n.d.).
CLARK, G. T., *Medieval Military Architecture in England*, 2 vols. (1884).
CLAYTON, P. B., 'The Inlaid Tiles of Westminster Abbey', *Arch. Journ.* lxix (1912), 36.
CLIFTON, A. B., *The Cathedral Church of Lichfield* (1898).
CLUTTON-BROCK, A., *The Cathedral Church of York* (1899).
COCKERELL, C. R., *Iconography of the West Front of Wells Cathedral* (1851).
COCKERELL, Sir S. C., *The Work of W. de Brailes* (Cambridge, 1930).
COOK, G. H., *Portrait of Durham Cathedral* (1948).
—— *Portrait of Salisbury Cathedral* (1949).

COOK, G. H., *Portrait of Lincoln Cathedral* (1950).

—— *Portrait of St. Albans Cathedral* (1951).

—— *Medieval Chantries and Chantry Chapels* (1947).

CORBAN, W. B., *The Story of Romsey Abbey* (Gloucester, 1947).

COXE, H. O., *The Apocalypse of St. John the Divine* (1876).

CROMBIE, A. C., *Robert Grosseteste and the Origins of Experimental Science, 1100–1700* (Oxford, 1953).

CRONE, G. R., 'The Hereford World Map', *Journ. of the Royal Geographical Society* (1948).

CROSSLEY, F. H., *English Church Monuments, A.D. 1150–1550* (1921).

—— 'Monastic Influence on the Construction of Parochial Churches', *Chester and N.-Wales Arch. Soc.* (1939), 138.

—— *English Church Design, 1040–1540 A.D.* 2nd ed. (1948).

DART, J., *Westmonasterium, or the History and Antiquities of the Abbey Church of St. Peter's, Westminster*, 2 vols. (1723).

DE BRUYNE, E., *Études d'esthétique médiévale*, 3 vols. (Bruges, 1946).

DELISLE, L., and MEYER, P., *L'Apocalypse en français au XIIIᵉ siècle* (Bibl. nat. fr. 403) (Paris, 1901).

DEMAISON, L., *La Cathédrale de Reims* (Paris, 1910).

DENHOLM-YOUNG, N., *Richard of Cornwall* (Oxford, 1947).

DIMOCK, A., *The Cathedral Church of Southwell* (1898).

DUGDALE, W., *Monasticon Anglicanum*, ed. J. Caley, H. Ellis, and B. Bandinel, 6 vols. in 8 (1817–30).

—— *The History of St. Paul's Cathedral* (1658), ed. H. Ellis (1818).

DURAND, G., *Monographie de l'Église Notre Dame, Cathédrale d'Amiens* (Amiens, 1901).

EDWARDS, J. G., 'Edward I's Castle-Building in Wales', *Proc. of the Brit. Academy*, xxxii (1951), 15.

EDWARDS, K., *The English Secular Cathedrals in the Middle Ages* (1949).

EGBERT, D. D., 'The Tewkesbury Psalter', *Speculum*, x (1935), 376.

—— 'The so-called "Greenfield" La Lumière as Lais and Apocalypse', *Speculum*, xi (1936), 446.

ESCHER, K., *Englische Kathedralen* (Munich, 1927).

ESDAILE, K. A., *Temple Church Monuments* (1933).

EVANS, H. A., *Castles of England and Wales* (1912).

EVANS, J., *English Art, 1307–1461* (Oxford, 1949).

—— 'A Prototype of the Eleanor Crosses', *Burl. Mag.* xci (1949), 96.

FELTON, H., and HARVEY J., *The English Cathedrals* (1950).

FLICHE, A., THOUZELLIER, C., and AZAIS, Y., *La Chrétienté Romaine (1198–1274): Histoire de l'église*, x (1950).

FOCILLON, H., *Art d'Occident: Le Moyen Âge roman et gothique* (Paris, 1947).

FORMILLÉ, C., 'The Monumental Work of the Cosmati at Westminster Abbey', *R.I.B.A. Journ.* 3rd series, xviii. 69.

FOX, Sir C., *Illustrated Regional Guide to Ancient Monuments: South Wales* (1949).

FRANCOVICH, G. DE, 'Miniature inglesi a Velletri', *Bolletino d'Arte* (1930), 17.

FREEMAN, E. W., *Architectural History of Exeter Cathedral* (1888).

FREY, D., *Englisches Wesen in der bildenden Kunst* (Stuttgart, 1942).

FREYHAN, R., 'English Influences on Parisian Painting of about 1300', *Burl. Mag.* liv (1929), 320.

FRYER, A. C., *Wooden Monumental Effigies in England and Wales* (1910).

—— 'Monumental Effigies made by Bristol Craftsmen, 1240–1550', *Archaeol.* lxxiv (1925), 1.

GALBRAITH, V. H., *Roger Wendover and Matthew Paris* (Glasgow, 1944).

GALLOWAY, J., *Eleanor of Castile, Queen of England, and the Monuments Erected to Her Memory* (1910).

GARDNER, A., *English Sculpture c. 1300* (1946).

—— *English Medieval Sculpture* (Cambridge, 1951).

GARDNER, A., and HOWGRAVE-GRAHAM, P. P., 'The "Queen Margaret" Statue at Lincoln', *Antiq. Journ.* xxix (1949), 87.

GARDNER, S., *A Guide to English Gothic Architecture* (Cambridge, 1922).

—— *English Gothic Foliage Sculpture* (Cambridge, 1927).

GASQUET, F. A., *Henry III and the Church* (2nd ed. 1910).

GIBBS, M., and LANG, J., *Bishops and Reform, 1215–1272* (Oxford, 1934).

GIRDLESTONE, C. M., 'Thirteenth Century Gothic Architecture in England and Normandy', *Arch. Journ.* cii (1945), 111.

GLUNZ, H. H., *History of the Vulgate in England from Alcuin to Roger Bacon* (Cambridge, 1933).

GOUGH, R., *Sepulchral Monuments of Great Britain*, 6 vols. (1786–96).

GREENWELL, W., *Durham Cathedral* (Durham, 1904).

GRIGSON, G., MEYER, P., and HÜRLIMANN, M., *English Cathedrals* (1950).

GROSS, W., *Die abendländische Baukunst um 1300* (Stuttgart, 1948).

GRUNDMANN, H., 'Neue Forschungen über Joachim von Fiore', *Münsterische Forschungen* (1950).

HABERLEY, L., *Medieval English Paving Tiles* (Oxford, 1937).

HAHNLOSER, H. R., *Villard de Honnecourt* (Vienna, 1935).

HALLETT, C., *The Cathedral Church of Ripon* (1909).

HARLECH, LORD, *Illustrated Regional Guides to Ancient Monuments under the Ownership or Guardianship of the Ministry of Works: England and Wales.* 4 vols. (2nd ed. 1949).

HARRISON, F., *Treasures of Illumination: English Manuscripts of the Fourteenth Century, c. 1250–1400* (London and New York, 1937).

HARRISON, F., *The Story of York Minster* (11th ed. 1950).

HARTSHORNE, A., *Portraiture in Recumbent Effigies and Ancient Schools of Monumental Sculpture in England* (Exeter, 1899).

HARVEY, A., *The Castles and Walled Towns of England* (1911).

HARVEY, J. H., *The Gothic World, 1100–1600* (1950).

—— *Gothic England: A Survey of National Culture, 1300–1550* (2nd ed. 1948).

—— 'The Medieval Office of Works', *Journ. Brit. Arch. Ass.* vi (1941), 20.

—— *English Medieval Architects* (1954).

HASELOFF, A., 'La Miniature dans les Pays Cisalpins depuis le Commencement du XIIᵉ jusqu'au Milieu du XIVᵉ Siècle', in Michel, A., *Histoire de l'Art*, ii, part 1 (2nd ed. 1922).

HASELOFF, G., *Die Psalterillustration im 13. Jahrhundert* (Kiel, 1938).

HASKINS, C. H., *Studies in the History of Medieval Science* (Harvard University Press, 1924).

—— *Studies in Medieval Culture* (Oxford, 1929).

HASTINGS, M., *Parliament House, the Chambers of the House of Commons* (1950).

—— *St. Stephen's Chapel* (Cambridge, 1955).

HEMP, W. J., 'Conway Castle', *Archaeol. Camb.* xcvi (1941), 163.

HERBERT, J. A., *Illuminated Manuscripts* (1911).

—— *Schools of Illumination from MSS. in the British Museum, II: English, 12th and 13th Centuries* (1915).

HILL, J. W. F., *Medieval Lincoln* (Cambridge, 1948).

HINNEBUSCH, W. A., *The Early English Friars Preachers* (Rome, 1951).

HODGES, C. C., 'The Architectural History of Selby Abbey', *Yorks. Arch. and Top. Ass. Record*, xiii (1893).

——, 'The Stone Carvers in the Nine Altars and Choir of Durham Cathedral and Their Other Works', *Proc. of the Newcastle-on-Tyne Soc. of Antiq.*, 3rd ser. x. 272.

HOLLAENDER, A., 'The Sarum Illuminator and his School', *Wilts. Arch. and Nat. Hist. Mag.* l (1942–4), 230.

—— 'The Pictorial Work in the "Flores Historiarum" of the so-called Matthew of Westminster', *Bull. of the John Rylands Library*, xxviii (1944), 361.

HOPE, W. ST. JOHN, 'On the Sculptured Doorways of the Lady Chapel of Glastonbury Abbey', *Archaeol.* lii (1890), 85.

—— 'On the Funeral Effigies of the Kings and Queens of England', *Archaeol.* lx (1897), 517.

—— 'Fountains Abbey', *Yorkshire Arch. Journ.* xv (1898), 269.

—— *The Cathedral Church and Monastery of St. Andrew's, Rochester* (1900).

—— 'Quire Screens in English Churches', *Archaeol.* lxviii (1917), 43.

HOPE, W. ST. JOHN, and BRAKSPEAR, H., *The Cistercian Abbey of Beaulieu* (1906).

HOPE, W. ST. JOHN, and LETHABY, W. R., 'The Imagery and Sculptures on the West front of Wells Cathedral Church', *Archaeol.* lix (1904), 125.

HOWARD, F. E., *The Medieval Styles of the English Parish Church* (1936).

HUGHES, H. H., 'The Edwardian Castle and Town Defences at Conway', *Archaeol. Camb.* xciii (1939), 75, 212.

HUNTER, J., 'On the Death of Eleanor of Castile, Consort of King Edward the First and the Honours Paid to her Memory', *Archaeol.* xxix (1942), 167.

HUTTON, G., *English Parish Churches* (1952).

JAMES, M. R., *Catalogue of MSS. and Early Printed Books in the Library of J. Pierpont Morgan* (1906).

—— *The Trinity Apocalypse* (Roxburghe Club, 1909).

—— *La Estoire de St. Aedward le Rei* (Roxburghe Club, 1920).

—— *The Apocalypse in Latin and French* (Oxford, 1922).

—— *The Douce Apocalypse* (Roxburghe Club, 1922).

—— *Illustrations to the Life of St. Alban in Trinity College, Dublin, MS. E. i. 40* (Oxford, 1924).

—— 'The Drawings of Matthew Paris', *Walpole Soc.* xiv (1925–6), 1.

—— *Abbeys* (1925).

—— *The Apocalypse in Latin, MS. 10 in the Collection of Dyson Perrins* (Oxford, 1927).

—— *The Apocalypse in Art* (1931).

—— *The Dublin Apocalypse* (Roxburghe Club, 1932).

KANTOROWICZ, E. H., *Laudes Regiae* (University of California Press, Berkeley and Los Angeles, 1946).

KATZENELLENBOGEN, A., *Allegories of the Virtues and Vices in Medieval Art* (1939).

KEMP, E. W., *Canonization and Authority in the Western Church* (Oxford, 1948).

KER, N. R., *Medieval Libraries of Great Britain* (1941).

KIMBLE, G. H. T., *Geography in the Middle Ages* (1938).

KNOOP, D., and JONES, J. K., *The Medieval Mason* (Manchester, 1933).

—— 'The English Medieval Quarry', *Econ. Hist. Rev.* ix (1938), 17.

KNOWLES, D., *The Religious Houses of Medieval England* (Cambridge, 1940).

—— *The Religious Orders in England* (Cambridge, 1948).

KNOWLES, D., and ST. JOSEPH, J. K., *Monastic Sites from the Air* (Cambridge, 1952).

KURTH, B., 'Matthew Paris and Villard de Honnecourt', *Burl. Mag.* lxxxi (1942), 227.

LAFOND, J., *The Stained Glass Decoration of Lincoln Cathedral* (n.d.).

LAVEDAN, P., *Histoire de l'Urbanisme*, I (Paris, 1948).

LE COUTEUR, J. D., *English Medieval Painted Glass* (1926).

LEGG, J. WICKHAM, *The Sarum Missal* (Oxford, 1916).

LEFRANÇOIS-PILLION, L., *La Cathédrale d'Amiens* (1937).

LETHABY, W. R., *Westminster Abbey and the King's Craftsmen* (1906).

—— 'Notes on Sculptures in Lincoln Minster: The Judgment Porch and the Angel Choir', *Archaeol.* lx, pt. 2 (1907), 379.

—— 'Chertsey Tiles', *Walpole Soc.* ii (1913), 69.

—— 'English Primitives', *Burl. Mag.* xxix (1916), 189, 281, 351; xxx (1917), 133; xxxi (1917) 45, 97, 192, 233; xxxiii (1918), 3, 169.

—— *Westminster Abbey Re-examined* (1925).

—— 'Old St. Paul's', *Builder*, cxxxviii (1930).

LINDBLOM, A., *La Peinture Gothique en Suède et en Norvège* (Stockholm, 1916).

LITTLE, A. G., *Collectanea Franciscana*, i (Aberdeen, 1914), 1.

—— *Studies in English Franciscan History* (Manchester, 1917).

—— 'Franciscan History and Legend in English Medieval Art', *British Soc. of Franciscan Studies*, xix (1935-6).

LLOYD, N. A., *History of the English House* (1931).

LONDON MUSEUM CATALOGUES, No. 7: Medieval Catalogue (1940).

LONGMAN, W., *A History of the Three Cathedrals Dedicated to St. Paul* (1873).

LOOMIS, R. S., and LOOMIS, L. H., *Arthurian Legends in Medieval Art* (Oxford and New York, 1938).

LOVELL, W., 'Queen Eleanor's Crosses', *Arch. Journ.* xlix (1892), 17.

LYNAM, C., *The Abbey of St. Mary, Croxden* (1911).

MACGIBBON, D., and ROSS, T., *The Ecclesiastical Architecture of Scotland*, 3 vols. (Edinburgh, 1896-7).

MAILLET, G., *La Vie Religieuse au temps de St. Louis* (Paris, 1954).

MÂLE, E., *Religious Art in France in the 13th Century* (transl. from 3rd ed., 1913).

MARSHALL, G., *The Cathedral Church of Hereford* (Worcester, 1951).

MARSHALL, M. H., 'Thirteenth Century Culture as illustrated by Matthew Paris', *Speculum*, xiv (1913), 465.

MARTIN, A. R., *Franciscan Architecture in England* (1937).

MARX, J., *La Légende Arthurienne et le Graal* (Paris, 1952).

MESSENT, C. J. W., *The Monastic Remains of Norfolk and Suffolk* (Norwich, 1934).

MILLAR, E. G., 'Les Principaux MSS. à peintures du Lambeth Palace à Londres', *Bulletin de la Société française de Reproductions de MSS. à peintures*, viii (1924).

—— *English Illuminated Manuscripts from the 10th to the 13th Century* (Paris and Brussels, 1926).

—— *A Descriptive Catalogue of the Western MSS. in the Library of A. Chester Beatty*, 2 vols. text, 2 vols. plates (1927).

MILLAR, E. G., *The Rutland Psalter* (Roxburghe Club, 1937).

—— *A Thirteenth Century York Psalter* (Roxburghe Club, 1952).

—— 'Fresh Materials for the Study of English Illumination', *Studies in Art and Literature for Belle da Costa Greene* (Princeton, 1954), 286.

MILLER, K., *Die ältesten Bildkarten* (Stuttgart, 1895).

MOORMAN, J. R. H., *Church Life in England in the Thirteenth Century* (Cambridge, 1945).

MOREY, C. R., *Medieval Art* (New York, 1942).

MOREY, C. R., GREENE, B., DA COSTA, and HASSEN, M. P., *Exhibition of Illuminated MSS. from the Pierpont Morgan Library* (New York, 1934).

NEALE, J. P., and LE KEUX, J., *Views of the Most Interesting Collegiate and Parochial Churches in Great Britain*, 2 vols. (1824–5).

NEUSS, W., *Die Apocalypse des Heiligen Johannes in der altspanischen and altchristlichen Buchillustration* (Münster, 1931).

NEW PALAEOGRAPHICAL SOCIETY, *Facsimiles of Ancient Manuscripts, etc.*, 1st series (1903–12), 2nd series (1913–30).

NOLLOTH, H. E., *Beverley and its Minster* (1930).

NOPPEN, J. G., 'William of Gloucester, Goldsmith to King Henry III', *Burl. Mag.* li (1927), 189.

—— 'Sculpture of the School of John of St. Albans', *Burl. Mag.* li (1927), 79.

—— 'Further Sculpture of the Westminster School', *Burl. Mag.* liii (1928), 74.

—— 'An Unknown Thirteenth Century Figure', *Burl. Mag.* liii (1928), 250.

—— 'Recently Cleaned Sculpture at Westminster', *Burl. Mag.* lviii (1931), 139.

—— 'The Westminster School and its Influence', *Burl. Mag.* lvii (1930), 72.

—— 'The 13th-century Lady Chapel at Westminster Abbey', *Builder*, xcviii (1938), 374.

OAKESHOTT, W., *The Sequence of English Medieval Art* (1950).

OLIVER, G., *Lives of the Bishops of Exeter* (Exeter, 1861).

OMAN, Sir C., *Castles* (1926).

—— 'The Goldsmiths at St. Albans Abbey during the 12th and 13th Centuries', *Trans. of the St. Albans and Herts. Archit. and Arch. Soc.* (1930–2), 215.

PALAEOGRAPHICAL SOCIETY, *Facsimiles of Manuscripts, etc.*, vols. i and ii (1873–83); 2nd series (1884–94). See also NEW PALAEOGRAPHICAL SOCIETY.

PANOFSKY, E., *Gothic Architecture and Scholasticism* (Latrobe, 1951).

PANTIN, W. A., *Durham Cathedral* (1948).

PERKINS, J., *Westminster Abbey: Its Worship and Ornaments*, 3 vols. (1938–52).

PETERSON, E., *Das Buch von den Engeln* (Leipzig, 1934).

PEVSNER, N., *The Leaves of Southwell* (1945).

PEVSNER, N., 'Harlech und Beaumaris, der Höhepunkt britischer Burgen-architektur', *Burgwart*, xxxix (1938), 32.

POWICKE, Sir F. M., *Stephen Langton* (Oxford, 1928).

—— *King Henry III and the Lord Edward*, 2 vols. (Oxford, 1947).

—— 'The Compilation of the Chronica Majora of Matthew Paris', *Proc. of the Brit. Academy* (1944), 147.

—— *The Thirteenth Century, 1216–1307* (1953; Oxford History of England, vol. iv).

PRICKETT, M., *Historical and Architectural Description of the Priory Church at Bridlington* (Cambridge, 1831).

PRIDEAUX, E. K., and HOLT SHAFTO, G. R., *Bosses and Corbels of Exeter Cathedral* (Exeter, 1910).

PRIOR, E. S., *A History of Gothic Art in England* (1900).

—— *The Cathedral Builders in England* (1905).

—— *Eight Chapters on English Medieval Art* (Cambridge, 1922).

PRIOR, E. S., and GARDNER, A., *An Account of Medieval Figure Sculpture in England* (Cambridge, 1912).

RACKHAM, B., *The Ancient Glass of Canterbury Cathedral* (1949).

READ, H., *English Stained Glass* (London and New York, 1926).

REES, W., *Caerphilly Castle* (Cardiff, 1937).

RICHARDS, R., *Old Cheshire Churches* (1947).

RICHARDSON, W., *Monastic Ruins of Yorkshire*, 2 vols. (York, 1851).

RICKERT, M., *Painting in Britain: The Middle Ages* (1954).

ROCK, D., *The Church of Our Fathers, as seen in St. Osmund's Rite for the Cathedral of Salisbury*, 4 vols. (1905).

ROPER, I. M., *The Monumental Effigies of Gloucestershire and Bristol* (Gloucester, 1931).

ROST, H., *Die Bibel im Mittelalter* (Augsburg, 1939).

RUSSELL, J. C., *Dictionary of Writers of 13th Century England* (1936).

—— 'The many-sided Career of Master Elias of Dereham', *Speculum*, v (1930), 378.

RUSSELL, J. C., and HIERONIMUS, J. P., 'The Shorter Latin Poems of Master Henry of Avranches relating to England' (Medieval Academy of America, 1935).

SALZMAN, L. F., *Building in England down to 1540* (Oxford, 1952).

SAUNDERS, O. E., *English Illumination*, 2 vols. (Florence and Paris, 1928).

—— *A History of English Art in the Middle Ages* (Oxford, 1932).

SAXL, F., and WITTKOWER, R., *British Art and the Mediterranean* (Oxford, 1947).

SCOTT, G. G., *Gleanings from Westminster Abbey* (London, 1863).

—— *The Chapter House of Westminster Abbey* (1867).

SEDLMAYR, H., *Die Entstehung der Kathedrale* (Zürich, 1950).

SHARPE, E., *Architectural Parallels* (1848).

—— *The Seven Periods of English Architecture*, 3rd ed. (1888).

SIMPSON, W. D., *Castles from the Air* (1949).

—— 'Flint Castle', *Archaeol. Camb.* xcv (1940), 20.

—— 'Harlech Castle and the Edwardian Castle-plan', *Archaeol. Camb.* xcv (1940), 153.

SMALLEY, B., *The Study of the Bible in the Middle Ages* (2nd ed. Oxford, 1952).

SRAWLEY, J. H., *The Story of Lincoln Minster* (1947).

—— *Robert Grosseteste, Bishop of Lincoln* (1953).

STANLEY, A. P., *Historical Memorials of Westminster Abbey* (1868).

STEIN, H., *Le Palais de Justice et la Sainte-Chapelle de Paris* (Paris, 1937).

STEVENSON, F. S., *Robert Grosseteste* (1898).

STONE, L., *Sculpture in Britain: The Middle Ages* (1955).

STOTHARD, C. A., *The Monumental Effigies of Great Britain* (1817).

STRANGE, E. F., *The Cathedral Church of Worcester* (1900).

STRAYER, J. R., 'The Laicisation of French and English Society in the Thirteenth Century', *Speculum*, xv (1940), 82.

SWARZENSKI, H., 'Unknown Bible Pictures by W. de Brailes and some Notes on Early Bible Illustration', *Journ. of the Walters Art Gallery*, i (1938), 55.

SWEETING, W. D., *The Cathedral Church of Peterborough* (1898).

TANNER, L. E., *Unknown Westminster Abbey* (1948).

TANNER, T., *Notitia Monastica or an Account of all the Abbies, Priories and Houses of Friers, formerly in England and Wales*, ed. J. Nasmith (Cambridge, 1787).

TAYLOR, A. J., 'The Date of Caernarvon Castle', *Antiquity*, xxvi (1952), 25.

—— 'The Castle of St. Georges-d'Espéranche', *Antiq. Journ.* xxxiii (1953), 33.

THOMPSON, A. H., 'The Cathedral Church of the Blessed Virgin Mary, Southwell', *Trans. of the Thoroton Soc.* xv (Nottingham, 1911), 15.

—— *Military Architecture in England during the Middle Ages* (Oxford, 1912).

—— *The Historical Growth of the English Parish Church* (Cambridge, 1913).

—— *The Ground Plan of the English Parish Church* (Cambridge, 1913).

—— *English Monasteries* (Cambridge, 1923).

—— *The Cathedral Churches of England* (1925).

—— *The Building of York Minster* (1927).

—— *The English House* (Hist. Association Pamphlet, 1936).

—— 'Master Elias of Dereham and the King's Works', *Arch. Journ.* xcviii (1941), 1.

—— *Netley Abbey* (1937).

THOMPSON, E. MAUNDE, *English Illuminated Manuscripts* (1895).

THOMPSON, H. YATES, *Illustrations of 100 MSS. in the Library of H. Yates Thompson* (1907–18).

THOMSON, S. HARRISON, *The Writings of Robert Grosseteste* (Cambridge, 1940).

TOUT, T. F., *Edward I* (1920).

—— 'Medieval Town Planning' (*Collected Papers*, iii, 1934, 59).

TOY, S., 'The Town and Castle of Conway', *Archaeol.* lxxxvi (1936), 163.

—— *Castles* (1939).

—— *The Castles of Great Britain* (1953).

TRISTRAM, E. W., *English Medieval Wall Painting, II: The Thirteenth Century*, 2 vols. (Oxford, 1950).

TURNER, T. HUDSON, *Some Account of Domestic Architecture in England from the Conquest to the End of the Thirteenth Century* (Oxford, 1851).

VALLANCE, A., *English Church Screens* (1936).

VAUGHAN, R., 'The Handwriting of Matthew Paris', *Trans. of the Cambridge Bibliographical Society*, v (1949–53), 376.

VENABLES, E., *Episcopal Palaces* (1895).

VICTORIA AND ALBERT MUSEUM, *An Exhibition of the Royal Effigies, Sculpture and other Works of Art prior to their being re-installed in Westminster Abbey* (1945).

VITZTHUM, G. G., *Die Pariser Buchmalerei von der Zeit Ludwigs des Heiligen bis Philipp von Valois* (Leipzig, 1907).

WÄCHTEL, A., *Die weltgeschichtliche Apocalypse-Auslegung des Minoriten Alexander von Bremen* (Werl, 1937).

WAGNER, A. R., *Heralds and Heraldry in the Middle Ages* (Oxford, 1939).

—— *A Catalogue of English Medieval Rolls of Arms* (Oxford, 1950).

WALL, J. C., *Shrines of British Saints* (1905).

WALLACE, W., *St. Edmund of Canterbury* (1893).

WALTERS ART GALLERY, *Illuminated Books of the Middle Ages and Renaissance* (Baltimore, 1949).

WARNER, G., *Illuminated Manuscripts in the British Museum* (1903).

WATSON, A., *The Early Iconography of the Tree of Jesse* (1934).

WATSON, E. W., *The Cathedral Church of Christ in Oxford* (1935).

WEBB, G., *Ely Cathedral* (1951).

—— *Gothic Architecture in England* (The British Council, 1951).

—— 'The Sources of the Design of the West Front of Peterborough Cathedral', *Arch. Journ.* cvi, Suppl. (1952).

—— 'The Decorative Character of Westminster Abbey', *Journ. of the Warburg and Courtauld Institutes*, xii (1949), 16.

WEBSTER, J. C., *The Labors of the Months in Antique and Medieval Art* (Evanston and Chicago, 1938).

WESTLAKE, F. H., *Westminster Abbey*, 2 vols. (1923).

WILLIAMS, L. F. RUSHBROOK, *History of the Abbey of St. Albans* (1917).

WILLIS, R., *The Architectural History of Chichester Cathedral* (Chichester, 1861).

WILSON, R. M., 'English and French in England 1100–1300', *History*, xxviii (1943), 37.

WOOD, M. E., *Thirteenth-Century Domestic Architecture in England* (1950).

WOODFORDE, C., *A Guide to the Medieval Glass in Lincoln Cathedral* (1933).

—— *English Stained and Painted Glass* (Oxford, 1954).

WORDSWORTH, C., *Ceremonies and Processions of the Cathedral Church of Salisbury* (1901).

WORMALD, F., 'The Rood of Bromholm', *Journ. of the Warburg and Courtauld Institutes*, i (1937), 31.

—— 'More Matthew Paris Drawings', *Walpole Soc.*, xxxi (1946), 109.

—— 'Paintings in Westminster Abbey and Contemporary Paintings', *Proc. of the Brit. Academy, 1949*, xxxv (1952), 161.

WYNN REEVES, P., *English Stiff Leaf Sculpture* (unpubl. dissertation for London Univ., 1952).

ZARNECKI, G. *Later English Romanesque Sculpture, 1140–1210* (1953).

—— 'The Faussett Pavilion,' *Archaeol. Cantiana*, lxvi (1954), 10.

ADDITIONAL BIBLIOGRAPHY (1968)

BEER, E. J., 'Gotischen Buchmalerei', *Zeitschr. f. Kunstgeschichte* xxv (1962); xxx (1967).

BRANNER, R., 'Westminster Abbey and the French Court Style', *Journ. of Soc. of Arch. Hist.* (1964).

BROWN, R. A., COLVIN, H. M., and TAYLOR, A. J., *The History of the King's Works: The Middle Ages*, 2 vols. (1963).

EGBERT, V. W., 'The Portal of the Church of the Blessed Virgin Mary at Higham Ferrers', *Art Bulletin* xli (1959).

FLITCHEN, J. F., *Construction of Gothic Cathedrals* (1961).

FRANKL, P., *Gothic Architecture* (1962).

HASSALL, A. G. and W. O., *The Douce Apocalypse* (1961).

HENDERSON, G., 'The Lambeth Apocalypse', *Journ. of Warburg and Courtauld Institutes* xxx (1967).

SHAPIRO, M., 'An Illuminated English Psalter of the Early 13th Century', *Journ. of Warburg and Courtauld Institutes* xxiii (1960).

TUDOR-CRAIG, P., 'The Painted Chamber at Westminster', *Arch. Journ.* cxiv (1957).

TURNER, D., *Early Gothic Illuminated Manuscripts in England* (1965).

VAUGHAN, R., *Matthew Paris* (1958).

WEBB, G., *Architecture in Britain: The Middle Ages* (1956).

INDEX

References in **black** type are to plates

I. WELLS CATHEDRAL: NORTH TOWER OF WEST FRONT

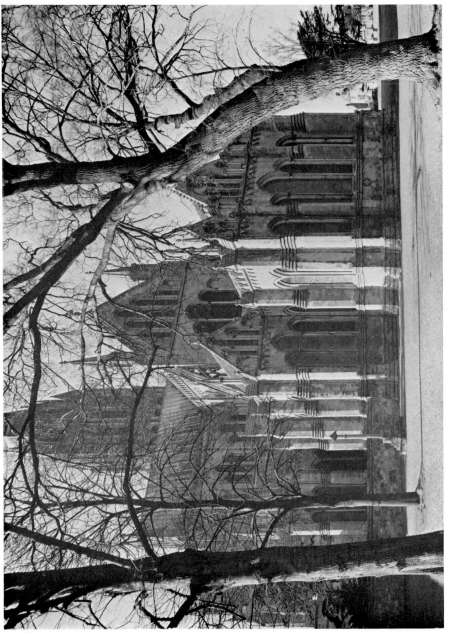

2. SALISBURY CATHEDRAL FROM THE SOUTH-EAST

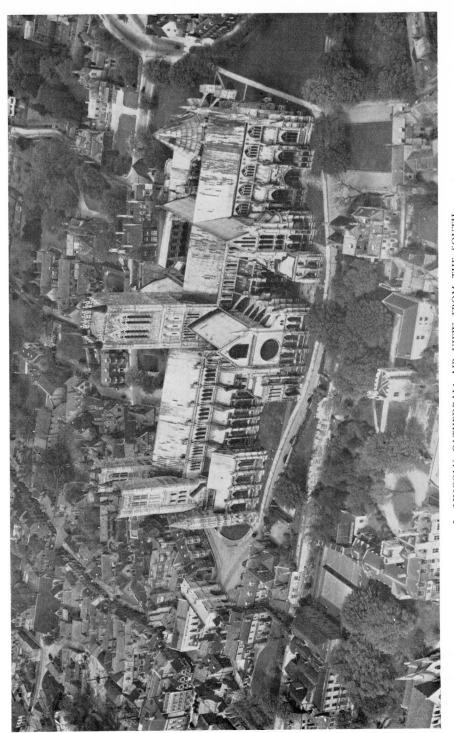

3. LINCOLN CATHEDRAL: AIR VIEW FROM THE SOUTH

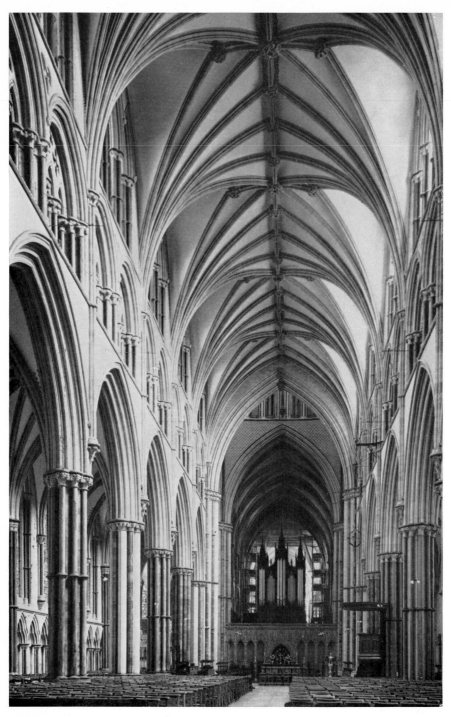

4. LINCOLN CATHEDRAL: NAVE

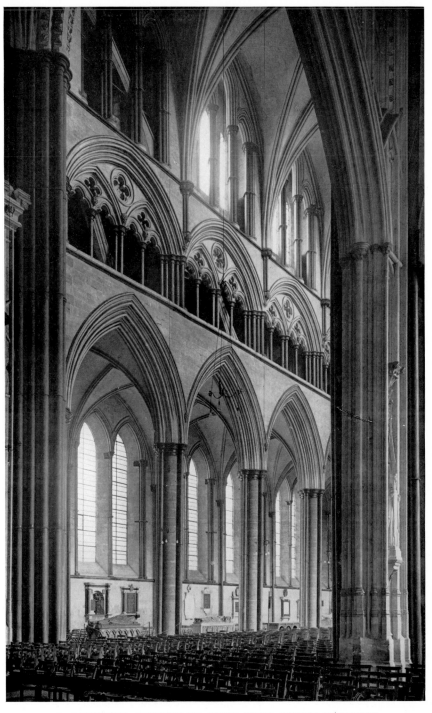

5. SALISBURY CATHEDRAL: NAVE FROM NORTH TRANSEPT

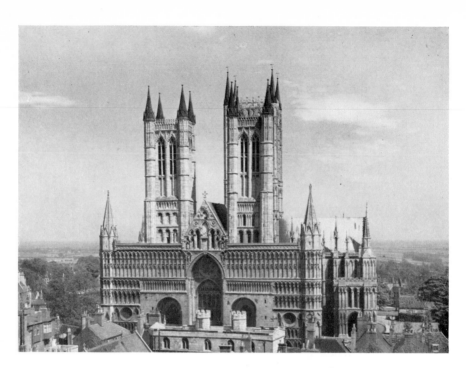

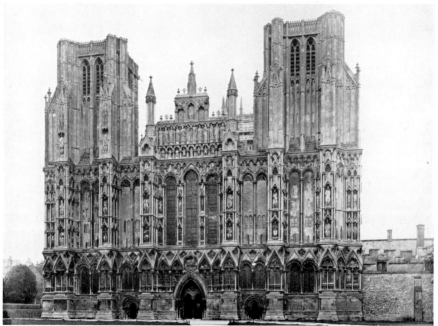

6. *a*. LINCOLN CATHEDRAL: WEST FRONT
b. WELLS CATHEDRAL: WEST FRONT

7. *a.* BEVERLEY MINSTER FROM THE SOUTH
 b. SOUTHWELL MINSTER: CHAPTER-HOUSE AND NORTH TRANSEPT

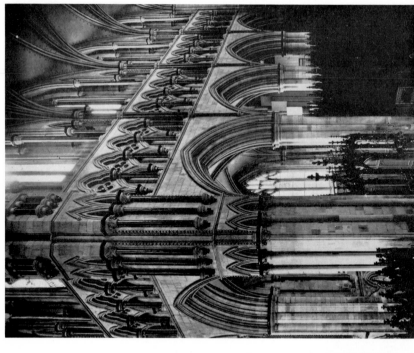

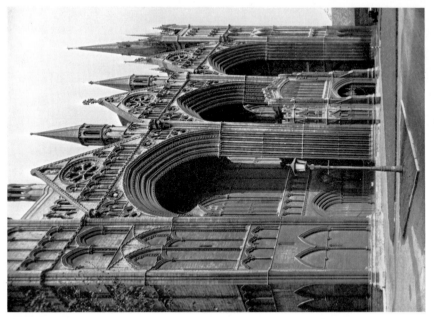

8. *a.* PETERBOROUGH CATHEDRAL: WEST FRONT

b. BEVERLEY MINSTER: THE CHOIR

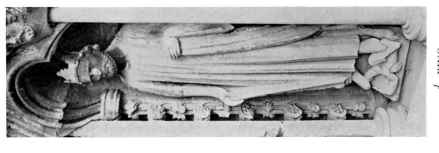

d. KING

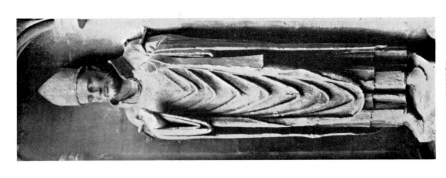

c. BISHOP

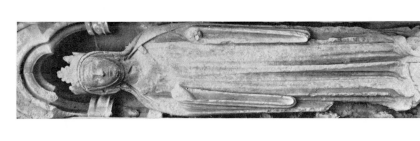

b. LADY

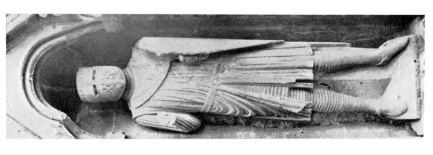

a. KNIGHT

9. FIGURES FROM WEST FRONT OF WELLS CATHEDRAL

a. HERMIT *b*. LADY

IO. WELLS CATHEDRAL

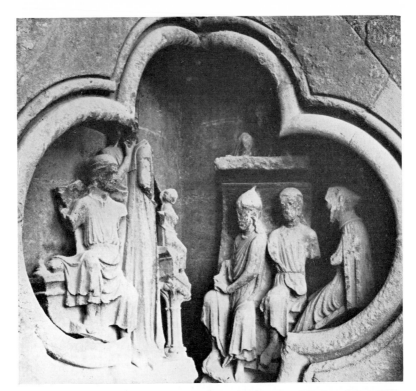

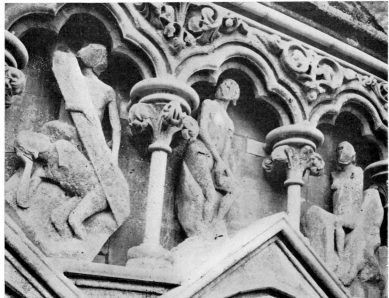

a. CHRIST AND THE DOCTORS
b. RESURRECTION OF THE DEAD

II. WELLS CATHEDRAL

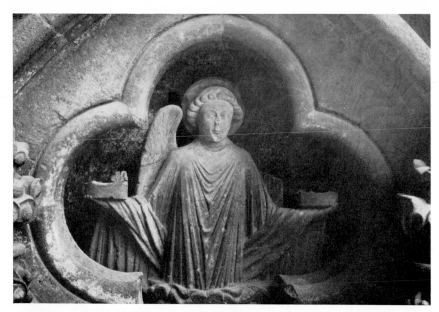

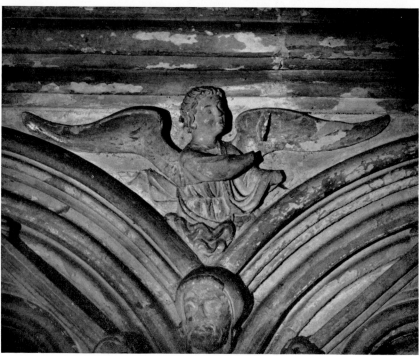

12. *a.* WELLS CATHEDRAL: ANGEL WITH CROWNS
b. SALISBURY CATHEDRAL: ANGEL ON CHOIR SCREEN

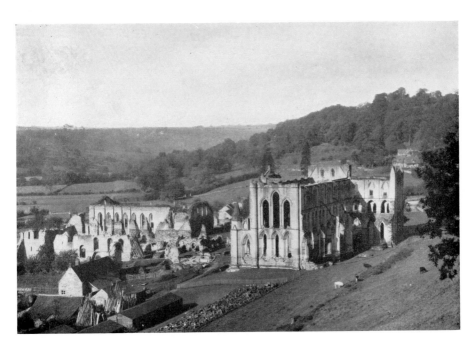

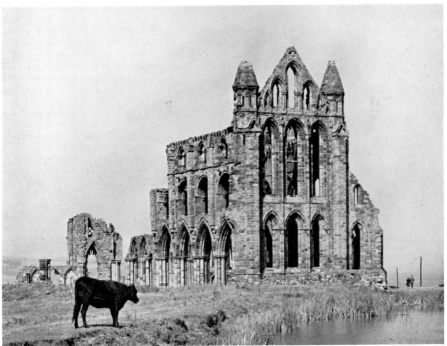

13. *a.* RIEVAULX ABBEY
b. WHITBY ABBEY

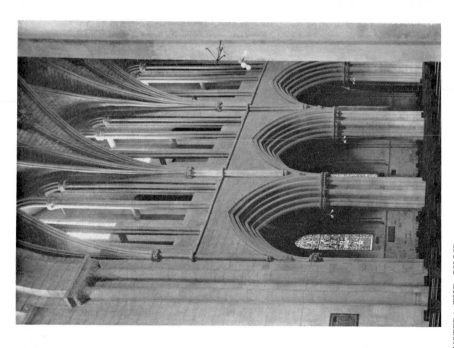

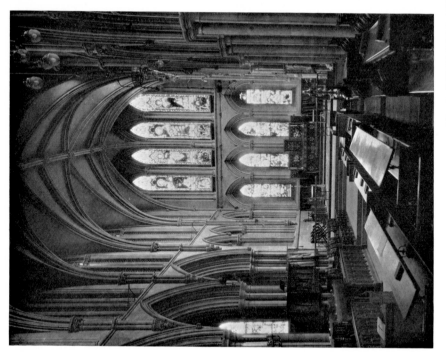

14. *a.* SOUTHWELL MINSTER: THE CHOIR
b. PERSHORE ABBEY: THE CHOIR

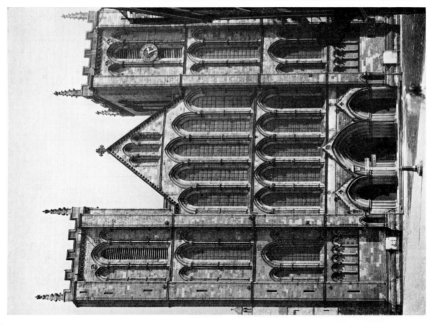

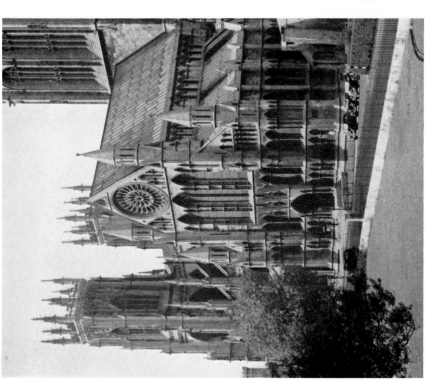

15. *a.* YORK MINSTER: SOUTH TRANSEPT
b. RIPON MINSTER: WEST FRONT

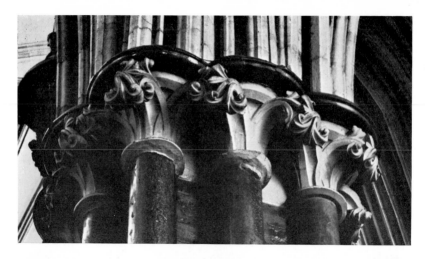

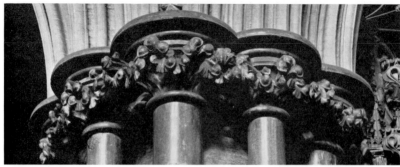

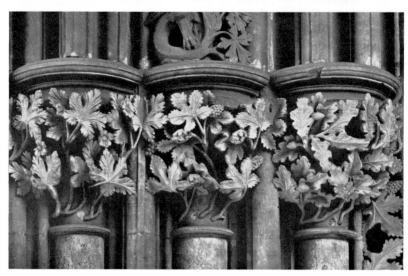

16. CAPITALS. *a*. LINCOLN CATHEDRAL: NAVE. *b*. ELY CATHEDRAL: CHOIR.
c. SOUTHWELL MINSTER: CHAPTER-HOUSE

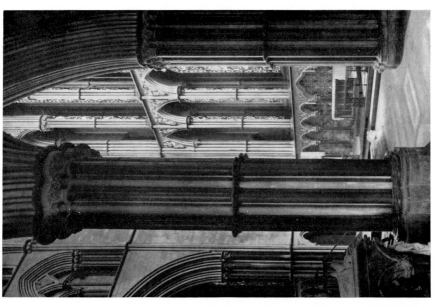

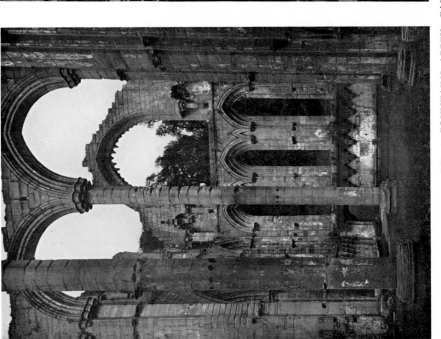

17. *a.* FOUNTAINS ABBEY: EASTERN TRANSEPT
 b. WORCESTER CATHEDRAL: EASTERN TRANSEPT

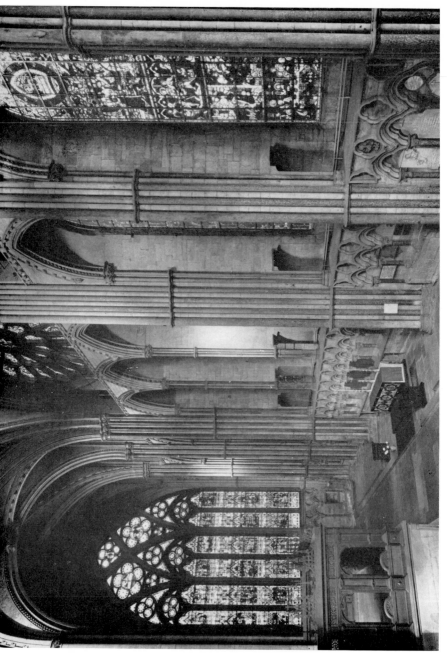

18. DURHAM CATHEDRAL: CHAPEL OF THE NINE ALTARS

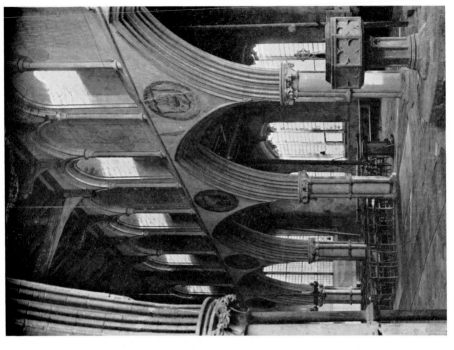

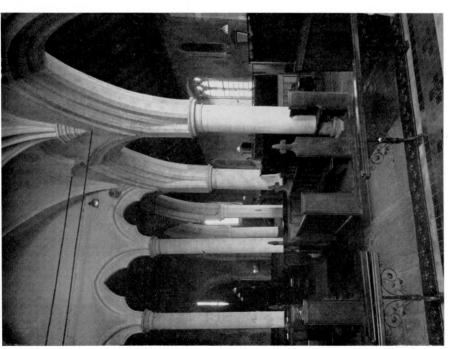

19. *a*. WESTWELL: THE SCREEN
 b. WEST WALTON: THE NAVE

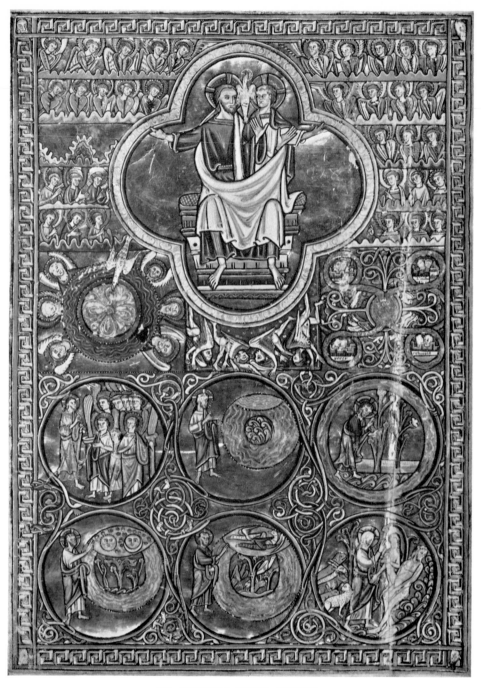

20. LOTHIAN BIBLE: GENESIS

21. INITIALS. *a* and *c*. BIBLE, B.M. MS. Burney 3.
 b. BIBLE, Cambridge University Library, MS. Dd. VIII. 12

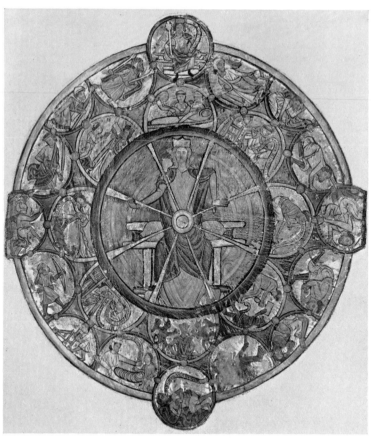

22. *a*. WHEEL OF FORTUNE AND STORY OF THEOPHILUS:
Fitzwilliam Museum MS. 330

b. LOTHIAN BIBLE: STORY OF JOB

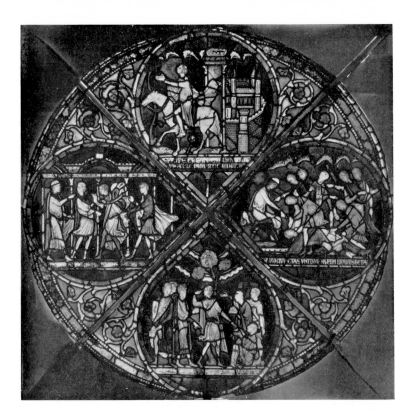

23. *a.* CANTERBURY CATHEDRAL, WINDOW: STORY OF EILWARD
OF WESTONEY

b. PSALTER: Trinity College, Cambridge, MS. B. 11. 4: STORY OF
JOSEPH

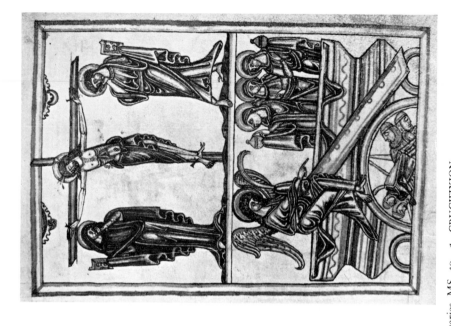

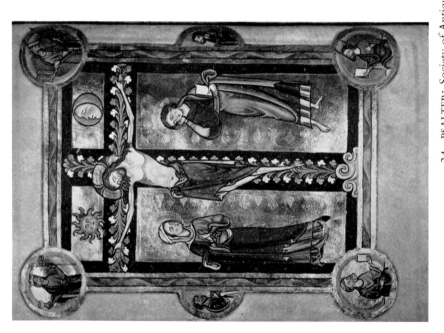

24. PSALTER: Society of Antiquaries, MS. 59. *a.* CRUCIFIXION
b. CRUCIFIXION AND THE THREE WOMEN AT THE TOMB

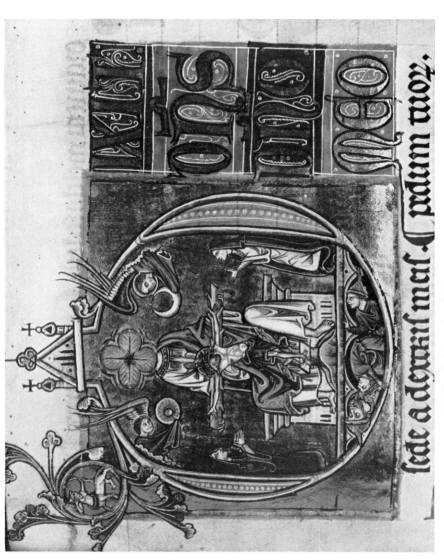

25. PSALTER: Trinity College, Cambridge, MS. B. 11. 4: INITIAL TO PS. 109

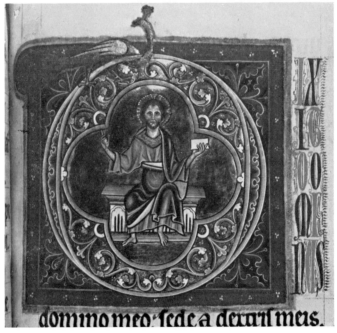

26. *a.* PSALTER: C.C.C.C. MS. M. 2: NOLI ME TANGERE
 b. PSALTER: Fitzwilliam Museum, MS. 12: CHRIST IN
 MAJESTY

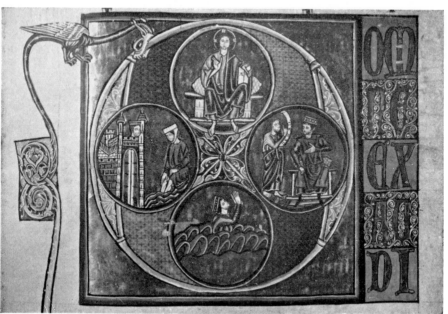

27. PSALTER: New College, MS. 322

a. SAUL AND DAVID
b. DAVID AND BATHSHEBA

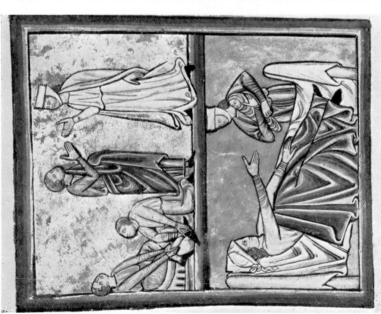

28. PSALTER: Walters Art Gallery, Baltimore, MS. 500

a. STORY OF RUTH *b.* LOT LEAVES SODOM

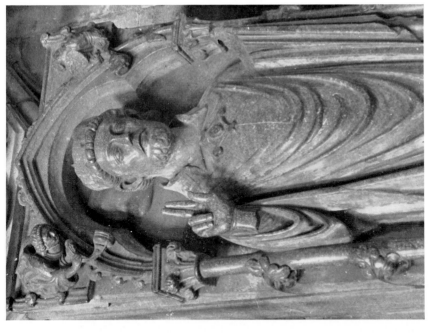

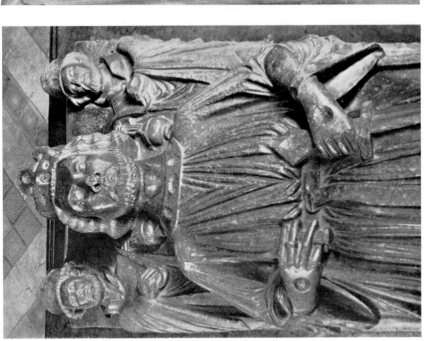

29. *a.* WORCESTER CATHEDRAL: EFFIGY OF KING JOHN

b. ELY CATHEDRAL: EFFIGY OF BISHOP WILLIAM OF KILKENNY

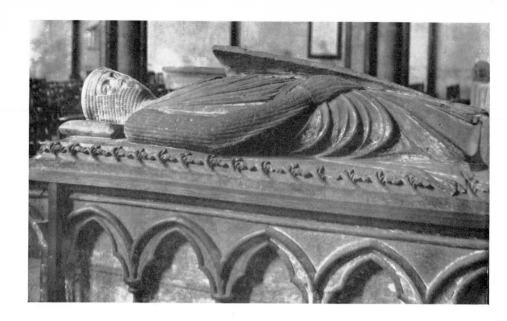

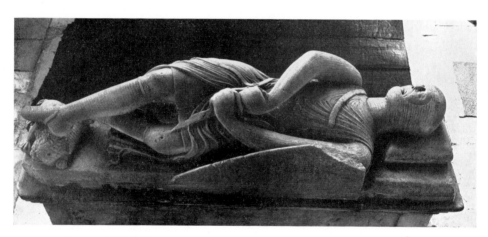

30. *a*. SALISBURY CATHEDRAL: EFFIGY OF WILLIAM LONGESPÉE

b. DORCHESTER, OXON.: EFFIGY OF A KNIGHT

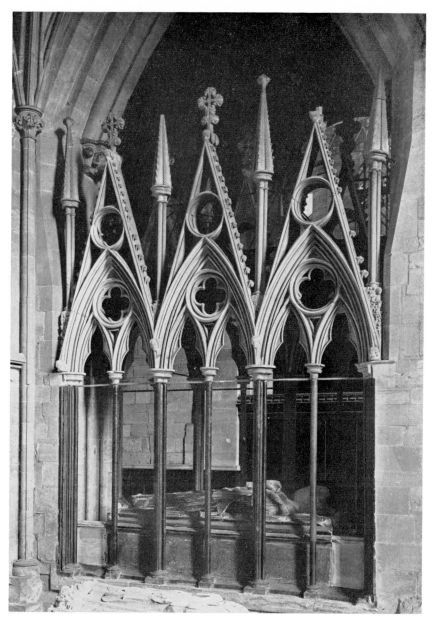

31. HEREFORD CATHEDRAL: TOMB OF BISHOP PETER
OF AIGUEBLANCHE

32. SALISBURY CATHEDRAL: TOMB OF BISHOP GILES BRIDPORT

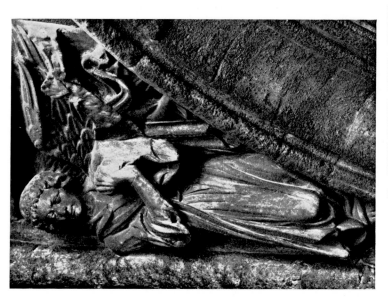

33. WESTMINSTER ABBEY: ANGELS FROM NORTH AND SOUTH TRANSEPTS

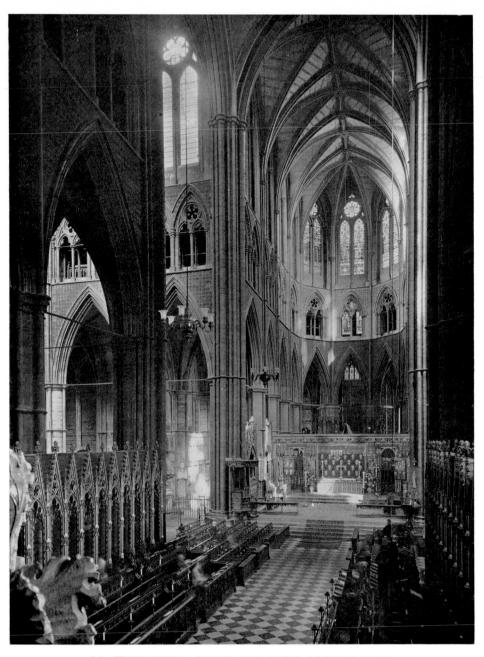

34. WESTMINSTER ABBEY: THE CHOIR LOOKING EAST

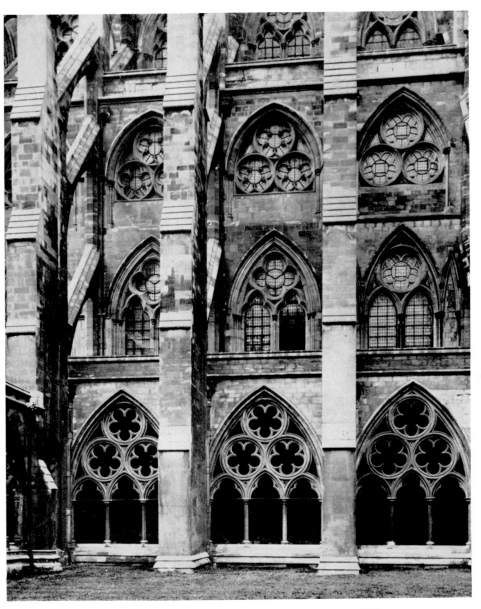

35. WESTMINSTER ABBEY: EXTERIOR FROM SOUTH

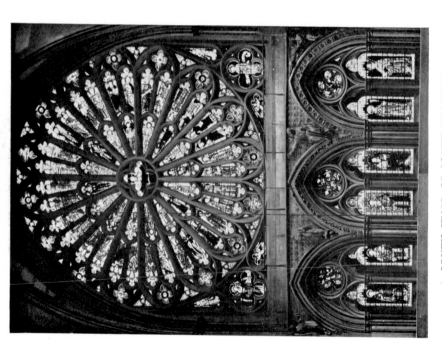

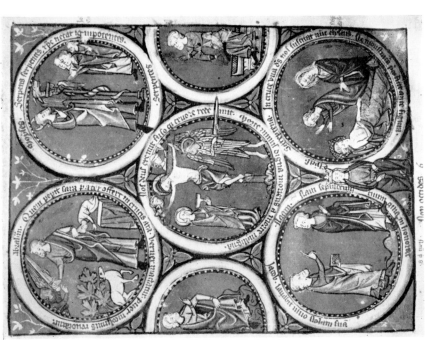

37. *a.* TYPES AND ANTI-TYPES: Eton College, MS. 177
b. PRAYING KNIGHT: B.M. MS. Royal 2 A. XXII

38. WESTMINSTER ABBEY: HEAD STOPS

39. BOSSES. *a.* CHESTER CATHEDRAL: VIRGIN AND CHILD. *b.* WESTMINSTER ABBEY: CENTAUR AND DRAGON. *c.* DURHAM CATHEDRAL: FOUR EVANGELISTS

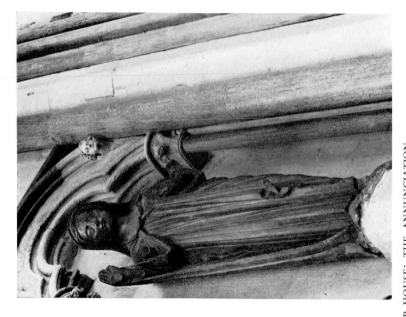

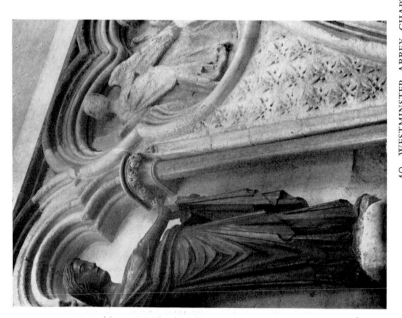

40. WESTMINSTER ABBEY CHAPTER-HOUSE: THE ANNUNCIATION

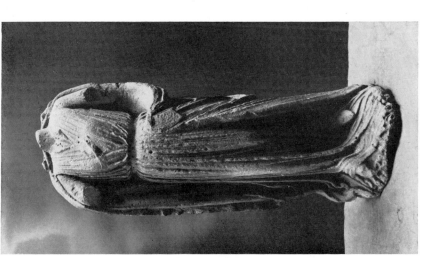

41. *a.* WINCHESTER CATHEDRAL: FEMALE FIGURE

b. ANNUNCIATION. Cambridge University Library, MS. Kk. IV. 25

42.　*a.* VIRGIN AND CHILD.　　*b.* KINGS OF ENGLAND.　　B.M. MS. Royal 14 C. VII

43. *a.* SOCRATES AND PLATO. *b.* SPERA BESTIARUM. Bodl. MS. Ashmole 304

44. CHRONICA MAJORA

 a. THE THREE MAGI. C.C.C.C. MS. 26

 b. HENRY III AND THE RELICS. C.C.C.C. MS. 16

 c. TREATY BETWEEN EARL RICHARD AND THE SARACENS. C.C.C.C. MS. 16

45. HISTORIA ANGLORUM AND CHRONICA MAJORA
 a. GRIFFIN'S ESCAPE. B.M. MS. Royal 14 C. VII
 b. GRIFFIN'S ESCAPE. C.C.C.C. MS. 16
 c. CAPTURE OF THE CROSS BY SALADIN. C.C.C.C. MS. 26

46. CHRONICA MAJORA. C.C.C.C. MS. 16

 a. THE WANDERING JEW

 b. DEATH OF GILBERT MARSHAL

 c. ST. FRANCIS RECEIVING THE STIGMATA

47. *a*. CORONATION OF KING ARTHUR. Manchester, Chetham's Library, MS. 6712
 b. CORONATION OF ST. EDWARD. Cambridge University Library, MS. Ee. III. 59

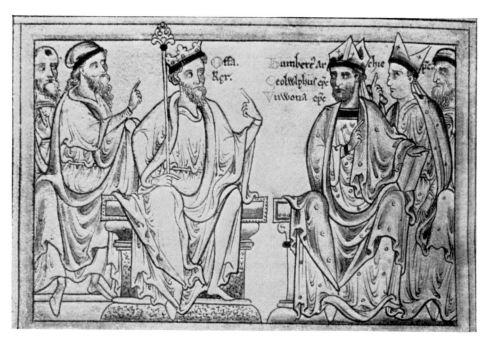

48. LIFE OF ST. ALBAN. Trinity College, Dublin, MS. E. i. 40

a. ST. ALBAN ORDERED TO WORSHIP PAGAN IMAGES

b. OFFA AND THE BISHOPS IN CONFERENCE

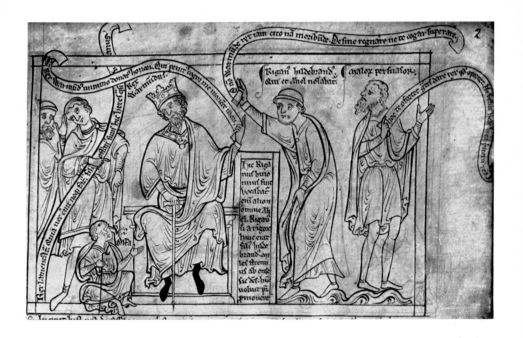

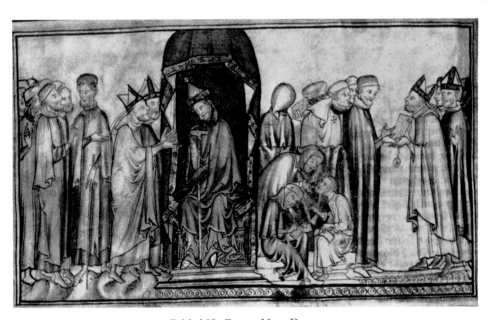

49. *a*. LIFE OF OFFA. B.M. MS. Cotton Nero D. 1
 b. LIFE OF ST. EDWARD. Cambridge University Library, MS. Ee. III. 59

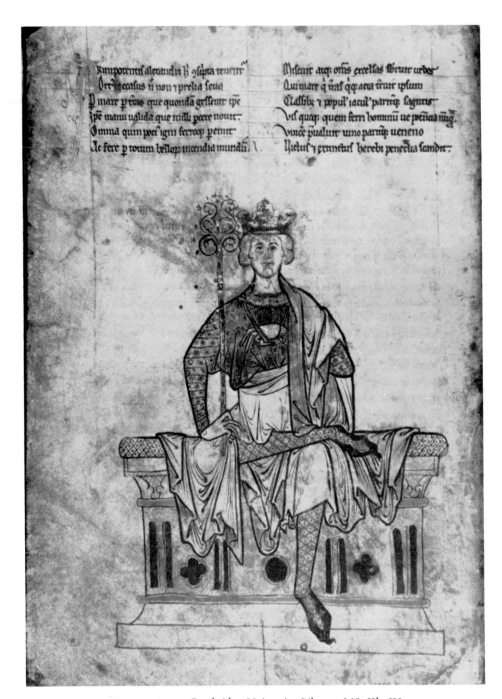

Omnipotens alexandri hic scepta tenetur
Orbis et casus ni non et prelia seua
P mare pelras que quonda gesserat ipse
ipse manu ualida que nulla potere nouit.
Omnia quin poes igni ferroq petiuit
Ac fere p totum bellog incendia mundi.

Miscuit atq; omis excelsas Gruit urbes
Quimare q uas qq aera tuit ipsum
Classib; et popul iaecul'parteq; sagitis
Vis quoq; quem ferri hominu ue potitua mig.
Vince pualuit uino parteq; ueneno
Uictus et extinctus herebi penetrla scandit.

50. ALEXANDER. Cambridge University Library, MS. Kk. IV. 25

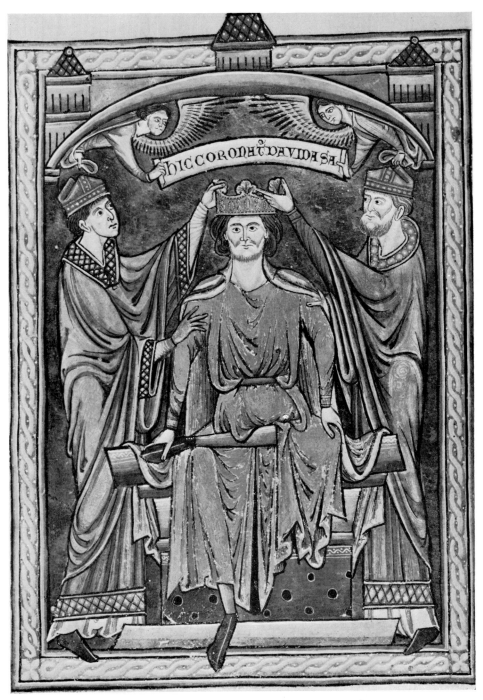

51. CORONATION OF DAVID. Pierpont Morgan Library

Sianerunn est super nos lumen uultus tui domine deus deisith lenciehn in cede

S Outtur an veronica tale noun a dd mihere sie dda ad

52. HEAD OF CHRIST
a. LAMBETH APOCALYPSE. *b.* C.C.C.C. MS. 16

53. HEAD OF CHRIST. B.M. MS. Royal 2 A. XXII

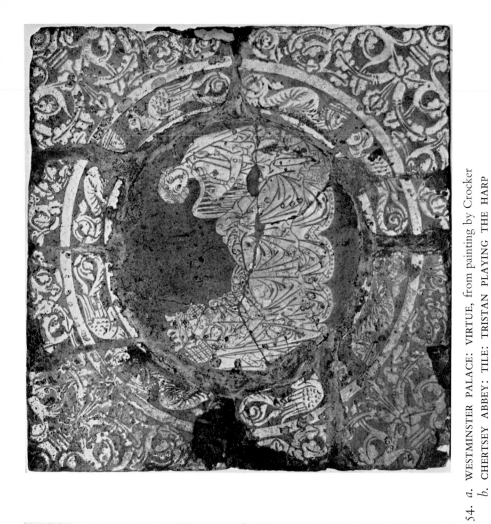

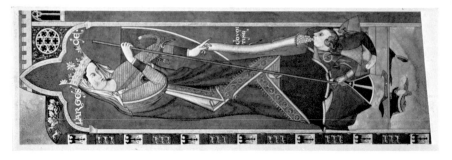

54. *a.* WESTMINSTER PALACE: VIRTUE, from painting by Crocker
b. CHERTSEY ABBEY: TILE: TRISTAN PLAYING THE HARP

55. *a.* CHRIST OF THE APOCALYPSE. B.M. MS. Cotton Nero D. I.
 b. THE HEAVENLY JERUSALEM. Trinity College, Cambridge, MS. R. 16. 2

56. THE ADORATION OF THE LAMB

Trinity College, Cambridge, MS. R. 16. 2

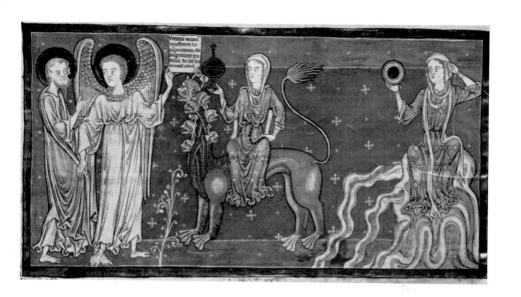

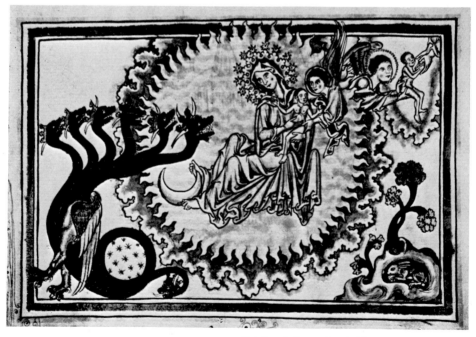

57. *a*. THE WOMAN ON THE BEAST. Trinity College, Cambridge, MS. R. 16. 2

b. THE WOMAN AND THE DRAGON. Paris, Bibl. Nat. MS. lat. 403

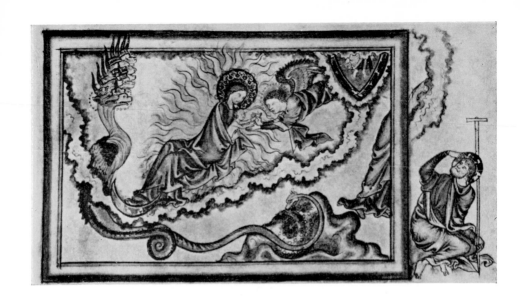

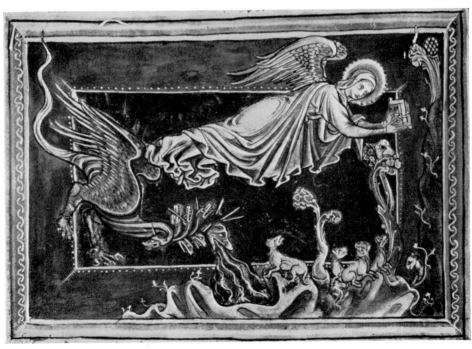

58. *a.* THE WOMAN AND THE DRAGON. Dyson Perrins MS. 10
b. LAMBETH APOCALYPSE

59. *a*. THE SLAYING OF THE WITNESSES. B.M. MS. Add. 42555
b. THE HEAVENLY JERUSALEM. Eton College, MS. 177

60. LAMBETH APOCALYPSE: LEGEND OF THEOPHILUS

61. *a.* CHICHESTER MISSAL: INITIAL TO CANON OF THE MASS
 b. CHICHESTER ROUNDEL

62. EVESHAM PSALTER: CRUCIFIXION

63. CHICHESTER MISSAL: ANNUNCIATION

64. VIRGIN AND CHILD. *a*. AMESBURY PSALTER. *b*. LAMBETH APOCALYPSE

65. *a.* EVESHAM PSALTER: INITIAL
 b. AMESBURY PSALTER: INITIAL

66. a. BIBLE OF WILLIAM OF DEVON
b. PSALTER, Pierpont Morgan Library, MS. 756: VARIOUS SAINTS

67. *a.* OSCOTT PSALTER: THE MAGI

b. PSALTER, St John's College, Cambridge, MS. K 26: ABRAHAM AND THE ANGELS

68. *a.* BOOK OF PSALMS WITH COMMENTARY, Durham Cathedral, MS. A. II. 10: INITIAL

b. PSALTER, Coll. E. G. Millar, Esq.: JUDITH AND HOLOFERNES

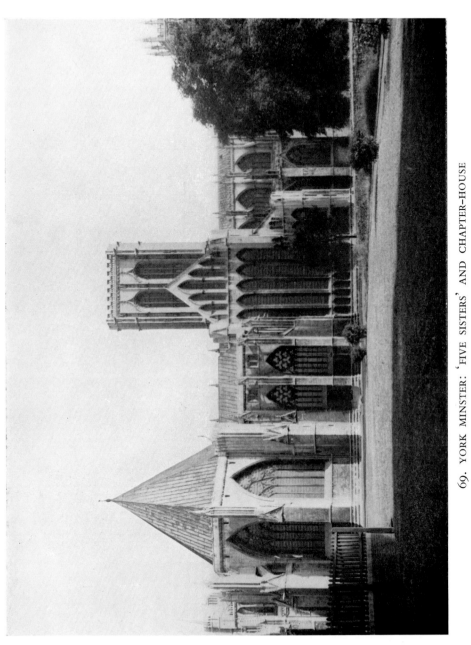

69. YORK MINSTER: 'FIVE SISTERS' AND CHAPTER-HOUSE

70. *a*. BINHAM PRIORY: WEST FRONT
 b. NETLEY ABBEY

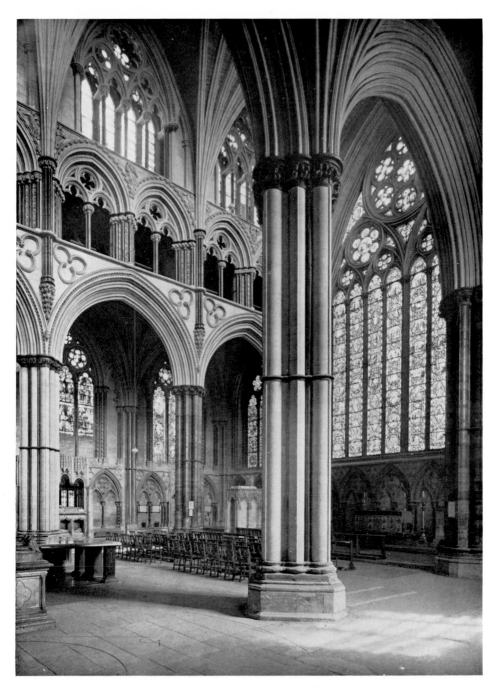

71. LINCOLN CATHEDRAL: ANGEL CHOIR

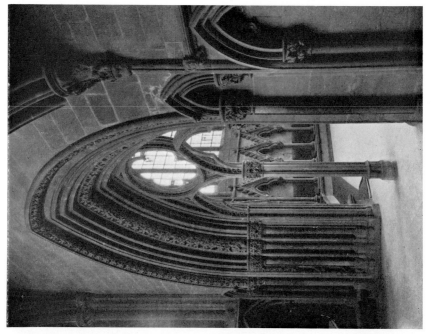

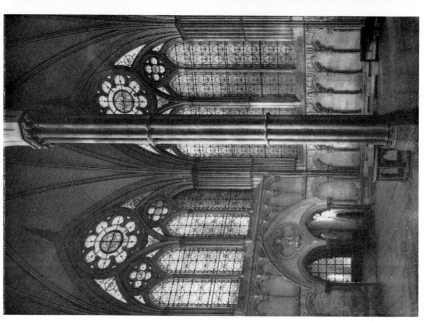

72. *a.* SALISBURY CATHEDRAL: CHAPTER-HOUSE
b. SOUTHWELL MINSTER: CHAPTER-HOUSE

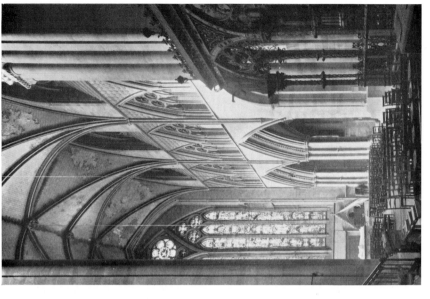

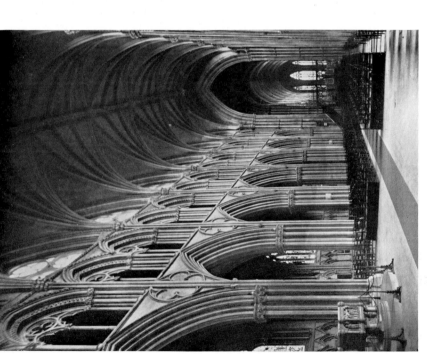

73. *a.* LICHFIELD CATHEDRAL: NAVE

b. HEREFORD CATHEDRAL: NORTH TRANSEPT

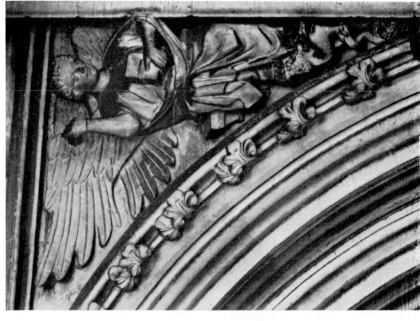

74. LINCOLN CATHEDRAL: ANGELS FROM ANGEL CHOIR

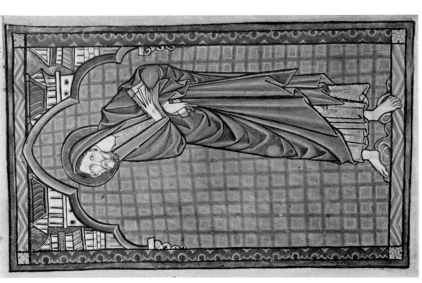

75. *a.* OSCOTT PSALTER: APOSTLE
b. LINCOLN CATHEDRAL: VIRTUES

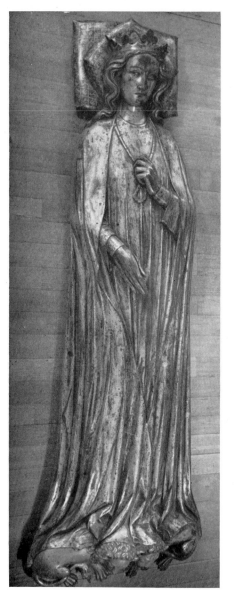 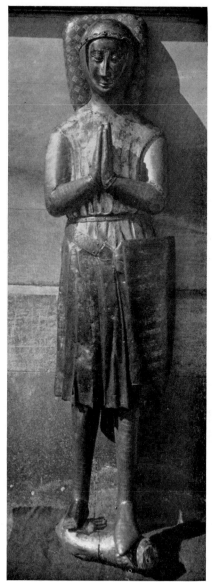

a. QUEEN ELEANOR *b*. WILLIAM OF VALENCE

76. WESTMINSTER ABBEY: EFFIGIES

77. *a.* CLIFFORD, HEREFORDSHIRE: WOODEN EFFIGY OF PRIEST
 b. HEREFORD CATHEDRAL: EFFIGY OF JOHN SWINFIELD

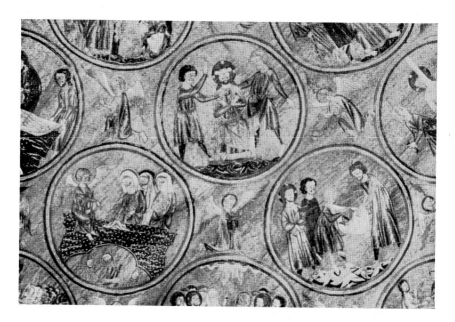

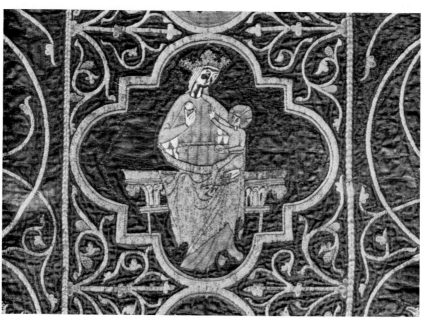

78. *a*. ANAGNI COPE: DETAIL
 b. CLARE CHASUBLE: VIRGIN AND CHILD

79. *a*. ASCOLI–PICENO COPE: HEAD OF CHRIST
b. VATICAN COPE: CORONATION OF THE VIRGIN

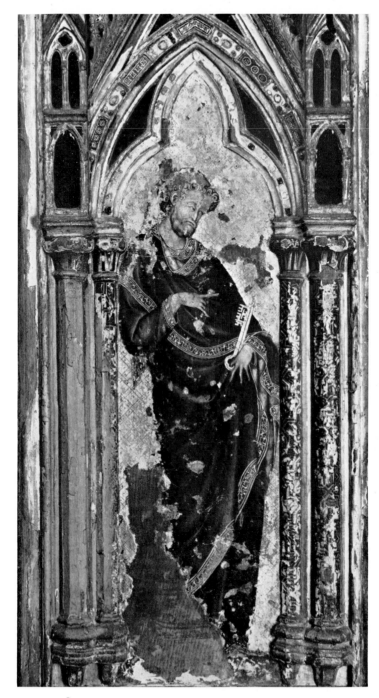

80. WESTMINSTER ABBEY, RETABLE: ST. PETER

81. WESTMINSTER ABBEY, WALL PAINTING:
INCREDULITY OF ST. THOMAS

82. *a.* SALVIN HOURS: MARTYRDOM OF ST. CATHERINE
b. PETRUS COMESTOR: CHURCH AND SYNAGOGUE

83. *a.* WESTMINSTER ABBEY, RETABLE: DETAIL
 b. DOUCE APOCALYPSE: THE ANGEL WITH THE MILLSTONE

84. *a.* DUBLIN APOCALYPSE: THE RIDER ON THE WHITE HORSE
b. PSALTER, Fitzwilliam Museum, MS. 370: ST. MARTIN AND THE BEGGAR

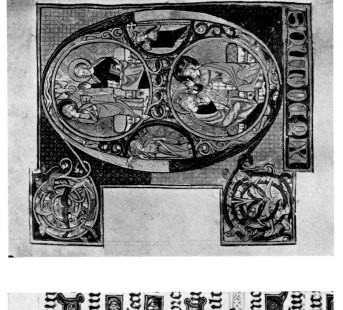

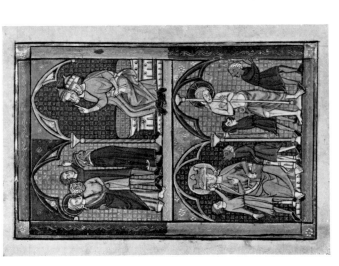

85. *a.* HUTH PSALTER: SCENES OF THE PASSION

b. TENISON PSALTER: ANGEL

c. HUTH PSALTER: ANNUNCIATION AND CORONATION OF THE VIRGIN

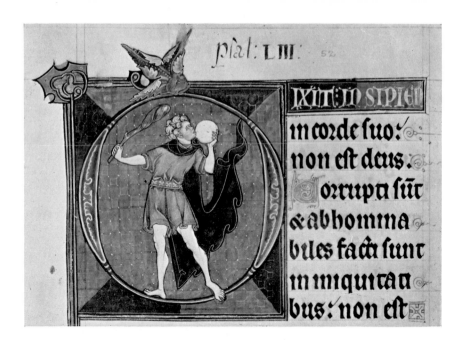

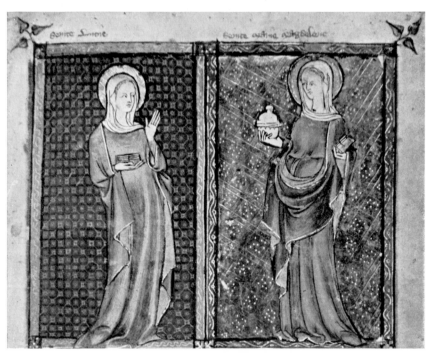

86. *a.* WINDMILL PSALTER: THE FOOL
b. TENISON PSALTER: FEMALE SAINTS

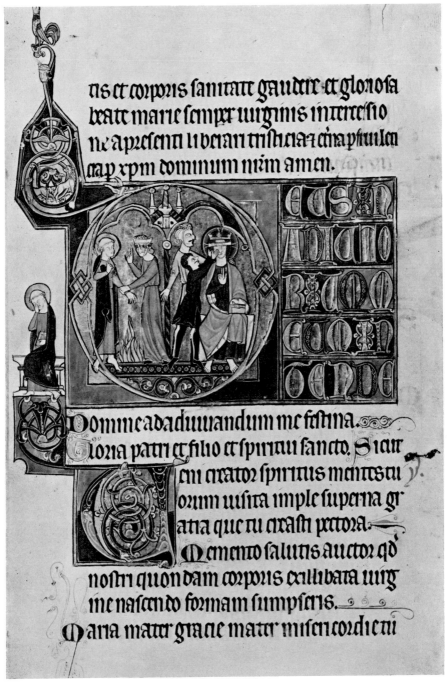

tis et corporis sanitate gaudere et gloriosa
beate marie semper virginis intercessio
ne a presenti liberari tristicia et etiam profuture
capi xpm dominum nrm amen.

Domine ad adiuuandum me festina.
Gloria patri et filio et spiritui sancto. Sicut
eni creator spiritus mentes tu
orum uisita imple superna gr
atia que tu creasti pectora.
Memento salutis auctor qd
nostri quondam corporis ex illibata uirg
ine nascendo formam sumpseris.
Maria mater gracie mater misericordie tu

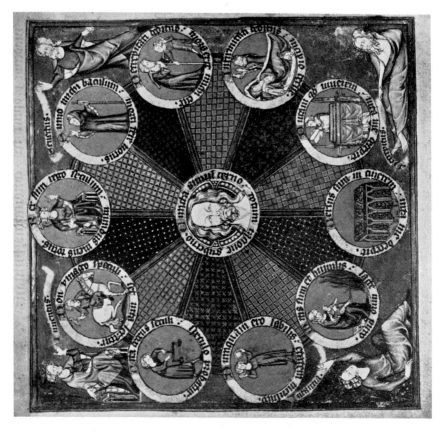

88. *a.* TENSION PSALTER: PASSION SCENES
b. ARUNDEL PSALTER: WHEEL OF THE AGES OF MAN

89. GREGORII MORALIA SUPER JOB: Emmanuel College, Cambridge, MS. II. 1. 1.

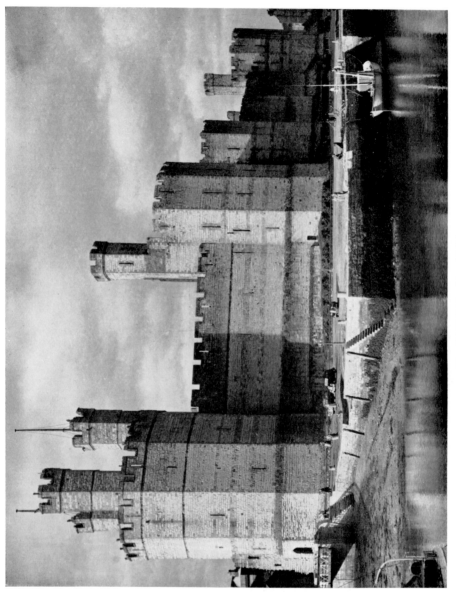

90. CAERNARVON CASTLE

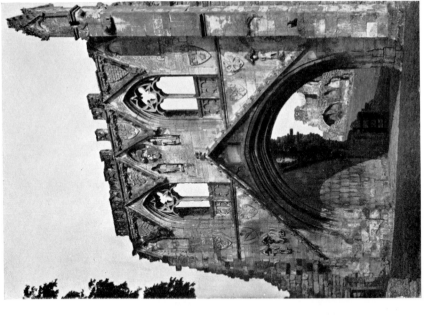

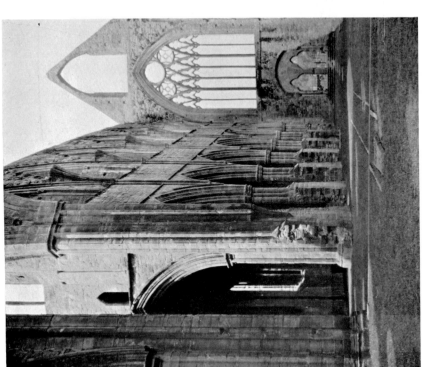

91. *a.* TINTERN ABBEY
b. KIRKHAM PRIORY: THE GATEHOUSE

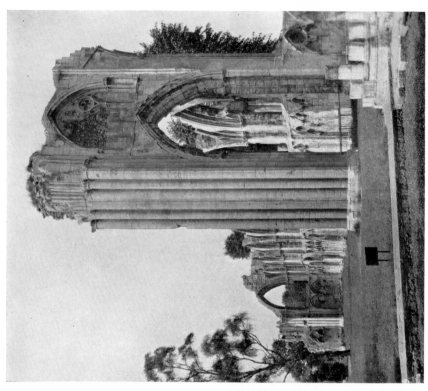

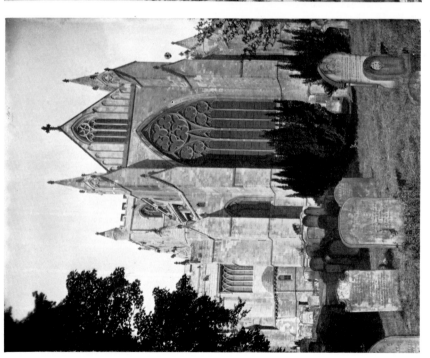

92. a. RIPON MINSTER FROM THE EAST
b. YORK: ST. MARY'S ABBEY, LOOKING WEST

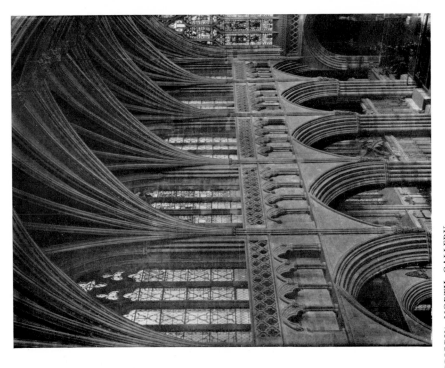

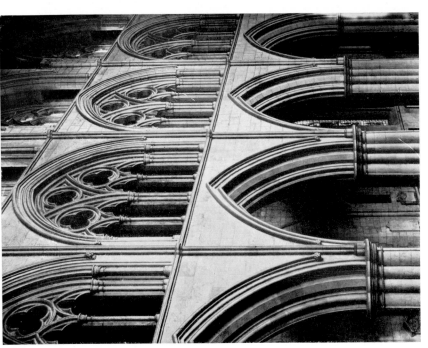

93. *a.* BRIDLINGTON PRIORY: NORTH GALLERY

b. EXETER CATHEDRAL: CHOIR TRIFORIUM

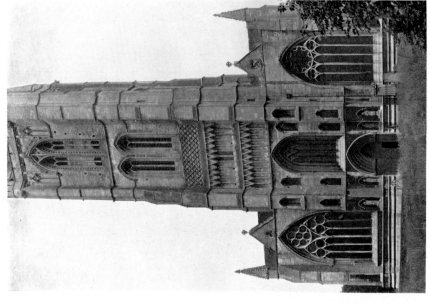

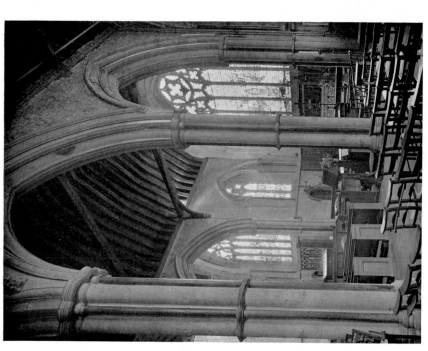

94. *a.* WINCHELSEA, ST. THOMAS, FROM THE SOUTH AISLE
b. GRANTHAM, ST. WULFRAM: WEST FRONT

95. *a.* CONWAY CASTLE
b. HARLECH CASTLE

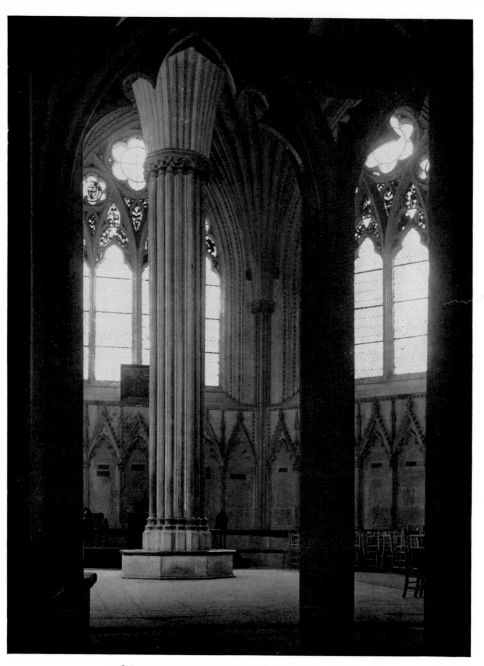

96. WELLS CATHEDRAL: THE CHAPTER-HOUSE